THE VISUAL ARTS
AND CHRISTIANITY IN AMERICA

THE VISUAL ARTS
AND CHRISTIANITY IN AMERICA

From the Colonial Period to the Present

New, Expanded Edition

John Dillenberger

Crossroad • New York

1989

The Crossroad Publishing Company
370 Lexington Avenue, New York, N. Y. 10017

Copyright © 1988 by John Dillenberger

The work of Constantin Brancusi is copyright ARS N.Y./ADAGP, 1988.

Printed in the United States of America

Library of Congress Cataloging-in-Publication Data

Dillenberger, John.
The visual arts and Christianity in America: from the colonial
period to the present/John Dillenberger. —New, expanded ed.
p. cm.
Bibliography: p.
Includes index.
ISBN 0-8245-0890-4
1. Christian art and symbolism—Modern period, 1500- —United
States. I. Title.
N7903.D54 1988
701′ .04—dc19 88-27596
 CIP

Dedicated to the next two generations

Benjamin, Bonnie, Denis, Eric, Kate, Lisa, Michael, Paul, Timothy, Tom

with admiration, hope, and love

CONTENTS

Notes on the Plates

Plates have the limited but necessary role of providing the visual points of reference for comments about the works themselves, though they are no substitute for the works of art. Their placement before the text of this volume is not to invite perusal of them alone, but to facilitate referring to them while reading the text. I have always found it easier when reading to refer to the beginning of a volume than the end. The same problem exists with reference to footnotes, but I certainly would not expect them first for aesthetic reasons. I am glad that the Press indulged me in the matter of the placing of the plates, in spite of its own reservations about doing so.

The plates are reproduced by permission, and I am grateful to many museums, galleries, universities, and individuals for this courtesy. When reading the caption for each plate, the reader should assume that permission has been granted by the institution or entity named. Only in instances where special instructions were supplied has this procedure been altered. Where no acknowledgements are given, the plates were printed from negatives made from our slides.

Plate 1

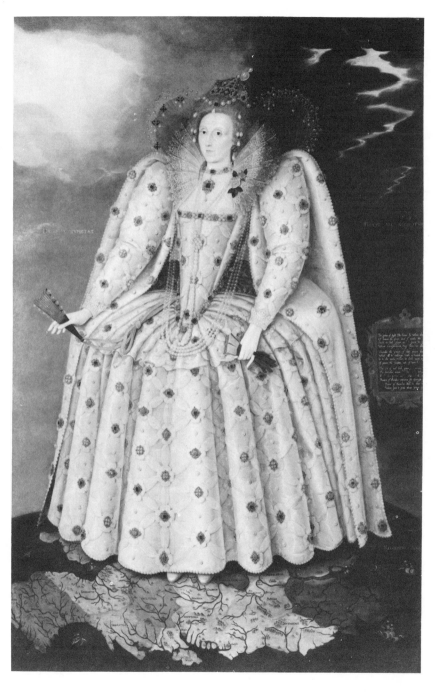

(Artist unknown), *Queen Elizabeth I*, ca. 1592. National Portrait Gallery, London.

Plate 2

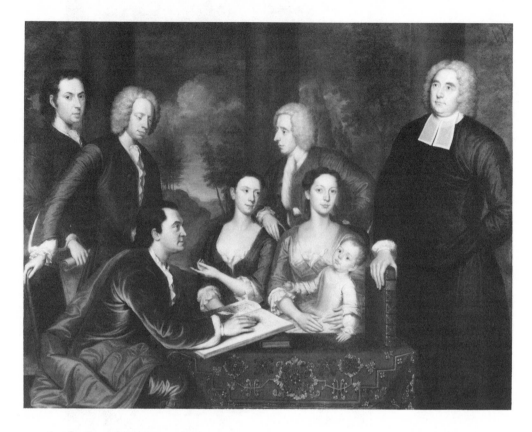

John Smibert, *The Bermuda Group—Dean George Berkeley and His Family*. Yale University Art Gallery; gift of Isaac Lothrop.

Plate 3

(Artist unknown), *A Council of Ministers*, ca. 1744. Courtesy of the Fogg Art Museum, Harvard University; gift of Dr. Francis L. Burnett and Mrs. Esther Lowell Cunningham.

Plate 4

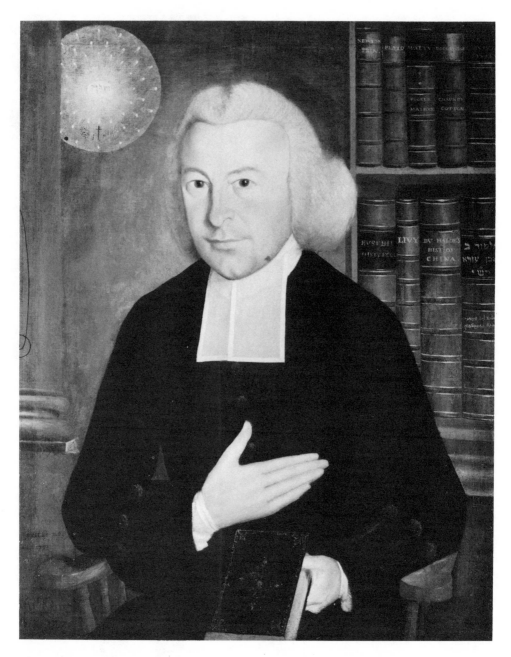

Samuel King, *Portrait of Ezra Stiles*, 1771. Yale University Art Gallery; bequest of Dr. Charles C. Foote.

Plate 5

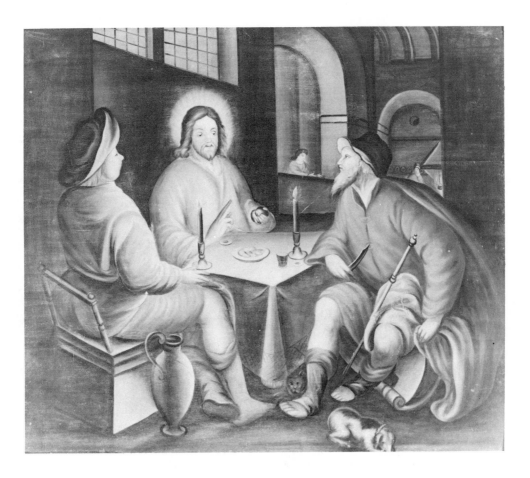

Attributed to Gerardus Duyckinck, *Christ at Emmaus*, early 18th century. Albany Institute of History and Art.

Plate 6

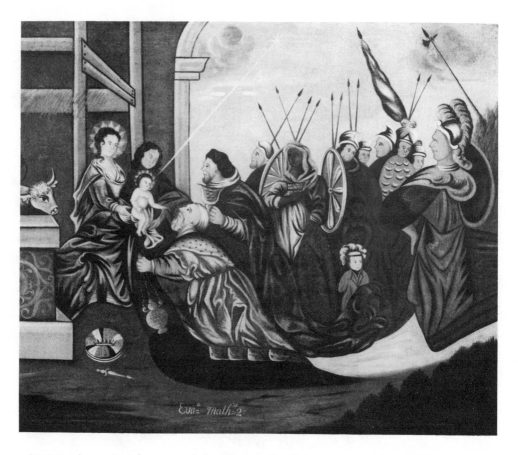

(Artist unknown), *Adoration of the Magi*, early 18th century. Abby Aldrich Rockefeller Folk Art Center, Williamsburg, Virginia.

Plate 7

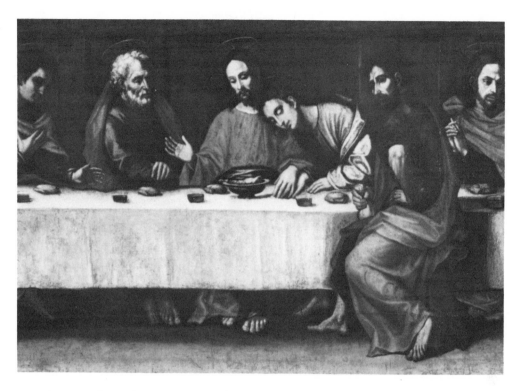

(Artist unknown), *Last Supper* (detail). St. Barnabas Church, Upper Marlboro, Maryland.

Plate 8

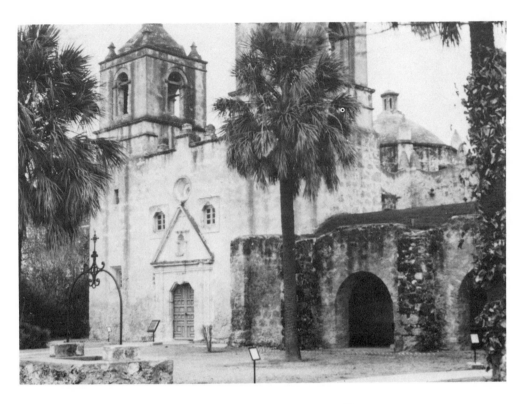

Mission Concepcion. San Antonio, Texas.

Plate 9

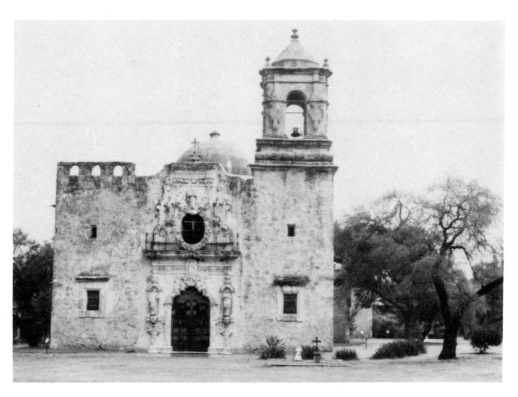

Mission San Jose. San Antonio, Texas.

Plate 10

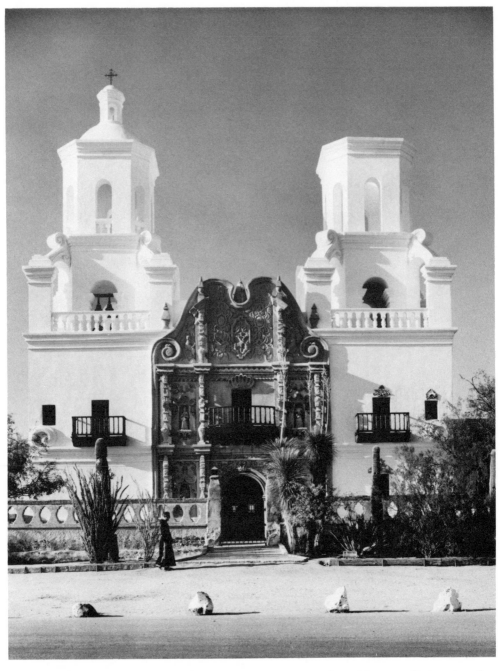

San Xavier del Bac, exterior. Tucson, Arizona. Arizona State Museum, University of Arizona. Helga Teiwes, photograper.

Plate 11

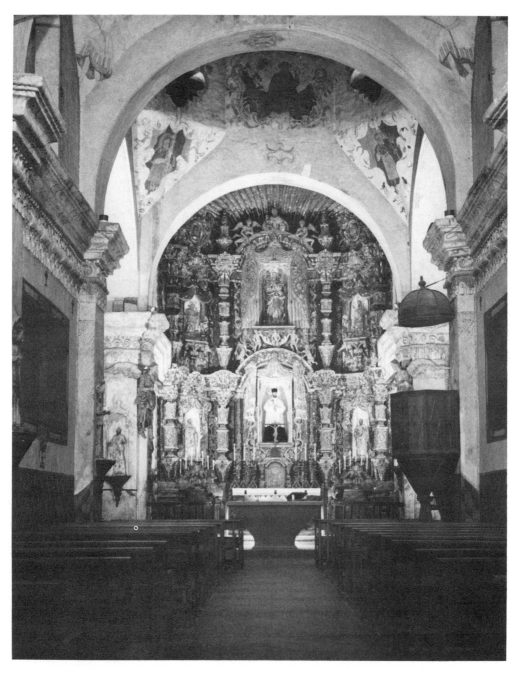

San Xavier del Bac, chancel. Tucson, Arizona. Arizona State Museum, University of Arizona. Helga Teiwes, photographer.

Plate 12

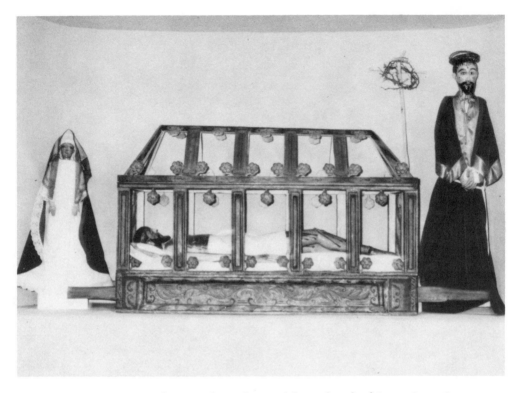

Fray Andrés García, *Christ in the Holy Sepulchre*. Church of Santa Cruz, Santa Cruz, New Mexico.

Plate 13

La Castrense reredos (detail). *Church of Cristo Rey*, Santa Fe, New Mexico.

Plate 14

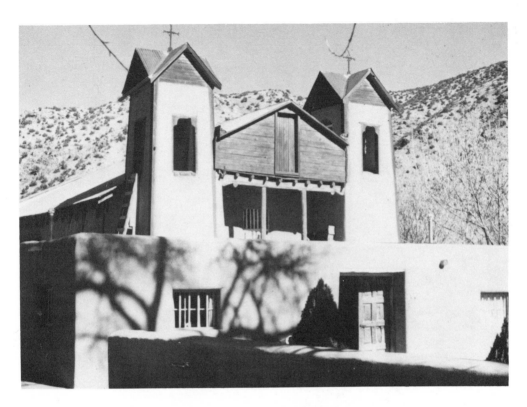

El Santuario. Chimayo, New Mexico.

Plate 15

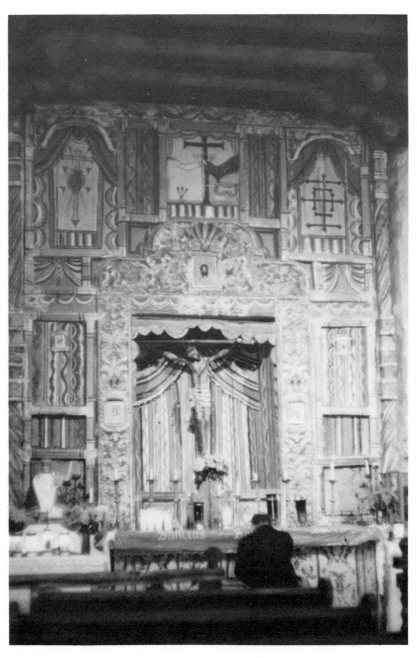

El Santuario, chancel. Chimayo, New Mexico.

Plate 16

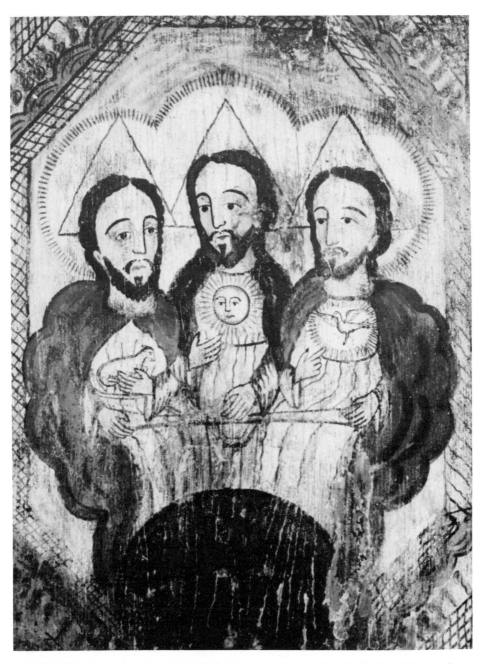

José Aragón, *La Santisima Trinidad* (The Holy Trinity), early 1800s. Historical Society of New Mexico, Collections in the Museum of New Mexico, Santa Fe, New Mexico.

Plate 17

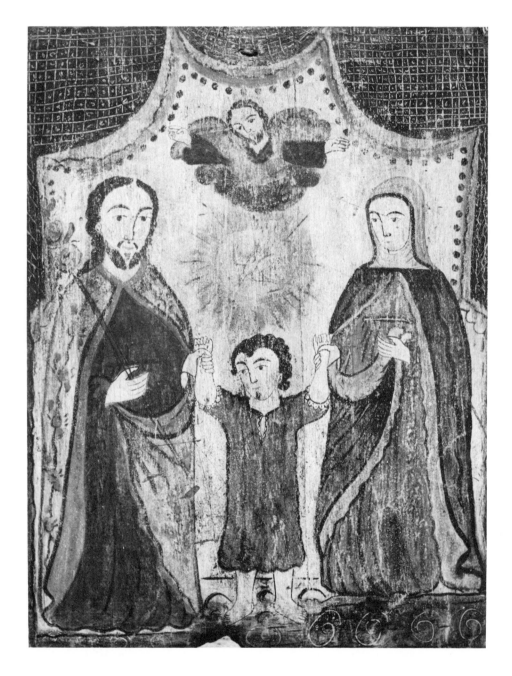

José Aragón, *Holy Family*. Taylor Museum Collection, Colorado Springs Fine Arts Center; gift of Alice Bemis Taylor.

Plate 18

Mission San Juan Bautista, chancel. San Juan Bautista, California.

Plate 19

Mission San Miguel Archangel, chancel. San Miguel, California. Photograph by
G. E. Kidder Smith, from his A *Pictorial History of Architecture in America*.

Plate 20

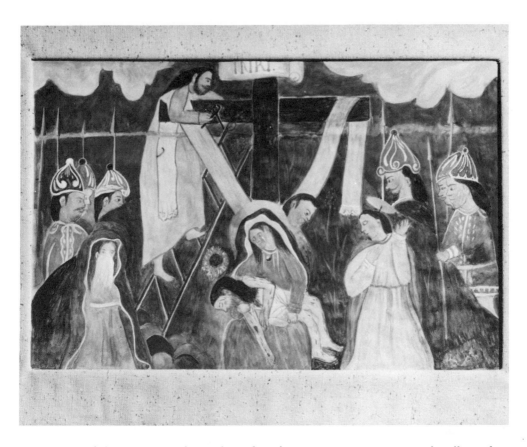

Stations of the Cross #13, facsimile. Index of American Design, National Gallery of Art, Washington, D.C.

Plate 21

Pala Mission, interior. Pala, California.

Plate 22

Father Anthony Ravalli, *The Blessed Virgin*, ca. 1850–57. Sacred Heart Mission, Cataldo, Idaho. Photograph courtesy of Harold Allen.

Plate 23

Father Anthony Ravalli, design of *Altar Wall*: carved and painted *Blessed Virgin* (center) and *St. Ignatius* (right). St. Mary's Mission, Stevensville, Montana. Photograph courtesy of Harold Allen.

Plate 24

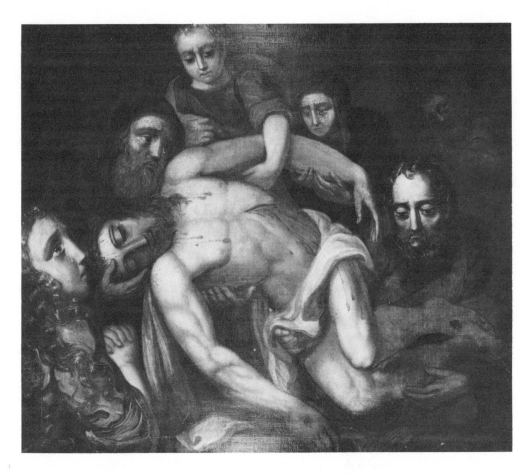

John Valentine Haidt, *Lamentation over the Dead Christ*, ca. 1760. The Moravian Historical Society, Nazareth, Pennsylvania.

Plate 25

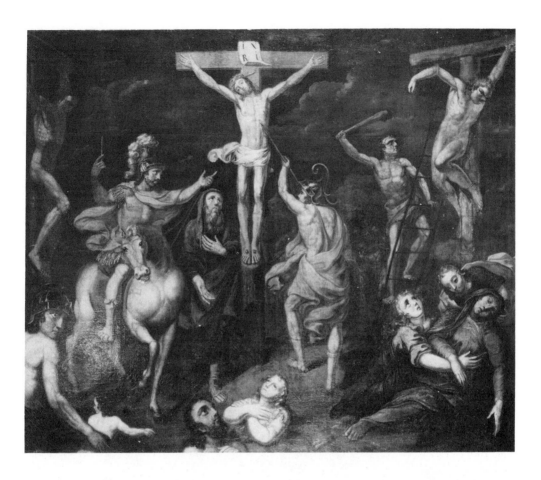

John Valentine Haidt, *The Crucifixion*, 1757. The Moravian Historical Society, Nazareth, Pennsylvania.

Plate 26

John Trumbull, *Timothy Dwight*. Copyright Yale University Art Gallery.

Plate 27

Jared B. Flagg, *Portrait of Horace Bushnell*, 1847. Wadsworth Atheneum, Hartford, Connecticut.

Plate 28

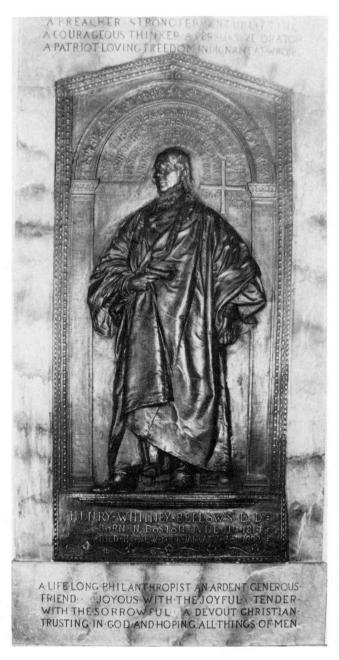

Augustus Saint-Gaudens, *Henry W. Bellows Memorial*. The Unitarian Church of All Souls, New York City. Photograph courtesy of U.S. Department of the Interior, Saint-Gaudens National Historic Site, Cornish, New Hampshire.

Plate 29

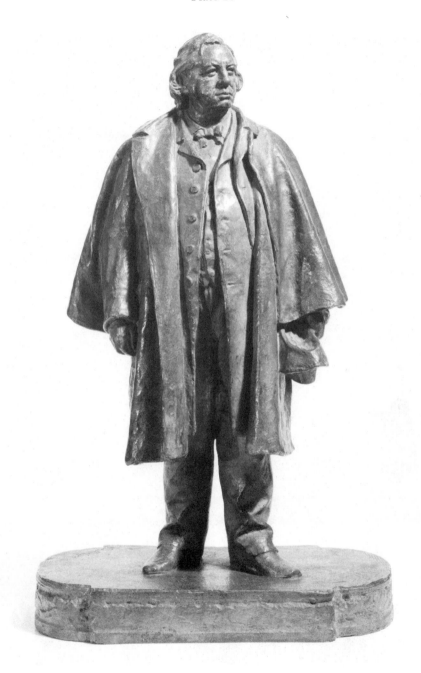

John Quincy Adams Ward, *Henry Ward Beecher*, 1891. The Metropolitan Museum of Art; Rogers Fund, 1917.

Plate 30

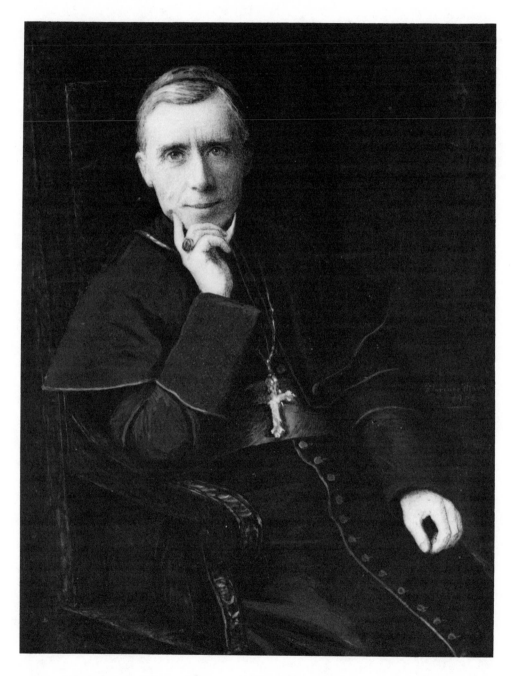

Florence MacKubin, *James Cardinal Gibbons*. The Walters Art Gallery, Baltimore, Maryland.

Plate 31

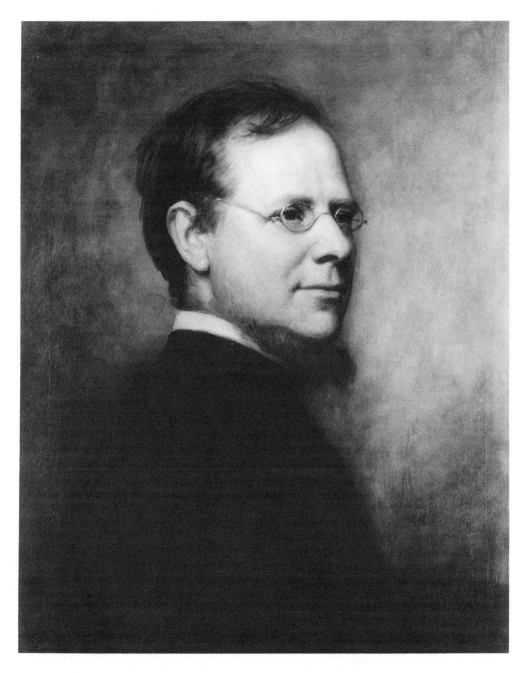

G. P. A. Healy, *Isaac Hecker*. The Paulist Archives, New York City.

Plate 32

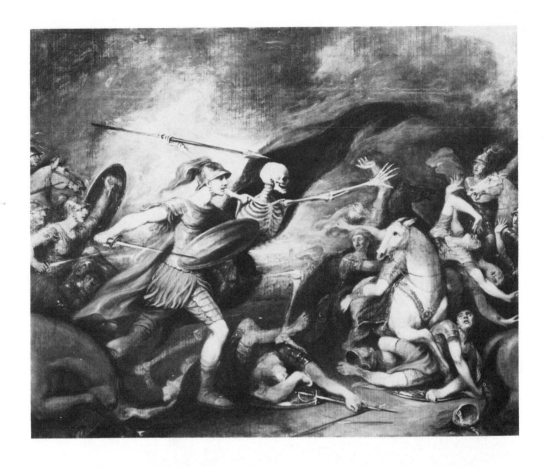

John Trumbull, *Joshua at the Battle of Ai, Attended by Death*, 1839–40. Copyright Yale University Art Gallery.

Plate 33

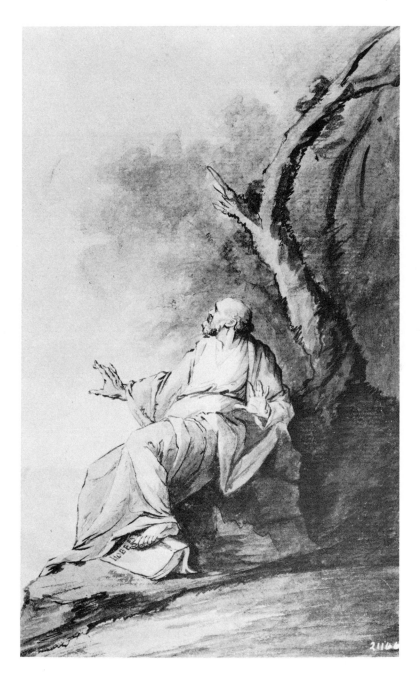

John Trumbull, *And Look Thro' Nature*. Fordham University Library, New York City.

Plate 34

Robert W. Weir, *Church of the Holy Innocents*, as engraved by S. V. Hunt for *The Home Book of the Picturesque*, 1852. U.S. Military Academy Library, West Point.

Plate 35

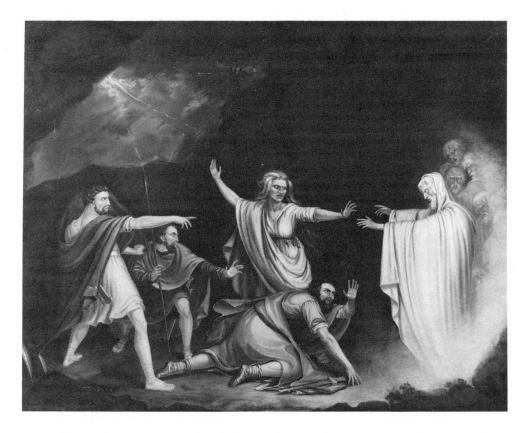

William Sidney Mount, *Saul and the Witch of Endor*, 1828. National Museum of American Art, Smithsonian Institution; gift of the International Business Machines Corporation.

Plate 36

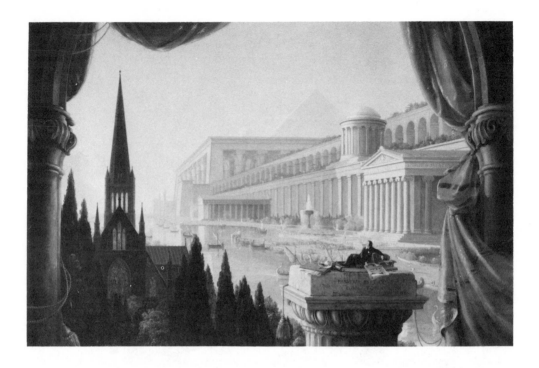

Thomas Cole, *The Architect's Dream*, 1840. The Toledo Museum of Art; gift of Florence Scott Libbey.

Plate 37

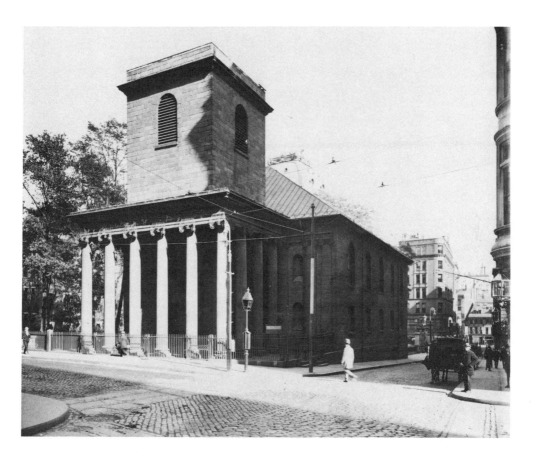

King's Chapel, Boston (photo about 1900). Society for the Preservation of New England Antiquities, Boston, Massachusetts.

Plate 38

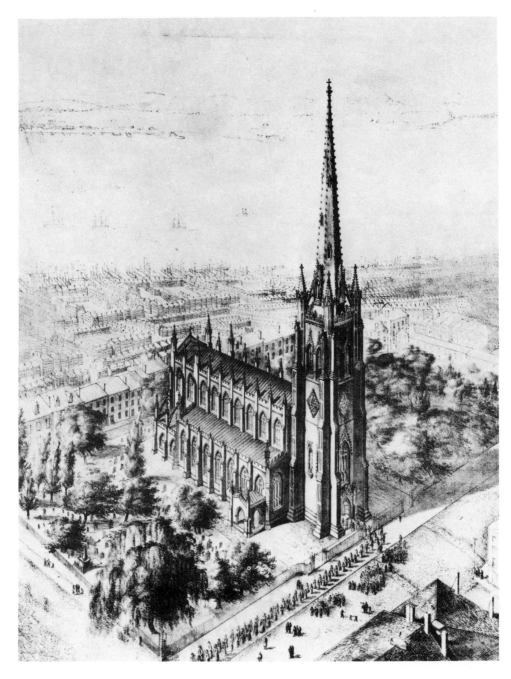

Richard Upjohn, *Trinity Church* (lithograph), New York City. Museum of the City of New York.

Plate 39

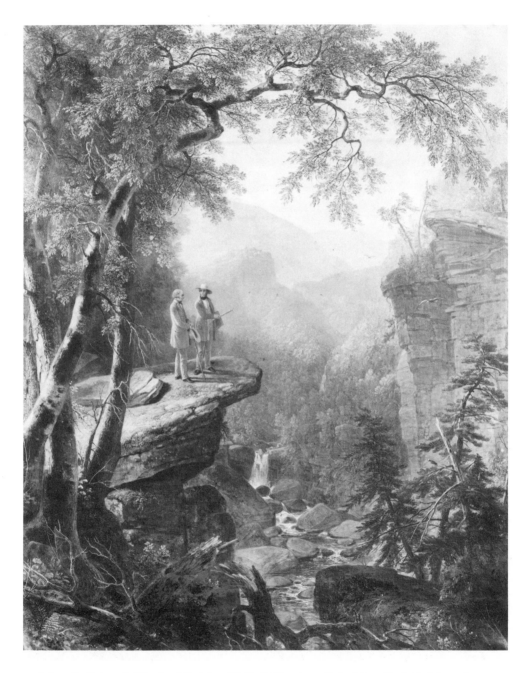

Asher B. Durand, *Kindred Spirits*, 1849. Collection of the New York Public Library; Astor, Lenox and Tilden Foundations.

Plate 40

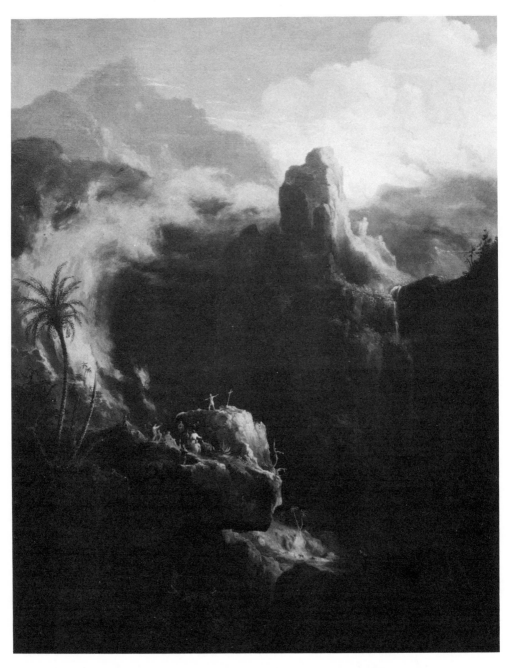

Thomas Cole, *St. John in the Wilderness*, 1827. Wadsworth Atheneum, Hartford, Connecticut.

Plate 41

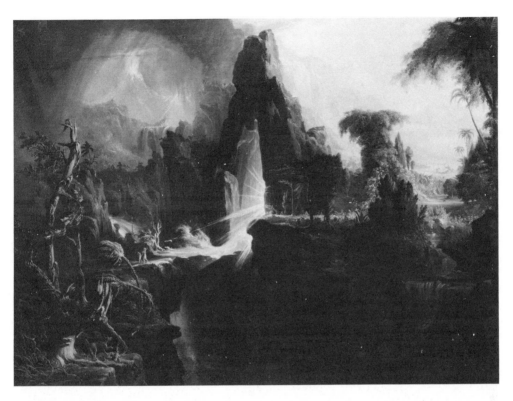

Thomas Cole, *Expulsion from the Garden of Eden*. Courtesy of the Museum of Fine Arts, Boston; M. and M. Karolik Collection.

Plate 42

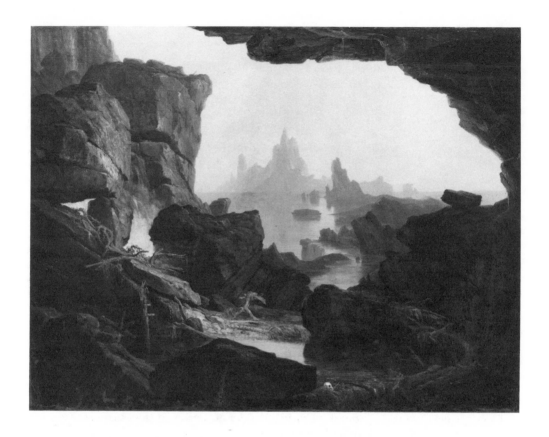

Thomas Cole, *The Subsiding of the Waters of the Deluge*. National Museum of American Art, Washington, D.C.; Museum Donative Purchase from Mrs. James Wallace Dean.

Plate 43

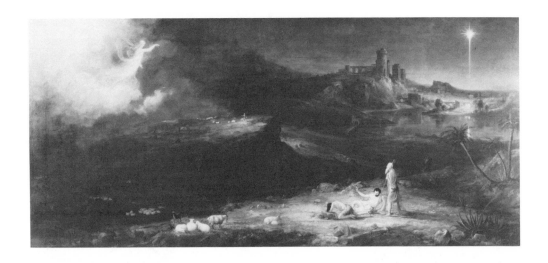

Thomas Cole, *Angel Appearing to the Shepherds*. The Chrysler Museum, Norfolk, Virginia; gift of Walter P. Chrysler, Jr., in memory of Colonel Edgar William and Mrs. Bernice Chrysler Garbisch.

Plate 44

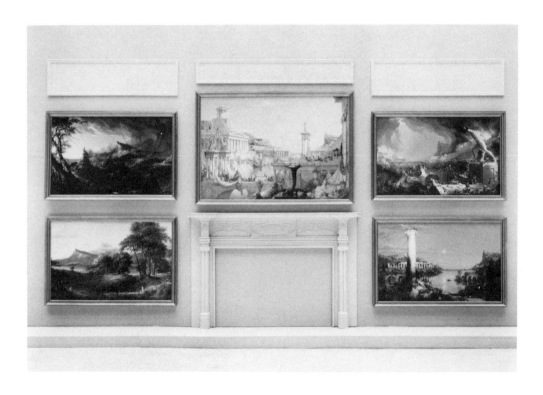

Thomas Cole, *The Course of Empire*. Installation following sketch by Cole in the Detroit Institute of Arts for Luman Reed's home. Courtesy of the Museum of Art, Munson-Williams-Proctor Institute, Utica, New York. Photograph by Larry Pacilio.

Plate 45

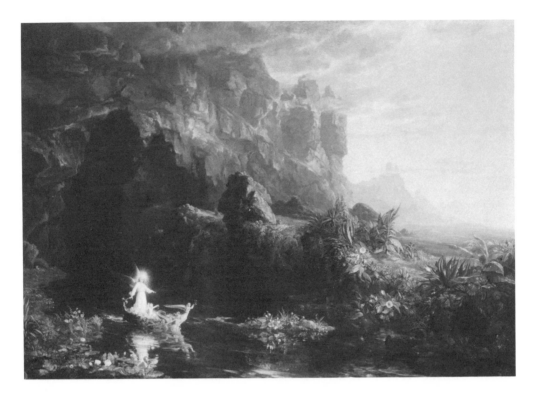

Thomas Cole, *The Voyage of Life: Childhood*, 1842. National Gallery of Art, Washington, D.C.; Ailsa Mellon Bruce Fund, 1971.

Plate 46

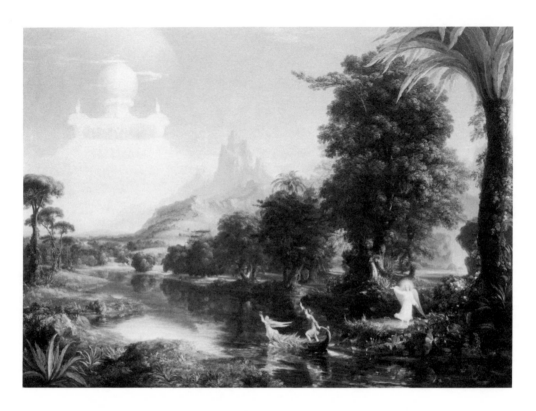

Thomas Cole, *The Voyage of Life: Youth*, 1842. National Gallery of Art, Washington, D.C.; Ailsa Mellon Bruce Fund, 1971.

Plate 47

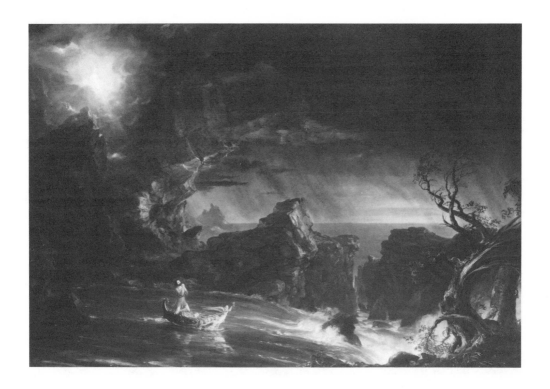

Thomas Cole, *The Voyage of Life: Manhood*, 1842. National Gallery of Art, Washington, D.C.; Ailsa Mellon Bruce Fund, 1971.

Plate 48

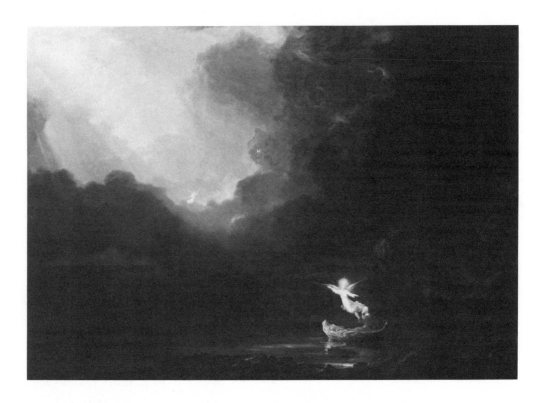

Thomas Cole, *The Voyage of Life: Old Age*, 1842. National Gallery of Art, Washington, D.C.; Ailsa Mellon Bruce Fund, 1971.

Plate 49

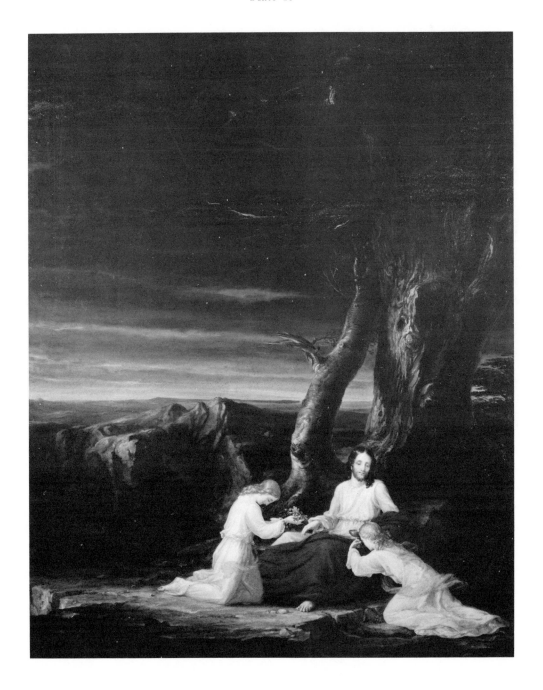

Thomas Cole, *Angels Ministering to Christ in the Wilderness*, 1843. Worcester Art Museum, Worcester, Massachusetts.

Plate 50

Thomas Cole, *The Cross and the World: Two Youths Enter Upon a Pilgrimage, One to the Cross, the Other to the World* (detail). Wichita State University Art Collection, Wichita, Kansas.

Plate 51

Thomas Cole, *The Cross and the World: The Pilgrim of the World on His Journey* (sketch). Albany Institute of History and Art.

Plate 52

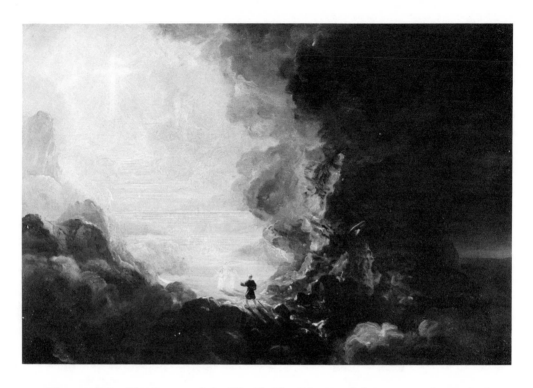

Thomas Cole, *The Cross and the World: The Pilgrim of the Cross at the End of His Journey* (sketch). 1844–45. National Museum of American Art, Smithsonian Museum.

Plate 53

Asher B. Durand, *The Beeches*, 1845. The Metropolitan Museum of Art; bequest of Maria De Witt Jesup, 1915.

Plate 54

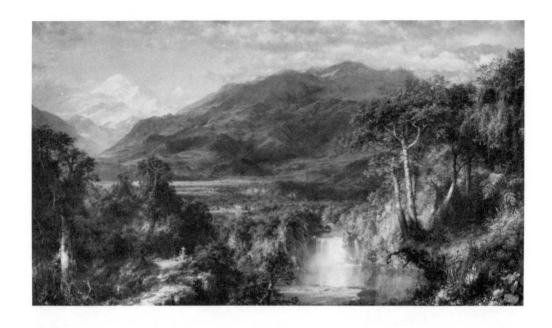

Frederick Edwin Church, *The Heart of the Andes*, 1859. The Metropolitan Museum of Art; bequest of Mrs. David Dows, 1909.

Plate 55

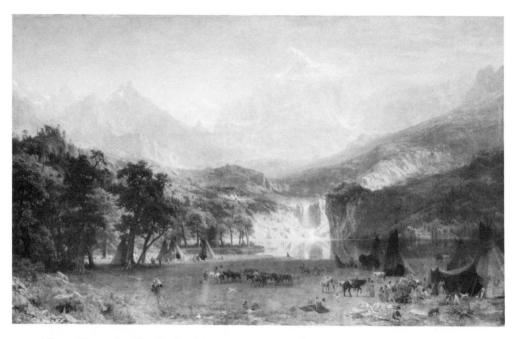

Albert Bierstadt, *The Rocky Mountains*, 1863. The Metropolitan Museum of Art; Rogers Fund, 1907.

Plate 56

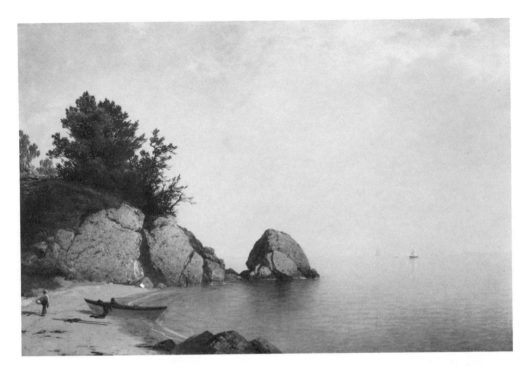

John F. Kensett, *Beach at Newport*, 1869–72. National Gallery of Art, Washington, D.C.; gift of Frederick Sturges, Jr.

Plate 57

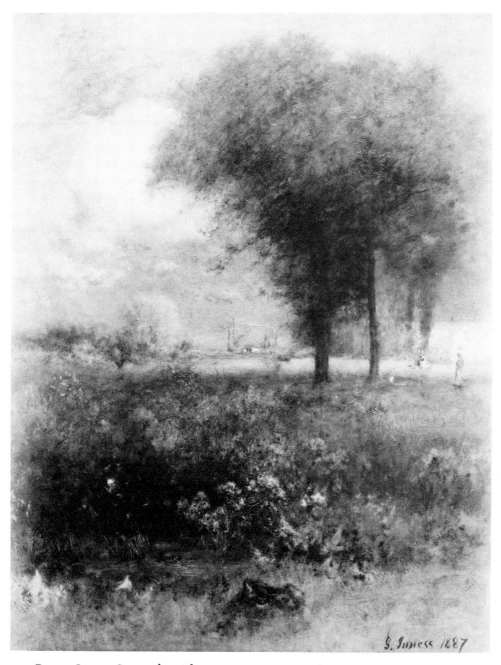

George Inness, *September Afternoon*, 1887. National Museum of American Art, Smithsonian Institution; gift of William T. Evans.

Plate 58

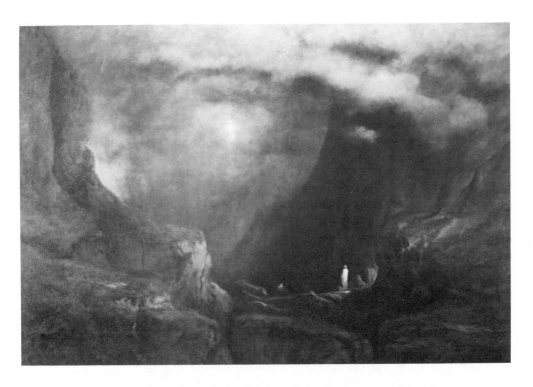

George Inness, *The Valley of the Shadow of Death*, 1867. Vassar College Art Gallery, Poughkeepsie, New York; gift of Charles M. Pratt, 1917.

Plate 59

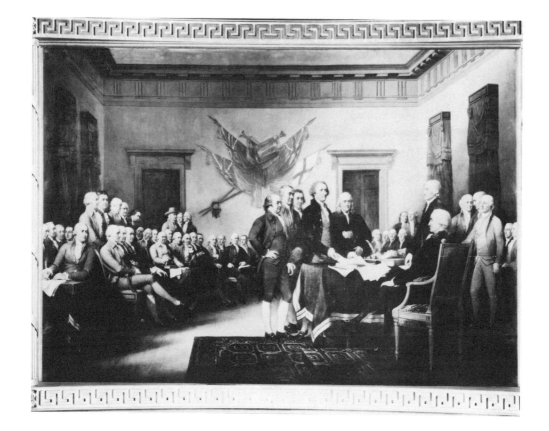

John Trumbull, *Declaration of Independence*, 1818. Courtesy of the Architect of the Capitol, Washington, D.C.

Plate 60

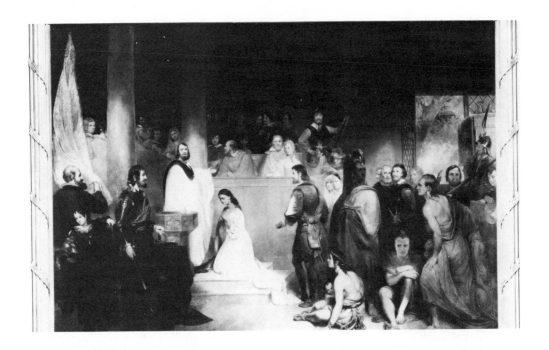

John Gadsby Chapman, *The Baptism of Pocahontas*. Courtesy of the Architect of the Capitol, Washington, D.C.

Plate 61

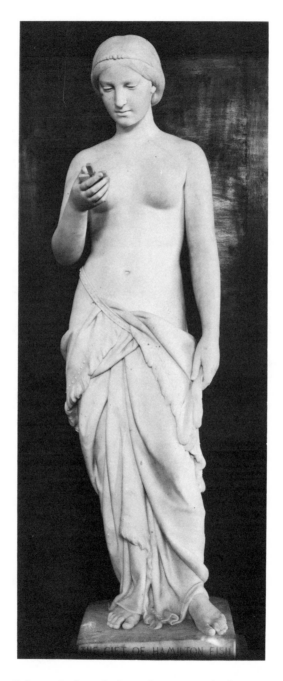

Erastus Day Palmer, *Indian Girl, or the Dawn of Christianity*, 1856. The Metropolitan Museum of Art; gift of the Hon. Hamilton Fish, 1894.

Plate 62

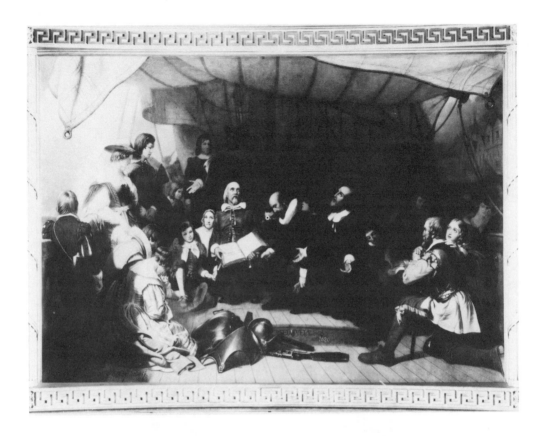

Robert W. Weir, *Embarkation of the Pilgrims.* Courtesy of the Architect of the Capitol, Washington, D.C.

Plate 63

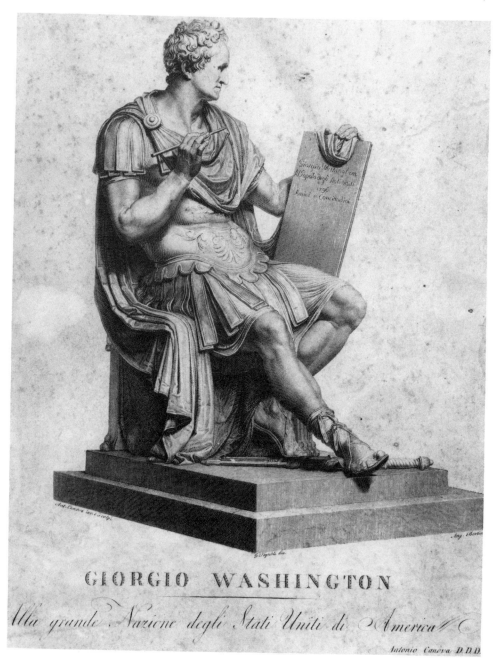

Antonio Canova, *George Washington* (statue), engraving. The North Carolina State Archives, Raleigh, North Carolina.

Plate 64

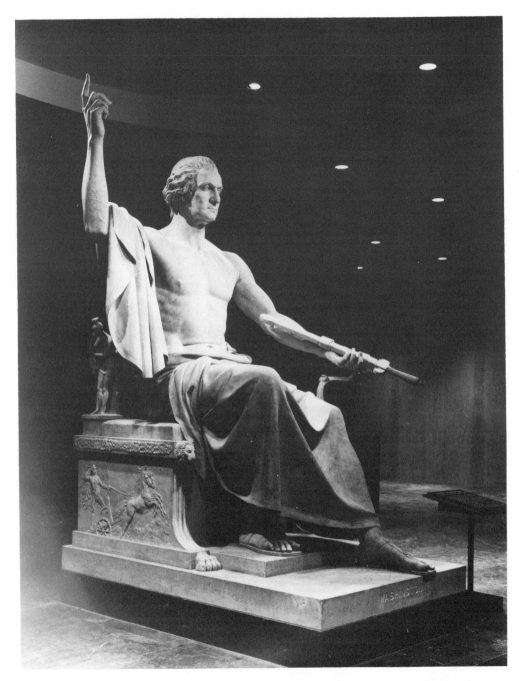

Horatio Greenough, *George Washington*, 1832–41. National Museum of American Art, Smithsonian Institution. Transferred from the U.S. Capitol, now located in National Museum of American History, Washington, D.C.

Plate 65

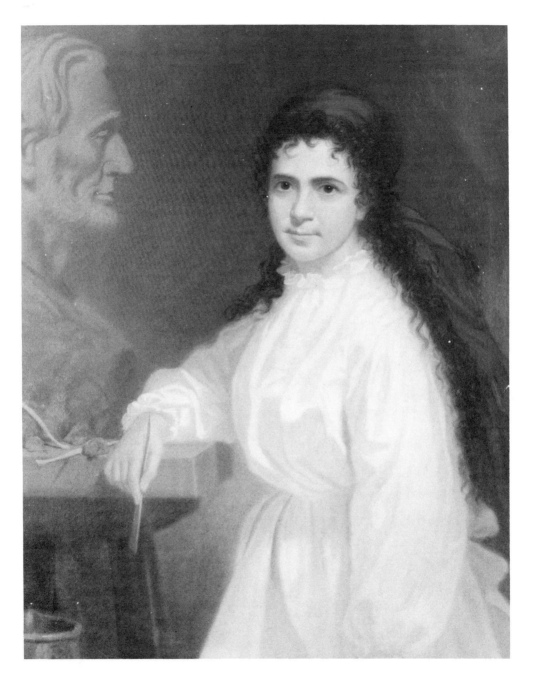

George C. Bingham, *Vinnie Ream with Lincoln Bust*. State Historical Society of Missouri, Columbia, Missouri.

Plate 66

Robert W. Weir, *War and Peace*. Courtesy of the U.S. Military Academy Library,
West Point.

Plate 67

Erastus Salisbury Field, *Historical Monument to the American Republic*, 1876.
Museum of Fine Arts, Springfield, Massachusetts; The Morgan Wesson Memorial
Collection.

Plate 68

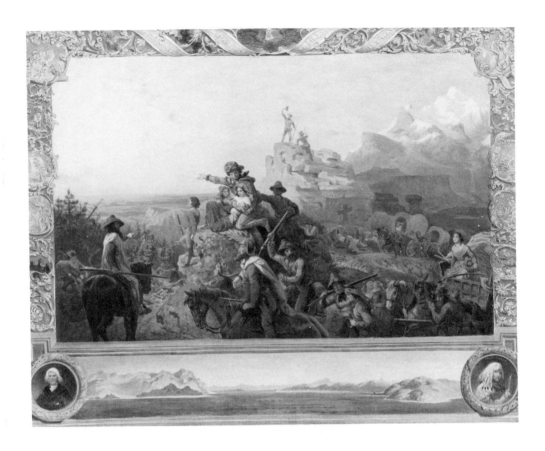

Emanuel Leutze, *Westward the Course of the Empire Takes its Way* or *Westward Ho!* (working model in oil for the mural in the United States Capitol), ca. 1861. National Museum of American Art, Smithsonian Institution; bequest of Miss Sarah Carr Upton.

Plate 69

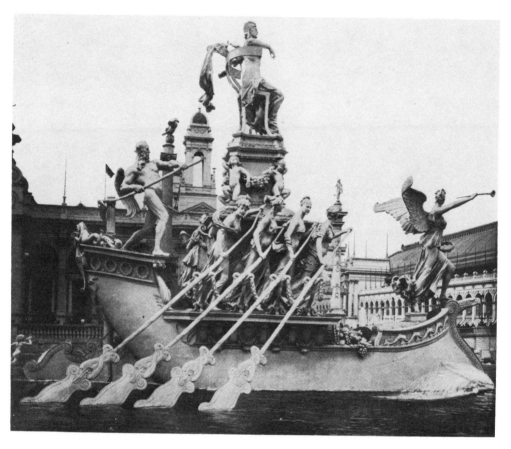

Frederick MacMonnies, *The Triumph of Columbia* or *The Barge of State*, 1893.
Courtesy of the New York Historical Society, New York City.

Plate 70

Louis Comfort Tiffany, *World's Columbian Exposition Chapel*, ca. 1893. Courtesy of The Morse Gallery of Art, Winter Park, Florida. Photograph by Theodore Flagg.

Plate 71

Mrs. H. Weed, *Death of Abel*, ca. 1830. Abby Aldrich Rockefeller Folk Art Center, Williamsburg, Virginia.

Plate 72

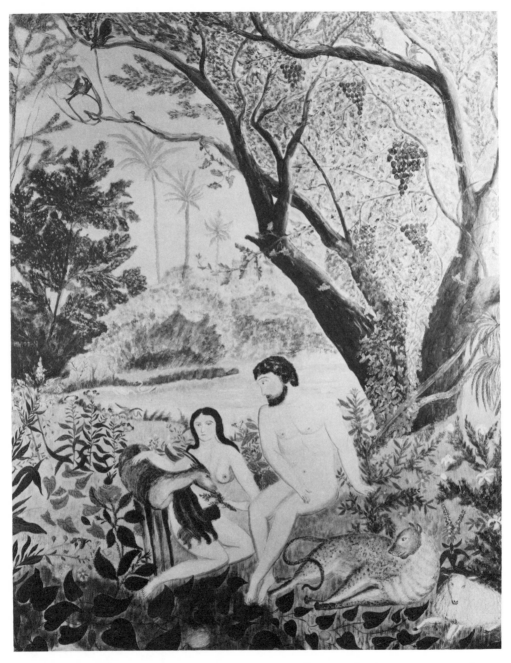

(Artist unknown), *Adam and Eve*, ca. 1830. Collection of Whitney Museum of American Art; gift of Edgar William and Bernice Chrysler Garbisch.

Plate 73

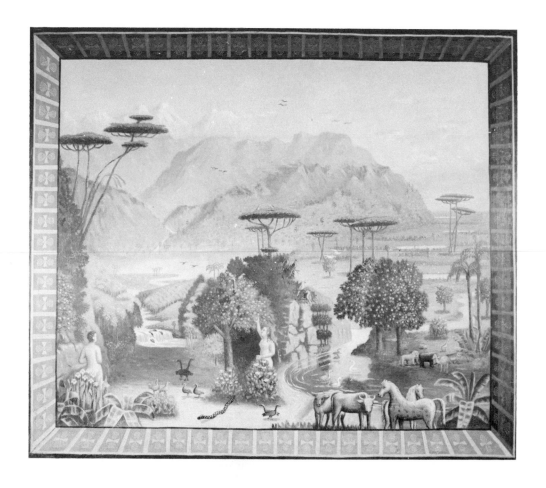

Erastus Salisbury Field, *The Garden of Eden*, ca. 1865. Shelburne Museum, Inc., Shelburne, Vermont.

Plate 74

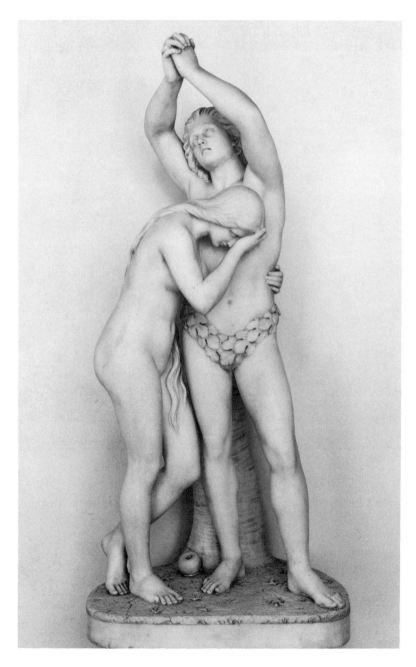

Thomas Crawford, *Adam and Eve*, 1855. Boston Athenaeum, Boston, Massachusetts.

Plate 75

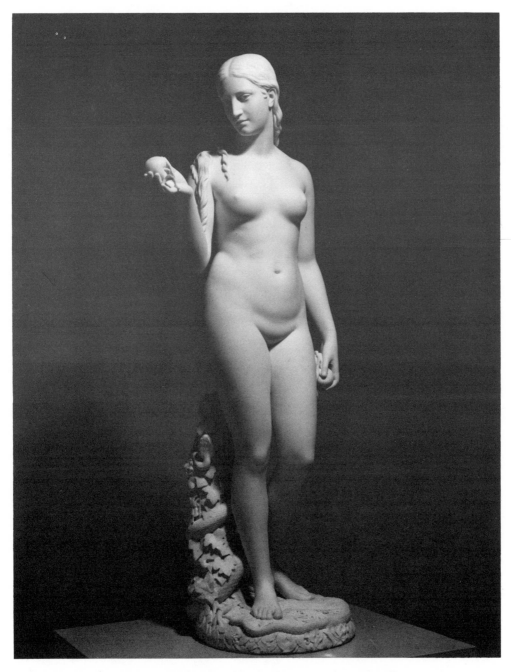

Hiram Powers, *Eve Tempted*, 1842. National Museum of American Art, Smithsonian Institution; Museum Purchase in Memory of Ralph Cross Johnston.

Plate 76

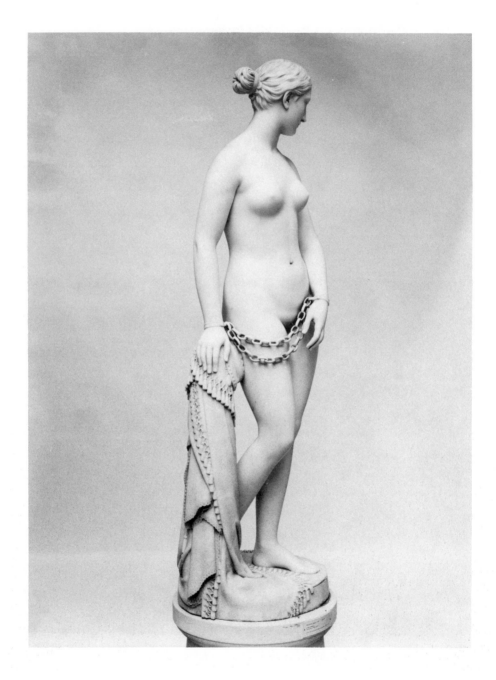

Hiram Powers, *The Greek Slave*, 1843. The Corcoran Gallery of Art, Washington, D.C.; gift of William Wilson Corcoran.

Plate 77

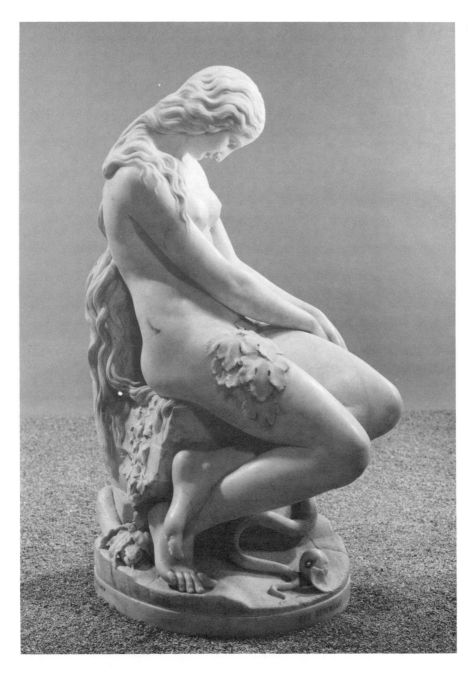

Edward S. Bartholomew, *Eve Repentant*, 1858–1859. Wadsworth Atheneum, Hartford, Connecticut.

Plate 78

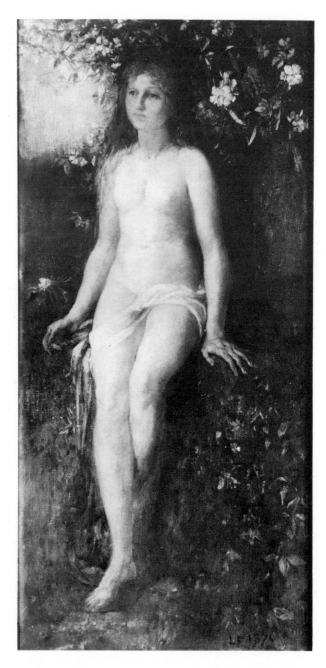

John La Farge, *The Golden Age*, 1870. National Museum of American Art, Smithsonian Institution; gift of John Gellatly.

Plate 79

Erastus Salisbury Field, *He Turned Their Waters into Blood*, 1865–80. National Gallery of Art, Washington, D.C.; gift of Edgar William and Bernice Chrysler Garbisch.

Plate 80

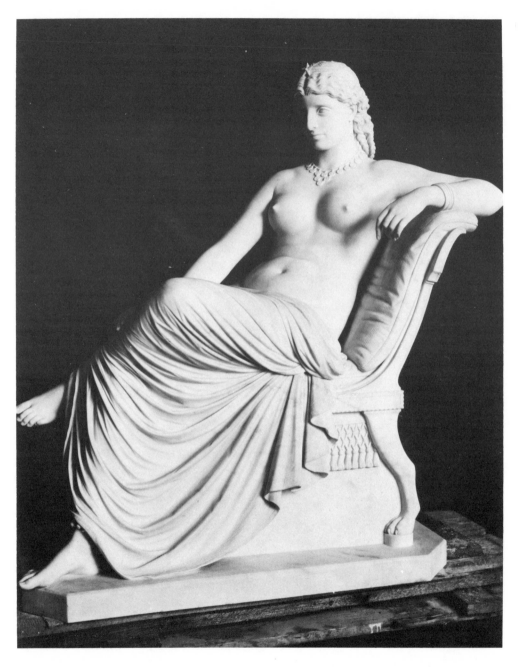

William Wetmore Story, *Salome*, 1871. The Metropolitan Museum of Art; gift of William Nelson, 1896.

Plate 81

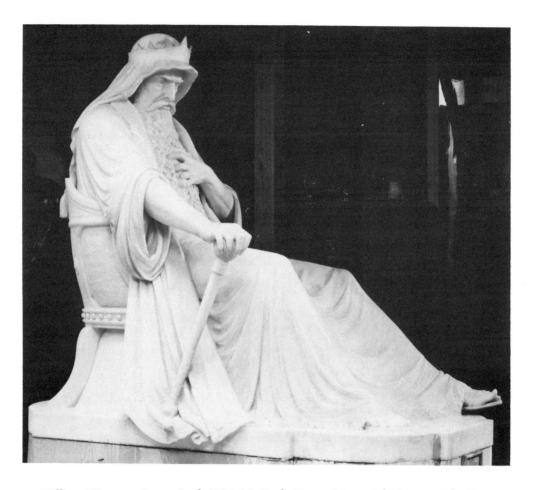

William Wetmore Story, *Saul*, 1882. M. H. de Young Memorial Museum, The Fine Arts Museums of San Francisco.

Plate 82

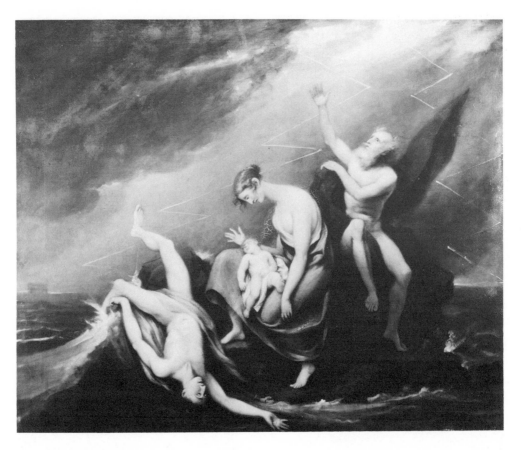

John Trumbull, *The Last Family who Perished in the Deluge*, 1838–39. Copyright Yale University Art Gallery.

Plate 83

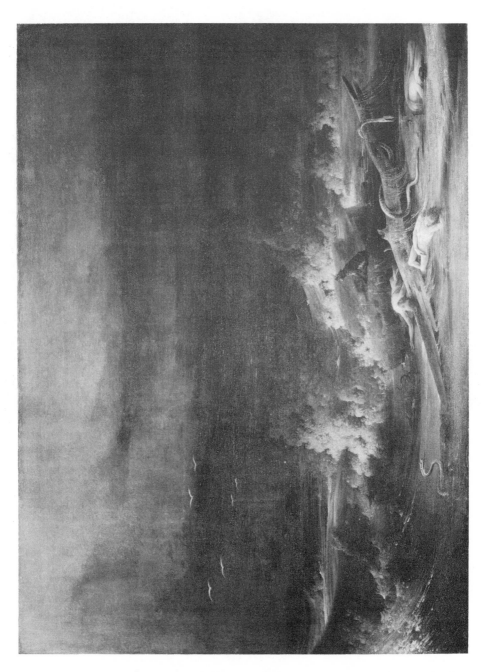

Joshua Shaw, *The Deluge*, ca. 1805. The Metropolitan Museum of Art; gift of William Merritt Chase, 1909.

Plate 84

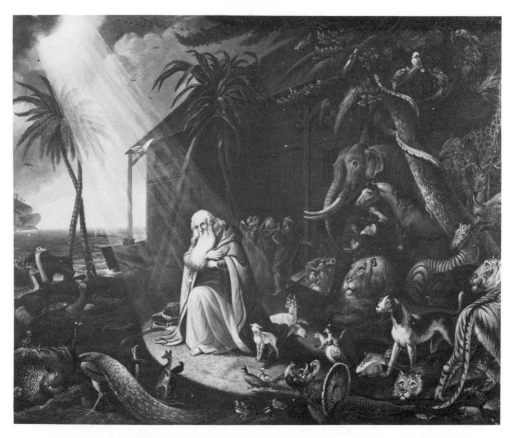

Charles Willson Peale, *Noah and His Ark*, 1819. Courtesy of the Pennsylvania Academy of the Fine Arts.

Plate 85

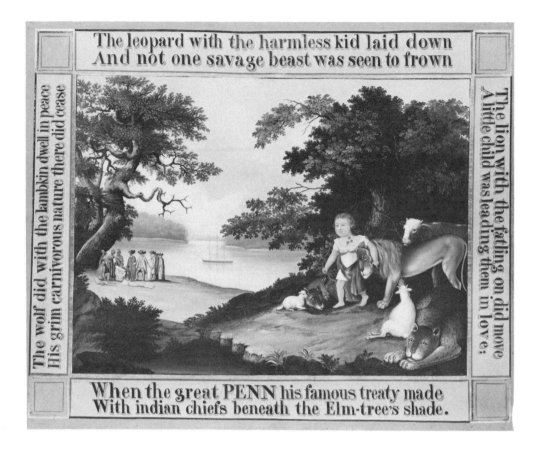

Edward Hicks, *The Peaceable Kingdom*, 1826. Philadelphia Museum of Art; The W. P. Wilstach Collection.

Plate 86

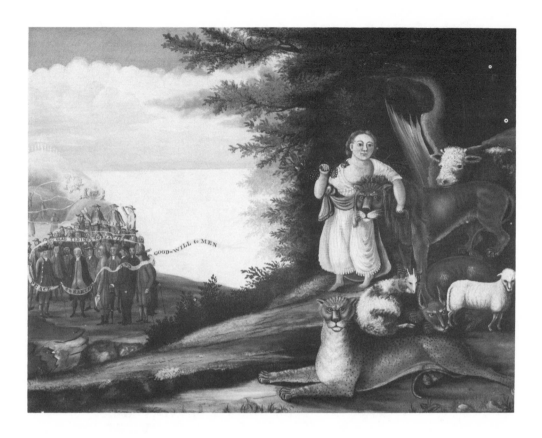

Edward Hicks, *The Peaceable Kingdom with Quakers Bearing Banners.* Copyright Yale University Art Gallery.

Plate 87

Edward Hicks, *The Peaceable Kingdom with Quakers Bearing Banners* (detail).
Copyright Yale University Art Gallery.

Plate 88

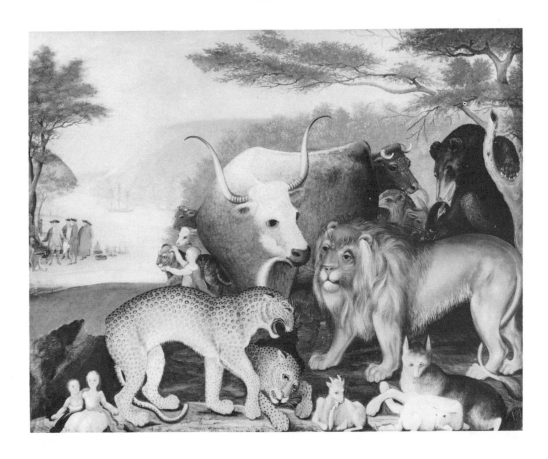

Edward Hicks, *The Peaceable Kingdom*, 1844. Abby Aldrich Rockefeller Folk Art Center, Williamsburg, Virginia.

Plate 89

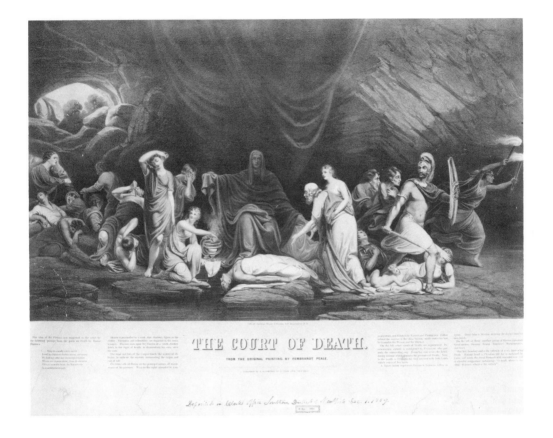

Rembrandt Peale, *The Court of Death* (engraving of painting). The Library of Congress, Washington, D.C.

Plate 90

Washington Allston, *The Dead Man Restored to Life by Touching the Bones of the Prophet Elisha*, 1811–13. Courtesy of the Pennsylvania Academy of the Fine Arts.

Plate 91

Washington Allston, *The Prophet Jeremiah Dictating to the Scribe Baruch*, 1820.
Copyright Yale University Art Gallery.

Plate 92

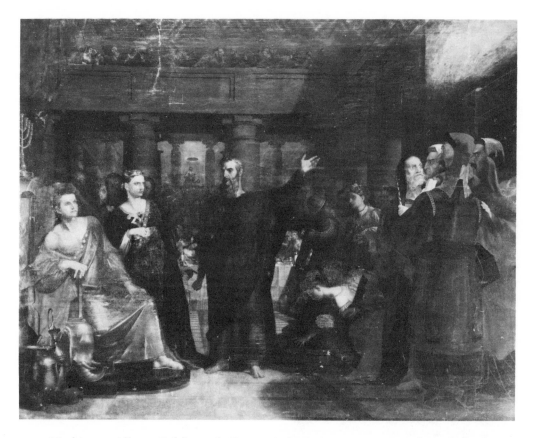

Washington Allston, *Belshazzar's Feast*, 1817–43. Detroit Institute of Arts; gift of Allston Trust.

Plate 93

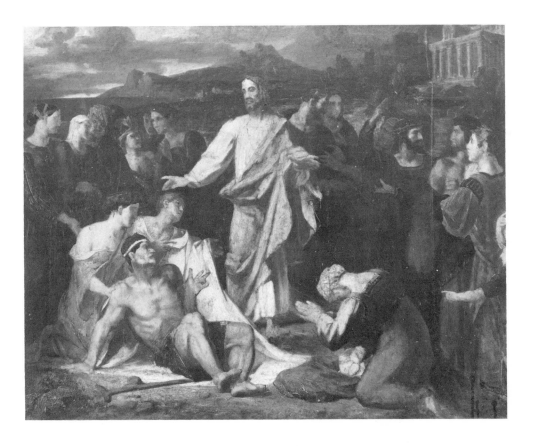

Washington Allston, *Christ Healing the Sick* (study). Worcester Art Museum, Worcester, Massachusetts.

Plate 94

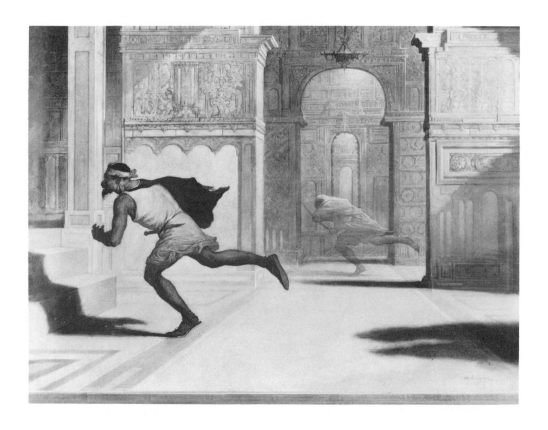

William Rimmer, *Flight and Pursuit*, 1872. Courtesy of the Museum of Fine Arts, Boston; bequest of Miss Edith Nichols.

Plate 95

William Rimmer, *God the Father Creating the Sun and Moon*, 1869. Courtesy of the Fogg Art Museum, Harvard University; Louise E. Bettens Fund.

Plate 96

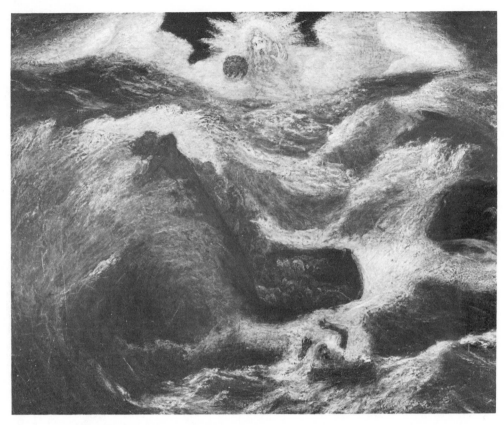

Albert Pinkham Ryder, *Jonah*, ca. 1885. National Museum of American Art, Smithsonian Institution; gift of John Gellatly.

Plate 97

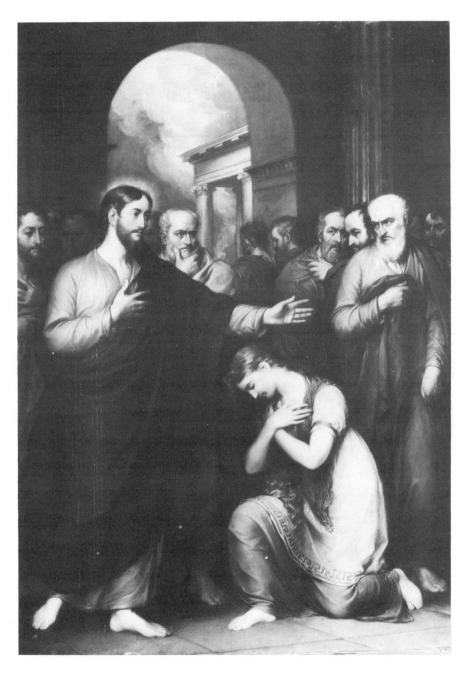

John Trumbull, *Christ and the Woman Taken in Adultery*, 1811. Copyright Yale University Art Gallery.

Plate 98

Samuel F. B. Morse, *Chapel at Subiaco*, 1831. Worcester Art Museum, Worcester, Massachusetts.

Plate 99

Robert W. Weir, *Taking the Veil*. Copyright Yale University Art Gallery.

Plate 100

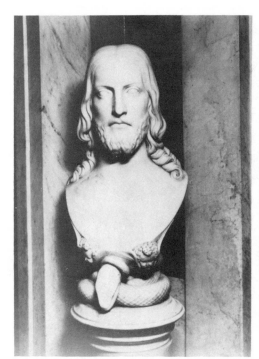

Horatio Greenough, *Christ* (ca. 1845–46) and *Lucifer* (ca. 1841–42). Courtesy of the Trustees of the Boston Public Library.

Plate 101

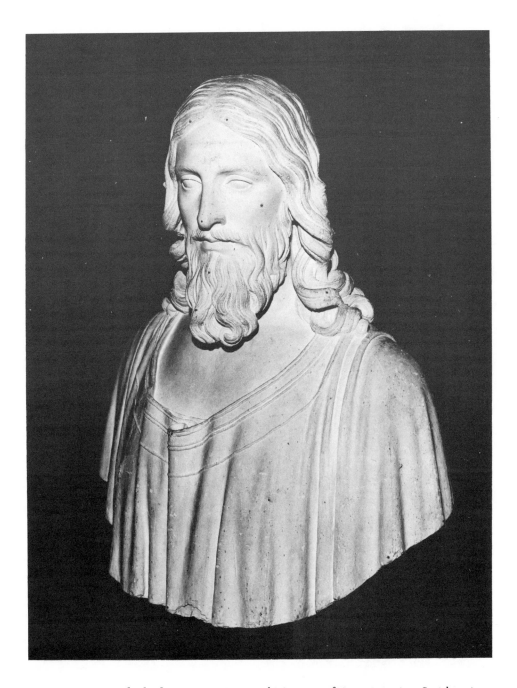

Hiram Powers, *Ideal Christ*, 1864. National Museum of American Art, Smithsonian Institution; Museum Purchase in Memory of Ralph Cross Johnston.

Plate 102

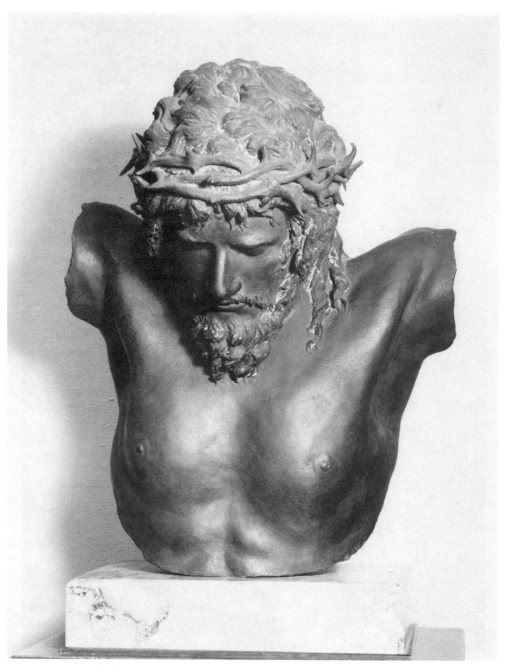

Moses J. Ezekiel, *Ecce Homo*, ca. 1899. Cincinnati Art Museum; gift of Harry W. Levy and George W. Harris.

Plate 103

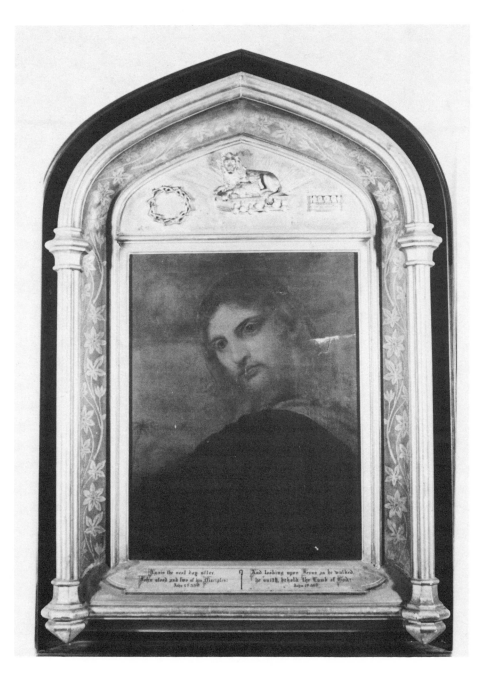

William Page, *Bust of Christ*. Private collection.

Plate 104

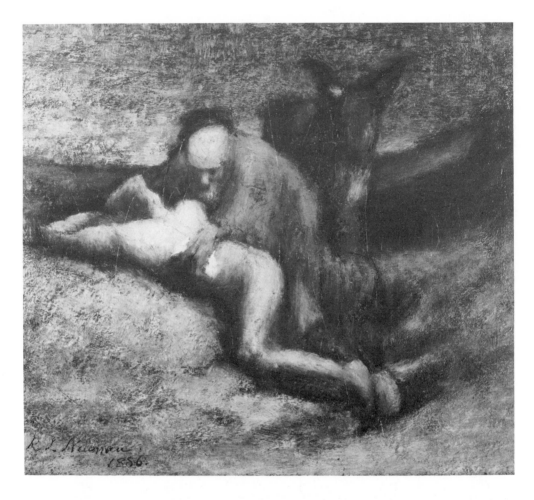

Robert Loftin Newman, *The Good Samaritan*, 1886. The Newark Museum, Newark, New Jersey.

Plate 105

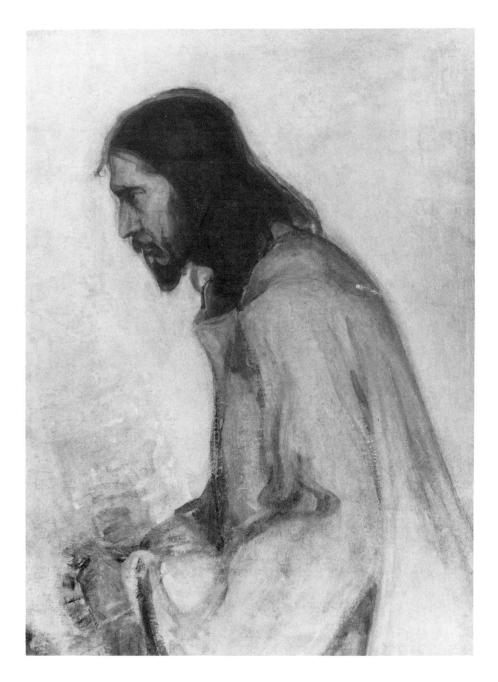

Henry Ossawa Tanner, *The Saviour*. National Museum of American Art, Smithsonian Institution. Transferred from the National Museum of African Art.

Plate 106

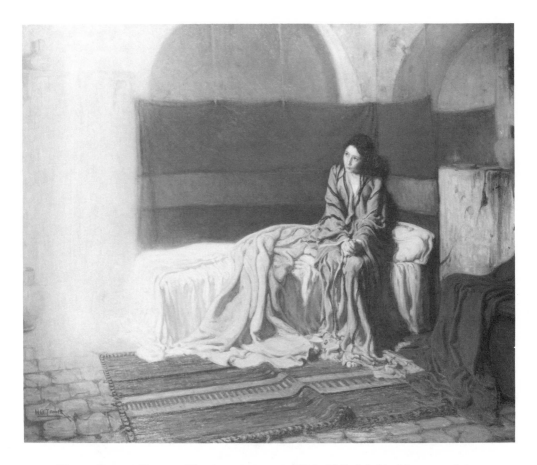

Henry Ossawa Tanner, *The Annunciation*, 1898. Philadelphia Museum of Art; bequest of Lisa Norris Elkins.

Plate 107

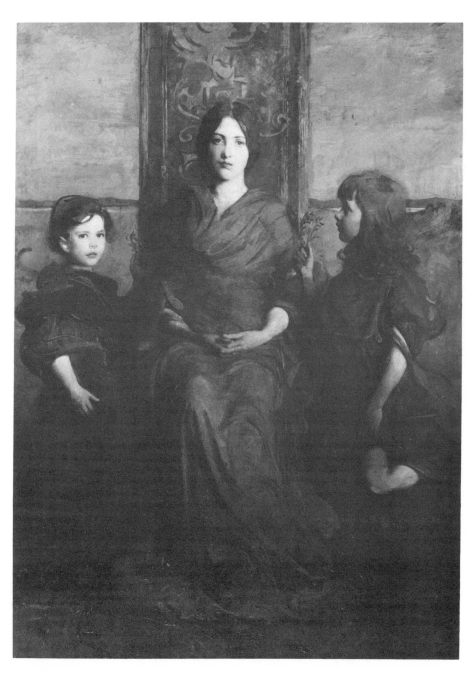

Abbott Thayer, *Virgin Enthroned*, 1891. National Museum of American Art, Smithsonian Institution; gift of John Gellatly.

Plate 108

Elihu Vedder, *Lazarus Rising from the Tomb*, 1899. Courtesy of the Museum of Fine Arts, Boston; gift of Edwin Atkins Grozier.

Plate 109

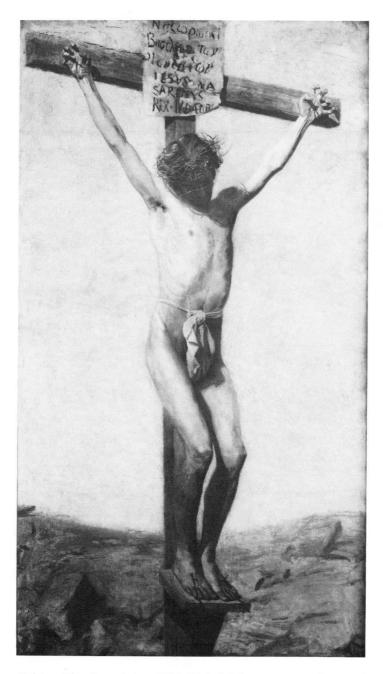

Thomas Eakins, *The Crucifixion*, 1880. Philadelphia Museum of Art; gift of Mrs. Thomas Eakins and Miss Mary A. Williams.

Plate 110

Elihu Vedder, *The Ninth Hour: Crucifixion*. Courtesy of Kennedy Galleries, Inc., New York City.

Plate 111

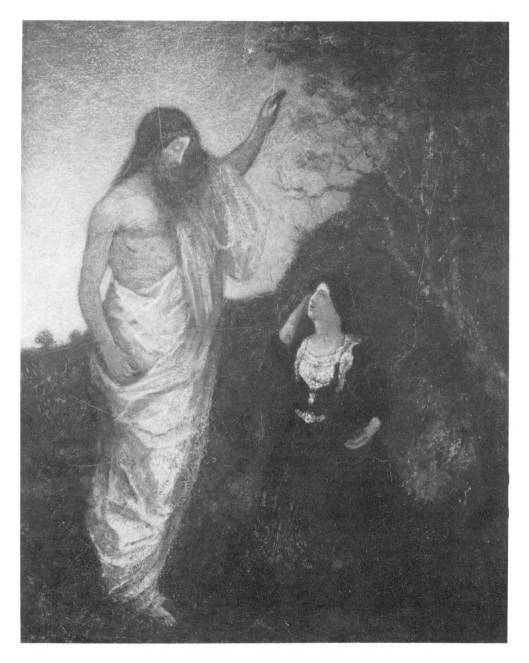

Albert P. Ryder, *The Resurrection*, 1885. The Phillips Collection, Washington, D.C.

Plate 112

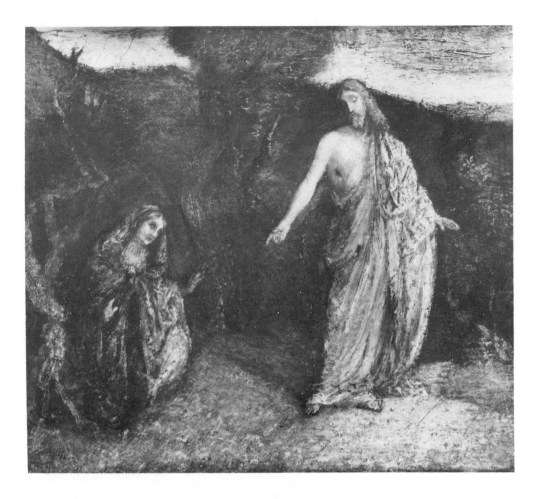

Albert P. Ryder, *Christ Appearing to Mary*. National Museum of American Art, Smithsonian Institution; gift of John Gellatly.

Plate 113

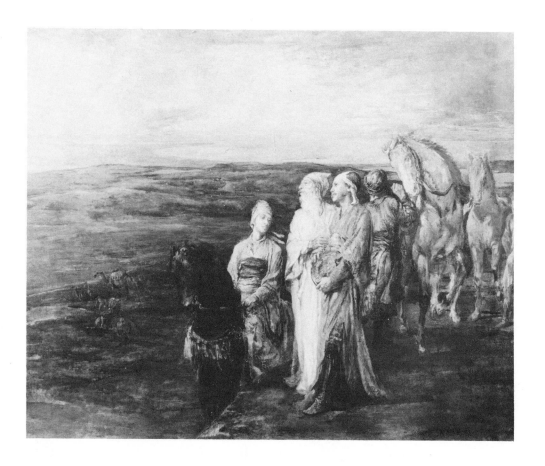

John La Farge, *Halt of the Wise Men*, ca. 1868. Museum of Fine Arts, Boston; gift of Edward W. Hooper.

Plate 114

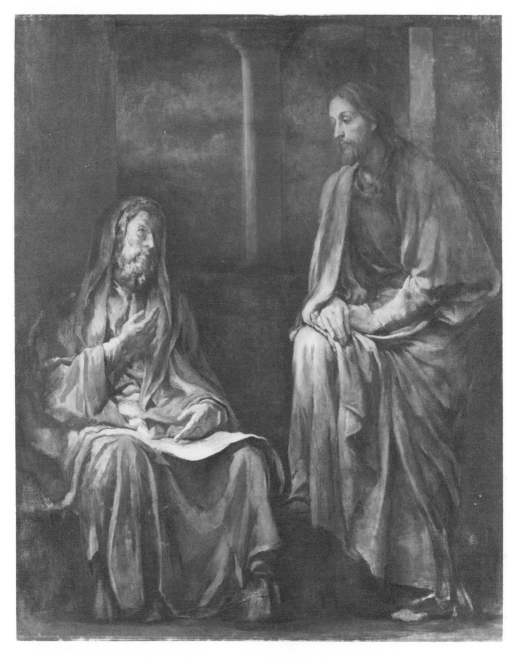

John La Farge, *Visit of Nicodemus to Christ*, 1880. National Museum of American Art, Smithsonian Institution; gift of William T. Evans.

Plate 115

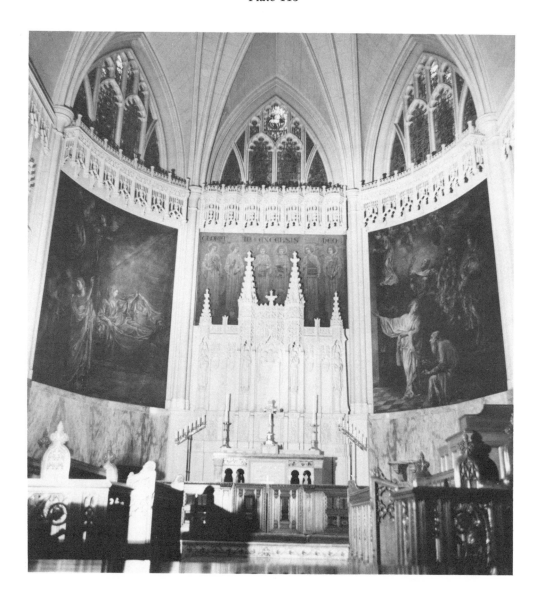

John La Farge, *Church of the Incarnation* (murals). Church of the Incarnation, New York City. Photograph by Richard Murray.

Plate 116

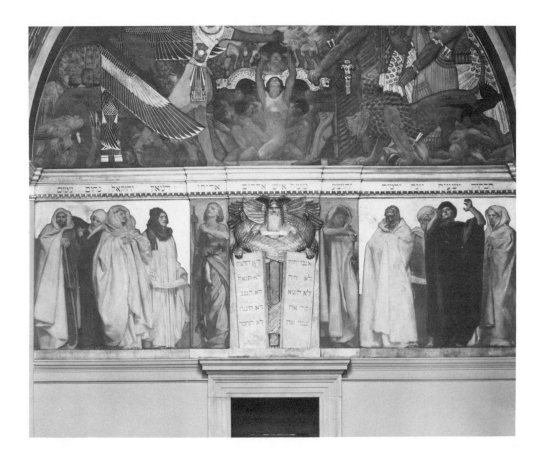

John Singer Sargent, *Pagan Deities, Oppression of the Children of Israel*, and the *Frieze of the Prophets* (detail). Courtesy of the Trustees of the Boston Public Library.

Plate 117

John Singer Sargent, *Dogma of the Redemption*. Courtesy of the Boston Public Library.

Plate 118

John Singer Sargent, *The Messianic Age*. Courtesy of the Trustees of the Boston Public Library.

Plate 119

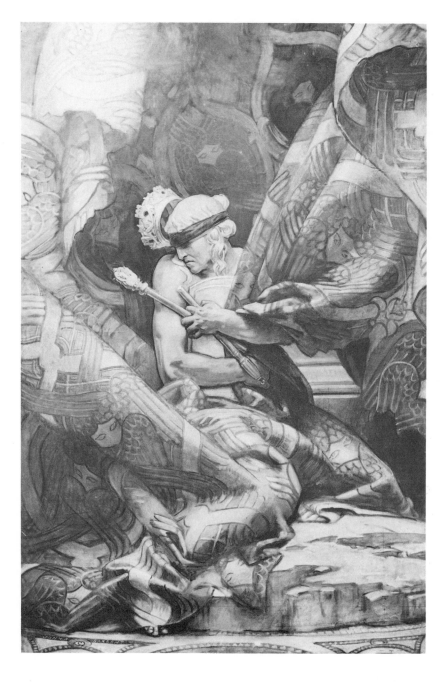

John Singer Sargent, *The Synagogue*. Courtesy of the Trustees of the Boston Public Library.

Plate 120

John Singer Sargent, *The Church*. Courtesy of the Trustees of the Boston Public Library.

Plate 121

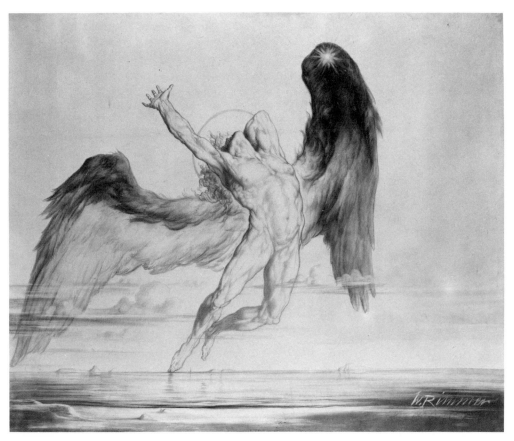

William Rimmer, *Evening: Fall of Day*, 1869. Courtesy, Museum of Fine Arts, Boston. Purchased.

Plate 122

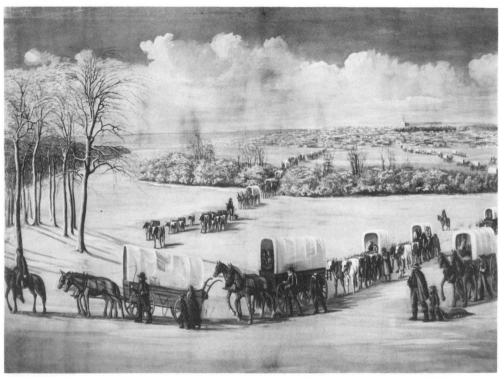

Carl Christian Anton Christensen, *Crossing the Mississippi on Ice*, 1865. Tempera on canvas. 6 × 10 feet. © by Corporation of the President of the Church of Jesus Christ of Latter-day Saints.

Plate 123

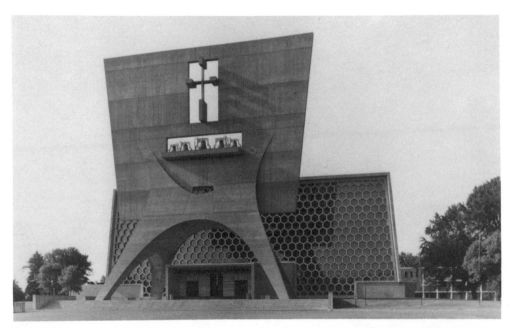

Marcel Breuer, *The Abbey and University Church of St. John the Baptist*, 1961. Collegeville, Minnesota.

Plate 124

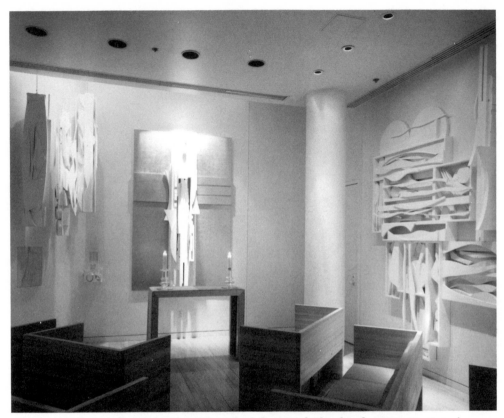

Louise Nevelson, *The Erol Beker Chapel of the Good Shepherd,* 1976. St. Peter's
Lutheran Church, 54th and Lexington, New York City.

Plate 125

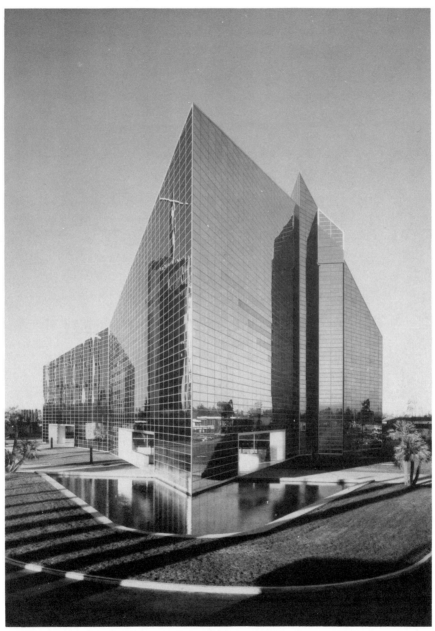

Philip Johnson, *Crystal Cathedral*, 1980. Garden Grove, California.

Plate 126

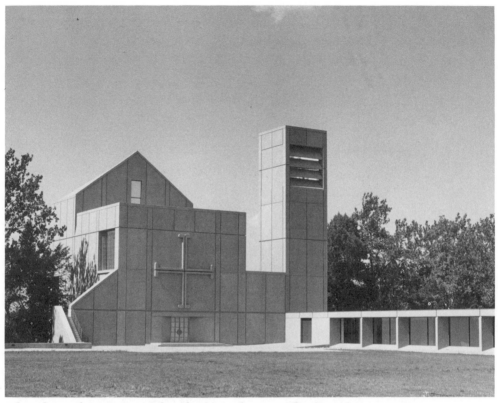

Edward Larrabee Barnes, *Chapel*, 1987. Christian Theological Seminary.

Plate 127

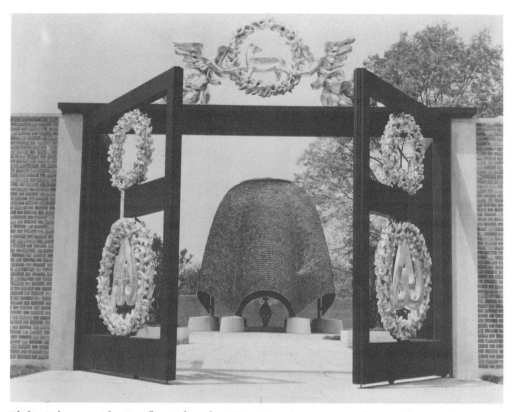

Philip Johnson, *The Roofless Church*, 1960. New Harmony, Indiana. Photograph by James K. Mellow.

Plate 128

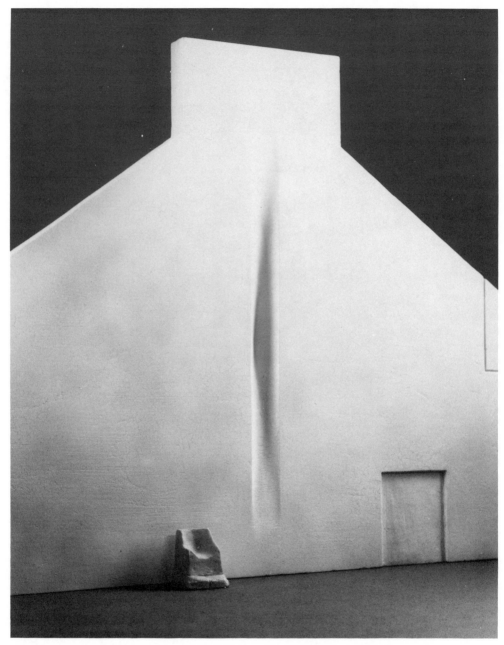

Stephen De Staebler, *Model for The Vision of St. Benedict*, 1988. New Harmony, Indiana. Collection of the Artist.

Plate 129

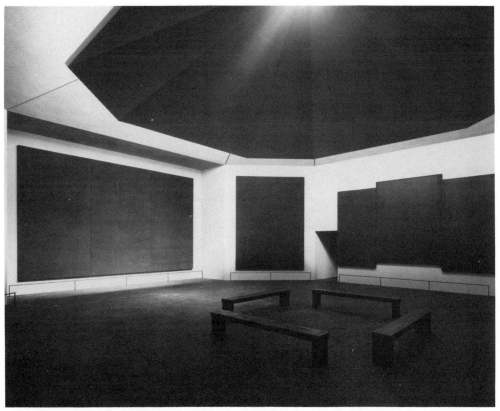

Mark Rothko, *The Rothko Chapel*, 1970. Houston, Texas.

Plate 130

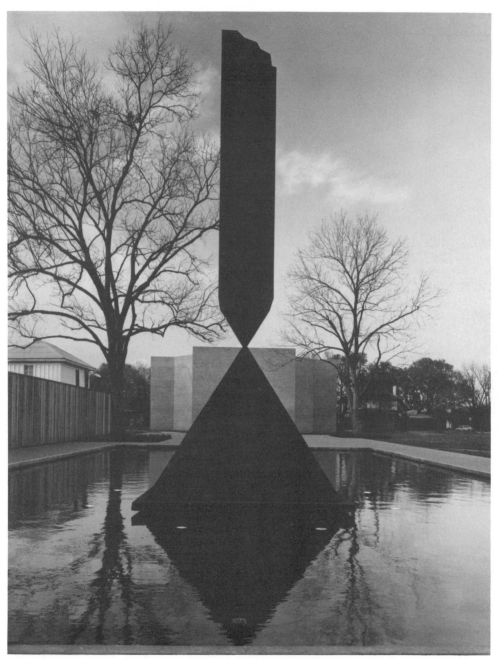

Barnett Newman, *The Broken Obelisk*, 1963–67. Rothko Chapel, Houston, Texas.

Plate 131

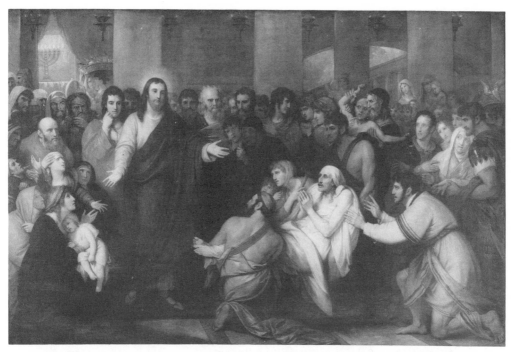

Benjamin West, *Christ Healing the Sick in the Temple*, 1815. Oil on canvas. 120 × 180 inches. Courtesy of Pennsylvania Hospital, Philadelphia.

Plate 132

Eliel and Aero Saarinen, *Firestone Baars Chapel*, 1947. Courtesy of Office of Public Relations, Stephens College, Columbia, Missouri.

Plate 133

Aero Saarinen, *Kresge Chapel*, 1955. Massachusetts Institute of Technology, Cambridge.

Plate 134

Lloyd Wright, *Wayfarer's Chapel*, 1949–1951. Palos Verdes, California.

Plate 135

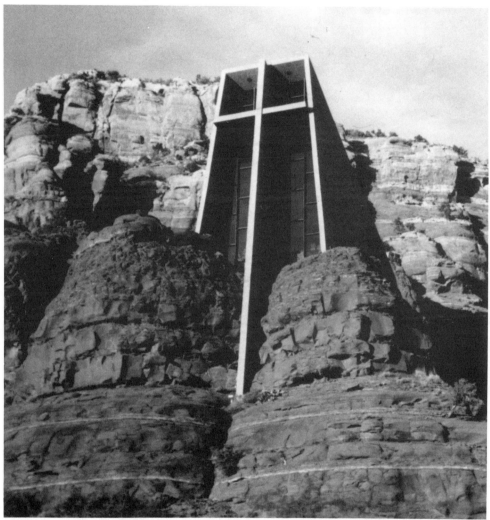

Anshen and Allen, *Chapel of the Holy Cross*, 1955–56. Sedona, Arizona.

Plate 136

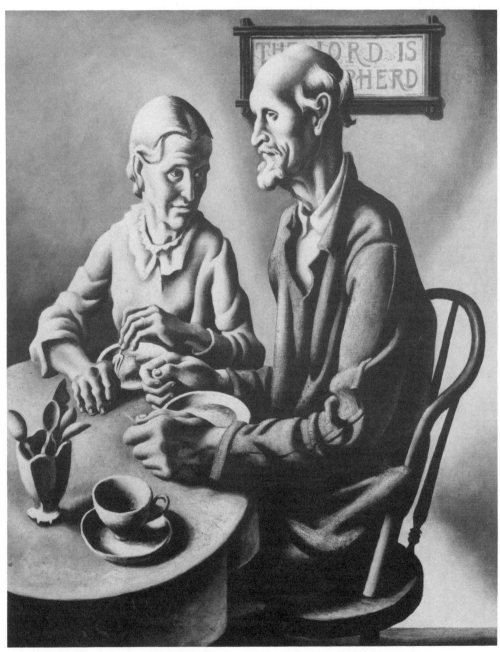

Thomas Hart Benton, *The Lord is My Shepherd*, 1926. Tempera on canvas. 33 ¼ × 27 ⅜ inches. Collection of Whitney Museum of American Art, New York. Gift of Gertrude Vanderbilt Whitney. 31.100.

Plate 137

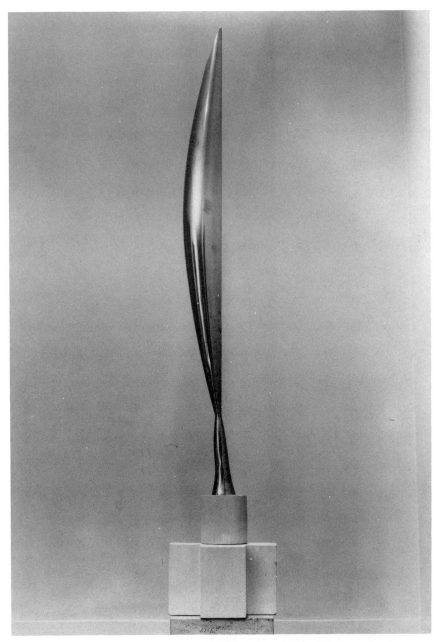

Constantin Brancusi, *Bird in Space*, c. 1943. Bronze, 6′ (182.9 cm) high; on stone pedestal; overall 89 ⅜″ (228 cm) high. Collection, The Museum of Modern Art, New York. Gift of Mr. and Mrs. William A. M. Burden.

Plate 138

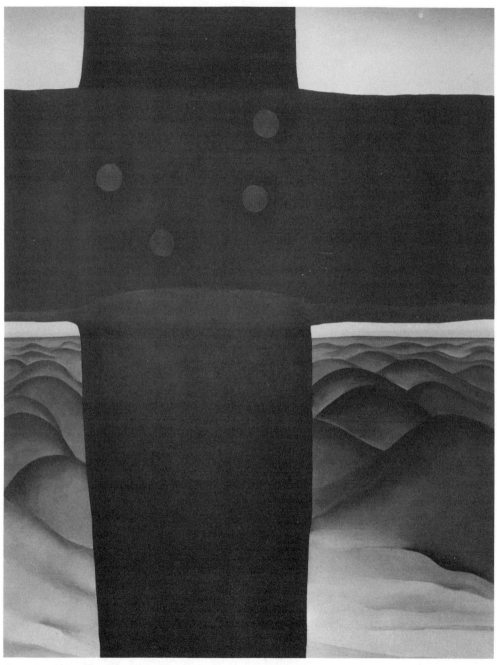

Georgia O'Keeffe, *Black Cross, New Mexico*, 1929. Oil on Canvas. 99 × 77.2 cm. Courtesy of The Art Institute of Chicago. Special Picture Fund, 1943.95.

Plate 139

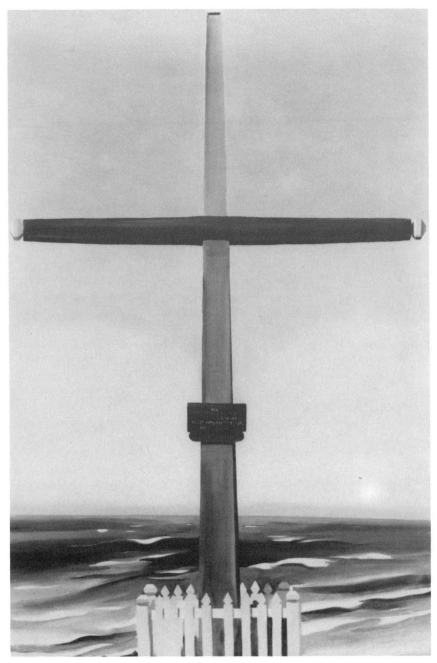

Georgia O'Keeffe, *Cross by the Sea, Canada*, 1931. Oil on canvas. 36 × 24 inches. The Currier Gallery of Art, Manchester, N. H. Purchased with Currier Funds, 1960.1.

Plate 140

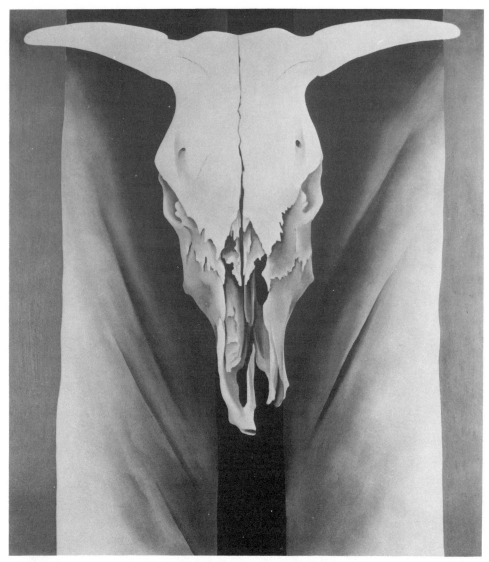

Georgia O'Keeffe, *Cow's Skull: Red, White and Blue*, 1931. Oil on canvas. 39 ⅞ × 35 ⅞ inches. The Metropolitan Museum of Art, The Alfred Stieglitz Collection, 1949. (52.203).

Plate 142

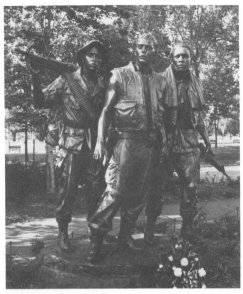

Frederick Hart, *Three Servicemen Statue*, 1984. Courtesy of Office of Public Affairs, National Park Service, National Capital Region, Washington, D. C.

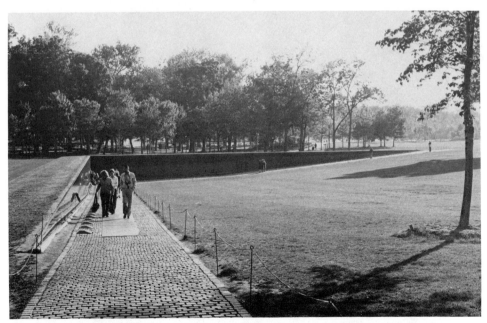

Maya Lin, *Vietnam Verterans Memorial*, 1982. Granite. 246.75 × 10.1 feet. Courtesy of Office of Public Affairs, National Park Service, National Capital Region, Washington, D. C.

Plate 141

Plate 143

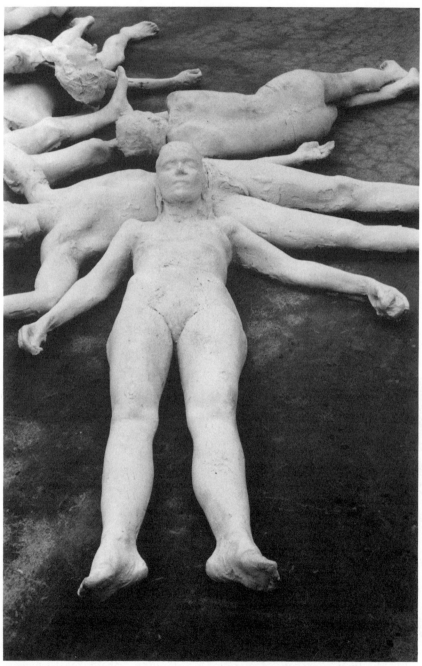

George Segal, *Adam and Eve*, detail from *The Holocaust*, 1984. Legion of Honor, San Francisco.

Plate 144

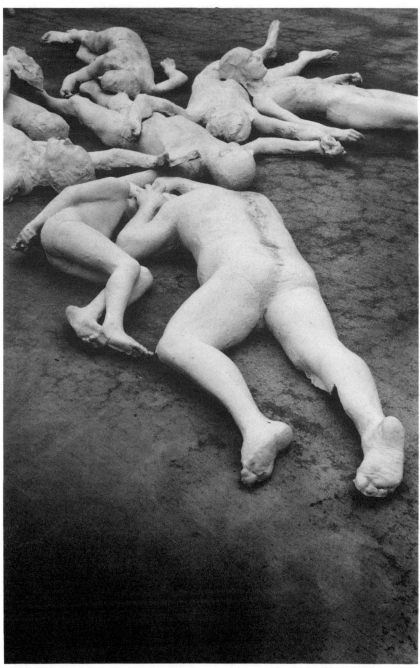

George Segal, *Abraham and Isaac*, detail from *The Holocaust*, 1984.
Legion of Honor, San Francisco.

Plate 145

Barnett Newman, *Vir Heroicus Sublimis,* 1950–1951. Oil on canvas. 7′ 11 ¾″ × 17′ 9 ¼″ (242.2 × 513.6 cm). Collection, The Museum of Modern Art. Gift of Mr. and Mrs. Ben Heller.

Plate 146

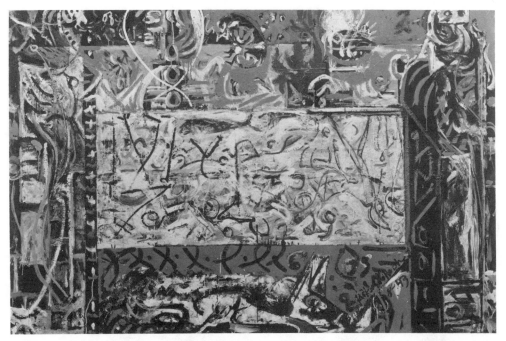

Jackson Pollock, *Guardians of the Secret*, 1943. Oil on canvas. 43 ⅜ × 75 ⅜ inches (122.9 × 191.5 cm). The San Francisco Museum of Modern Art. Albert M. Bender Collection. Albert M. Bender Bequest Fund. Purchase. 45.1308.

Plate 147

Helen Frankenthaler, *Jacob's Ladder*, 1957. Oil on canvas. 9′ 5 ¾″ × 69 ⅞″ (287.9 × 177.5 cm). Collection, The Museum of Modern Art, New York. Gift of Hyman N. Glickstein.

Plate 148

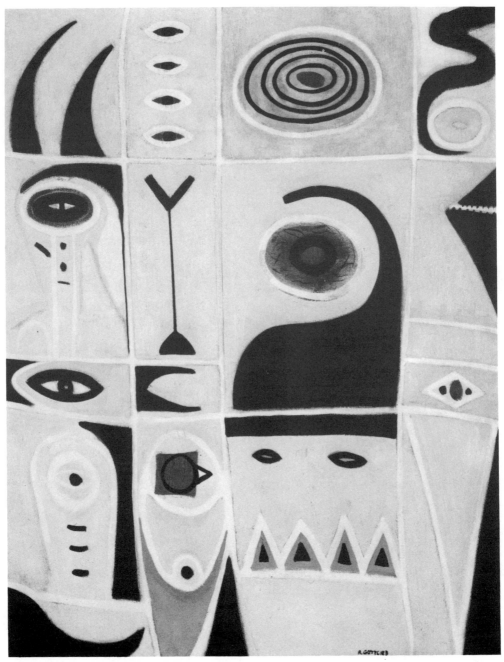

Adolf Gottlieb, *Evil Omen*, 1946. Oil on canvas. 38 × 30 inches. Collection of Neuberger Museum, State University of New York at Purchase. Gift of Roy R. Neuberger.

Plate 149

Lee Krasner, *Gaea*, 1966. Oil on canvas. 69″ × 10′ 5 ½″ (75.3 × 318.8 cm).
Collection, The Museum of Modern Art, New York. Kay Sage Tanguy Fund.

Plate 150

Joan Mitchell, *Ladybug*, 1957. Oil on canvas. 6′ 5 ⅞″ × 9′ (197.9 × 274 cm).
Collection, The Museum of Modern Art, New York. Purchase.

Plate 151

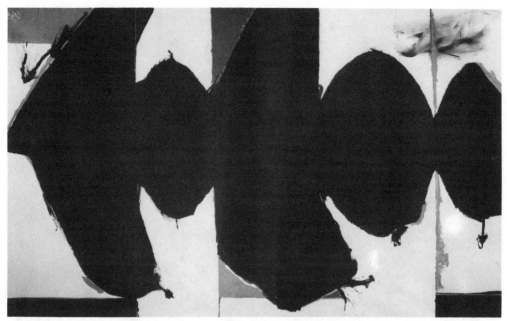

Robert Motherwell, *Elegy for the Spanish Republic, 108,* 1965–1967. Oil on canvas. 6′ 10″ × 11′ 6 ¼″ (244.1 × 268 cm). Collection, The Museum of Modern Art, New York. Charles Mergentine Fund.

Plate 152

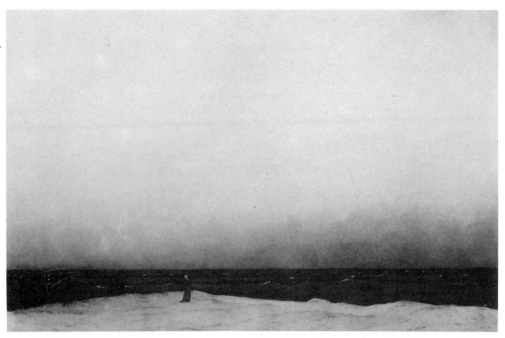

Caspar David Friedrich, *Monk by the Sea*, 1808–1809. Courtesy of Marburg/Art Resource, New York.

Plate 153

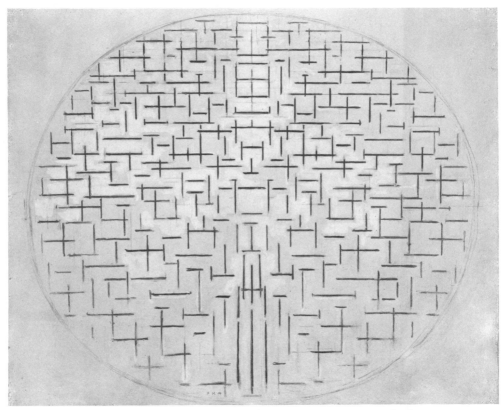

Piet Mondrian, *Pier and Ocean (Sea in Starlight)*, 1914. Charcoal and white watercolor. 34 ⅝ × 44 inches (87.9 × 111.2 cm). Collection, The Museum of Modern Art, New York. Mrs. Simon Guggenheim Fund.

Plate 154

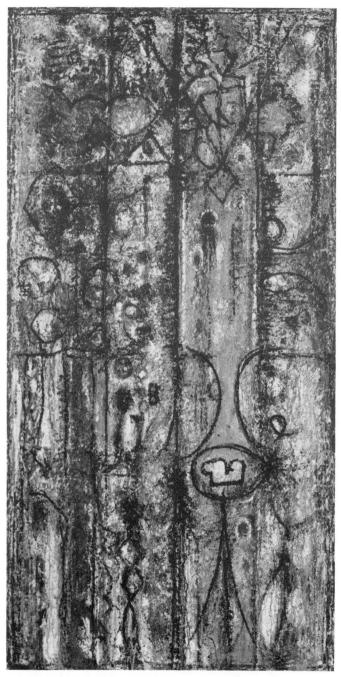

Richard Pousette-Dart, *The Magnificent*, 1950–1951. Oil on canvas. 86 ¼ × 44 inches. Collection, Whitney Museum of American Art, New York. Gift of Mrs. Wolfgang S. Schwabacher. 53.43.

Plate 155

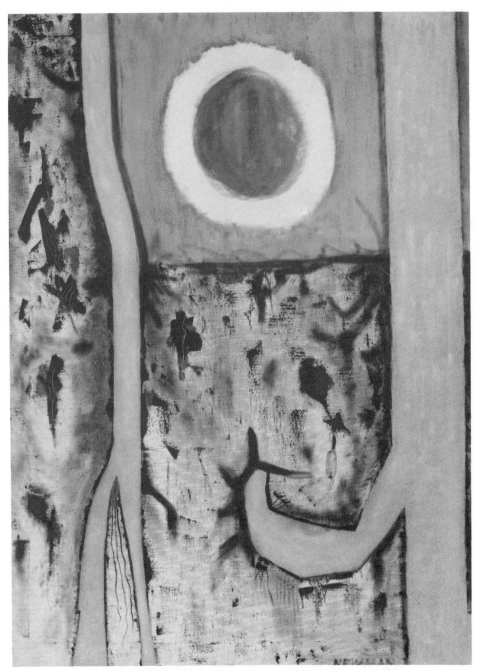

Barnett Newman, *Genetic Moment*, 1947. Oil on canvas. 38 × 28 inches.
Collection of Annalee Newman.

Plate 158

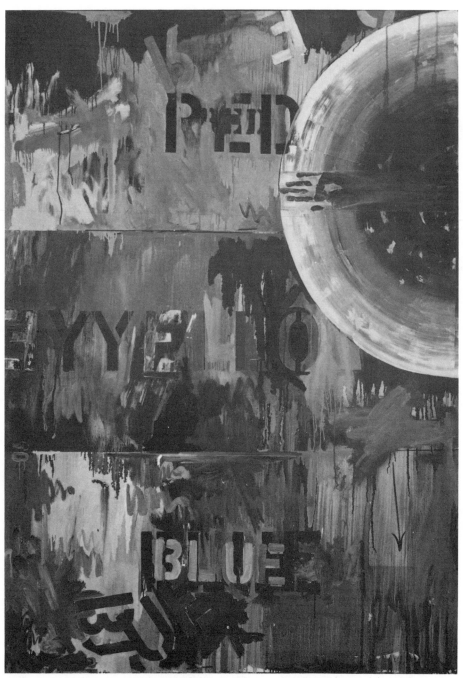

Jasper Johns, *Periscope (Hart Crane)*, 1963. Oil on canvas. 67 × 48 inches. Collection of the Artist. © Jasper Johns/VAGA, New York, 1988.

Plate 156

Barnett Newman, *The Voice*, 1950. Egg tempera and enamel on canvas. 8′ ⅛″ × 8′ 9 ½″. Collection, The Museum of Modern Art, New York. The Sidney and Harriet Janis Collection.

Plate 157

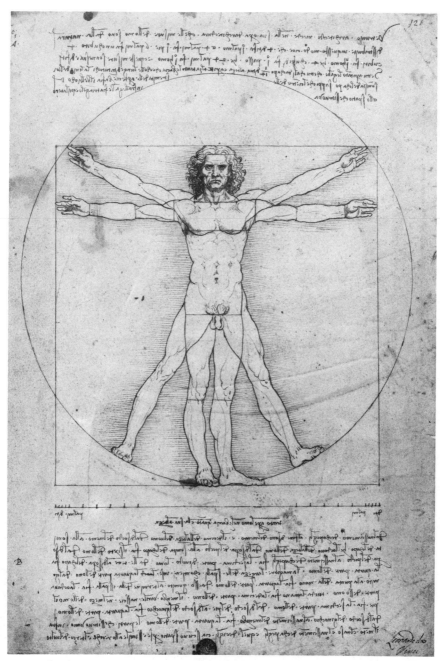

Leonardo da Vinci, *The Proportions of the Human Figure, after Vitruvius*, c. 1492. Academy, Venice. Courtesy of Alinari/Art Resource, New York.

Plate 159

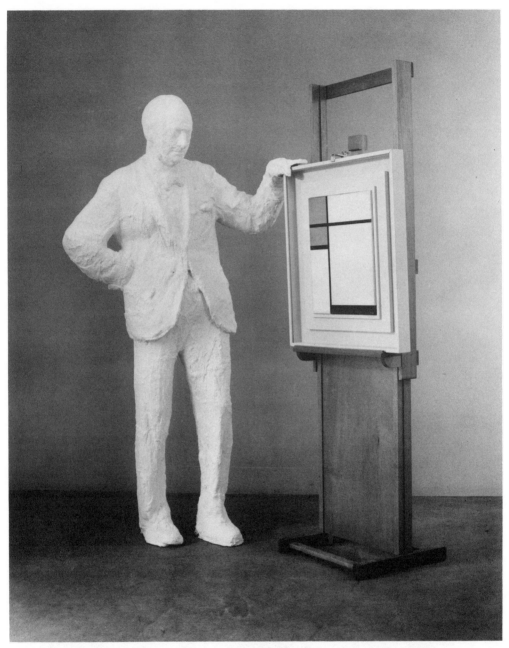

George Segal, *Portrait of Sidney Janis with Mondrian Painting*, 1967. Plaster figure with Mondrian's *Composition*, 1933, on an easel; figure, 66″ (167.6 cm) high; easel, 67″ (170 cm) high. Collection, The Museum of Modern Art, New York. The Sidney and Harriet Janis Collection.

Plate 160

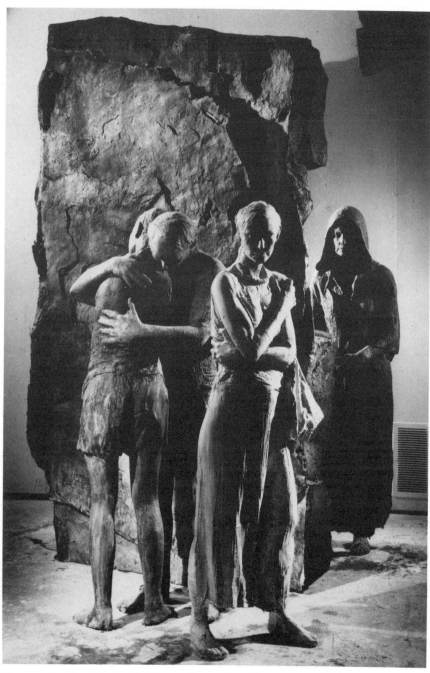

George Segal, *Abraham's Farewell to Ishmael*, 1987. Painted Plaster.
102 × 78 × 78 inches. The Sidney Janis Gallery, New York.

Plate 161

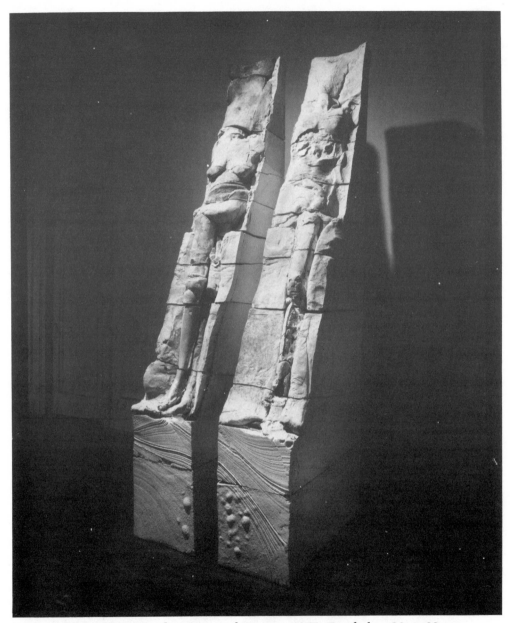

Stephen De Staebler, *Standing Man and Woman*, 1975. Fired clay. 96 × 33 × 33 inches. Collection of the artist.

Plate 162

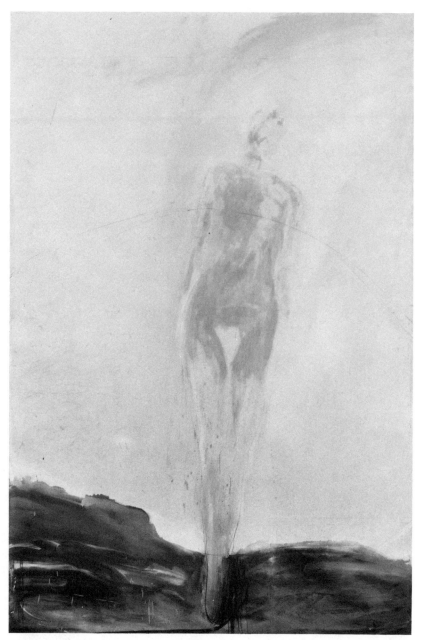

Nathan Oliveira, *Spirit II*, 1971. Acrylic and oil on canvas. 10 x 6½ feet. Collection of the artist.

Plate 163

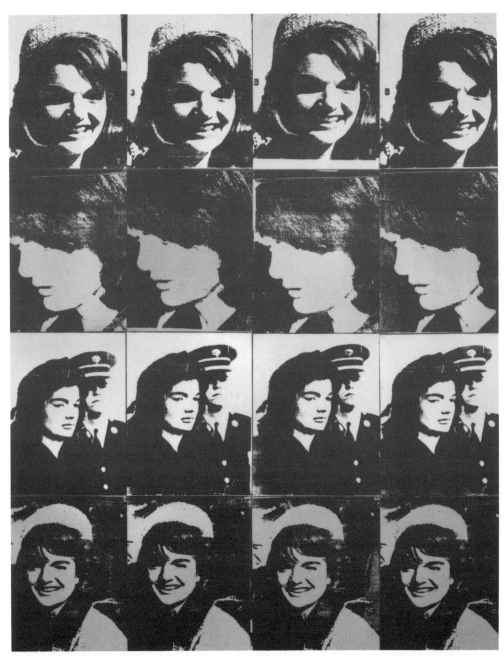

Andy Warhol, *16 Jackies*, 1964. Acrylic and silkscreen enamel on canvas. 80 × 64 inches. Collection, Walker Art Center, Minneapolis. Art Center Acquisition Fund, 1968.

Plate 164

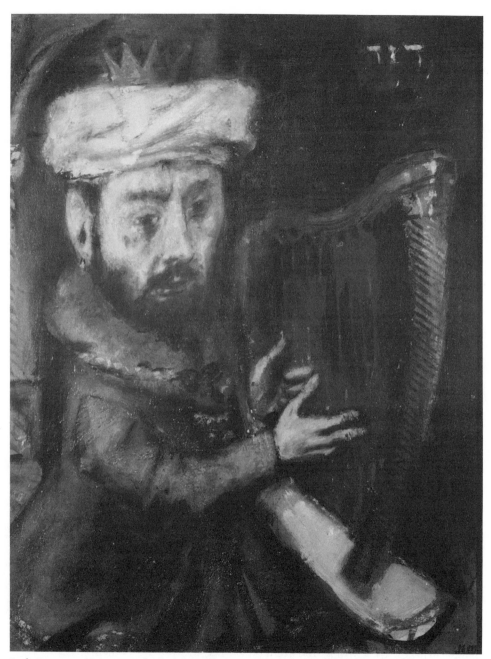

Jack Levine, *King David*. 1941. Collection of Mr. and Mrs. Solomon K. Gross, New York.

Plate 165

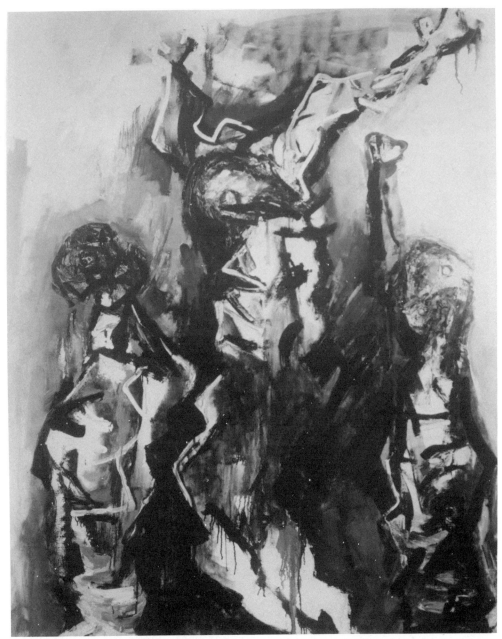

Abraham Rattner, *Crucifixion*, 1964. Oil on canvas, 63 ¾ × 51 ¼ inches.
Museum of Modern Art, Vatican Museums, Vatican City. Photograph courtesy of
Kennedy Galleries, New York.

Plate 166

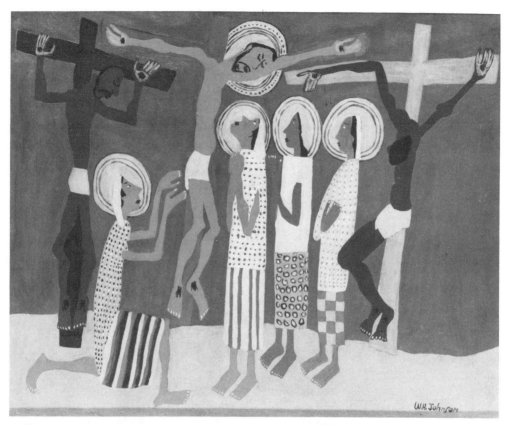

William H. Johnson, *Calvary*, c. 1939. Oil on board. 27 ¾ × 33 ⅜ inches.
Collection, National Museum of American Art, Smithsonian Institution,
Washington, D. C. 1967.59.979. Gift of the Harmon Foundation.

Plate 167

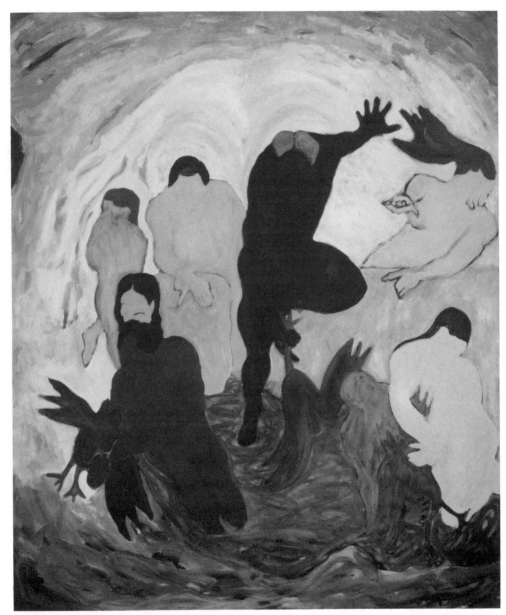

Bob Thompson, *St. Matthew's Description of the End of the World*, 1964. Oil on canvas. 60 × 60 inches (182.8 × 152.8 cm). Collection, The Museum of Modern Art. Blanchette Rockefeller Fund.

Plate 168

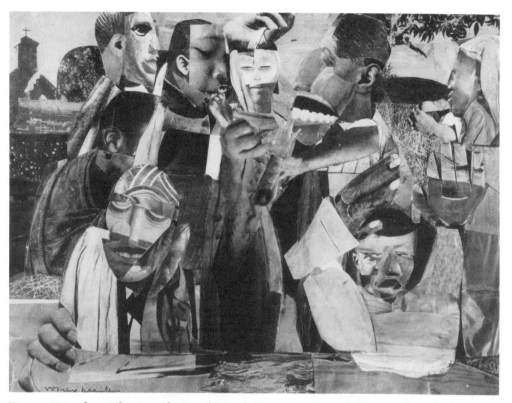

Romare Bearden, *The Prevalence of Ritual: Baptism*, 1964. Collage on board.
9 × 12 inches. Hirshhorn Museum and Sculpture Garden, Smithsonian
Institution, Washington, D. C. Gift of Joseph H. Hirshhorn, 1966.

Plate 169

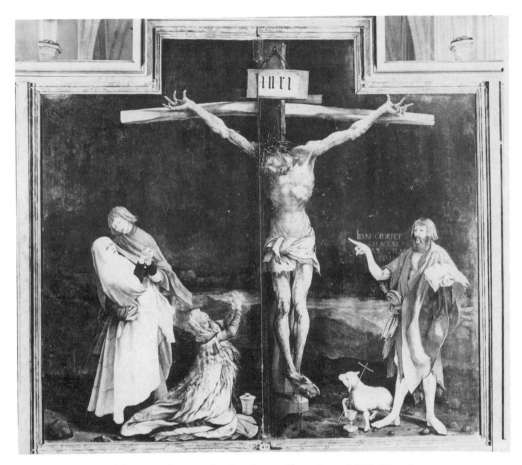

Mathias Grünewald, *Crucifixion, The Isenheim Altarpiece*, 1515. Musée d'Unterlinden, Colmar.

Plate 171

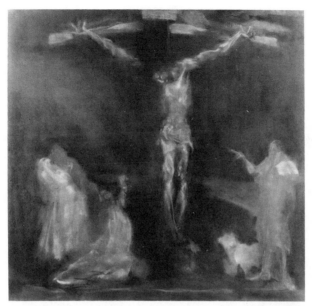

James Rosen, *Homage to Grunewald, The Isenheim Altarpiece,* 1975.
Collection of The Graduate Theological Union, Berkeley.

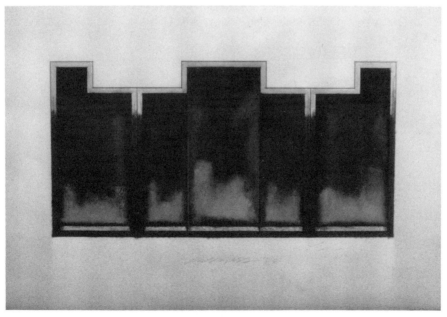

Jim Morphesis, *Colmar Variations,* 1980. Collection of the Artist.

Plate 170

Plate 172

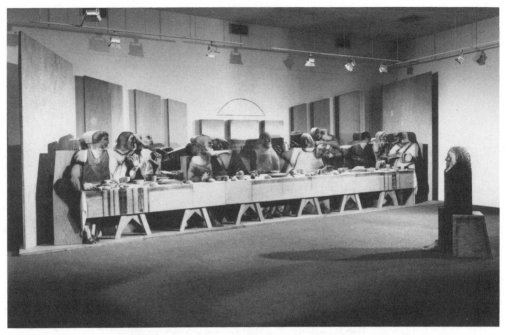

Escobar Marisol, *Self Portrait Looking at The Last Supper*, 1982. Wood, Brownstone, Plaster, Paint, and Charcoal. 121 × 358 × 67 inches. Collection, The Metropolitan Museum of Art. Gift of Mr. and Mrs. Roberto C. Polo, 1986 (1986.430.1–129). Photograph courtesy of Sidney Janis Gallery, New York.

Plate 173

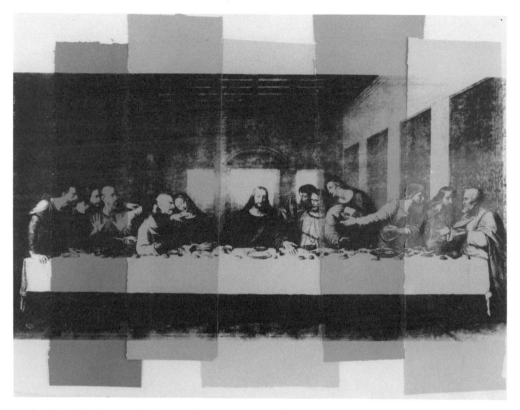

Andy Warhol, *Untitled*, 1986. Silkscreen and collage. 23 ½ × 31 ½ inches.
Courtesy of Robert Miller Gallery, New York.

Plate 174

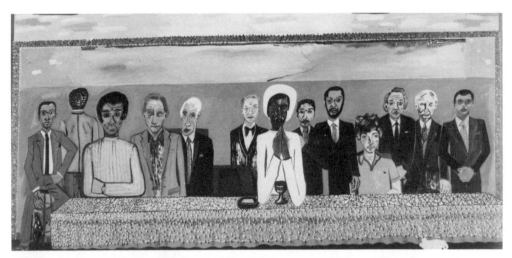

Frederick Brown, *The Last Supper*, 1982. Oil on canvas. 108 × 252 inches.
Courtesy of Marlborough Gallery, Inc., New York.

Plate 175

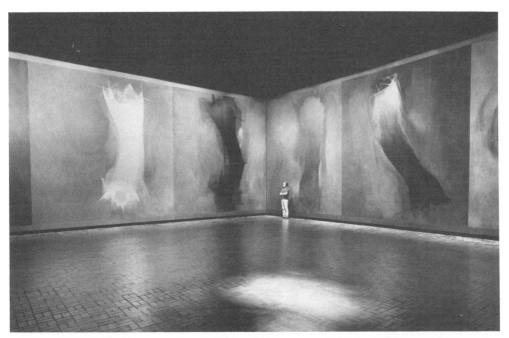

Cleve Gray, *Threnody*, June–August 1973. Polymer acrylic, duco enamel, and oil on canvas. Fourteen images, 240 × 240 inches (each image). Collection, Friends of the Neuberger Museum of Art, State University of New York at Purchase. Gift of the Artist. Photograph courtesy of the Artist.

Plate 176

Cleve Gray, *Roman Walls*, 1980. Collection of the Artist.

Plate 177

Cleve Gray, *In Prague*, 1984. Collection of the Artist.

Plate 178

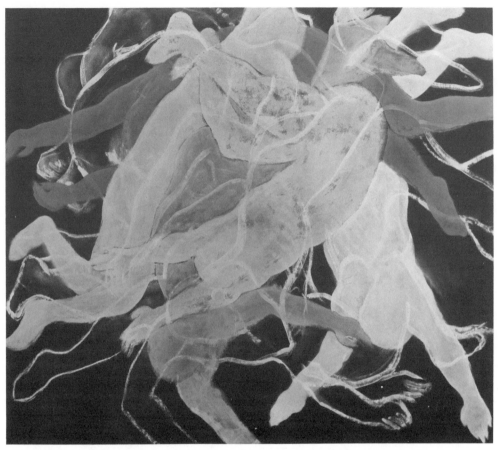

Cleve Gray, *Sleepers Awake (After Bach)*, 1985. Collection of the Artist.

Plate 179

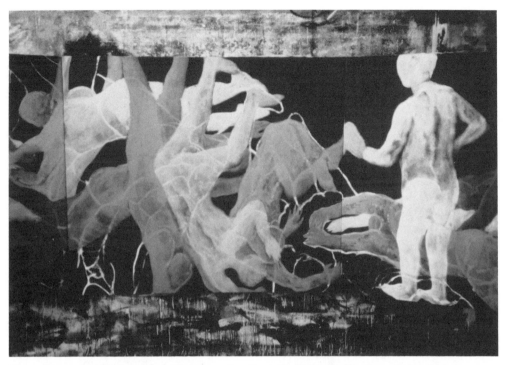

Cleve Gray, *Joy Unbounded (Resurrection Series)*, 1985. Collection of the Artist.

Plate 180

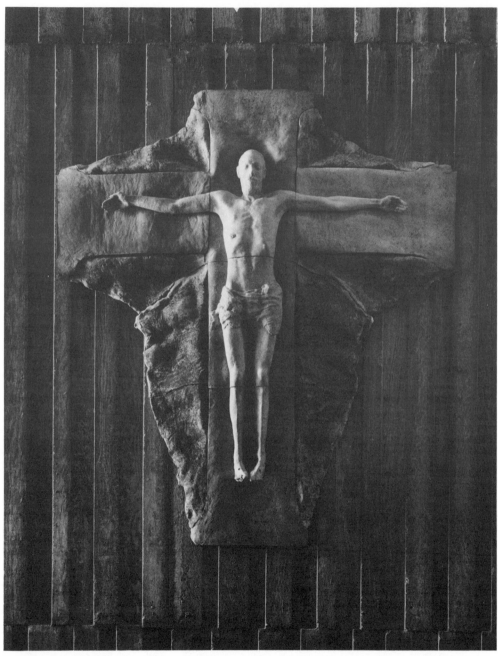

Stephen De Staebler, *Crucifix*, 1968. Stoneware clay. 8 × 7 feet. Holy Spirit
Parish, Newman Hall, Berkeley, California.

Plate 181

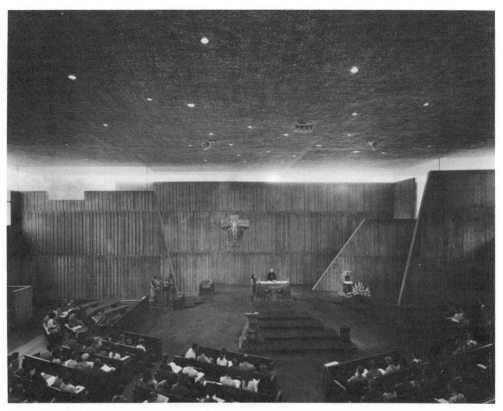

Stephen De Staebler, *Sanctuary*, 1968. Stoneware clay and bronze. Holy Spirit Chapel, Newman Hall, Berkeley, California.

Plate 182

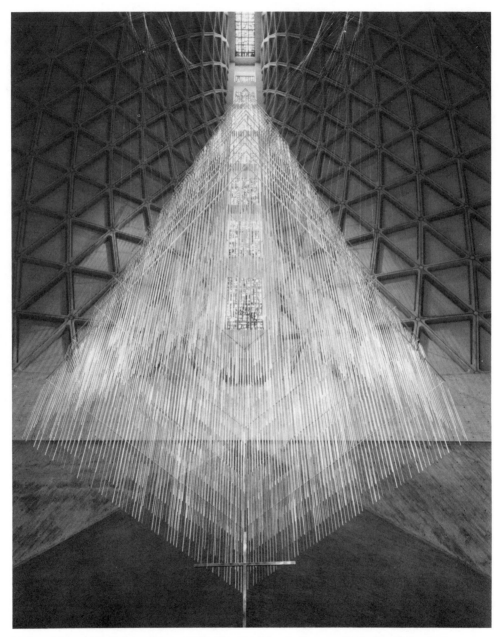

Richard Lippold, *Baldacchino*, 1969–70. St. Mary's Roman Catholic Cathedral, San Francisco, California.

Plate 183

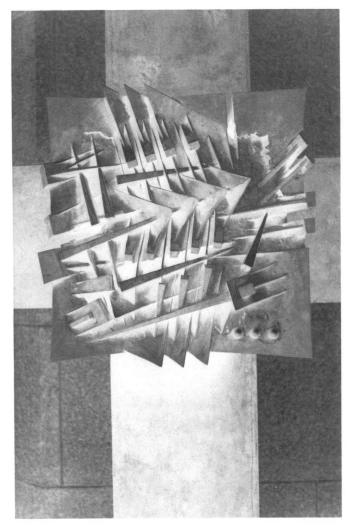

Arnaldo Pomodoro, *The Exterior Cross*. Bronze, 8 × 6 feet.
St. Peter's Lutheran Church, 54th and Lexington, New York.

Plate 184

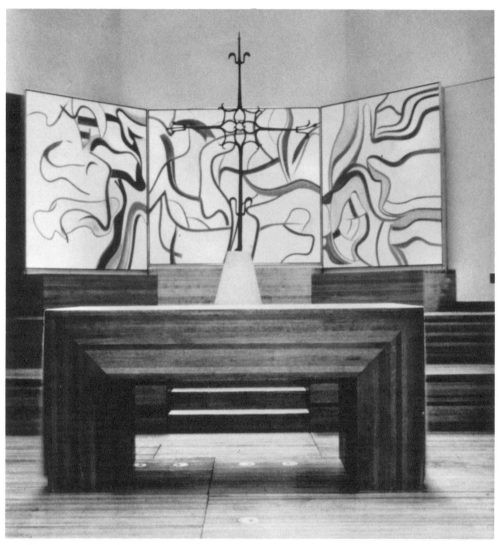

Willem de Kooning, *Triptych*, 1986. St. Peter's Lutheran Church, 54th and
Lexington, New York.

Preface

This volume is the story of a neglected slice of American culture, namely, the currents in which the visual arts and Christianity intersected. Church historians have largely ignored the visual arts, and art historians have usually included the religious dimensions only as an iconographical report. In the last twenty-five years, however, significant works on individual artists and religious themes have begun to appear. But this is, I think, the first attempt in recent history to provide a comprehensive report.[1] Being comprehensive, however, is not without its dangers, for considerable selectivity is involved in what one includes and excludes. Moreover, I have chosen to give considerably more time to some artists than to others, in the hope that the reader will thereby experience the issues more vividly than would be the case if it were a catalogue or dictionary summary. In the process, interpretation is both inevitable and desirable.

This volume is divided into four sections. The first, "Protestant and Catholic Approaches to the Visual Arts," deals with two divergent traditions in the eighteenth and nineteenth centuries. Since English cultural patterns form the background for New England Protestants, the reasons for the absence of the visual arts in English life are explored, followed by an account of the emergence of public interest in the visual arts and the role of early American artists (chapter 1).[2] In marked contrast is the self-evident, central place of the visual arts in the Catholicism of the Southwest, West, and Northwest (chapter 2).

The second section, "Nineteenth-Century Views of Art and Architecture," describes the ways in which the visual arts and religion were viewed by different segments of society. Protestant clergy moved from having no interest in the visual arts to a positive assessment, even if a circumscribed one (chapter 3). The religious journals, too, moved from exhibiting little interest in the visual arts to publishing major articles on their place and nature (chapter 4). Looking now from the side of the artists toward religion, one notes the variety of religious viewpoints, indeed, a kind of mirror of the society at large. The way in which such views influence the style, content, and subject matter of the visual arts is a complex one, about which partial assessments may be made (chapter 5). Because articulated views of architecture were elevated to theological significance and precipitated the debate over the appropriateness of the Neo-Classical versus the Neo-Gothic styles for church architecture and

the life of the church, these issues provide a specific context for particular views of the visual arts (chapter 6).

The third section, "Nineteenth-Century Art in Private and Public Life," deals with the works of art with implicit and explicit religious subject matter. The first two chapters in this section deal with religious subjects influenced by, but seldom directly based on, Scripture: first, diverging views of nature as reflected in painting (chapter 7) and, second, paintings and sculptures which visibly exhibit American civil religion (chapter 8). Then, Old Testament themes are explored (chapter 9), as is the image of Christ and the gradual emergence of commissions for churches and public buildings (chapter 10).

The fourth section, "The Visual Arts in the Twentieth Century," deals with many of the same themes as the nineteenth, but there are also differences in the style and content of these two eras. The aim in this section is both to articulate and delineate the distinctive characteristics of art in relation to spiritual and religious perceptions, as well as to contrast those with the nineteenth century. Starting with an account of the contrasts, materials follow on the view of art expressed in religious journals, the views of individuals who influenced new perceptions about art and architecture, an account of the initiation of exhibitions and catalogues on religion and art, and the emergence of societies in the field of religion and art (chapter 11). Turning to the visual arts themselves in relation to spiritual and religious perceptions, attention falls also on developments in the visual arts as such. Included, too, are materials on the distinctive way in which nature is perceived in the arts, and how civil religion appears. In both instances, the differences between nineteenth- and twentieth-century views become clear (chapter 12). Then, issues in the relation of twentieth-century art to religious institutions, particularly the church, are explored (chapter 13).

Two additional observations may be helpful. First, since this volume centers on paintings, sculpture, and architecture, materials such as gravestone sculpture,[3] stained glass, and liturgical objects are not included. Second, it is obviously more difficult to assess the twentieth century, particularly the last four decades in which I have done my work, than the previous period. Hence, the delineations may be more venturesome, thereby even affecting the style of presentation.

Having frequently been asked how I came to work in the visual arts, it may be appropriate to add a note on my pilgrimage. Initially, my professional life centered in historical theology, first, in the Reformation period and, subsequently, in continental developments. My interest in historical theology stemmed from my attempt in the 1940s to understand Paul Tillich's theological and cultural works. Working with him, first as a student, then as an assistant, and finally as a colleague, drove me, not to systematic formulation as a first love, as in his case, but rather to historical investigation, penetration, and reconstruction as a part of theological work. An interest in the range of concerns that preoccupied him likewise led me to historical interests considerably wider than the history of dogma or theology.

At Union Theological Seminary in New York City, I was among those who in the early forties urged Tillich to give courses on the Reformation and to deal with art in courses and special lectures. I can still visualize the photographs of Greek sculpture which he passed around in class, and the recollection of visits to museums in the forties and fifties is still vivid. Perhaps my response to both revealed a curiosty about and an affinity for these areas deeper than I then knew. In the ensuing years, major attention first went to the history of Protestant theology, set in a broad cultural setting. During that time, I continually encountered the problems created by the new science for the theological world, resulting in a project that culminated in *Protestant Thought and Natural Science* (New York, 1960). Indeed, I was impressed by the role of imagination and the unexpected events in the new science, a factor that later seemed to me to be analogous to what was going on in the arts, in contrast to sociology or psychology or philosophy.

In any case, my interest in art increased. It received renewed simulation through my marriage in 1962 to Jane, whose professional training in art history and in religion led her to teach art history in theological schools, and whose training in curatorial aspects of museums led her to undertake several exhibitions. My book, *Benjamin West* (San Antonio, 1977), centering on the context of his religious paintings, was the first public expression of that interest.

While I was never tempted to become an orthodox theologian in the seventeenth-century sense of encompassing all disciplines under a theological outlook, I have always felt that the breadth of the concerns of those theologians was correct. Between the seventeenth and twentieth centuries, however, knowledge has so grown, and disciplines have so multiplied and become so subject to change, that no one can encompass the whole today. We can only work with pieces and facets of knowledge, with a vision of the whole. I do not lament this situation, but rather rejoice in the illumination which results from the diverse modalities of perception found in disciplines as different as science, art, and religion. Attempts to present a unified whole sidetrack the multilayered source of insight.

Since the first three sections of this text, covering the colonial period through the nineteenth century, are reprinted directly from the 1984 edition, I have not been able to incorporate the most recent research in these areas. Considerable work has been done on women artists in recent years, though one has to admit that even the materials that have emerged only testify to the hegemony of men in that period. Symbolic of such research is the 1987 catalogue for the inaugural exhibition of the National Museum of Women in the Arts in Washington, D.C., entitled *American Women Artists 1830–1930*. While there are other areas, too, in which new work has been done, I want to refer here only to additional publications which would make a difference in my own work were I writing those earlier sections today. The dissertation by Diane Apostolos-Cappadona, "The Spirit and the Vision: The Influence of Romantic Evangelicalism on Nineteenth-Century American Art" (1988), sets Cole more clearly in the context of Romanticism and Evangelicalism than anyone to date. She has also reexamined the church documents having to do with Cole's baptism and sheds new light on that issue. David Bjelajac, in *Millennial Desire and the Apoc-*

alyptic Vision of Washington Allston (Washington, D.C. 1988), provides a positive context for understanding Allston's painting, *Belshazzar's Feast*. For a viewpoint that understands Allston's rapid departure from England with his unfinished Belshazzar painting and his subsequent inability to complete it, including the suggestion of Allston's possible homosexuality, in quite different terms, see Phoebe Lloyd's article "Washington Allston: American Martyr?" (*Art in America* 72 [March 1984], pp. 144ff.).

With respect to my own research, it is not possible to mention the names of all the librarians and staff members of libraries and museums who made material available to me. My thanks go to all of them. Among the libraries are: the Archives of American Art, Frick Library, General Theological Seminary, Graduate Theological Union, Harvard Divinity School, Library of Congress, Massachusetts Historical Society, Museum of Modern Art, National Gallery of Art, National Museum of American Art, National Portrait Gallery, New York Historical Society, New York Public Library, Princeton Theological Seminary, Union Theological Seminary, University of California at Berkeley (including the Bancroft Library), Trinity College (Hartford), U. S. Military Academy at West Point, Vassar College, Valentine Museum (Richmond), Wadsworth Atheneum (Hartford), Yale Divinity School.

Over the years, research for this project was facilitated by the help of the following: the Lilly Endowment, the National Endowment for the Arts, and the National Endowment for the Humanities. Throughout my work on the visual arts, Robert W. Lynn has been encouraging and helpful, and a frequent conversation partner.

In addition to Jane, it is my pleasure also to acknowledge the helpfulness of the following: the late Joshua C. Taylor, whose learning, interest, and friendship filled many hours; Lillian Miller, whose conversation and written notes were always helpful and sent me in new directions; Doug Adams, whose queries and careful annotations of issues needing clarification were at my side in writing the final draft. Then there are the host of individuals whose associations touched facets of this work: Lois Fink and Richard Murray, both on the curatorial staff of the National Museum of American Art, were conversation partners on facets of this work at an earlier stage of its evolution. Mary Ann Noonan Guerra and Henry Guerra, together with Raymond Judd, Jr., shepherded us through the San Antonio Missions and provided much needed assistance; Alan Vedder shared his rich knowledge of the New Mexican scene; Ellwood C. Parry III, his extensive knowlege of Thomas Cole; DeWolf Perry, his materials and knowledge of his forebear, Robert W. Weir. Then there are the artists, some of whom became special friends in the process of sharing their insights and art, such as the late Barnett Newman, George Segal, and Cleve Gray.

In this as other recent work, Diane Apostolos-Cappadona has been of considerable help on particular facets of research and interpretation, as well as through her editorial work. To her, and also to Frank Oveis and Werner Linz, I record my special thanks.

Berkeley, California, 1988

THE VISUAL ARTS
AND CHRISTIANITY IN AMERICA

ONE

Protestant and Catholic Approaches to the Visual Arts

1

English Christianity
and the Visual Arts of the Colonies

The visual arts had dropped out of the lives of the Colonists long before they settled in New England. To understand that, we must turn initially to the religious and social context from which the Puritan tradition emerged. Medieval English history, particularly the outlook and practice of Wycliffe and the Lollard tradition of the fourteenth and fifteenth centuries, was more decisive in forming the subsequent Puritan colonial ethos than was the Reformed tradition of the Continent. Though the Lollards were officially suppressed, there is considerable consensus among historians that their viewpoint continued to influence large segments of the population in towns and cities, as contrasted with the landed gentry, nobility, and crown. While there was considerable interest initially in the writings of Luther and later in the writings of the Swiss and Rhineland reformed Protestants, the English Protestant reading of continental writers took on the coloration and religious thought forms indigenous to the English Lollard tradition.[1]

Many of the ideas later associated with Protestantism in the popular mind were already characteristic of the Lollard tradition, and these ideas continued in dissenting Puritan thought. They stand in marked contrast to the continental conceptions. First, preaching is central to the Lollard Puritan development and the sacraments are less important. Except for the Anabaptist tradition, continental Protestantism, even when it differed on the concept of "presence" in relation to the elements of bread and wine in the communion, continued to stress the equal presence of the Word in proclamation *and* in sacrament. Overcoming the neglect of preaching on the Continent, in contrast to England, did not lead to the neglect of the sacraments, nor to relegating them to a secondary level.

Second, in the Lollard tradition scriptural statements provided direct models for the life of the contemporary church. Moreover, each individual's personal, unique relation to the text was considered appropriate for discerning its meaning. While the continental reformers also stressed the centrality of scripture for understanding the locus and nature of faith, for them, again with the exception of the Anabaptists, scripture was neither a necessary model for the life of the church, nor personally or privately interpreted. Scripture was interpreted in the continental church with the help and guidance of tradition. The historic nature of the church was accepted, and resistance to Rome was possible only because

the history of the church, as well as of scripture, could be claimed for the continental reformers' own position. History was not bracketed out.

Third, similar comparisons can be made on specific doctrines. For example, the concept of predestination as the experienced acceptance of God's determining activity, which was so central to Puritan theology, was modeled more on Lollard thought than on the work of either Luther or Calvin, where, by contrast, predestination affirmed that being a believer remains a mystery.

Fourth, theologically central to the Lollard conception of the Christian life was that of life's moral nature. Moral, in this sense, means simplicity of life, as contrasted with the opulence of church or state, associated with speculative knowledge and with alleged magical power in images and symbols.

The Lollard-Puritan moral passion affected and transformed theological ideas even when the source sounded continental. William Clebsch writes of the earliest English Protestants that they took ". . . Luther's cardinal teaching on justification by faith as axiomatic. But, whereas for Luther faith and justification primarily denoted the humble posture of forgiven sinners in the presence of a compassionate God, the Englishmen construed justification by faith as initiating a morally blameless life characterized by observing God's laws in one's daily deeds. For Luther, faith resulted in a trust that could sin bravely, while for the Englishmen faith resulted in an obedience that could eschew sin."[2]

The growth of the Lollard position coincided initially with the rising lower middle-class, with the Anglo-Saxons rather than the more wealthy, powerful Normans. This early social split continued into seventeenth-century England. Religious and social alliances produced fissures in the body politic. Such conflicts, to be sure, existed on the Continent as well, but there the population of a particular region, from top to bottom, from serf to ruler, usually joined in conforming to a single religious persuasion. If one did not like the religion within a circumscribed area, one could, in principle, move to another relatively homogeneous region. In England, the social-religious split was present in every region, even though the religious policies of the particular king or queen were allegedly enforced.

The Lollard and subsequent Puritan moral ethos was generally in conflict with the ethos of the ruling class of church and state. The Lollards and Puritans did not neglect trying to shape the life and culture around themselves. They tried to form both through associations and conventicles as an alternative to the establishment, always with the hope that the establishment would eventually be displaced by their own creations. The model for such thinking was not found in the history of the church, but in the New Testament community and its preceding archetype, the history of Israel. As a symbol, Israel stood for a lowly people who had reached fulfillment only to lose it because of their own defections from the religious and moral life demanded of God's people. Now, in England and then in New England, a new Israel must emerge whose credentials remained intact. That English identification with Israel, as a religious people who became a nation, which so eloquently is focused in Foxe's *Book of Martyrs*, occurs

nowhere else in western history. It represents the intentional ignoring and obliteration of history between biblical and English times.

Such an approach meant that religious dimensions, however spiritual, were simultaneously and directly social and political. It explains why English Christianity in its dissenting form never hesitated to try to form and control populations which did not share its predelictions and faith convictions. It meant further that other religious dimensions, and other liturgical and cultural expressions, even when considered as analogues of God's opulent presence, were rejected. The religious-social horizon shrank and other conceptions were forbidden.

Hence, the Lollard and Puritan objections to images and to the visual arts rested on several conjoined factors. The essential moral stance of this Christianity did not turn toward imagination, except when dealing with the scriptural text. Moreover, images, painting, and sculpture belonged to an upper-class life in both church and state.

W. R. Jones has written: "The Lollard penchant for moralizing about art, which they condemned as promoting luxury, avarice, and vainglory, was the product not only of their preference for the simpler religion, which they *thought* they saw depicted in Scripture, but also a sort of medieval 'populism' which derived from social and economic prejudice."[3]

We hardly need to be reminded of the corruption and manipulation associated with relics, and with the financial needs of church and state dignitaries at the time of the Reformation. There had been a long history of protest to which, at the eve of the Reformation, was added the new humanist development. The humanist development shared with earlier protest an articulation of the moral nature of Christianity, a rejection of the corruption and abuses of the time, and a suspicion of the visual imagination, presumed to be a major source of that corruption. One need only compare Erasmus, a continental humanist whose philosophy was most at home in England, with Luther, for whom the visual imagination was never abandoned, though he criticized its current practice.

Only in the light of such a history is Henry VIII's easy and successful suppression of the monasteries understandable. The confiscation of objects which could be turned into revenue, and the destruction of paintings and statues, could be used by him as a way of striking an opulent church associated with Rome.[4] Though he did not share the assumptions of those who readily accepted such an iconoclastic development, it was a shrewd political move.[5]

Consequently the first major iconoclastic wave in England was initiated by a regime sympathetic to the developing continental Reformation, but on the basis of political motives acceptable and congenial to those who continued the Lollard stance. During the reign of Edward VI and then under the Marian exile, considerable contact was maintained with continental figures of the Reformation, particularly the Reformed branch. In the latter Reformed branch, painting and sculpture in the churches were also frequently destroyed: witness Zwingli referring to the newly whitewashed Zurich minster as "positively luminous."[6] Nonetheless, though the Reformed tradition on the Continent generally continued to

be suspicious of the visual arts in the church, the arts did not fall outside the horizons of private and public life. By contrast, the almost total absence of the visual arts in the life of all English citizens, below nobility and crown, is a special phenomenon demanding further amplification.

Aside from the collections of nobility and crown, to which English citizens generally did not have access, the visual arts were to be found primarily in monasteries and churches. Their destruction, first under Henry VIII, and then again during the Cromwellian period, meant that the exclusion of art from the church created a vacuum. The result was that most individuals never encountered the visual arts, apart from limited exposure to portraits.

This English history affected early Anglicanism as well as the Puritan tradition. During the long reign of Elizabeth, there were differences of opinion as to whether art should be allowed in the churches. But her policy as head of the church was clear enough: "Images were to be destroyed, painting to be effaced and replaced by texts."[7] While older wall paintings were painted over—ironically enough preserving them for our day—some new wall paintings were executed. These consisted mainly of verbal texts and emblematic or moral subjects not considered susceptible to sensuous seduction. Such new paintings, writes Caiger-Smith, were "for the most part irreproachable emblematic or moral themes, such as Moses and Aaron with the Commandments, or figures of Time and Death, incapable of arousing old, idolatrous attractions."[8]

While the various European heads of state and the upper nobility were interested in the visual arts and established collections, the English development even at that social level was not as pronounced as on the Continent. During the sixteenth century, upper-class landed Englishmen did travel to Italy, as did their counterparts from France, Spain, and the German countries. But, while Francis I of France, Phillip II of Spain, and Rudolph II of Germany decorated their palaces with antique sculptures procurred in Italy, the English had less interest in such objects. On the other hand, the influence of Italy on English poetry and music was extensive. But Italian allusions to the visual arts fell dead on English ears. As late as the early nineteenth century, the Italian sculptor Canova, recommending Flaxman to his English compatriots, said, "You English see with your ears."[9]

Seventeenth-century English travelers to the Continent did return with items of interest. But the objects are generally small in size, such as jewelry, porcelain, ceremonial arms and armor; the sculpture they brought home frequently tended to be small in size and exhibited an interest in the decorative arts.[10]

Even when collections existed, many were dispersed by sales or destroyed by fire. Those which survived remained behind the private doors of lords or kings, where they were not to be seen. Special arrangements could be made, but no one but the rich could afford the fees, which were extracted directly or indirectly, by servants who stood at the many entrances and exits. This was true as late as the end of the eighteenth century:

. . . it is safe to say that at the dawn of the nineteenth century the great majority of the people in England had never had the opportunity of seeing a good picture. It is true that exhibitions had been held in London since 1760, but only a small fraction of the population had visited them; and to the royal collections of works of art and those in private houses, there was no access for a poor man unless he entered the rooms that contained them in the capacity of a workingman or a servant.[11]

Hence, the collections that did exist lay outside the purview of most of the English. But all English classes enjoyed the delights of hearth and home and, in principle, believed that the beauty manifested in the things of this world exhibited the glory of God. No work of humanity could equal the Creator's work; but all things together exhibited God's beauty and glory. It was, hence, part of the English fabric of life to be interested in illustrated manuscripts and books, vessels for liturgical use, elegant furniture, china, and clothing. The English were interested in good houses and jewelry, designs for signs, equipment, household items, wine, and books.[12] This is the background out of which the Colonists came.

While paintings were infrequently imported into the seventeenth-century colonies, the previously mentioned comforts and embellishments were sought and supplied with amazing rapidity. Porcelain dishes of exquisite design, originally brought or imported in the seventeenth century, might be taken across the country to California or Oregon in the nineteenth century. Such migrations demanded extreme care in transporting these objects, care not dissimilar to what would have been the case with paintings.

Such items were thought to have an elevating moral character, lifting one above the elemental brutishness of existence. So successful were the New Englanders in accenting the so-called refinements of life, that they eventually became an elite group, the Federalists, who could not tolerate the coarse Jacksonians. The early New Englanders had no inhibitions about the good life. The strictures we associate with them and with Puritanism are mainly nineteenth-century developments. However, the long association of the visual arts with the practices and theology of Catholicism—indeed, the conviction that the visual was in fact the seductive power which led to such an outlook—and the equally long association of painting and sculpture with wealth and upper classes, together excluded the visual arts from an acceptable Puritan life.

One would not hesitate, however, to point in England to the English preeminence in literature. Just as England had no counterpart to Michelangelo, Raphael, Bernini, or Rembrandt, the Continent had no counterpart to Shakespeare, Donne, and Milton, though there were important individual figures, such as Cervantes and Molière. Moreover, while the English contact with the Continent was limited to importing contemporary artists and to acquisitions for crown and nobility, active exposure to the philosophy, poetry, and literature of the Continent fructified England's own literary tradition. The English literary output became so strong that many considered poetry a higher art than painting and

sculpture until well into the nineteenth century. As inheritors of this tradition, the Americans, Allston and Cole, wrote poetry as well as created paintings, and they wanted to be understood as literary figures as well as painters. Seventeenth, eighteenth, and early nineteenth century clergy in New England considered themselves literary figures. Sermons were carefully prepared, for they were meant to be literary creations, as well as instruments of the divine. In this orientation, New Englanders were following ancestral patterns.

The precision and clarifying power of the English language and, hence, of English literature, represents a cultural development indicative of distinctive perceptions long prepared. It has been indicated that already in the medieval period the Lollards pushed for a Christianity understood in moral terms, stripped of theological mysteries and dubious images. It has been pointed out that the spiritual home of Erasmus was England. Indeed, the Protestantism of the English churches was filtered through moral humanistic eyes. The decided preference was for clarity (*claritas*), with an equally decided suspicion of mystery.

The debate between Erasmus and Luther, while couched as the question of the power or the impotence of the will, essentially centered in the difference between the power manifest in the clarity of human motivation and the continued mystery of the self with respect to its sources of power. Here the English fell on the former side, that of Erasmus, opting for the clarity of the word and for an operative equation, namely, the clarity and identity of words, reality and Word. While the continentals interpreted the Word as the light that shines into our darkness without dispelling all the shadows, the English saw the Word as the light whose clarity takes all shadows away. For the continentals, the mystery of another world enlightened this world, with its attendant mysteries, while for the English, the ambiguities of this world, troublesome as they were, were not the sign of demonic powers but of obstacles to be overcome by the light that had come into the world.

The English and the continentals did not differ on the efficacy of the Word. But they differed on what it did. If the power of the Word is characterized by what it brings to clarity, as contrasted with the mystery it discloses as it remains mystery, one confronts a difference in perception not susceptible of resolution. The perceptions are already divergent starting points. On the Continent, the Reformed tradition lived with the sense that the Word in preaching and sacrament (and these are on an equal level) remained mystery, and a mysterious presence, in the light it brought. On the English scene, from Baptist to Anglican, the Word in preaching and in sacrament was the Word of clarity which, in principle, expunged mystery.

The development of the Reformed tradition in England was decidedly different from that development on the Continent. There is, moreover, in the New World, a pronounced difference between the English, on the one hand, and the Reformed Dutch, Swedes, and Germans, on the other. They read the same books, including Calvin, but with differing perceptions. On the Continent, Calvin's stress on spiritual presence in the Lord's Supper is considered allied with

Luther's concept of Christ's presence, however differently the two understood the mode of presence. Both are remote from Zwingli's conception of words, sign, and signification. But on the English scene, Calvin is more directly associated with the Zwinglian stand than on the Continent. At best, the *Book of Common Prayer* is a mixture of ideas considerably closer to Zwingli than to Calvin, much less to Luther. The English debates centered in ancient liturgical and ministerial-priestly functions, and in the relation of the church to society. Presence with reference to the sacraments was not an issue until the Tractarian movement in the nineteenth century.

The Puritan-Anglican battle between Word and sacrament was fought in a common framework. It was the issue of which accent accorded most closely to the centrality of the Gospel, theologically and historically understood. But, in both instances, it was understood that the moral nature of humans was to be addressed, and each side claimed that its outlook represented purity and the right practice of the church. If the Puritans were averse to art in the church, it was because art seemed an obstacle to the centrality of proclamation; if Anglicans were for art in the church, it was still on a modest scale, and not for reasons of the significance of art as a purveyor of religious perception, but because art belonged to the right and older ordering of the life of the church. Even William Laud, that arch opponent of the Puritans, was not interested in art as such. He had a "low" conception of presence in the eucharist and was concerned rather for order and dignity, for everything in its rightful and clear place.[13] In short, Laud fought with the Puritans over the order and life of the church, but the Anglican Laud saw less mystery in the sacrament than did the Reformed churches on the continent.

The English debate was over the primacy of language as proclamation, or language as the vehicle of liturgical practice and tradition. But in both, language was a clarifying act, enabling one to say, "Now I see." Liturgically, it meant that the accent increasingly identified the *Word* with the *words* in proclamation and the *words* associated with sacrament. The English Anglican *via media* stressed the practices of the ancient church without their mysterious, substantive power, a situation which was changed only with the impact of the Tractarian movement in the nineteenth century.

From the sixteenth to the eighteenth-century, the English Protestant tradition had all the earmarks of a linguistic, hearing culture, in which the eyes were directed by being told what to see. With such a clarifying power for language the English produced a significant literature and molded theology totally by language, at the same time narrowing the horizons of visual perception. Seeing was not a mode of learning to be trusted in its own right. The mystery of faith and sacrament was replaced by a clear understanding of what God does, including the nature of humanity's response. When language informs seeing, and mystery is expunged from the center of God's dealing with humanity, the virtue of clarity is gained at the expense of other sensibilities. At best, art is then an appendage, not really expressive of humanity's spirituality. It can then be

ignored. In those rare instances when art confronts one in its mysterious power, it must obviously be subversive, threatening the clarity of the mind. Art which is not dangerous is like the Elizabethan portrait (Plate 1), in which all is light, and there are no shadows at all.

English life and religion, Puritan and non-Puritan alike, reflect a literary predilection, and art is either not on the horizon of consciousness or is accorded a secondary role. The literary penchant of English culture has characterized much of American life into the twentieth century.

> Literature is the dominant and popular art of the United States. . . . Though every school boy can speak of Washington Irving, few can tell of the troubled life and romantic work of Washington Allston. We are brought up on Defoe's *Robinson Crusoe*; we ignore Hogarth. Every American has heard of *Don Quixote*, but few can recognize the spirit of those greatest of painters, Cervantes' contemporaries, El Greco and Velazquez. . . . Most of us are still proud that we don't know anything about painting, but we know what we like.[14]

Hence, the arts of painting and sculpture have played a secondary role. Still it must also be pointed out, as James Flexner has shown, that native painting and sculpture appeared on the American scene prior to a native, as contrasted with a borrowed, literature.[15] Moreover, it should also be noted that the first significant painting tradition in the New World emerged from those very English who had little familiarity with or interest in art. But that occurred a century and a half after the first English colonists settled in Plymouth and the Boston area.

We have seen that the New England colonial disregard for the visual arts had a long antecedent history in which, indeed, religious factors were paramount. But this religious outlook owed more to the Lollard and the humanistic traditions than to continental Reformation roots. Moreover, the religious factors were deeply enmeshed in social differentiations and in the politics of church and state.

Portraits were the one form of the visual arts that did not come under systematic attack. They were an art form amenable to all classes in society, though the portraits themselves, in their difference in style and content, are a good barometer of class differences.

The painting tradition in England in the sixteenth and seventeenth centuries was not distinguished. There are no counterparts in England to the sixteenth-century continental giants—Michelangelo, Raphael, Titian, and Dürer—nor to the seventheeth-century figures, Rubens and Rembrandt. So meager was the tradition of painting in England that artists were imported to do the portraits desired by patrons. Rubens, who painted portraits and mural commissions for the English crown and nobility, was the most notable of these. Holbein made several trips to England in order to find patronage. A decade later, in 1536, he became Painter to Henry VIII, in whose court "he was applauded as a face-painter who could produce a likeness and faithfully depict fine jewels and elaborate cloths."[16]

Elizabeth (1558–1603), who ascended the throne just over a decade after Henry's death, also had a pronounced taste for elaborate embroidery and embellishment of clothing as is evident in the other likenesses of the period and in

portraits that signified Elizabeth's place (Plate 1) in the order of things. Under Charles I (1625–49), who was a collector of old masters and who had an accompanying interest in contemporary arts and artists, the elaborate and embellished portrait was carried to its height, mainly under the influence of Van Dyck, who had returned to England in 1632. While the ethos of the Commonwealth period was not conducive to artistic endeavors, the tradition of portraits continued, as the numerous portraits of Cromwell testify. In these portraits, attributes indicating position in society—special architectural settings, fine clothing, or a handsome dog—disappeared, and the half-figure portrayed against an amorphous dark background became the dominant form.

The English portrait tradition emerged among the upper-class gentry and the court. They, in turn, may have been influenced in this direction by what they knew of their counterparts in Italy. Roy Strong has called attention to the probable connection between the sixteenth-century hall of Paolo Giovo, Bishop of Nocera, and the subsequent English long halls in the houses of the gentry, in which the owners exercised in winter and, simultaneously, communed with the portraits of the "worthies" exhibited on the walls of the hall. Moreover, from the Italians, the English learned the many uses provided by such an arrangement: "The guiding principle of such a collection was partly antiquarian, partly moralistic, for lessons of virtue and vice were to be read from the countenances of the great gathered in the museum at Como."[17] Among the gentry, a collection, whether of portraits, artifacts, or some Italian and German paintings, provided a social reputation and stimulated delight as a weapon against melancholia.[18]

While the preceding viewpoint has the particular coloration of the upper class, a simpler version was also characteristic of the outlook of society at large. Portraits combined the moral and the pleasing, a conjunction fondly desired by the English. Hence, portraiture cut across the social boundaries. While remembering, recalling, and seeing the contours of the likenesses of the great, one saw virtue, sometimes godliness, and great deeds personified. Such portraits served a didactic purpose, and if one was a member of the family whose effigy was portrayed, ancestral portraits were a stimulus to familial pride. Moreover, such portraits did not, like paintings, cry out for total attention in and of themselves. They took their place in pleasing surroundings.

While portraits provided a pleasing lesson for both the middle class and the court, portraits were not painted of everyone. Their moral and refining nature, it was believed, confined the choice of subjects to those who had significance. That meant that portraitists depicted magistrates, successful merchants, and members of the professions, including the clergy. In America the significance of the clergy in the seventeeth and eighteenth century makes the large number of clergy portraits intelligible.

There is a marked contrast between the Puritan clergy portraits generally and the portraits of nobility, the Crown, and the Anglican bishops. That difference, it was assumed until recently, is that the former were inferior modifications of the latter, that is, provincial in that sense. It is now clear, however, that

the portrait tradition in England and the colonies stemmed directly from the English medieval period.[19] Stylistically, Puritan and early colonial portraits generally have been traced to a continuation of a medieval tradition outside London—indeed to the very areas from which the Puritans came. Thus, the portrait tradition in Puritanism, like its religious inheritance from the Lollards, also has medieval roots.

In the early colonial Puritan portraits, then, we have to do with the continuation of a tradition, rather than with a falling away because of primitive circumstances. By the eighteenth century, however, stylistic sophistication did emerge in paintings done in the colonies. Artists with wider exposure to subsequent English developments in London and in other major centers, found their way to the new world and to the new potential portrait market. Nevertheless, in this period, the stylistic rendering of the Puritan clergy was less competent than equivalent portraits in England, partly because a lag had developed between those who came to do the colonial portraits and those who stayed on in England. The emphasis in portraits of Puritan clergy was more on the "likeness", and less on the sumptuous or diversified settings of other emerging upper-class figures.

Generally, artists did portraits of individuals, but on occasion, group portraits.[20] Among the more interesting in the latter category are two paintings, one by John Smibert, *Dean George Berkeley and His Family* (Plate 2), done in Newport during Berkeley's stay, and the anonymous naive painting, *A Council of Ministers* (Plate 3), in which each figure faces us individually as if each one was unaware of the other's existence.

Of particular interest among clergy portraits is Samuel King's *Portrait of Ezra Stiles* (Plate 4), a prominent Newport clergyman who became president of Yale in 1778. Stiles' own account of the symbols in the painting discloses his knowledge of Judaism, possibly of the Kabbala, and a tradition of light and glory somehow akin, or derived from, the Christian philosopher Dionysius.[21]

It was not until the turn of the nineteenth century that the English colonies produced paintings with religious subject matter. Contrasting sharply with the English colonies is the Dutch settlement of the upper Hudson valley, where, in the eighteenth century, paintings with religious subject matter were executed along with portraits. Thirty-eight such religious paintings have been identified.[22] Moreover, one of these, with the attribution, *The Naming of John the Baptist* (R. H. Love Galleries, Inc., Chicago) carries a 1713 date and the signature of Gerardus Duyckinck, who was the son of Gerrit Duyckinck and the first cousin of Evert Duyckinck III, who were also limners of the time.[23] On the basis of stylistic factors and examination of the wooden panels, the following paintings of this Hudson River group have been attributed to Gerardus Duyckinck—*Esther and Ahasuerus* (Columbia County Historical Society, The Luykas Van Alen House Museum, Kinderhook, N.Y.), *The Four Evangelists* (Albany Institute of History and Art), *Christ at Emmaus* (Plate 5), *Christ Healing the Blindman* (Ibid, Columbia . . .), *Christ on the Road to Emmaus* (National Gallery of Art). Also, on stylistic grounds the remaining thirty-six have been tentatively assigned

to several groupings of limners.

Some of the sources for the iconography of these paintings has been traced through recent intensive study. Major sources are both the illustrated Dutch Bibles published between 1702–1714 by the Keur family in Dortrecht and in Rotterdam, and the illustrated books about Biblical episodes, principally editions of work by Nicolaus Visscher and Matthew Merian.[24]

The subjects, with few exceptions, are part of a standard repertoire and many are repeated again and again. There are five versions of Isaac Blessing Jacob, four each of Christ on the Road to Emmaus and the Adoration of the Magi (Plate 6), three each of The Finding of Moses and The Annunciation, two of the Judgment of Solomon. The paintings represent dramatic events of Old Testament history or events associated with the life of Christ. Hence, there is no compelling reason for trying to associate particular painting subjects with concrete circumstances in the life of the Dutch in the Hudson Valley.[25]

On the other hand, the circumstances of Dutch life generally may be relevant. The commercial, rather than land or government, centered life of the Dutch, made art a part of the ambience of life. It was a commodity to be bartered and traded. Such art, whether portraits, familiar scenes, or Biblical events, belonged to public and private life, not to the Church. Hence, the walls of homes, rather than churches, included religious subjects. No liturgical or church setting was intended.

Moreover, these paintings belong to the tradition of naive, as contrasted with professional or high art. The result is a certain freshness of style which comes partly from being free of the tradition of art, partly as the result of an untutored awkwardness. They are quaint, homey, easy to identify and to identify with, for their way of depiction does not stretch what we already know, but, rather, visually confirms it.

Records indicate that during the same period as the Albany paintings, Gustavus Hesselius, a Swedish painter in the new world, painted a *Last Supper* for St. Barnabas Episcopal Church, Upper Marlboro, Maryland. The subject, comparatively rare on the Continent in the eighteenth century even among Protestants, is prominent in English Anglican churches, and usually placed over the altar—as was the case originally at St. Barnabas. St. Barnabas Church today does own a *Last Supper* (Plate 7), but scholarly opinion leans to the judgment that this particular painting is not by Hesselius. The Hesselius painting, originally done in 1721, disappeared during the American Revolution when the church was temporarily abandoned. A *Last Supper* appeared in an auction room in the Georgetown section of Washington, D.C., was hastily identified as that by Hesselius, and eventually was placed in St. Barnabas Church. While the painting could be an imported work rather than a colonial production, there is no compelling reason to doubt that it is an eighteenth-century American painting, even if not by Hesselius.[26]

The painting, three feet by ten feet, is certainly related to late fifteenth century Italian prototypes, such as Leonardo's famous painting. The architectural

setting and a close comparison of the posture of several figures, show marked similarities to Andrea del Sarto's *Last Supper*. The painting may be based on an engraving, but, if so, the source has not yet been found. Furthermore, it may be based on several sources, particularly since an awkward crowding of the figures at the left, as if the artist had run out of space, would hardly occur if a single painting source were involved.

As in the Leonardo *Last Supper*, the apostles are arranged along one side of a narrow table facing us, with Christ as the central figure, artistically and psychologically. But, unlike Leonardo, the mood is introspective, with Christ reflecting quietude and sadness, and the disciples, with troubled, indrawn faces. These faces contrast sharply with Judas, alone on the opposite side of the table, gripping his money bag and staring vacuously towards us as he starts to leave. Like the Albany paintings, this, too, has an awkwardness in spatial relationships and the loss of anatomical understanding characteristic of provincial works of art.

As we have seen, English Christianity, a unique tradition with roots in the medieval, Lollard development, did not have a tradition of the visual arts. These arts had fallen outside the framework of both religion and society except for portraiture. The portraits, as well as the religious impulses, stemmed from the medieval tradition, so that the English and American portraits shared in the lack of a polished and developed style. That the visual arts played a role among the nobles and crown and had a distinguished style, need not concern us, since that had no effect on broader English life as such. Hence, the absence of the visual arts in the Colonies, and the particular style of colonial portraits did not reflect a divergence from the English tradition, but, rather, its continuation. A limited, eighteenth-century emergence of painting with religious subject matter in the Colonies was either Dutch or Anglican. Only among the Spanish Catholics, as we shall note in the next chapter, was the situation dramatically different.

2

Spanish Catholicism and Catholic Art

The *Last Supper*, by Hesselius, discussed in the previous chapter, represents a tradition in painting, though even among Anglicans, this tradition was not prominent until later in the eighteenth century. The visual seldom provided a focal point in the architectural setting or in liturgical functions of Anglicans until after the middle of the nineteenth century. However, we do know that art functioned in the liturgical life of the French and Spanish settlements in America from their very beginnings. Unfortunately, few works survive from before the mid-eighteenth century.

An early eighteenth-century French altar frontal from Jeune, Lorette, Quebec, has a Madonna and Child at the center, in a setting of nature and surrounded by a group of Indians.[1] But the extant buildings we connect with French culture in New Orleans and St. Louis are from the nineteenth century. The Cathedral of St. Louis the King, New Orleans, Louisiana, has paintings, sculpture and murals. But even these nineteenth-century works have been extensively restored. Over the main altar is the Mural, *St. Louis, King of France Announcing the Seventh Crusade*, and on the ceiling near the sanctuary is the *Nativity of Christ*. On the ceiling of the nave is a mural in which the Saviour, surrounded by the apostles and placed just below God the Father, bestows authority on Peter, with the counsel in French, "Feed my lamb, feed my sheep". The Old Cathedral in St. Louis, Missouri, now known as the Basilica of St. Louis the King, is a chaste sandstone building with a decorative interior. Across the front is the inscription in Latin, "in honor of St. Louis", and on the portico, in Latin, "the one and triune God", above which one finds the word God in Hebrew.

In contrast to French Catholicism, Spanish Catholicism presents us with a rich surviving tradition, though there are no artistic remains from the early settlement in St. Augustine, Florida. Most of the extant works of art are a part of the Spanish tradition of the Southwest and the West and date from the late eighteenth and early nineteenth centuries. The Spaniards, who conquered or controlled and settled the Southwest, represented a world whose spirit and cultural understanding came directly out of Spain and Mexico, then called New Spain. If the New England states represented a transplanting of much that was English, the Southwest was even more Spanish at its core. It represented Catholicism largely untouched by either Renaissance or Reformation, antedating such forces and

splits in the rest of Europe. If Protestants were unsure of the role of art in the church, and if Roman Catholics in the rest of Europe now felt it necessary to defend art and sometimes purify it, Colonial Spanish Catholicism was not conscious of such problems. Art and images were part of daily domestic and liturgical life, powerfully expressing the forces that connected heaven and earth. Indeed, to have removed such images would have been to banish the vivifying embodiments by which God was known and made accessible. Seeing and sensing were modes by which the benefits of God were daily known and appropriated. Christ, the Virgin Mary, and a plethora of saints provided a visible network of available grace. Their embodiment in painting and sculpture was both a source of religious vitality and idolatrous predilections. Images were more real than words.

Whereas Protestants did not settle without Bibles, Spanish Catholics did not travel without the visual images of faith. In Spanish settlements, the chapel or church, with multiple altarpieces covered with images of the saints and of Christ's passion, was the center of the community's life. Such visible symbols were never out of sight. The Cross with its corpus, and the saints answering to the specific needs of a community, graced community events and public spaces.

Our attention will be focused on the missions in San Antonio, Texas; Tucson, Arizona; New Mexico and California.

The San Antonio missions, as contrasted with those of New Mexico, Arizona and California, survive from a earlier time, some dating from soon after the mid-eighteenth century. The Spanish missions of East Texas had been abandoned in 1731 because of the encroachments and competition for hegemony with the French, and because of unfriendly Indians; these East Texas missions moved to what became San Antonio (so named for the Feast of St. Anthony celebrated on the day the Spanish arrived), where they became the center for Spanish authority in Texas. The Franciscan missionaries and their Indian workers eventually built structures, which while neglected and ravaged by time, still show something of their original grandeur. Weather conditions in the area did not permit adobe construction, as in New Mexico, and hence the buildings were constructed of limestone and covered with plaster. Best known of the missions is the Alamo, in San Antonio, which was originally established in 1717 as Mission San Antonio de Valero, but there are now no remains of the mission church at the Alamo.

Mission Nuestra Senora de la Purisima Concepcion, usually known as Mission Concepcion (Plate 8), is located just south of San Antonio and was completed in 1755. Never having been rebuilt or restored, it shows the ravages of time; but here one also has an authentic building, untouched by the hands of restorers. The broad facade has a handsome portal carved with floral and geometric decorative patterns and medallions; at the upper left is the coat of arms of the Franciscan order and at the right, the Five Wounds of Christ: a deep niche above the door must have had a statue of the Virgin Mary of the Immaculate Conception to whom this mission was dedicated.

Initially painted inside and out, its four foot thick walls now have only traces of color on the facade and on the interior. In 1890 William Corner wrote that the

facade is "frescoed all over with red and blue quatrefoil crosses of different patterns and with large yellow and orange squares to simulate great dressed stones." In the Baptistry, which is just to the right of the front entrance, "a semi-circular font projects from the south wall, its half bowl carved with what appears to be a symbolical figure with outstretched arms supporting the rim."[2] It is still visible today though considerably less distinct. Over the font is a painting which even in its poor condition can be identified as a thorn-crowned *Christ on the Cross*. The Baptistry also has indecipherable traces of painting designs on the walls.

Also at Mission Concepcion, one of the transept altars had, in 1758, a thorn crowned face of the suffering Christ, while the other altar had a painting of Our Lady of the Pillar. A separate room, to the south of the nave, and with separate entrance, has remnants in the ceiling of the Eye of God, an image invoked for protection for children and crops which is still prominent in the religious culture of the Huichol Indians of Mexico.

Mission San Jose y San Miguel de Aguayo (1768–82), usually known as Mission San Jose (Plate 9), is the most prominent of the extant missions, impressive in size and with a handsome ornately carved facade. While the facade has been restored, original work remains and the total effect is impressive. The elaborate carved portal is set between two flanking towers which were to be crowned with sculptured belfries; unfortunately only one of these was built. Directly above the door is a carving in high relief of Our Lady of Guadalupe, an image of a miraculous painting venerated in a pilgrimage shrine north of Mexico City. Flanking the carved doors are statues of St. Joachim and St. Anne, the parents of the Virgin Mary. The hearts carved above these figures represent those of Joseph and Mary, parents of the Christ child. In the upper zone, above an oval window are angel heads and the figure of St. Joseph, patron of the mission; above him is a representation of the Sacred Heart of Jesus and on either side are St. Dominic and St. Francis of Assisi. The saints are placed in elaborate niches with conch-like canopies, and surrounded with garlands of flowers and decorative carving. The walls of the church were originally covered with an abstract floral motif in red, yellow and blue, which gave the effect of "sparkling tiles". Fragments of the paint remain on one of the towers. The interior, too, was painted but none of the original decoration remains today.

Perhaps better known than the facade is the richly carved window on the South wall, known as the Rose window, or Rosa's window, allegedly in memory of the sculptor Pedro Huizar's lost love, Rosa. The facade dates from about 1778, and Rosa's window from about 1790. San Jose is regarded in many of its details as the most authentic Spanish Baroque in this country.[3] The facade and Rosa's window at San Jose were carved not by an indigenous craftsman, but by Pedro Huizar who was born and trained in Mexico. While the church is built of porous tufa, the facade and window were carved of a denser limestone called Concepcion stone.[4]

Wall paintings, as we noted, have largely disappeared. Sculpture, imported from Mexico and in some instances directly from Spain, was to be found in the

missions, and what is there today, while true to the tradition, may have been placed in the missions during restorations. In San Jose, a statue of Christ in a side chapel is probably of an early date. At San Juan Capistrano sculptures located over the altar include St. John, the Virgin Mary, and Christ, plus additional figures at the front of the chancel area. At Mission Espada statues of St. Francis, Christ, and Our Lady of Lourdes are to be seen.

Two points should be kept in mind. First, as contrasted with New Mexico, the San Antonio missions are more Spanish in tone and style. Second, the art objects in San Antonio are imports, primarily from Mexico or Spain, or both. Unlike New Mexico, there was no tradition of creating paintings or sculptures locally.

Works of art on a grand scale survive from the late eighteenth century in Mission San Xavier del Bac, near Tucson, Arizona (Plate 10). Dedicated to the "Apostle to the Indies," San Xavier del Bac was the northernmost mission to the Indians created by the indefatigable Jesuit, Eusebio Francisco Kino, in 1700.[5] The present building was erected by the Franciscans under the leadership of Juan Bautista Velderrain and Juan Bautista Llorens, between 1783 and 1797. The shift from the Jesuits to the Franciscans was made as a result of the expulsion of the Jesuits from Spanish lands, which became known in Mexico in 1767. At the time of the transfer from the Jesuits to the Franciscans, records make reference to statues of Francis Xavier and Mary as the Sorrowing Mother, both prominent subjects in the subsequent church structure.

The mission church today is, as it must have been in its own time, an imposing, white-stuccoed structure. It is only slightly more than a hundred feet long, approximately thirty feet wide in the nave, and measures fifty feet to the top of the dome. Yet, it seems to rise out of the desert plain of the Santa Cruz River, with hills and mountains on the horizon. A visitor to the church in 1797 states that it is constructed of

> burned brick and lime. The roof is barrel-vaulted. The church is very large. It has five altars, four in the crossing and High Altar: the High Altar has a reredos of burned brick and lime, and it is painted and gilded, and the other altars are only painted, and all are adorned with 32 statues of saints including the four that are in the four pillars in the body of the church, and all are very beautiful. Moreover, the walls of the church, the octagonal drum, the cupola, as also the choir are adorned with various images and mysteries in fine paintings which are applied on the wall, but in such a manner that they appear to be on canvas. There are four windows in the drum of the crossing, all with glass. The church has two towers, one unfinished, but the only thing lacking is the dome. The pavement of the floor of the church is of mortar and well-polished.[6]

Stylistically, the interior is in the Mexican Churrigueresque style, with the *estípite* (a columnar effect consisting of what appear to be inverted triangles stacked on each other, bound to the whole with imaginative tracery) as an integral part of the wall surface. While this is a development which distinguishes it from the European baroque, the resulting effect is in the baroque spirit. Sculpture, painting, and decorative motifs define the total space. Sculptural work is

variously carved out of stucco or stone or polished wood. The heads and arms of the sculptured saints are mounted on wooden props, the latter concealed by actual garments.[7]

Central to the chapel in the west transept is Jesus the Nazarene, with St. Francis of Assisi, above, and, below, a reclining priestly vested figure representing St. Francis Xavier. On the north end of this west transept is the figure of St. Joseph, with St. Dominic above at the same level as St. Francis. On the south wall of the west transept, above the confessional, is a fresco of Our Lady of the Pillar. The high altar in the east chancel is dedicated to Our Lady of Sorrows. On the north side of the east transept is the sculptural figure of Mary, the Immaculate Conception (La Purisima), while in the south side of the chancel is the fresco of the Blessed Mother, Queen of the Holy Rosary. Among these major sculptures are niches with additional figures and paintings of draperies, angels, and decorative motifs.

The central figures on the main altarpiece or retablo (Plate 11) at the end of the chancel are God the Father at the top, the Immaculate Conception in the middle, and Francis Xavier at the bottom. These are flanked on the left, from top to bottom, by Cain, Peter, and possibly Simon or John; and on the right, from top to bottom, by Abel, Paul, and Andrew. The interest in Francis Xavier, Jesuit missionary to Asia, dates of course from Father Kino's founding of the mission, and he is here depicted as a somewhat austere and emaciated bearded man, wearing biretta and full priestly robes, which when removed, disclose his heart in an open chest and a base of willow wood props. The Immaculate Conception, while not declared dogma until 1854, already had a long and intensely popular history. Since the beginning of the eighteenth century, Mary of the Immaculate Conception was considered the patroness of Spanish lands.

Here at San Xavier del Bac Mary is a young woman, her hands raised in adoration, her dress and the adjacent space adorned with flowers, her feet resting on the crescent moon. On the north wall of the east apse, where Mary again appears, as the Immaculate Conception, she wears a crown with stars, but does not stand on the crescent moon. Historically, the crescent moon and the crown with stars, deriving from the Book of Revelation, are attributes of Mary of the Immaculate Conception.

Raising even more of an iconographic problem is the designated figure of God the Father. God the Father is often depicted with his right hand in the gesture of blessing and with his left hand holding the world surmounted by a cross. If this is indeed the God figure, this scheme certainly represents the kind of piety in which the Christ figure is eclipsed, since Christ appears only in subsidiary locations, such as the suffering Christ in the west transept, the crucifix above the main altar, and the crucifix held by the Francis Xavier figure.

In the retablo (altar screen) the *estípite* columns and over-all decorative motifs provide the setting for the figures. Among the many decorative details that might be mentioned, two are of historic interest. First, the scallop shell, so conspicuously used in the decorative motifs, alludes to the special place of St. James (Santiago) of

Compostella in Spanish life and faith. Twelfth-century pilgrims to Compostella returned with shells attached to their cloaks, symbols of the good works to be done. Father Kino noted in his diary in 1692 that the legend of the Holy Virgin's prophecy to St. James, which promised that Spain would convert the rest of the world, was his destiny to fulfill.[8]

Second, running as a band around the interior of the church, are twisted cords, symbolic of the cord St. Francis wore around his waist. It is as if the cord held the interior together, much as the cord held the cloak to the saint's body.

San Xavier del Bac has singular importance as one of the few remaining churches with a complete decorative scheme, and one which is unusually homogeneous, being completed within a decade. Though the individual sculptural forms have a provincial crudity, the total symphony of sculptures creates a striking and moving whole. It belongs to a tradition developed in the major centers of Mexico. Here it is found in a far-away, desert-like land, with relatively few inhabitants. The mission church was already in decline at a time when artistic creation in New Mexico was at its height. From approximately 1820 until the twentieth century, San Xavier del Bac deteriorated, and was sometimes abandoned, being restored only in our own century.

Until the erection of San Xavier del Bac in 1783, developments along the Rio Grande in New Mexico were similar to those along the Santa Cruz. Portable objects were standard ware, and modest, but embellished chapels were created. Late sixteenth and seventeenth century padres and Spanish settlers, particularly in the Santa Fe area, brought art objects when they came. Priests who entered what is now known as New Mexico in the seventeenth century carried a standard issue of required materials, including paintings and carved images of Christ and the saints. But the supply was not adequate. Paintings on animal skins (buffalo, elk, etc.) were done as a way of increasing the number of images in a situation in which canvas was not available. Indeed, painting on animal hides continued until well into the nineteenth century, though the number known today is but a fraction of the original production. There was much destruction of images and skin paintings during the Pueblo revolt of 1680, though the major production of skin paintings was after the reconquest. But by 1817–20, Bishop de Guevara from Durango strongly objected to "the indecency of skin paintings" and the general sad state of images, ordering both removal and reform. Nevertheless, E. Boyd in her book, *Popular Arts of Spanish New Mexico*, provides the subjects and location of fifty-seven skin paintings known to her.[9]

Compared to later buildings, the early seventeenth-century churches were modest. Nevertheless, in addition to the objects of liturgical use and veneration, church walls were frequently painted in the seventeenth century as a help in communication to Indian neophytes, who obviously presented a language barrier. Most of these structures have disappeared or been modified, with the result that we have only traces of these early paintings done with soluble pigments. But there are sufficient traces of such painted walls at Quarai Pueblo, San Jose at Giusewa, and San Bernardo de Aguatubi (Awatavi) to suggest Franciscan Spanish

iconographic sources.[10] Some of the sources for composition come from prints and some from the memory of past history. The result, of course, is that much of the work reflects earlier sources.

While the eighteenth-century developments in New Mexico were an extension of the seventeenth, the stepped-up mission enterprises demanded more images, and, as a result, in the eighteenth century, artisans began to create images locally, the supply arriving from Mexico being inadequate. Many of the late eighteenth-century bultos (sculpture), retablos (paintings), and reredos (altar screens) are recorded in inventories, and some of these are extant. Moreover, in many cases we know who the artisans were, sometimes because the official hierarchy recorded its dislike of particular creations. Among these artists is Fray Andrés García, whose *Christ in the Holy Sepulchre* (Plate 12) is still to be found in the church at Santa Cruz. A lay carver was Bernardo de Miera y Pacheco. To him is attributed the Saint Joseph which stands beside the high altar in San Jose de Gracia at Las Trampas, and the St. Michael in the chapel of San Miguel in Santa Fe.

New Mexican art came to its fullest expression during the second, third, and fourth decades of the nineteenth century. It is contemporary with, though unrelated to, major works by Edward Hicks, Thomas Cole, Horatio Greenough, which we will consider later. Its creation did not take place in the most favorable of times. Mexican independence from Spain meant that clergy who continued to be loyal to Spain had to leave. While the Franciscans were only partially affected by these developments, Mexican secular clergy were not adequate in numbers to fill the need. Nonetheless, it was during this period that eastern trade with the area created the Santa Fe Trail, and that local artisans created the folk art which has become so fascinating to us today.

When such folk art was first viewed by travelers and traders of eastern Protestant origin, it was considered crude; moreover, it confirmed their anti-Catholic attitude toward saints and sensuality. Supervisory visiting bishops from Mexico also questioned much of the art, partially because of its crude character when contrasted to the art they knew, and partially because of the casual and sometimes slovenly care given to liturgical objects. Fray Francisco Atanasio Dominguez's 1776 investigative visitation to New Mexico from Mexico led him to describe the contents of San Jeronimo de Taos as follows: "The altar screen, and the images in the round which have been mentioned, canopy with three gradins, tabernacle, casket, pulpit, confessional, lamp, chandeliers, balustrade of the false transept, beams on the floor, and the small tower were all provided by Father Garcia, who made the images with his own hands. And it is a pity that he should have used his labor for anything so ugly as the said works are. . . ."[11] With the shift to non-Spanish bishops after the American occupation of New Mexico, the attitude did not change initially. The Roman Catholic vicar apostolic, the Reverend John B. Lamy, who was sent to Santa Fe from Cincinnati in 1851, did not respond positively to the santeros art. With a cultured European background, he found the local art crude, though he soon adopted a more approving stance. Today, the distinction between folk and professional art is almost universally

accepted, with due appreciation for the artists who had no professional training, as contrasted with those who did.

Iconographically, in New Mexico, as in San Antonio and Tucson, the art is derived from Spain, through Mexico. Many of the first works brought to New Mexico, as in San Antonio, had been imported from Spain, and some had been created in Mexico. But in New Mexico a local art tradition developed. The New Mexican work of the late eighteenth century and the first four decades of the nineteenth century is, of course, based entirely on this Spanish-derived tradition. But the santeros art also shows the effects of increasing isolation from the original sources of that tradition. Many of the original sources were examples of professional, high art. In the physical and psychic isolation from the centuries-old civilizations of Spain, the New Mexican artists confronted the achievements of the past detached from their long nurtured Spanish roots and techniques. The low level of technical competence and the limited materials at hand did not make it possible to create imitations of the art which influenced them. While iconographically based on earlier prototypes, the retablos were simplifications adapted to the use of the materials at hand—the pine and cottonwood panels and pigments available. In the case of the carved images called bultos, a simple form was often covered with cloth dipped in gesso to provide the appearance of drapery. Though the materials demanded simplifications, the level of technical competence of the artists could not have resulted in high art even with more favorable materials. But technique, material, and competence had achieved a level of commensurability, conducive to an expressive folk tradition. The figures are typically rigidly frontal and are disproportionately narrow in depth. Color and embellishment supplement line to provide the contours of the figures, lending a decorative charm to many of the paintings and carvings.

More than any other body of religious art, the santos of the Catholic churches of the Southwest can be understood only in the context of the place of worship, be it church, chapel, or private oratorio. The museums and collectors who own individual panel paintings, sculptures, or an entire altar reredos, are aware of this and often exhibit the santeros work in chapel-like settings. Yet in the museum the viewer is deprived of the experience of traveling to the adobe church in its remote mountain valley setting, of seeing the reredos in the dim interior light in which the multiplicity of images of the saints provide a special ambience. Here are santos and bultos of the great leaders of the church and the orders—St. Ignatius Loyola and St. Francis of Assisi as well as St. Barbara, St. Ann, St. Lucy. However, rather than being the heroic and impassioned figures depicted by the Counter Reformation artists, the santeros saints and Holy Family, Christ, and the Virgin have the charm of child-like simplicity. Only in representing suffering does the santero depict passion. Sufferings they knew were depicted in macabre detail in such figures as Fray Andrés García's *Christ in the Sepulchre* (Plate 12).

The characteristic decoration for the adobe church was the reredos, a large painting placed behind the center altar, and also at side altars in transepts and

along the nave walls. The altar screens of two churches influenced many of the subsequent developments.

The first of these was carved in stone in 1761 for the new La Castrense or Our Lady of Light, a military chapel no longer extant but of considerable importance in Santa Fe at the time. Today, the altarpiece (Plate 13) stands in the adobe church of Cristo Rey constructed in 1940 in Santa Fe. The stone reredos stands as one of the unique and enduring works of the time. More importantly this reredos became a kind of pattern and inspiration for the creation of dozens of wooden altar screens in various chapels.

One of the finest and at least until recently one of the best preserved altar screens is in San Jose de Gracia, Laguna Pueblo, west of Albuquerque, probably executed in the first decade of the nineteenth century. While it was thus done approximately a half-century after La Castrense, the realism of its two-dimensional style, the lack of perspective, and the use of tempera pigments led E. Boyd to suggest that "this example may well have shaped the New Mexican santeros school as much as the 1760 stone altarpiece influenced the plan of all the succeeding wood altar screens made after that date."[12] The painter of this work, dubbed the Laguna Santero, simplified and spiritualized an already provincial Baroque inheritance, creating a native folk tradition.[13] Four columns, with finials on the top of each, frame three figures, with St. John Nepomuk at the left, St. Joseph with Christ child in the center, and at the right, St. Barbara. These form a unity of design. Above the frieze over the figures is the Holy Trinity, consisting of three separate, seated figures, each with attributes.[14]

Two churches still provide the characteristic spirit of this Spanish Catholicism, El Santuario de Chimayo, and the church at Santa Cruz. El Santuario (Plate 14), built in 1816, sits in a valley of the bleak and beautiful Sangre de Christo mountains between Taos and Santa Fe where many other early churches are located. The two-towered adobe structure has a double carved door opening into a small vestibule and then a narrow nave with characteristic wooden beams supported by handsomely carved corbels. As in all of the old churches, floors, walls and ceiling curve and bulge, having a sense of the malleable earth which composes them. The thick walls lead the eyes to the altar and its striking reredos which covers most of the end wall of the church. The reredos vibrates with color and pattern; it is subdivided into separate panels with emblems and the Franciscan coat of arms in the upper range. Decorative patterns at the sides surround a handsome imported Mexican gold-covered, carved frame which in turn enframes the Crucifix, thought to be a replica of a miraculous image in Guatemala, "Our Lord of Esquipulas." On each of the side walls, two additional reredos are placed facing each other. Each is divided into three panels horizontally and vertically, each of these being inhabited by a saint. One of these is thought to be by José Aragón and depicts God the Almighty in the crowning lunette and Our Lady of Carmel, the Child Jesus, St. Francis of Assisi, St. Jerome, St. Anthony of Padua, and the Archangels Gabriel, Raphael, and Michael. The main altar screen (Plate 15) was apparently painted by Molleno, and one of the side

panels, probably by Rafael Aragón, who was unrelated to José Aragón.[15] Thus, three of the most important folk artists seem to have done work for El Santuario.

El Santuario is a pilgrimage church and one can daily see the faithful at worship, individually and corporately, much as they did over a century ago. Devotion accents the veneration of the saints and many come for the sacred well, entered from the sanctuary, to obtain the health-giving earth, today referred to as "holy dirt."

The church at Santa Cruz (La Inglesia de Santa Cruz de la Cañada) is one of the largest of the early religious structures, having a wide transept with chapel at either end. Alan Vedder, the conservationist, reports that originally the church had seven reredos, though only the main altar reredos and two additional ones remain today. His skillful work in removing Victorian additions and layers of repainting have brought the large central altarpiece back to the harmonious colors and lively patterns of the early nineteenth century. Probably the work of Rafael Aragón, the floral motifs, angels heads and abstract patterns provide an enframement for the crucifix, also attributed to Rafael Aragón, and for the oil paintings imported from Mexico. These include the Holy Trinity, St. Teresa of Avila, St. Joseph with the Christ Child, St. Francis Xavier, St. Barbara, St. Rosalie of Palermo, St. Cajetan, St. Jerome. The Church at Santa Cruz also has a *Santo Entierro* (The Dead Christ in a Sepulchre) by Fray Andrés García (Plate 12). Such life-size carvings of the crucified Christ show the lined and bleeding face, emaciated torso with the cavernous and grisly red wound, and the flesh torn from the knees. During Holy Week liturgies, the figure is carried in procession. The presence of the sculpture in the Church is a reminder of the third order of St. Francis, the Penitente, whose liturgical and penitential rites still are part of the religious life of the Southwest as witnessed by the existence of the Catholic confraternity, Hermanos de Nuestro Padre Jesus in the Santa Cruz parish.[16]

José Aragón, mentioned above in connection with a reredos at El Santuario, has emerged as one of the most interesting and competent of the folk artists. Whether born in Spain, as one tradition has it, or in Mexico or New Mexico, it is clear that he was the most European of the New Mexico artists, literate and sophisticated.[17] He was apparently in New Mexico in the 1820s and 1830s, for tree rings in the panels of his signed paintings corroborate those dates. His *St. Michael the Archangel* (Museum of New Mexico, Santa Fe) is faithful to the traditional saga of the slaying of the dragon. We moderns are inclined to smile, for we no longer participate in the drama of the perpetual slaying of the demons. His *Holy Trinity* (Plate 16) is represented as three figures side by side, each of them pointing to their identifying symbol on the breast—the Father to the sun, the Son to the lamb, the Holy Spirit to the dove. This, too, is part of an ancient tradition. But by the eighteenth century, the world was generally aware that such pictorial representations were closer to tritheism than the monotheism the trinitarian formula was devised to protect. While such representations were proscribed by Pope Benedict XIV in 1745, word had apparently not reached José Aragón, whose artistic predelictions were determined by earlier art.

José Aragón's *Holy Family* (Plate 17) is a charming example of the natural inter-relation of the highest religious symbolism with the most concrete human experiences, an inter-relation which is so central to the Catholic tradition. Looking at the panel horizontally, one sees the earthly trinity of Joseph, the child Jesus, and Mary; the sturdy child Jesus is firmly held by his parents on either side, Joseph with his attribute, a flowering branch, in one hand, and Mary coiffed as a nun. Vertically reading, one sees God the Father above with a gesture that commands the scene below; then the dove of the Holy Spirit, hovering above the head of Jesus, who completes the Holy Trinity. The diagrammatic aspect of the composition is intentional; it forms a cross with the dove at its intersection.[18]

The missions of California[19] contain a considerable number of paintings and statues, but many of these have been removed to the museum sections of the missions. Moreover, most of these works were imported rather than locally executed objects, as is the case in the San Antonio area. In the Carmel mission, for example, are to be found candlesticks, a vessel for holy water, and a statue of the Virgin, all brought from Mexico by Father Junipero Serra.

Several of the missions have impressive interiors, particularly the reredos behind the main altar. Among the most impressive is the main reredos painted in yellow, green and red by one Thomas Doak, an Anglo-American in California in 1818, for Mission San Juan Bautista (Plate 18). The side walls, previously white washed, have been restored with decorative floral patterns, and each of the two side altars stands in front of a painted reredos that complements the main one painted by Doak. At Mission Santa Ines, decorative motifs are also to be found and more than fifty paintings, mostly, however, eighteenth-century Mexican works of mediocre quality.

Mission San Miguel Arcangel, built between 1816–1821 half way between Los Angeles and San Francisco, retains much of the appearance and spirit of the original California missions because of its well preserved wall paintings. Painted by Don Esteban Carlo Munras, a native of Barcelona who settled in Monterey, the interior walls (Plate 19) are covered with illusionist architectural motifs—a series of Doric columns with a handsome entablature and finally a painted balustrade, all in blue-green, shrimp pink and maroon.[20] This design is supplanted on both sides of the nave near the chancel by two immense stylized sea shells. The altar has six columns which support a three dimensional architrave. This defines the space for three sculptures on pedestals and it also supports a wood sculpture of rays of light surrounding the eye of God. In sheer scale, the eye of God sculpture is unique among the missions.

Both the New Mexican and California artists were generally Spanish rather than Indian, though Indian workmen were involved. In California, several significant traces of Indian iconography and Indian work do exist. At Mission San Luis Rey, the baptismal font was apparently made by an Indian, and the decorative motifs in the church as well. There are also traces of Indian painting and decorative motifs at the San Fernando Mission. On exhibition at Mission San Gabriel are the *Stations of the Cross* (Plate 20) painted on cotton sailcloth,

woven by an Indian.[21] This series is stylistically quite unlike any of the other religious paintings of the Catholic missions or churches. It is certainly based on a European source, but the strange disjunctions of size and shape, the startling decorative patterns, and the preference for the profile rather than full face for the figures make the series strangely expressive. Attention also has been called to the faces, some of which seem to be Indian types.

The second and more extensive illustration of Indian work is Mission San Antonio de Pala, founded as a sub-mission by Mission San Luis Rey to serve the Pala Indians. The interior side walls, restored after removing the whitewash once used to cover the designs, disclose Indian symbols set in a Christian context (Plate 21). The nave walls have painted columns connected by slender painted arches with a saw-tooth edging on the underside of the arch. Under each arch we see a mysterious face looking forth at us; on each head is an ovoid helmet or crown, again with a saw-tooth edging. Beneath each head a triangular shield or breast plate floats in undefined space. Beneath are a succession of hemispheres surmounted by a cross. For the Indians, the saw-tooth pattern represents the water of the heavens, alternatively giving us destructive rains and gentle showers. The X shape formed by the top of Indian tepees was so central to their imagery that it found its way into the designs of paintings as a decorative mode. The triangles represent fertility and life-giving forces.[22] Thus, Indian paintings and symbols form part of a liturgical setting; but since they can be read in a Christian or Indian context, they illustrate the power and bewilderment of transcultural symbolism.

The San Antonio, Arizona, New Mexico, and California missions variously mirror Spanish Catholicism, mainly reflecting the work of the Franciscans and, on occasion, the Jesuits. Continental Jesuits other than Spanish were active in Kentucky, Louisiana, and the Pacific Northwest. While European countries and Spanish lands in the New World were expelling the Jesuits, some American bishops welcomed them. In 1828, Benedict Joseph Flaget, Catholic Bishop of Louisville, Kentucky, had appealed to the Jesuit superiors to establish a college in his diocese. Not receiving a reply, he founded St. Joseph's College in Bardstown, Kentucky, and turned it over to the clergy of his diocese.

In 1831, a group of Jesuits arrived in New Orleans and announced to Bishop Flaget that they would soon arrive in Louisville to found a college, as requested. Bardstown having been founded in the meantime, Bishop Flaget had the Jesuits take over a struggling school, St. Mary's, outside Lebanon, Kentucky. It was to this struggling school that Father Nicolas Point arrived from France in 1836. But a few months later, apparently because of his interest in missions, he was sent to Louisiana, thence to St. Louis, and eventually to the missions to the Indians of the northwest, the Flatheads, the Coeur d'Alenes, and Blackfeet Indians, as assistant to his superior, Father Pierre Jean De Smet. De Smet had visited the area in response to requests to Jesuit missionaries from the Indians themselves, for Catholic Iroquois had migrated from near Montreal to the Bitter Root valley in Montana and intermarried with the Flatheads. The mission, which started in the

Flathead area, initially centered in the creation of St. Mary's, south of Missoula in the Bitter Root valley. But it was expanded to the Coeur d'Alenes Indians and to the Blackfeet.

Important for subsequent history is that two Jesuits in these missions, the Belgian Nicolas Point and the Italian, Antonio Ravalli, had artistic gifts which they utilized in their mission work.[23]

Nicolas Point used his native sketching and painting skill at many levels. Like others of the time, he did Indian portraits and sketched their hunts and festivals. But in addition to that genre, he used his artistic skills in conveying and communicating the Catholic faith, and in depicting their consequent faith, practices, and rituals. Consequently, the journals of Point, with text and watercolor sketches, provide us with both a well-rounded verbal and a colorful visual picture of the Indians. Together they document the role of his painting in conveying the rudiments and scope of the Catholic faith.[24]

Nominally Catholic, that is, converted without instruction as to faith and practice, and in some cases not aware of Catholicism at all, the Indians presented a challenge to Point and his fellow Jesuits. Point particularly tells us what he encountered and how his art played a role. Writes Point:

> At the end of a five months' trip on horseback, we had to turn our attention to the task of Christianizing the savages. One might think that then no further opportunity for sketching would arise. However, brief experience showed that the savages learned more quickly through their eyes than through their ears, whereupon I made a great effort to speak to them through pictures. In order that there might not be any lack of decorum in our instructions, silent preaching was elevated to the dignity of scenic representations. Some scenes showed the mysteries; others, the sacraments; some represented the precepts; others, prayers. Still others depicted the great virtues and the vices. Finally, there was one large scene, called the "Way of Heaven" because in it one saw, together with the important series of laws given to man, the succession of periods from the Old and New Testament, all of which summarized Christian doctrine. This method of instruction had two noticeable advantages. While the truths entered their souls through their eyes, the great virtues were infused into their hearts. The inspiration for these drawings came, for the most part, from the great religious ceremonies enacted before them and from the most noble actions of their great men. These pictures tended, naturally, to impress the Indians very vividly.[25]

That discerning strategy implies that Point took the seeing mode of perception, so central to Indian life, quite seriously. But even Point believed, and therefore encouraged, that a settled existence, rather than a hunting economy, was essential to the practice of faith.

Father Ravalli, also recruited to the Indian mission by De Smet, too used his abilities as architect, sculptor, and painter on behalf of the churches and communities he served. For the five years prior to 1850, he was assigned to St. Mary's, but when the mission was temporarily closed, he was transferred to the Coeur d'Alenes Indians. Here he designed and furnished the paintings and sculpture for the still-extant building of the Mission of the Sacred Heart, Cataldo, Idaho. For

the church, he carved and painted the *Blessed Virgin* (Plate 22) and *St. John the Evangelist*. In 1866, he returned to St. Mary's, where he built the present building and created its sculpture. For St. Mary's, he did (Plate 23) the *Blessed Virgin and the Christ Child*, the *Blessed Virgin* over the altar, and *St. Ignatius*, on the side opposite the *Blessed Virgin and the Christ Child*.[26]

Father Ravalli's architecture, sculpture, and painting are based on European models, probably from books with baroque examples. But, as in the Southwest, Father Ravalli's gifts and materials were matched in a way that shows the integrity of his effort and the persistence of the baroque style in a setting so remote from the European centers of its origin. Unlike Point, his work shows no signs of the influences of the culture of the Indians with whom he worked. Rather, his old world, Catholic faith expressed itself through European style and content, albeit modified by the cruder materials at hand and the modesty of his artistic gifts.

There are other Catholic developments in which the European tradition is repeated rather than transformed. One of these is Conewago Chapel started under the auspices of Catholics from Maryland. Conewago soon became the center of Catholic life and Jesuit missions for Pennsylvania and western Maryland. The present Edgegrove, Pennsylvania, building four miles west of Hanover, Pennsylvania is a mid-nineteenth century extension of a stone building erected in 1787, (the nave of the present building) and is known as the Basilica of the Sacred Heart of Jesus; it is the first church in the United States dedicated to the Sacred Heart. The nave ceiling has a fresco of the Assumption, apparently done by a Philadelphia painter by the name of Gebhart in 1845. For the newly completed part of the building, the Austrian artist, Franz Stecher, a former Jesuit, did the paintings in 1851. Essentially, these paintings celebrate various trinitarian motifs centering in the Father presenting Christ to the world as a Sacred Heart.[27] Stylistically, they represent then current European traditions, and are unaffected by the new world in which they were done.[28] In this sense, Conewago chapel is like a host of other Catholic churches that might be mentioned.

Mention is made of three figures who erected Catholic churches in Hawaii, executed sculptures to inhabit them, and painted the interiors. These ranged from Brother Michel's work in the 1870s and 1880s, to the work of the Belgian Father John at the turn of the century, and to that of Father Evarist Gielen in the first decades of this century. Chief among these is the so-called painted church, St. Benedict's, at Honaunau on the island of Hawaii. The vault over the nave is painted in brilliant hues, with six palm trees appropriately spaced. The columns, too, are brilliant, with white, ochre, yellow, blue, and green. On the sides of the altar are sculptures of Christ and Mary. Six pictures by Father John are to be found between the windows, *The Handwriting on the Wall, The Temptation of Jesus*, and *The Appearance of the Cross to St. Francis* on the left wall, with *Hell, Symbolic Picture = Symbolic of a Good Death/Rays of Hope Shining in the Dark Cell* and *Cain and Abel (and Eve trying to revive him)* on the right wall. In order to catch the full spirit of the church, it is necessary to note that no surface area is left without some ornamental, emblematic, or

figural painting. Stylistically, the paintings are a folk translation of the classical European tradition.[29]

Summarizing this Catholic tradition, we note the emergence of a notable folk tradition in the Southwest, and a few individual artists there, like José Aragón, whose artistic sensibility provided excellence in this particular genre. No such gifted individual artists are known to have worked for the California or the Texas missions. In Montana, the painting skills of Father Point are undoubtedly unique in execution and intent. By contrast, the European-trained Father Ravalli, in the same area as Point, carved statues in which we see the residue of the Baroque ecstasy animating the disproportionately tall or short figures of his saints. The works in Pennsylvania echo their European background, as do those in Hawaii. But, generally, one cannot say that the art which is so integral to Catholic liturgical life is distinguished in quality during the period we are discussing. Catholic churches of the East, for the most part, had imported objects which, by mid-nineteenth century, were largely reproductions, often of poor quality. In the West, when the art was authentic, it was of the folk art genre.

Finally, in this specifically religious orientation to art, we come to the Moravians of Pennsylvania, who represent a Protestant version of the Catholic tradition. The Moravian tradition stems from the Hussite and Waldensian groups, who frequently were suppressed but never totally lost their identity.

They were given shelter and eventually spiritual direction by the European Count Zinzendorf. While they emerged in the eighteenth century as a distinct Protestant group, the Moravians nevertheless stressed their ancient, ecclesiastical heritage. Moravian theology is pietistic in temperament, but the Lord's Supper is celebrated regularly and frequently out of its older, Catholic heritage. Though the Moravians worship without an altar, they hang paintings within the confines of the rooms or spaces in which the community worships. Here, painting as a church tradition, while not strong, is pre-Reformation. The Reformation upheaval in which art and Rome were negatively identified simply falls outside Moravian history and experience.

John Valentine Haidt became a Moravian in 1740, began to paint with Zinzendorf's approval in 1746, and was at Herrnhaag and then Herrnhut during the period when the Moravian stress on the wounds and body of Christ took on exaggerated forms, with intense mystical identifications with the crucified one. Even Zinzendorf referred to the Brethren as "little blood worms in the sea of grace," and spoke of "the Church, Christ's bride, as being born in his side wound." Many called themselves "bloodthirsty beasts," "wound worms," "side-hole beasts." During the same period, "gaudy biblical scenes decorated their ordinarily plain chapels. They used tableaux and transparencies to make more real the suffering of the Christ on the cross." They called their church the "visible-wound church."[30]

Whatever Haidt's relation to these events, it is undoubtedly in this period that he wrote Count Zinzendorf: "If they will not preach the martyrdom of God anymore, I will paint it all the more vigorously."[31] His paintings of Christ certainly

stress the wounds even after the period when that was officially discouraged. While designated official painter for the Moravian community, he continued to accent the wounds of Christ. The prominence of the gaping wound is evident in *Lamentation Over Christ's Body* (Plate 24) and in the two versions of *Christ Revealing His Wound* (Moravian Historical Society, Nazareth, Pennsylvania), in one of which Thomas has his hand deep in the wound. The power of identification with the blood and wounds of Christ is also evident in Moravian hymns, though here, too, the more blatant manifestations gradually disappeared.

Haidt also painted diverse scenes from the life of Christ, from the *Nativity* to the *Crucifixion* (Plate 25). These figures stand before us in colorful array and are so arranged in relation to each other that they draw us into their feelings and thereby into the drama of Christ. But the preponderant number of his paintings have to do with the Crucifixion, or what Haidt called "the martyrdom of Christ." It may be noted that the wounds of Christ are in Christ's left side. This is a minority tradition for the wounds are usually on Christ's right side.[32]

TWO
Nineteenth-Century Views of Art and Architecture

3

Clergy Views of the Visual Arts

In the fixed and ordered New England society, a person of note had a portrait painted.[1] Such a portrait was not merely a likeness prized by family and descendants. The portrait of a noble person brought recollections of the moral fiber and concrete contributions of one who had obtained standing in an ordered society. New England society may have been radical in its formation, but it was considered a structure in which everyone had a place, in which the parameters of action were defined rather than dynamically acquired. It was a society that refracted the glory of God in the structures of God's world. Hence, the doxa, or praise of God, consisted in fitting into the order of things. Society was an emanation, an ordering of, a falling in line with what the creative imagination of God had set before one. Indeed, creativity and imagination on the part of humanity usurped God's role; therefore, obedience, obligation, and duty defined humanity's lot.[2] Seventeenth- and eighteenth-century American theology did not find a way of reconciling the artistry of God with the vitalities of humanity. Only the suppression of humanity's imagination and creativity seemed to guarantee, in the light of grace, the creature's safe and non-transgressing role before the Creator.

By the time of Jonathan Edwards in the eighteenth century, that fixed order of things, in which heart and mind and society cohered, was falling apart. The attempts to make orthodoxy more consistent, i.e., the accent on the emotional aspects of religion, on the stress on moral sentiment as constitutive of humanity, and on the notion that all knowledge is based on forms of sensation, represented diverse alternatives which, taken together, undermined the previous unity. Of his contemporaries, only Jonathan Edwards seemed to see what was happening. His brilliant theological work accepted many of the new elements, but set them in a vision more grand than that of his Puritan forebears. In philosophical theological language, his regard for the beauty of being as being, the excellency of "the consent of being to being,"[3] was aesthetically satisfying, if not intoxicating, and ontologically and theologically true. In more traditional terminology, Edwards perceived and deeply felt the plan of God for the whole world, a divine drama for the manifestation of God and the redemption of the world, in which humanity participated in its rightfully assigned role. That scheme was good and beautiful. The result was a vision which encompassed all that was considered central to the nature and economy of God. However, Edwards's grand view did not win its way.

The orthodox Calvinist view of the world was rejected by many, though it continued in the Princeton theology, stripped of the broad philosophical, visionary context of Edwards. The sensationalist philosophy of Locke and the moral sentiment of Shaftsbury, which had been combined and utilized by Edwards as an epistemological base for an over-arching structure of thought that moved the human heart, gave way, either to the influence of Scottish realism, or to the idealistic philosophy emanating from Kant. Revivals, which had a theological context in Edwards, soon created their own momentum, obeying no laws but their own dynamics, as spelled out eventually by Charles Finney. While Edwards's vision was greater than the combination of these four major currents—Calvinism, the philosophy of Locke and of Shaftsbury, and revivalism—his forms of expression were so dependent upon them that the vision could not survive the independent development of these ingredients.

Edwards's vision still accepted that thought and feeling were constitutive of humanity in God's scheme of things. However, drama and the visual were not seen by him as constitutive of humanity. Though the sense and taste of things, as of honey, is valued by Edwards, it serves as an analogy for thought and feeling. By itself, taste is forbidden fruit—a tantalizing possibility not to be enjoyed in and of itself. Similarly, the dramatic and the visual are not essential to humanity, indeed, lie outside its appropriate horizons. Hence, the concept of beauty in Edwards broadens the horizon of thought and feeling; but it does not extend beyond those horizons. It hardly touches what the word "beauty" has meant historically.[4] It is an aesthetic devoid of the visual arts. But in this he was reflecting the society of the time. Writes Perry Miller:

> We must bethink us that in 1730, this plebian, dissenting, serious-minded society was a world unto itself, accepting Newton, gradually absorbing Locke, approving Addison and adoring *Robinson Crusoe*, beginning to record Bunyan as fit reading for apprentices and farmhands. . . . It was ignorant of Shakespeare and the stage and of sculpture, and understood only the simplest music, but it loved Georgian architecture, fine crockery, and clean linen.[5]

However, by the last three decades of the eighteenth century and for the first part of the nineteenth, the visual arts begin to emerge and clergy and theologians begin to make comments on them. Yet art is discussed in the context of the generally shared goal of providing refined knowledge and of exhibiting piety. For example, Ezra Stiles (Plate 4), whose portrait was done by Samuel King in 1771, fully explains the attributes in the painting, making it a veritable account of all that he believes, thinks, and stands for. Indeed, Stiles suggests that in the painting the "emblems are more descriptive of my Mind than the effigies (painting) of my face."[6] But the portrait was more compelling than he knew, outshining all of the explanations proffered by Stiles.

Stiles was a learned man, a tutor at Yale, minister of the Second Congregational Church at Newport, Rhode Island, President of Yale from 1778 until his death in 1795. He was a middle-of-the-road Calvinist, described as the gentle

Puritan. But his learning was cumulative rather than probing, tempting him to repeat the impressions of others as matters of fact. For example, according to Stiles, John Smibert, having painted two or three Siberian Tartars in the household of the Grand Duke of Tuscany in Florence, immediately recognized the Newport, Rhode Island, Indians "to be the same people as the Siberian Tartars whose pictures he had taken."[7] For Stiles, painting represented a discipline which, like theology and learning generally, added to the fund of knowledge, which in turn glorified God.

A quite different minority voice was that of the Reverend William Smith, an avid Anglican who was the founding provost of what became the University of Pennsylvania. Learned and cultured, he gathered young poets, writers, and painters around him in Philadelphia, including the young Benjamin West. In 1758, he founded the *American Magazine*, dedicated to promoting the artistic promise of the Americans. But his influence did not extend widely beyond the Philadelphia circle.[8]

Considerable knowledge of the arts is manifested by the Reverend James Bannister, who wrote two articles on the history of architecture for the *Massachusetts Magazine* in 1789. These articles, in which Greek architecture is extolled, are important, not so much for new information as for the knowledge and interest they reveal on the part of a clergyman in the late eighteenth century.[9] The Reverend Dr. Cutler, as part of the activities associated with the ordination of the Reverend Mr. Story, gives an extended description of the Indian mounds near Marietta, Ohio, with extensive awareness of their artistic-architectural background.[10]

Timothy Dwight (Plate 26), revivalist preacher and theologian, was the successor of Ezra Stiles as President of Yale. In addition to *The Conquest of Canaan*, published in 1785, he was known for his additional poems, *America, The Triumph of Infidelity, Greenfield Hill*, and the suggestive essay, *A Dissertation on the History, Eloquence, Poetry of the Bible*, originally given at the Yale Commencement in 1772. Today the poems are more notable for their moral-theological position than for their observations on art. Dwight's interest in the world around him was comprehensive and deep. While busy with the affairs of Yale and trying to turn both it and the nation from infidelity to faith through the agency of revival measures, he traveled widely through New England, both for his health and when on vacations. Never idle, he wrote down what he saw, publishing the results in four volumes. Moreover, the volumes were meant to counteract misrepresentations of the American scene by foreign travelers.[11] Rather than criticizing the American scene for its crudity when contrasted to Europe, Dwight pointed out that one should see the significant things that have been accomplished in such a short time.

> Few of those human efforts, which have excited the applause of mankind, have demanded equal energy, or merited equal approbation. A forest, changed within a short period into fruitful fields, covered with houses, schools, and churches, and filled with inhabitants, possessing not only the necessaries

and comforts, but also the conveniences of life, and devoted to the worship of
JEHOVAH, when seen only in prophetic vision, enraptured the mind even of
Isaiah; and when realized, can hardly fail to delight that of a spectator. At
least, it may compensate the want of ancient castles, ruined abbeys, and fine
pictures.[12]

Timothy Dwight also wrote explicitly on taste, and in this he was influenced
by Lord Kames. The word taste symbolized those indefinite aspects of refine-
ment of spirit beyond the elemental requirements for the survival of society. To
Kames and to Dwight, nature and art, properly discerned, and seen in their
moral context, defined taste.

Applied to the scenes of nature, and the works of art, a good taste is an apti-
tude to discern instinctively and clearly, the various articles, which, in those
objects, are the sources of pleasure to our minds; such as beauty strictly so
called, grandeur, sublimity, resemblance, contrast, novelty, motion and force.
As it respects human conduct, it is a ready discernment of propriety, grace,
ease, elegance, and dignity. In the imitative arts, it is a similar discernment of
the justness of the imitation, and of the beauty of those means, by which it is
accomplished.[13]

Taste is thus a matter of refinement, made possible by leisure and financial
means, and it contributes to the religious and moral life of man. It is an ingredi-
ent in the way God governs, called the moral government of God; it is the key
concept in Dwight's theology and in that of many of his contemporaries. Such a
concept of taste joined the Divine Plan with human effort and it required practi-
cal advice.

This concept of taste is well represented in more than thirty letters to a
young lady, written by the Reverend John Bennett for the *American Museum,
or Universal Magazine* during 1792. They cover a wide spectrum—poetry,
painting, sculpture, drawing, reading, astronomy, relaxation, pleasures, tea
parties—from an allegedly Christian point of view. All is moral, useful, and
restrained, with ideas of women yet untouched by women's suffrage. But art
belongs to life, is considered less susceptible to danger than poetry, and can be
the source of practical delight.

A little taste for the fine arts, painting, sculpture, and architecture, will be of
singular use. It will render every excursion you make, and every curiosity you
behold, exceedingly delightful, and enable you to become entertaining to all,
with whom you converse. A person thus accomplished, surveys an elegant pile
of building, the designs of a Palladio, the landscape of a Claude Lorrain, the
portraits of a Titian, or the transfiguration of a Raphael, with uncommon rap-
ture, and can entertain herself, for hours, with a ruin or a castle, in which the
unskillful can see nothing but deformity, or the corrosions of time.[14]

Drawing, in particular, can be of immeasurable use and serve high moral
purposes.

It will agreeably exercise your ingenuity and invention. It will teach you to
discover a superior finish in all the varied landscapes and scenery of nature; to

survey the works of distinguished masters, with a higher relish and a more poignant curiosity; and it will heighten all the innocent pleasures of your retirement. When nature howls with winds, or is covered with snow, you will be able, in a moment, to call a fancy spring upon the canvas, of which the blossoms will be forever fragrant, and the trees ever green. You may thus have birds always on the spray, and larks apparently trilling out praise to their bountiful Creator.[15]

Of the clergy considered thus far, only Timothy Dwight carries us into the nineteenth century. A more sophisticated view of the arts and considerable acquaintance with them characterizes the clergy by the third and fourth decades of the nineteenth century. But the conviction that art not only does, but must, serve moral aims and purposes continues for several decades more.

Nineteenth-century clergy can be divided between those who made an occasional statement about the arts, while still fundamentally ignoring them, and those for whom they were considered a part of the life of humanity. Then, as now, though probably with more credibility then, clergy participated in laying the cornerstones of academies, or opening up exhibitions, or participating in conferences involving the arts. All agreed that the arts, properly used and understood, were meant to provide refinements to society, to take off society's rough edges, to instill a concept of beauty. In that respect, the arts were allied with the moral and the ethical. Writer after writer, whether of the clery or of the other professions, remarked on the priority of the moral life, on the role of the arts in relation to the moral. Conversely, for most of them the arts understood in and of themselves were considered immoral. The latter was particularly considered to be the case in tyrannical societies, whereas democratic societies viewed art in its proper context.

Such discussion centers in the role of art in public and private life. Clergy consciousness does not extend to the introduction of the visual arts into the church. Music, of course, had come to be widely accepted, and, in many places, stained glass as well. Clergy, too, frequently traveled abroad, sometimes, in the nineteenth century, in pursuit of health, and sometimes for the gaining of knowledge and cultivated exposure.[16] Not infrequently, they wrote of their experiences, either in private letters that were later collected, or in accounts for newspapers, which subsequently were published in book form. Such accounts covered a wide range of subjects, with painting and sculpture ranging from central to peripheral attention. When the visual arts are included, the objects seen and the attitudes expressed are strikingly similar, as if the clerical travelers had followed the same guidebook. Indeed, the comments on art are so alike that the materials appear to border on plagiarism. While not profound as either literature or thought, these books do represent a serious attempt to come to terms, indeed to appropriate, the wider cultural world of Europe and the Near East. Whether the traveler's stay was several months or several years, the comments in articles and books appeared with the regularity of their travels. Of course, clergy, both before and since, have visited the wider world, but it is doubtful that exposure to the wider cultural world has been so extensive or so seriously pursued before or

since. For the traveling clergy, Guido Reni and Domenchino competed success-
fully and favorably with Michelangelo and Raphael. Landscape subjects with
religious themes were celebrated through the works of Salvator Rosa and Claude
Lorrain. Contemporary expatriate artists were visited in their Italian studios.
What is said of the contemporary artists is usually minimal, but, on occasion,
their reports become the sources of information not otherwise available, as, for
example, H.W. Bellows' "Seven Sittings with Hiram Powers," *Appleton's Journal
of Popular Literature, Science and Art* (1869), or Orville Dewey's *Powers'
Statue of the Greek Slave* (New York, 1847).

While the similarity of approach is overwhelming, there is disagreement on
three issues. First is the question of the supremacy of nature or of art. This dif-
ference is well expressed by Cyrus Bartol, on the one hand, and George B.
Cheever, on the other. Bartol writes

> Mount Blanc may fall out of memory, and the Pass of the Stelvio fade away;
> but the argument for religion,—argument I call it,—which was offered to my
> mind in the great Madonna of Raphael [Dresden] cannot fail.[17]

But, standing on top of the Milan Cathedral and seeing the mountains in Italy,
George B. Cheever comments, "The sight of such mountains makes the cathedral
dwindle, makes you feel as if, while art can indeed be beautiful, there is nothing
but nature that can be truly sublime."[18]

The second is the issue of Roman Catholicism and its world of art. Protestant
writers are distressed by what they see in the churches and are sure that the
visual arts compound the problem. Yet the individual works of art are recog-
nized to be overwhelming. For some, Raphael can be forgiven anything, consid-
ering his genius in painting. For none can his life be separated from his art.

The third is simply a disagreement on specific cathedrals, about which there
is more difference of opinion than on individual paintings. Horace Bushnell is
upset by St. Paul's, London, asking what would Jesus Christ say to all of this
array of music, priesthood, and architecture.[19] Another time he remembers that
the organ made more of an impression than the cathedral. But St. Peter's, Rome,
overwhelmed him by its prodigious scale and its sense of sublimity.[20] On the
other hand, Stephen Higginson Tyng is not impressed by St. Peter's, while
admitting that in some ways it stands alone:

> In grandeur, elegance, grace, finish, display, this building stands alone proba-
> bly on earth. But it produces no solemn impression. It looks too new, has too
> much show, seems all of the present age, brings one into no connection with
> the past. Its Grecian and Roman architecture does not admit of serious impres-
> sion. . . . A stroll through York Minster or Westminster Abbey, produces an
> impression which St. Peter's has no power to make.[21]

Denominational patterns are evident in the aggregate, though there are
obvious exceptions. Presbyterians generally do not pay much attention to the
visual arts, and when they do, they are largely suspicious of the role of imagina-
tion. Congregationalists sometimes disclose a general cultural interest in the arts,

but it is unrelated either to their religious views or to the church. The reform clergyman, George Washington Bethune, and the Baptist, Elias Magoon, are among the most prominent clergy interested in the arts; but they are certainly not representative of their denominations. The generalization can be made that the number of clergy interested in and associated with the arts was highest among Unitarians, and, after the beginning of the Tractarian Movement, among Episcopalians.

We turn now to important individual clergy and their relation to the visual arts. Horace Bushnell (Plate 27), to whom reference has already been made, was undoubtedly the most creative theological voice of his time. Like Edwards, he took on the intellectual currents of his time. He learned a good deal from the writings of Samuel Taylor Coleridge, particularly the *Aids to Reflection*. His imaginative mind solved most problems by setting them in a wider context, by the use of language in a suggestive, poetic frame, and by seeing the Gospel as a new sensibility of an aesthetic nature.

> . . . the Gospel is, in one view, a magnificent work of art, a manifestation of God which is to find the world, and move it, and change it, through the medium of expression. Hence it requires for an inlet, not reason or logic or a scientific power so much as a right sensibility. The true and only sufficient interpreter of it is an esthetic talent, viz., the talent of love, or a sensibility exalted and purified by love.[22]

In other writings, similar passages are found on occasion. But there is no sustained discussion of the visual arts. Bushnell took an extended trip to Europe, but what he says on the visual arts falls into the general pattern of travelers of the time.[23] It is ironic that Bushnell, whose imagination should have led him to a more sensitive appreciation of the visual arts, was among the least perceptive, and that Henry Ward Beecher, whose outlook should have led him to a narrow, shallow view of the arts, understood them so well.

George Washington Bethune was more directly involved in art affairs than was Bushnell. Of Scotch and Huguenot ancestry, Bethune was reared in a cultivated, wealthy New York family. After graduating from Princeton, he was ordained in the Dutch Reformed Church, and successively held pastorates in Rhinebeck, New York, Philadelphia, Brooklyn Heights, and New York City. He was also a musician and poet, and an avid fisherman who anonymously edited and greatly expanded the content of Walton's *Compleat Angler*. He traveled widely, making several trips to Europe, and finally died of a stroke in 1862, while in Florence.

A prolific writer and extensive lecturer on wide-ranging topics, Bethune could hardly have escaped the world of art. Aware that his own interest in the arts stemmed from his more privileged background, he yet believed that an awakening to the enriching role of the arts would follow the production of great art. Hence the artist, he felt, had a great responsibility, for the future rested in the artist's own creations.[24]

Granted that Americans of his time would probably deface the ancient monuments of Europe were they to be found in the backyards of their own houses and cities, and that usefulness and utility dictated where expenditures of energy and money went, Bethune was nevertheless convinced that Americans, once introduced and nourished in a taste for the arts, would pursue the arts with a passion similar to their exploits and achievements in other areas. Etchings and engravings, he argued, could be used to great advantage in developing such taste, being more effective than poor paintings.[25] In an address before the National Academy of Design reported on in the *Bulletin of the American Art Union* (May, 1851), he sounded the all-too-familiar theme that, until recently, Americans had been busy taming the forest and building a political society.[26] The emergent interest in art, including its appropriate place in a body politic as distinct from a dubious life of its own, was found to be encouraging. Indeed, in Bethune's thinking, as among many of his his contemporaries, the absence of art in the early Puritan experiment served art well in the long run. The result was the emergence of the appropriate social and moral ambience for its rightful role. The Anglo-Saxons particularly provided an ennobling, moral context for the visual arts, denied to a society in which art serves seductive and sensual purposes.[27] In the field of architecture, Bethune hoped that a new American style would develop, but, for the moment, he favored the clear, light, and therefore moral characteristics of the Grecian style. He had no sympathy for the gloomy Gothic, being unaware, as were his contemporaries, that the Gothic windows originally admitted much light before grime lessened their luminescence.

In Samuel Osgood, literary and civic interests were intertwined with artistic interests, and together they formed his ideal for the appropriate fabric of society. Considering the social tasks which Americans had set for themselves, the interest in art, tardy as it was, suggested Osgood, came to appropriate expression at the right time. Looking at the past, he proclaimed that Michelangelo's patronage served a society in which freedom and moral character were not in the forefront of social attention. By contrast, the American sculptor Thomas Crawford did his *Armed Freedom* for the nation's capital as an expression of the free, moral fabric of the nation itself. The arts, though late, came when society and the artistic mode could form an appropriate unity.

Osgood represented the well-connected, cultured, Eastern clergyman. Harvard-trained in the Unitarian heritage, he briefly assisted James Freeman Clarke, edited the *Literary Western Messenger* in Louisville, Kentucky, during 1836–37, but returned, first to New Hampshire, then Providence, and, in 1849, he succeeded Orville Dewey as pastor of the Church of the Messiah in New York City. For several years, he was also associated with Henry Whitney Bellows in the editing of the *Christian Inquirer*. In the 1850s, he contributed both to the *Bulletin of the American Art Union* and to *The Crayon*. He was also active in the affairs of the New York Historical Society, in which historical and artistic concerns received equal attention. In his article, "Art Among the People," Osgood suggests that art is a nobler legacy than antique furniture, and he contends for the significance of art

over photography. He also notes that, while religion and art are associated in America, indeed most suggestively in landscape painting, the same is not true of the Church and art. Stained glass, he suggests, is widely accepted, though it is more glaring and ostentatious than works of the pencil, as paintings were then called. He dares hope that art may do for the Church what travel and literary criticism have done for clergymen's homilies. In 1869, he traveled in Europe, visiting many of the American artists abroad, and, on his return, took orders in the Episcopal Church, and lived a life of lecturing, preaching, and literary endeavours. In the 1870s, he delivered a lecture before the New York Historical Society, "Thomas Crawford and Art in America," which was published in pamphlet form.[28]

Equally important was Orville Dewey, who defended the work of the sculptor Hiram Powers. A graduate of Williams and Andover, but uncertain in his religious thought, Dewey became an associate to William Ellery Channing, then held a brief pastorate in New Bedford, Massachusetts, and then became minister of the Church of the Messiah in New York City, from which position he resigned in 1848 for reasons of health. He was the first clergy member of the Artists' Club, and he saw art as a medium which served realities greater than oneself, an ideal appropriate to democratic society. In architecture, he preferred the Gothic and among contemporary sculptors, he particularly liked Thorwaldsen.

Dewey was aware that the visual arts had always been associated with Roman Catholicism. Unwilling to attack Roman Catholic Christianity directly, Dewey (as his fellow Unitarian, Cyrus Bartol) talked of the tendencies of its system, namely, a Roman Catholic tendency to substitute imagination and sentiment for real feeling and virtue.[29] Hence, alleged artistic abuse was not of the essence of Roman Catholicism. On this issue, the Unitarians were more generous in their assessment of Roman Catholicism than the Congregationals, Presbyterians, or the Anglicans.

Refinement is important but it must be appropriate. Hence, Dewey remarks that

> the dresses of a fashionable American lady, for a single year, would place a beautiful painting on her parlor wall, which would contribute to the improvement and pleasure of herself and her friends for life—while her dresses contribute to nobody's improvement or pleasure, but her milliners and mantuamakers.[30]

Churches, too, he contended, could buy significant paintings if they pooled the modest resources of their constituencies.

Henry Whitney Bellows (Plate 28), Harvard graduate, became a prominent Unitarian clergyman in New York City and, for more than a decade, edited the *Christian Examiner*. He was a member of the Union League Club, of which he did an historical sketch, and was instrumental in turning its attention to art as its political zeal for the Republican Party waned. The core of support for the creation of the Metropolitan Museum of Art came from the Union League Club.

Bellows preached a sermon on "The Moral Significance of the Crystal

Palace,"[31] in 1853, which to him combined nature and man's ingenuity, both the product of God, in a more finished form which we know as art. Hence, he saw the structure of the Crystal Place itself as a work of art, even as it was the depository for sculpture, painting, and other artifacts.

Bellows also founded and was head of the United States Sanitary Commission during the Civil War. In addition to providing medical facilities and know-how during the Civil War, the arts, too, were part of the Sanitary Fairs which were held in various sections of the country.

Bellows apparently had a discerning eye, and he confesses that it was seeing sculpture in the Naples Museum that made him see "the human body itself as a representation of beauty and grandeur and significance,"[32] having previously believed that the face had been the exclusive medium of the soul's expression.

Elias Magoon, Baptist clergyman who served parishes in Richmond, Virginia; Cincinnati, Ohio; New York City, Albany, and Philadelphia, was unique among the clergy in that he built a major collection of art, which, to this day, forms the original section of the Vassar College Art Gallery. Not yet in his mid-twenties, Magoon, for reasons I have not been able to discern, decided to collect art as a major part of his vocation as a Christian. In a letter to Matthew Vassar, dated May 30, 1864, Magoon wrote:

> Thirty years ago, without the first dollar that was my own and without one friend in the world who sympathised with my imagination, I set about gathering a collection that should illustrate human progress under and along the divine purpose, Christianity illustrated by its monuments.[33]

It is apparent that for him a didactic interest in the arts was paramount. Magoon believed that the arts, particularly the visual arts, were nearer to the springs of creation and the pulse of the divine life than was science. Hence, an education which did not make the arts central left out the one essential ingredient. In a report of the Committee on the Art Gallery of Vassar Female College, 1864, chaired and written by Magoon, with the painter Samuel F. B. Morse also a member, it was affirmed that from the very beginning of the collegiate plan,

> Art stood boldly forth as an educating force, to have its first fair play in the history of education. Somebody, at length, had to come to see that man's delight in God's work is the mightiest means of moral culture, and that such exactly is true art.[34]

Moreover, it was clear to Magoon that his collection was meant not only to disclose art as the medium of the divine, but also to show the progress of the human race in the arts themselves. In *Westward Empire*, Magoon, while appreciative of the art of the past, contends that the arts, just as did political theory, moved westward with increasing rapidity. The net result, of course, is that in the Age of Washington, as Magoon calls his own time, art developed in the free soil of America and will surpass all previous art.[35] Moreover, he believed that the genius of American art, reflecting the land and people, was particularly strong in landscape painting and in the art of watercolor.

That a clergyman should build a major collection would on first reflection imply that he had an independent means of wealth. While various branches of his family were fairly affluent, the evidence seems to suggest that most of the collection came from special funds provided by friends, by the judicious use of agents, and by the twisting of arms by Magoon himself. Indeed, Magoon pressured contemporary artists to provide a painting for his collection at moderate prices, or as a gift.[36] He was well acquainted with the contemporary artists, and he carried on extensive correspondence with John Ruskin. Magoon himself took two trips to Europe for his own exposure to the world of art and for the sake of building the collection, first, in 1844, and then again in 1854.[37]

Magoon was the trustee behind the creation of an art gallery at Vassar and finally he sold his collection to Matthew Vassar for the college in 1864. Apparently offered to the University of Rochester first, to which Magoon gave some paintings, the collection was sold to Vassar for $10,000, with Magoon offering in addition to catalogue the collection. Along with the collection went many books with engravings of world art.

There were others, in addition to Magoon, who were starting collections. The layman, Thomas Jefferson Bryan, a Philadelphian and a Harvard graduate, who is sometimes known as the first American collector and connoisseur, lived in Paris for twenty years, during which time he collected a considerable number of paintings, some ostensibly by the old masters. This collection consisted mainly of paintings with Christian subject matter. He established in his home in New York City at Broadway and Thirteenth Street what was known as the Bryan Gallery of Christian Art, for which an admission charge of twenty-five cents was made. For a time the material was deposited with Cooper Union, but in 1867 it was deeded to the New York Historical Society, where on its walls, if one reads the labels, one can still see the core of the Bryan Gallery of Christian Art. An 1853 checklist lists 230 paintings in an annotated catalog, and by 1871 it had grown to 381 canvases and one marble. It was installed at the New York Historical Society in 1866.

The Dusseldorf Gallery, devoted to German art, was established in New York in 1857. Much of this material had Christian subject matter in the Pre-Raphaelite tradition.[38]

The Anglican bishop of California, William Ingraham Kip, also knew the tradition of collecting and had an interest in the visual arts. From his father, he inherited paintings, particularly of his forebears, including ones done by Smibert, Copley, Inman and Harding. In his collection, too, at one time was Rogers's *Isaac* (1861), which Kip's father offered for sale. Further, Kip's father, after being unsuccessful as an agent for the artist John Vanderlyn, himself purchased his *Marius Amidst the Ruins of Carthage* (ca. 1806). This, too, came to the bishop and eventually to the M. H. de Young Museum (The Fine Arts Museums of San Francisco) through two succeeding owners, one being M. H. de Young who gave it to the museum in 1922.

Kip's collecting seems more a matter of personal and cultural inheritance

than a self-conscious stance, as in the case of Magoon. His interest in the arts was recognized in that he was listed as an honorary member of the San Francisco Art Association during the 1870s. Kip also traveled widely, wrote well and with considerable knowledge of art, as in his volumes, *The Christian Holy Days in Rome* (New York, 1846; brought up to date 1869) and the partly illustrated volume, *The Catacombs of Rome* (1855; sixth ed., 1887).

While active in public life during the Civil War, Washington Gladden and Henry Ward Beecher represent two clergy with a pronounced interest in art. Washington Gladden is frequently referred to as the originating spirit of the Social Gospel Movement. Having had pastorates in New York State, Brooklyn, North Adams, and Springfield, Gladden was also for a decade Religious Editor of the *New York Independent*. His pastorates, particularly the one in North Adams, brought him into close relation with working men and women and resulted in a lifelong identification with their problems. Also his activity as editor of a journal brought him into investigative reporting, involving him in the exposure of the Tweed Ring.

These experiences are certainly not unrelated to his conviction that Christianity is essentially an ethical religion. "Conduct," he stated (and sometimes gave credit to Matthew Arnold for the aphorism), "is three-fourths of life, but conduct is not everything," for "art, as well as morality, has valid claims upon the life of man."[39] Essentially, the two belong together, and since morality is three-fourths of life, it obviously has the priority. Art considered by and in itself is aestheticism, serving the self and leading to degradation. A mercantile culture, he suggests, is particularly susceptible to that disease.

History, Gladden states, should help to orient us. When Greek civilization made art the center of its life, decay set in. "The heroic age of Greek sculptors, architects, poets, makers of all sorts, was the [previous] age of Pericles; and the art of that time was the servant of patriotism and religion."[40] If Greek civilization gave way to art as an end to itself, at the other extreme, the Puritans knew only duty. However if Gladden had to choose, the choice is clear, though neither alternative is adequate. "Morality is the principal thing; art ought to be subordinate; civilization without art would be better than civilization without righteousness. But neither would be complete civilization."[41]

Gladden is aware that some art may just please us and do no more, without being a negative influence. Landscape painting and still-life may have that character. But this leads to the judgment that "the great paintings of the world are those which represent the characters and actions of men."[42]

In some respects, Gladden reflects views we have already seen among other clergy, but the accent is slightly different, for Gladden no longer talks of the refining power of the arts and thus its relation to morality; rather, the ethical, a category broader than the moral, is a direct companion of the aesthetic. Art remains art, that is, it has its own integrity as it serves great human subjects. The one-fourth that belongs to the aesthetic domain, must be related to, but is not identical with, the ethical. Precisely because he knew this, Gladden could say, "it

is doubtful whether, historically, the relation between sound ethics and good art has always been as close as Ruskin insists."[43]

Nevertheless, John Ruskin is Gladden's hero. His articles make repeated reference to Ruskin. In his William Belden Noble lectures of 1913, Gladden gave individual lectures on the following: Dante, Michelangelo, Fichte, Victor Hugo, Wagner, and Ruskin. That range of figures indicates a cosmopolitan, cultured mind. But in the lecture on Ruskin, which he entitled, "Ruskin, the Preacher," a double intent is soon evident and, indeed, the interest in art is the minor theme.

> It was not, however, in these studies of nature and art that John Ruskin's most eloquent work was done, but rather in the prophetic teachings of the latter half of his life. . . . Up to his fortieth year his main interest was in art; from his fortieth to his eightieth year his chief thought was given to man in his social relations.[44]

Both in his writings and in his actions, Ruskin identified himself with the need to improve the life of the working class. It may be that Ruskin influenced the formation of the Social Gospel in America more than has been realized. Certainly, Gladden, while appreciative of Ruskin's writings on art, was even more appreciative of his social role.

The outlook on art of John Ruskin also influenced Henry Ward Beecher (Plate 29). In his novel, *Norwood*, Beecher has two of the main characters, Dr. Wentworth, and the artist, Frank Esel, discuss the views of Ruskin. Wentworth, admitting that there are "briar thickets" and "noxious plants" in Ruskin's views, concludes that "taken as a whole, the landscape is rich and grand."[45] Hence, his counsel is, expose yourself to Ruskin. He will give you a fever and you will go through a purge. What survives at the end is worth the discomfort. Esel found in Ruskin that art became an instrument, not an end in itself. Art fell into its appropriate place.[46]

But it needs to be said that Beecher, both through the statements of the characters in his novel and in direct statements in speeches and essays, did not reduce the visual arts to mere illustrations of other modalities. Art is related to the moral, but it is not identical with that category. It may be described as a semi-moral faculty.[47] Nor is art imitation, a depiction of what one also sees apart from art. It touches deeper, "secret chords of feeling," realities greater than the appearances.[48] Beecher quotes George Inness, whom he considered the best painter of American nature, to the effect that art is based on intuitions arising out of the materials around one.[49] In a section in *Norwood*, Beecher connects art with imagination, contending for its independent though analogous role to thought.[50] Later in the novel, Beecher notes that among the Puritans, imagination went in the direction of systems of thought and speculation, and "that peculiar influences prevented the development of imagination in the direction of poetry, and music, or of the fine arts."[51] Beecher further suggests that among the theologians, only Edwards, in another time, might have had, and been able to, let his artistic genius come forth.[52]

Beecher, as was his custom, looked ahead. The visual arts, formerly connected with church and state, now were rising out of the concerns of a democratic society, from among the people themselves. In the long run, he considered that soil more productive for the future of art than its past. At the same time, great art, in spite of the changes in taste, arise from the depths of human feelings that do not change; hence, such art speaks across the ages and sometimes even increases in meaning and power. Leonardo da Vinci's Madonna can become, "in Protestant America," even more powerful as "A Mother of Men."[53]

Beecher's convictions about the visual arts of architecture and painting found active expression. The "Statement of the Trustees of Plymouth Church to Architects," extraordinarily detailed and programmatically clear, reflected Beecher and the outlook of his congregation. The church was to be an auditory space for 6,000 people, requiring that there be no obstruction, adequate ventilation, light that illumines but does not dazzle the eyes, and so arranged that all is "within the control of one voice, speaking without undue exertion."[54] The architect is to be free of traditional "Church or Ecclesiastical Architecture." Accent falls on the space being cheerful, genial, hopeful, joyful. A bell tower is not desired in an age of watches, and ornamentation is not desired, for architectural effects are to be secured by "a judicious use of masses of form, by fine lines, and by a skillful employment of the necessary members of the building."[55] Programs and architectural conception are well matched, though neither are traditional.

Beecher's second active role in the visual arts was as a collector. His collection of books, paintings, and prints was shown after his death at the American Art Association. A review noted that "perhaps the collection is strongest in the department of fine arts."[56] His books included important series on painting and sculpture, and his paintings, which were sold subsequently, included early Inness landscapes, and work by Whitridge, McEntee, George L. Brown, and additional artists, now less well known. Moreover, Beecher had more than a casual acquaintance with many of the artists of his time, particularly with George Inness and William Page.

Among historians generally, Beecher has a reputation as being pompous, facile, and shallow. He is a master of the obvious and it is sometimes difficult to like him. As an apostle of the common man, he believed that their lot would be like the fortunes of the upper-class figures of his associations. In that setting, Beecher can be read in two ways. One can, as historians usually do, see him as the spokesman for the unexamined, presumptuous shallowness of the Gilded Age. Or one can see him as one who, having absorbed so much of that ethos, remarkably transcended it. His views and conduct with respect to the visual arts in my opinion lie more in the latter than in the former direction.

Josiah Strong, Anglo-Saxon nativist, mission executive, with a strong sense of the destiny of America, combined many of the elements discussed in the previous section. Heir of Lyman Beecher and Horace Bushnell on the need for education in the west, companion of Gladden and Henry Ward Beecher in believing that the new urban wealth was both a danger and a promise, Strong believed in

the progress of America if wealth could serve humanity rather than become an object of greed. It is in that context that Strong discusses art, for, while God may be bountiful in creation, humans need to make choices. There are junctures of history when money may be invested in art, but there are also junctures when human need is so great that art must be laid aside.[57]

Clergy interest in the visual arts in the late eighteenth and early nineteenth centuries was more extensive than most of us would have assumed. However the visual arts were usually seen as a tool or adjunct. When the arts stand by themselves, when their power is unrelated to other modalities, considerable suspicion exists with respect to their role. It is only in the twentieth century that the arts came into their own in the culture at large and then, to some extent, also among the clergy.

We have dealt thus far with the emergence of an active interest in the visual arts among Protestant clergy. Among Roman Catholic clergy, the role of the visual arts was assumed to be appropriate in both church and public life. Images belonged to liturgical and personal devotional life. But that did not guarantee quality. The Spanish art previously considered ranged from a high artistic level of folk art to crude images; but it was largely indigenous. Non-Spanish Catholic art for churches, with a few notable exceptions, had little artistic merit, much of it being of the religious supply store variety. The place of images was, however, defended, particularly in the light of the continued Protestant suspicion of art in the churches.

Four prelates of note, Archbishop John England, Archbishop John Hughes, James Cardinal Gibbons, and John Lancaster Spalding, wrote favorably of the role of images and of the Protestant misunderstanding of the Catholic position. In the correspondence of England with the Editors of the *Gospel Messenger and Southern Episcopal Register*, England puts the case for images as follows: "If we consider the image itself, as in some degree connected with the service of God, and formed to aid us, in elevating our mind to contemplate heavenly things, it acquires in our estimation, a sort of value like that of the ark with its cherubim, like that which you yourselves give your communion cups, which you would not place upon your table for every day use, through reverence for God, in whose service they are used."[58] England is concerned to reconcile the counsel to make cherubim with the prohibition of images in the Book of Exodus. (Exodus 20:1–5; 25:8.) The former, he contends, Protestants ignore, and the latter, they misrepresent. The misinterpretation rests, he contends, in a Protestant reading of verse 4 of Exodus 20 simply as a prohibition against the making of images when, in fact, the meaning is making images *"for the sake of giving them divine worship."*[59] Only in that way, he further suggests, does verse five make sense, for the counsel not to bow down to them nor serve them would be superfluous if they were not to exist.

Archbishop Hughes succinctly describes the role of the saints and images in a sermon preached at St. Mary's cathedral, Halifax, Nova Scotia, on August 22, 1852. "The Church does not command her children to pray to the saints, but to admit,

acknowledge, and profess a belief that it is good and profitable to honor them and invoke their intercession for us; beyond this she goes not."[60] But this is an issue of images, not art, for Archbishop Hughes preached many sermons at cornerstone layings or dedications of new churches, frequently defending extensive material investment in such buildings. But in these sermons there is no indication that the visual arts or architecture is significant as such. That issue is absent.

James Cardinal Gibbons (Plate 30), archbishop of Baltimore, had a section on sacred images in his oft revised edition of *The Faith of Our Fathers*, first published in 1876 and still reprinted three decades later. After a deft summary of iconoclastic movements, Gibbons rests his case for a proper view of the arts on the Council of Trent: "The images of Christ, and of His Virgin Mother, and of other Saints, are to be had and retained, especially in churches; and a due honor and veneration is to be given to them: not that any divinity or virtue is believed to be in them, for which they are to be honored, or that any prayer is to be made of them, or that any confidence is to be placed in them, as was formerly done by the heathens, who placed their hopes in idols; but because the honor which is given them is referred to the originals which they represent, so that by the images which we kiss, and before which we uncover our heads or kneel, we adore Christ, and venerate His saints, whose likeness they represent."[61]

Precisely the distinction between "honor and veneration" and "confidence . . . placed in them . . . by the heathens, who placed their hopes in idols" is used to counter the Protestant objections to images. The prohibition against images is understood in the latter sense, particularly since Exodus also demands the creation of images. Moreover, in Scripture, Lot prostrates himself before two angels, Jacob bows down before Esau, Nathan bows down before David, and the context indicates that this is an appropriate expression of honor, not worship, which would be idolatry. Hence, Gibbons declares, "When an Israelite prostrated himself before the king, no one thought of charging him with idolatry. If he had done the same thing in the presence of an idol, the very same bodily act would have been called idolatry. And why? Because all men would have judged by his action that he regarded the idol as a real divinity, and that he would express, in respect to it, the sentiments manifested by adoration, in the limited sense we give to the word."[62]

Positively, Gibbons provides five arguments in behalf of religious paintings. First, *"religious paintings embellish the house of God,"* for the interior of the church should be an image of the heavenly Jerusalem. Here again, a likeness is to be distinguished from identifying the church with the heavenly Jerusalem. Second, *"religious paintings are the catechism of the ignorant."* This ancient and medieval argument includes reference to Father De Smet, whose work among the Flathead Indians we noted in the previous chapter. Third, "by exhibiting religious paintings in our room, *we make a silent, though eloquent profession of our faith."* Fourth, "by the aid of sacred pictures, *our devotion and love for the original are intensified, because we can concentrate our thoughts more intently on the object of our affections."* Protestants, of course,

were convinced that precisely such emotional intensity erased the distinction between honor and worship. Fifth, "the portraits of the saints stimulate us to the *imitation of their virtues*," functioning, therefore, in religious terms much as portraits of noted individuals were thought to do. So, concludes Gibbons, the arts were meant to be the "handmaids of religion."[63]

The intimate connection between religion and art, namely that religion drives to artistic expression and that only religious art is great art, was elaborated by Archbishop John Lancaster Spalding in his essay, *Religion and Art*, first published in 1877 and again in 1905. The human in all its grandeur is a lively subject for art, but it is given uniquely in the majesty of Jesus where sorrow is mixed with other graces and we are lifted to new levels. Art, in expressing who he is and what we are meant to be, uses sense, not for sensuous purposes, but to elevate us to new levels of moral beauty. Virtue and beauty are thus conjoined and there is no art for arts sake.[64] In painting, the religious and the artistic come together in Christ and in the Immaculate Mother, giving us a spirituality above form. In these figures, we have "the subordination of physical to moral beauty. It could no longer be the artist's aim to paint a comely and fine-formed body, but a body ennobled, purified, and spiritualized by a generous, unselfish, and sympathetic soul. . . . It was no longer sufficient to be elegant and graceful; it was necessary, above all, to speak to the mind and soul. All levity and frivolity were banished. . . . It learned the secret of repose, without which it has been said no work of art can be great, and which is the measure of all artistic excellence."[65]

Such a view of art is not dissimilar to that expressed, for example, by Henry Ward Beecher or John Ruskin. But there is a greater consciousness among most of the Roman Catholic writers to the effect that a religious Christian understanding places limits on the artistic process.

The role of art becomes circumscribed. In the pastoral letter from the meeting of Catholic bishops in Baltimore, 1884, signed by Gibbons, it is noted that artistic merit is not an excuse for art that is "indelicate." Rather, the walls of homes should "be beautified with what will keep the inmates in mind of our Divine Lord, and of His saints, and with such other pictures of the great and good as will be incentives to civic and religious virtue."[66]

Father Isaac Hecker (Plate 31), founder of the Paulist Fathers, was at the forefront of significant developments in art and architecture for the church, mainly through building the Church of St. Paul the Apostle, in New York City, as the mother church of the new order. Hecker had traveled in Europe in order to examine churches and he had definite ideas of what he wanted, chief of which was that the nave was to be sixty-four feet wide to permit an unobstructed view of the high altar from any of the pews. The Church is an adaptation of thirteenth-century Gothic, with a somewhat Byzantine feeling within. The original plans called for spires, but the final towers were flat. For the interior, Hecker also consulted Augustus St. Gaudens, John LaFarge, and Stanford White. LaFarge was responsible for the original tinting of the ceiling, for two end windows high in the chancel, *The Angel of the Moon* near one of the end windows,

and designs for the baptistry and the altar of St. Patrick. Stanford White designed the impressive high altar with the splendid baldachin, flanked by altars of the Blessed Virgin and St. Joseph. Frederic MacMonnies executed the kneeling angels above the baldachin. Considerably later, Augustus Vincent Tack painted the mural above the altar dedicated to St. Therese and designed many of the votive lights.[67]

This is an impressive list of distinguished artists, whose careers at the time were in their early stages. It may be noted that St. Paul the Apostle was the only Roman Catholic Church for which LaFarge, himself a Roman Catholic, worked. Generally, his commissions were for Episcopal churches.

Whatever the limitations of the clergy of the nineteenth century with respect to their views of art, seen now with the wisdom of hindsight, their role in promoting the arts for public life, including its religious elements, is pronounced for their number. No other professional group was that effective. In part their leadership still reflected an older role for the clergy. Moreover, many of the clergy were among the cultured of the time, believing in a nurtured quality of life, even if that cultural vision did not extend to the church itself.

4

Religious Journals and the Visual Arts

It is to be expected that the religious press or religious journals would parallel the outlook of the clergy delineated in the previous chapter. Just as eighteenth century clergy had little to say about art, eighteenth-century religious journals are characteristically devoid of comment on the visual arts. In the latter decades of the eighteenth century and in the nineteenth, artists appeared on the American scene whose competence was recognized abroad. Then the fact of an indigenous art could no longer be ignored and its earlier absence had to be accounted for. Apologetically, writer after writer makes reference to the early preoccupations of settling a new country, which did not allow a context of leisure and refinement for art to be born. But in their wish to explain the vacuum, they distorted the facts. While art was absent, this was more English, as we noted in the first chapter, than it was a matter of the unsettled societies of the new settlements.

The introduction of the visual arts into a situation in which they had been absent makes it difficult for them to have a central place. Art was viewed as a matter of taste and refinement, but not as a necessity of the human spirit. Art therefore did not stand by itself, but served purposes already accepted in the society. Art could be added to the societal realities, but was troublesome when it challenged them. When art has been absent, and is introduced to a refining and purposeful society, its place in the scheme of things is supplemental rather than essential.

Since it is widely assumed that leisure was essential for art to develop, preoccupation with trade and commerce in the new nation was felt to be ambiguous. Such preoccupations left little time for refinement; on the other hand, they provided the financial resources for cultural development. George Washington Bethune, whose views on art were considered in the previous chapter, counseled that the time for business be limited and that its fruits be used to create the leisure so essential to the flourishing of the arts. He knew whereof he spoke, for his father had been a prominent merchant.

Most of the journal writers contend that American artists need to be encouraged. But that statement conceals a host of problems, ranging from under-evaluation to over-evaluation of the American artistic scene. In 1805, a writer for the *Literary Magazine and American Register* called to the attention of Americans that travelers from Europe could not understand why

> a civilized, peaceful, free, industrious, and opulent nation, of four or five
> millions of persons, sprung from one of the most enlightened nations of the
> globe, and maintaining incessant intercourse with every part of Europe, should
> have so few monuments of these arts among them, either in public or private
> collections.[1]

J. Q. Day, however, in "The Decline of the Arts" in the liberal Unitarian
Christian Examiner, writes that the idea of encouraging the arts is wrong-
headed, that the arts flourish when a "community spontaneously seeks to express
its moral and intellectual ideas in outward material forms."[2] That can hardly
happen among people whose English ancestors never had any distinction in the
visual arts. Nor will it necessarily happen as the nation matures, for many cul-
tures produced art when they were young. The arts have had their glory in the
days of Raphael and Michelangelo, in a religious age in which the religious, the
moral, and the material blended to exhibit reality to the eyes. But religion in the
meantime has become "more spiritual, more elevated and refined. It is now no
longer possible to embody the highest religious ideas in material shapes and
colors."[3] Hence, the spiritualization of religion has taken away one of the main
functions of art in the past. But art will not become extinct; it will be limited "to
the human and the natural."[4] Hence, life and nature are appropriate to the
visual arts; but religion at its best is not.

Most writers believe, however, that there is a relation between morality,
religion, and the visual arts, and that, therefore, art needs to be encouraged. But
encouragement only, writes F. D. Huntington, is not enough, for it will only
confuse the works of artisans with artists.[5] A developing taste in gardening and
landscape will do much to prepare the soil for the future, where beauty and
virtue coinhere.

> Can we not safely say, that a genuine love of natural beauty deepens, without
> assuming that it implants, moral sensibilities, that it lays one under new per-
> suasives to a holy life?[6]

Moreover, the arts and religion have an affinity, though in our age, Huntington
adds, modesty is appropriate, for it is not the age of faith or of cathedrals.

In an article on "The Fine Arts in America" in the *Christian Examiner* of
1845, the author is sanguine about the future of art in America. The circumstan-
ces of American life, while once depriving life of associations with art, are now
favorable. Arts and the love of arts are growing out of a new soil, where nature is
free and one has the soil of republican (democratic) institutions. The Puritans of
the old world, who associated art with all that needed to be opposed, in this new
land have become kinder, open to feeling. Hence, the future for art is quite
different than in England, where even Shakespeare and Milton are not typical,
and where in the visual domain, only landscape design is significant. But the
future of American art will depend on the capacity to represent the new ideas of
national and religious life, that is, "we must paint and carve men and women
after the likeness of ourselves."[7]

Hence, art, while considered a refining instrument, is also becoming a necessity, indeed necessary to express the soul of the new nation. In an article, "American Art and Art Unions," also in the *Christian Examiner*, the writer contends that art is not a luxury, but a medium of the senses through which "beauty and truth are made visible to the eye, noble sentiments are embodied, and thus most holy and exalted feelings are appealed to and quickened."[8] And all that at a moment! In landscape painting, the artist brings us into harmony with the being who created nature: in history painting, a never-fading luster is created which can excite us to more generous efforts. The Puritans and reformers were necessarily extreme in their reactions to the visual, but now we can move past them, even as we venerate the uncouth meeting house.[9] Art is currently still too imitative and like an ornamental appendage. But the good life can create good art, putting the good and the material together in rightful proportions.

Widespread is the idea that American art is not yet distinguished, but that it will become so. There are differences of opinion as to how this is to happen. Writing in the *Christian Examiner* of 1862, a reviewer states, "America as yet cannot be said to possess taste, because our civilization recognizes no universal demand for beauty."[10] Taste grows slowly in America, for there is no standard supplied by the past. Examples of excellence need to be borrowed from other cultures.[11] But to do that is not an easy solution. Greek and Italian art, for example, require a knowledge of their time, for such art found its "motives almost exclusively in elevated sentiment, poetical, historical, or religious, carefully avoiding the common or vulgar, seldom even finding subjects for their pencils in ordinary domestic life."[12] One cannot appeal to nature or to the ordinary when viewing the models from antiquity. Rather, one is confronted by a transcending, historic grandeur. Hence, the writer disagrees with Henry Ward Beecher, who, in an 1860 lecture before the Sons of New England, rejects most previous art because it does not deal with the common man. The writer grants Beecher his freedom to choose the German school, but not his freedom to distort history.

> We make no issue with those whose tastes prefer a boor's pipe or gin-flagon to a martyr's palm or saint's nimbus, a Flemish villager's carousal to an Italian tournament, a kitchen scrub to a Madonna, the ditch and dike to the valley or mountain. Such taste is as free to enjoy after its kind as any other. But it is not free to condemn on unsound premises, and to jumble historical truth and personal liking into a medley of falsity and injustice.[13]

In short, the common will not do. A reviewer of a biography of P. T. Barnum and Horace Greeley complained in 1855 that Americans have a way of equating the popular with the excellent.[14]

The hope of many is that a school of American art will develop, free of European domination, but more than a dry representation of American life. A writer in the *Christian Examiner* of 1863 is particularly interested in the emergence of an American school of art, which, while nourished on the English scene, will take on its own characteristics. If Leslie, Copley, and West are illustrations of

artists absorbed in the English scene, that is, Americans only by birth, Allston becomes the hero, for he renounced the European success he might have had and cast his lot with the American scene. The uniquely great American art is landscape art and Thomas Cole, its master. But the writer laments the development of a "simple naturalism," which, "like the Ancient Mariner's 'painted ship upon a painted ocean,' they both pall and appall the senses."[15] All in all, the writer has clear opinions on the bad and the excellent, but his survey of artists is comprehensive, running from Allston to LaFarge.

Throughout the nineteenth century, Americans are particularly conscious of being a new nation. It tempts them to believe that they will launch a new era in all domains of life; but the fact of newness and the absence of precedents also makes them insecure.

On the one hand, it was thought, one should not expect much because America was new; on the other hand, here was a new nation that could draw on the riches of Europe without its liabilities. The latter meant that America had more possibilities for significant art than any other nation ever had. In 1854, a writer said:

> We are a young nation it is true; but we are not a young people. We cannot measure ourselves by the two hundred years of our existence on this continent, or the eighty years of our independence. Our roots strike into the soil of twelve centuries in England.[16]

An often-repeated remedy for overcoming artistic poverty was the establishment of major galleries which collected sculptures and bas-reliefs, where copies of masters and originals might be displayed together, and where artists might see such works and learn from them for their own work. That would bring a shared heritage to the attention of Americans.[17]

Ever present was the conviction that a democratic society must have a positive influence on the visual arts and that history proves this to be the case. While much European art was associated with monarchs and an authoritarian Roman Catholicism, the great periods of art occurred when men were free, when they lived in republics, or were, as artists, given special concessions of freedom by those in power. George Washington Bethune, in a characteristic passage, combined all the motifs we have discussed.

> The Art of classical antiquity arose in a democracy, to the merchant Medici it owed its revival in modern times; in the commercial states of the Netherlands appeared the only original school out of Italy; and why should not Art flourish in our republic, where the lounging idler is a nuisance, and skillful occupation a title of respect?[18]

But even if the new democratic world encouraged art and artists, what was the role of the old world? Here, too, the counsel divided. Literary figures such as William Cullen Bryant and painters such as Asher B. Durand counseled that American artists ought to take their clue from nature and by that they meant American nature. But, as early as 1816, a writer in the *North American Review*, while cognizant of the diversity and grandness of American nature, nevertheless suggested that

nature was not enough for an artist, that an artist needed the companionship and instruction of both art and artists.[19] And, in 1839, a writer in the *Knickerbocker* suggested that to paint from nature, as was the constant call to American artists, was by itself too confining to create great artists and great works.[20]

Just a few months earlier, in the same volume (July, 1839), Thomas R. Hofland called for concentration upon American themes, such as nature, the Indian, and George Washington. These three themes did receive considerable attention. American artists painted American scenery, sculptors and painters depicted Washington (often with controversial results), and, as for Indian themes, these were ambiguously handled.[21] Hofland also pointed out that Europe which so many adored in the realm of art represented a past age, and that now American art had the possibility of standing in its own right. It needed only that encouragement and support be found for it in the body politic.

An early perceptive approach for understanding art in its cultural setting is evident in G. F. Simons' review article in the *Christian Examiner*, covering the book, *Historical Sketches of the Old Painters*, and the twelfth exhibition of paintings at the Athenaeum Gallery in Boston, 1838. The writer suggests that there are no simple answers as to why art emerges at certain junctures of history, that the single causes, upon examination, turn out to be false. The elimination of alternative explanations tempts him to assign the answer to Divine Providence, which may not be as simple-minded as it sounds inasmuch as it is the last rather than the first word uttered by the writer. More concretely, he wrote:

> In turning to our own times, and endeavoring to judge of the future by the past, we must not suppose that it is only a certain concurrence of influences that can produce great painters. Art, as well as religion or science, is a natural action of the mind of man, and a great variety of circumstances may be brought to foster it. *Its life is the perception of the spiritual in the material.* Whatever develops this, tends to advance Art.[22]

Indeed, the American scene should have a future. It has all the ingredients: an encouraging temperate climate (outside of New England, he adds); natural and grand scenery, beautiful and variegated; a variety of races whose intermingling should produce excellence; a government that favors art by letting it alone; and the beauty of a tranquil domestic life.[23]

In the claim that a total cultural complex determines the nature of art in any society, the writer agreed with the European traveller, Francis J. Grund. Grund maintained that the American problem was not lack of artistic talent but that its artists emerged at an unfortunate juncture when the spiritual vision was not great enough to carry and sustain great art.[24] Grund does not believe this problem will resolve itself quickly. But Simmons, in the *Christian Examiner* article, is more optimistic. He calls for fresh understandings, freed of the clichés about past and present art. It is we who must change, who need to overcome anachronistic views and straighten out our orientations. Art must be properly understood. And he then proceeds to specifics. Art discloses the abstract in concrete form. So

we should not be afraid of the concrete even when deity is the subject.

> Art . . . embodies the ministering angels in visible shape, and reveals the abode
> of beatified spirits; and when it aspires to represent even the Deity himself, it
> does not mean to say that God possesses a corporeal frame, but only strives to
> express its idea of his nature.[25]

With a proper understanding, traditional objections fall away. Nudity is no longer a problem, for

> modesty and unconscious purity are the only necessary garments. . . . It is to
> be observed, that a perfectly free exposure of the person in pictures and stat-
> ues, seems to excite no more passion in countries where it is common, than
> among us the open exposure of the face and hands, which a Turk would think
> indecent.[26]

In short, "insensibility to the spiritual in matter . . . is a radical defect of our people."[27] Art is seen on the surface and hence surface realities such as a soft finish become important, "an indication that a picture is regarded more as a piece of furniture, than as a creation of the human mind."[28]

If the perception of what art is about requires a sensibility akin to religion, it does not mean that the artist must as such be a religious man.

> The artist is not necessarily a religious man, but he has the spirit from which
> all religion springs. It is possible that he should be intemperate, voluptuous,
> and unjust. But his art is perpetually warring with these vices, and, unless it
> conquers, will retreat before them. He may be sensible to the beautiful quali-
> ties in external nature, without uniting them in his conception as God.[29]

The writer believes that in true man—and by this he means a Christian man—art and religion are united. But the true man is not doctrinaire either in terms of what he excludes or includes. It is, rather, that "he adds love to faith and knowledge."[30]

These remarks ring true as an orientation to art and as a delineation of the resources Protestantism could bring to understanding art. They are recorded, as were so many of the discussions of the role of art, in the liberal, Unitarian *Christian Examiner*, a journal dedicated to religion, and religion in relation to all cultural expressions. Several additional journals may be noted, the first two primarily because of their editors. Henry M. Field, editor and proprietor of *The Evangelist*, saw the visual arts largely as no longer necessary. He writes that

> when the art of Printing was unknown, and not one in a thousand ever read a
> book, it was perhaps necessary that Religion should speak to the eye by statues
> and paintings and an imposing ritual. But when mankind are educated to
> more spiritual conceptions of God and of his worship, it is reversing the order
> of nature to go back to the outward forms which suited the infancy of the
> world.[31]

Of current artists, the ideal, gentle, strong marble works of Thorwaldsen pleased him most; to other artists, he paid little attention. Samuel Irenaeus Prime, editor

and proprietor of *The Observer*, and a staunch Presbyterian, was more sophisticated and knowledgeable in his approach to the visual arts than was Field. But his published writing on his travels disclose a disarray of comments.[32] For him, too, Thorwaldsen is singled out for positive attention. Friend and collaborator of members of the Morse family through *The Observer*, Prime came to know Samuel F. B. Morse and was prevailed upon to edit his papers in biographical form on Morse's death. He also shared the anti-Catholic animus of Samuel F. B. Morse.

Two Protestant journals that should be particularly noted are the conservative *Princeton Review*, reflecting an orthodox Protestant Christianity, and the Transcendentalist journal, *The Dial*, reflecting a religious cultural approach without the evangelical core of the *Christian Examiner*.

An examination of the articles emanating from the more conservative theological position expressed in the *Princeton Review*, a journal originally published under other names, indicates that the visual arts did not receive attention until the 1870s. But Hebrew poetry was singled out as early as 1826, and, in 1838 and 1843, there were two extensive articles on church music.[33] But literature received most attention. Representative are such articles as: "The Evils of an Unsanctified Literature,"[34] and "National Literature, The Exponent of National Character,"[35] or the general article, "Moral Aesthetics; or the Goodness of God in the Ornaments of the Universe."[36]

Nor are the two articles on the visual arts particularly helpful. The artist, John F. Weir, in "American Art: Its Progress and Prospects,"[37] asserts that American art has had many phases and little quality, that its landscape painting has been overestimated and that more may be expected from the American artists now studying in Paris and Munich. But for that to happen, artists must also leave their art settings, their congenial, exotic art atmosphere, and express individuality, courage, national identity, and manliness.[38] Then deeper impulses will be joined with the aesthetic.[39] Henry Coppee in his article, "Painting in its Historic Relations," ranges through history with sweeping generalizations but comes to a definite conclusion at the end of his article.

> The American artist should abandon madonnas and saints, Italian brigands and alpine passes. Let him take home themes more varied, more picturesque, and more significant than all Europe can offer him. Of human personality he has the New Englander of the North, the Knickerbocker of New York, the cavalier of Virginia, the Quaker of Pennsylvania, the Huguenot of South Carolina, the creole of New Orleans, the Russian of Alaska, the Spanish Indian of New Mexico, the 'dialectic' heroes of Bret Harte and Mark Twain and John Hay: the manumitted Negro; last and least, the fast vanishing aborigines, who wither in the noonday of our civilization like forest flowers before the sun. And each has his thrilling story, fresher and truer than the traditional legends among which the early art of Europe found its subjects and its tones.[40]

Lastly, American artists can turn things around, and end the era of patronage. Since the artist is the beneficiary, artists are beginning to speak, not of patrons,

but of clients.[41] Henry Ward Beecher, whose approach we discussed in the last chapter, would have liked this democratic approach to the ordinary and common in American life.

In the articles in the Unitarian *Christian Examiner* or the *Princeton Review*, transcendent dimensions are purveyed in this-worldly dimensions; indeed, that is the function of art. In the Transcendentalist *Dial*, by contrast, nature, religion, beauty are identical. All three have transcendent dimensions by definition, by their very being. In *The Dial* article, "The beautiful . . . is the spiritual aspect of nature"; "Beauty is the revelation of the soul to the senses"; "The love of nature ends in the love of God."[42]

This is essentially the viewpoint of Emerson or Channing. It reflects the transcendentalist, semi-pantheistic view of the world, and the function of all the arts is to lay bare the spiritual or soul dimension in the unity of nature and humanity.

Common to the issues discussed in the journals, as was the case with the views of clergy, is that the visual arts are discussed in a cultural context, not in terms of their role in the church. Protestantism came to look upon art as a positive cultural sensibility, an outlook to be encouraged because it was analogous to, but not identical with, its own life. Art, like nature and morality, ministered to the good life of humanity; and the good life and a Protestant society belonged together. While each Protestant group wanted to be free to organize its own life, the corporate aims of the diverse Protestant groups were identical. They believed in a moral, purposeful culture, which their ethos had fostered, and which art, too, was now to serve. It was precisely for this reason that John Ruskin's views were accepted in the states before they were in England.

Writing of Ruskin's role prior to the Civil War, Roger Stein states:

> The fundamental importance of Ruskin's writing in America in these years before the Civil War was his identification of the interest in art with morality and religion as well as with the love of nature, his ability to build a loose but convincing system where art, religion, and nature were inextricably intertwined.[43]

Indeed, Ruskin was the man for the hour. Rejecting the allegedly voluptuous paintings of the late Renaissance in favor of more simple and "true to nature" works of earlier artists, Ruskin provided a moral dimension for the acceptance and rejection of art.[44]

Moreover, while regarding all art to be religious by nature, he, too, was not concerned about introducing art into the churches. He made it possible for Protestants to view Catholic art as a positive secular enterprise when it is freed from its liturgical setting. Ruskin himself had a Presbyterian background, which he interpreted freely and then abandoned entirely; but his religiousness, like the religiousness of America, was never in doubt. Art was to express life truly, morally, purposefully, and thereby religiously. All these levels form a consistent whole, in which a change in one affects all the others. That interrelation is expressed in a series of articles in *The Crayon* (1855–1860), which, in its first

issues, was a vehicle for Ruskin's views. First, a loss of religious vitality adversely affects art. Without reverence and religion, art becomes merely aesthetic and then it falls to a lower level, along with all the pleasures of sense.[45] In the following year, a writer in the same journal suggests that a deep, persuasive sentiment of religion has always been related to great ages of art. But, since we currently do not have such an over-riding religious sentiment, we do not have great art, though it can be said we have good art.[46]

Secondly, and positively, a religious vision and religious conduct produce significant art, indeed, to the point that an explicitly religious subject matter is not essential. In an article called "Christian Art," the writer explicitly states:

> I am far from thinking that Christian Art need be, or will be confined to subjects directly and professedly religious or devotional in character. The spirit of Christianity is neither narrow nor exclusive in its sympathies and tendencies, but fitted to embrace in its comprehensive grasp all that is pure, lovely, and noble, only rejecting and excluding, as utterly alien, whatever is essentially mean and base.[47]

Art and theology are parallel enterprises, in which the religious impulse is decisive for both. But that means "that the true distinction in the production of Art is not that of theological and secular, but of religious and profane, moral and immoral, of that which elevates, and that which does not elevate."[48]

So, in the third place, the reverential attitude of the artist is everything, and, of course, in a religious age, those aspects can be emphasized.

> The artists of the Middle Ages, whom we term, by excellence, religious, were so, not because they painted the subjects they did, but because in all that they did they were conscientious and reverential. . . . The old time artists were religious men, and their religion became part of all that they did, and if we could look into their private lives, we should doubtless find the same conscientiousness in their minutest transactions which is preserved in their art.[49]

Some stress that it was Raphael as a religious person who was responsible for the beautiful Madonnas, whereas a Madonna by a Frenchman would be no more religious than a painting of Louis XIV.[50] But the increasing stress on the lives of the artists, coupled with new and clearer knowledge of their biographies, led to questions about some of the artists and their works. Raphael was then no longer a saint. Guido and Michelangelo, as well as Raphael, are scrutinized and a parallel is seen between the sensuousness in their lives and the sensuousness of their art. Ruskin and Carlyle are quoted to the effect that a genuine religious outlook does not call for art, that art may be helpful to make the sacred vivid, but that essentially Protestantism was meant to save us from the mastery of the senses.[51] C. M. Butler, in an article, "The Relation of Art to Morals and Religion," is almost totally negative about the past history of art. It does not measure up to what the moral should be when religiously understood. This viewpoint covers not only the lives of the artists but also the subjects they choose—such as Lot and his daughter, Joseph and Potiphar's wife, Susanna and the Elders, or an undraped Eve.

The one positive note expressed in the article is the hope that American artists will combine talent with virtue, religion, and the positive interests of America.[52]

The stress on the lives of the artists has its parallel in the increasing accent on the singular experience of the individual. A fateful conjunction occurred, namely, the American experience of nature freed from the history of Europe, the "genial" experience of creating American institutions, and the experience-centered religion of the revivals. Together, they signalled that art could serve society by being the expression of common, shared experience, hence, embodied sentiment.

The evangelical movements were interested less in how God was to be understood than in how God was to be perceived or experienced, and even their opponents came to accept experience as a legitimate mode. Moreover, experience, while traumatic at moments, was meant to exemplify that the religious dimensions were natural and congenial, and belonged to humanity's hopes and aspirations, to humanity's citizenship in the world. In short, one's experience of God, which made one at home with God, also made one at home in the world, a place where shared experiences were the essence of life. Individuals believed that such an experiential religion was alone indigenous to America, and an expression of America's particular genius. In an article entitled "American Art," the writer rejected the idea that we ought to compare ourselves with either Greece or Europe. We must look to our own unique experience.

> We are a peculiar nation, we cannot compare ourselves with ancient Greece, forced to be original; nor yet with any of the kingdoms of Europe, forced by the gathered riches of Greece to be imitated.[53]

Something new is required, which American society alone provides. While the writer conceded that the utilitarian spirit meant that "the freight of California gold stirs the popular heart to a depth never reached by Cole's *Course of Empire*," he nevertheless is not in despair and concludes that we are essentially what we are on the basis of the "genial character of our institutions." America is a land of the heart; we experience nature, institutions, and our fellow man through the heart. In our minds and through our eyes, we can elaborate on the great mountains and scenes of America. But what is unique about Americans is the way in which they see, experience, and know nature.

> Our best pictures are not so much scenes, or even thoughts, as *sentiments*. Contemplating them, we are led to believe that the destiny of art among us is not tending to the production of mountain and lake scenery on canvas, that rival that of our country, so much as the production of sentiment in the mind of the spectator.[54]

If one then contrasts Greece and Europe, the difference, suggested the writer, becomes instructive:

> Greece, when she betook herself to the easel and chisel, was too analytic; the clear, cold air of philosophy fanned her walks. Modern Europe, less free than

Greece, has also been less inventive; the state has unduly influenced the cre-
ations of the artist. If Greece carried form to an extreme, modern Europe has
done the same to sensuous impressions. It remains for America to reconcile
them, and mark the last era of art—ideal sentiment.

Thus, the writer can continue:

> The physical features are impressive; the outline and contour of our inheritance
> unite in a remarkable degree variety and unity of design. The haunts of beauty
> are numerous; the forms of grandeur are found in mountain, lake, and stream.
> The state, instead of being an oppressive and enslaving institution, is little more
> than the servant of the individual. With these conditions, the artist can afford to
> dispense with galleries of art, and patiently instruct the people in their wayward-
> ness. He will not attempt, like Greece, to give us beauty in gods and goddesses,
> nor, like modern Europe, labour to express the idea of humanity as exhibited in
> the state or favoured by patronage; but resolutely strive to give us humanity
> itself, as reflected in the repose of his own heart. . . . American art is to show
> itself in *free living forms* that represent sentiment—forms in which the warmth
> of sense pervades the embodied thought, and over the whole is thrown that har-
> monious repose which wedded love sheds upon the happy man.[55]

The writer hopes for a new school of art, "a school of humanity by a free
representation of its sentiments." Aware that such a view could be religiously
misunderstood, the writer immediately disassociates what he had in mind from
pantheism and all those who confuse beauty with God. In what is essentially an
evangelical religious tradition, the author can state that the school of sentiment

> will arise out of the warmth and repose that mark the style of some of our artists;
> and, unless marred in its early state by some form of pantheism, or a deceptive
> sentiment that leads the artist himself to mistake the sense of beauty for the pres-
> ence and recognition of a personal God, may prosperously attain its goal, and
> claim the noble palm. Religious faith is an essential element of true art.[56]

There is no doubt that this orientation provided a setting for many genre subjects
and for popular art in general; and in both secular and religious, it became
very difficult to distinguish sentiment from the sentimental. The end result was
the Jesus of Sallman, which hangs to this day in the offices of the clergy and
Sunday school rooms throughout the nation.

There is another consequence in this development. Such art expresses, it was
assumed, a moral, spiritual view of the world which is uncontaminated by, and
survives, all organizational structures, whether secular or ecclesiastical. It is a
part of the anti-institutional spirit already so prominent in the nineteenth cen-
tury. Hence, true art had a role even religion could not play, since the latter was
fettered by ecclesiastical machinery.

> We have established the claim of art to a position among those studies which
> are indispensible to the moral and intellectual perfection of humanity, to an
> influence more enduring, even than political, social, or ecclesiastical organiza-
> tions, for they cease with life, but the knowledge of Beauty, having its mate-
> rial in every production of the Eternal One, must avail us while the Eternal
> endures, and be to us everlasting life and satisfaction.[57]

Ruskin is not to be identified with all that happened in this development of the role of art, but he had set art on that course. Ruskin himself was sophisticated enough to abandon later some of the theories that he initially expounded. It was his earlier theories which influenced the American scene so greatly. His teachings were not seriously challenged until the twentieth century. Indeed, Ruskin's influence was almost fatal to a profound conception of art. Fortunately, many artists who espoused his views were fine enough artists not to have his views affect their painting.

The preceding account centers in specifically Protestant journals and on journals that reflected the general Protestant orientation of the Eastern seaboard. When one turns to specifically Roman Catholic journals, likenesses and differences in relation to the dominant Protestant orientation become apparent. Catholic journals do not enter the debate about a democratic nation and its relation to the visual arts, and they hardly touch on the debate over the appropriateness of the Neo-classical versus the Neo-Gothic forms of architecture. Partly that is because there were few Catholic journals until after the middle of the nineteenth century. Archbishop John England was responsible for the *United States Catholic Miscellany*, published in Charleston, South Carolina, from 1822–35. But it, as other journals, served parochial, promotional interests and the visual arts received little attention.[58] Clergy serving the Catholic immigrants, to the chagrin of the Protestant counterparts, were concerned with the continuation and consolidation of their religious life and culture, and seemed uninterested in entering into, or particularly acknowledging, the new national Protestant experiment. That inward preoccupation meant also that the visual arts did not enter into Catholic consciousness as an issue. Catholics assumed the place of the visual arts for their liturgical life, but the quality of such objects did not arise as an issue for concern. The *Boston Quarterly Review* (1838–1842) and *Brownson's Quarterly Review* (1846–1865; 1872–1875), which reflected the more sophisticated view of Orestes Brownson and his colleagues, did not deal with the visual arts, though literature received attention. One wonders if Irish Catholicism and English Protestantism were not alike uninterested in the visual arts. The Latrobe designed Baltimore cathedral, for example, had little statuary and painting before the latter part of the nineteenth century.

Moreover, the debate between Catholics and Protestants over images had to do only with the role of the saints and not with the question of art. Providing objects of art with the question of quality in mind stemmed from continental Catholics, whereas among Irish Catholics, it emerged late in the nineteenth century.

Two Roman Catholic journals did give some attention to the visual arts. First, the *Catholic World*, refecting the Americanist viewpoint of Isaac Hecker, had occasional articles on the visual arts. One would expect that of Hecker, whose interest in art and architecture was evident in the building of the Church of St. Paul the Apostle. In an article in 1867 on "The Influence of the Catholic Church upon Modern Art,"[59] the thesis is that the Church provided the ethos which led art to develop with distinction, except for the English scene, where

religion and art were largely divorced. In 1871, there appeared articles on Mexican art. For the years 1879 and 1880, several survey articles appeared on Christian art, mainly delineating peaks in Western history. Similar survey articles appeared between 1911–1913 in the conservative Roman Catholic periodical, the *Ecclesiastical Review*, by one Celso Constantini.

The first volume of the *Catholic World* in 1865 reprinted a review of *The History of our Lord as Exemplified in Works of Art*, commenced by Mrs. Jameson and continued and completed by Lady Eastlake, from the *Dublin Review*. While sympathetic to the irenic and comprehensive character of the two volumes, the reviewer finds that the Protestant-Catholic difference is evident in that Lady Eastlake believes that only Scriptural subjects are legitimate for Christian art, while Catholics find the saints appropriate for art. Indeed, states the reviewer, the great Christian creations of art center in the saints.[60] It is therefore not unanticipated when an article appeared in 1868, entitled, "The Veneration of Saints and Holy Images."[61] The article covers familiar ground, namely, Protestants unfortunately do not distinguish between veneration and idolatry, that for Catholics Christ is central and the Virgin Mary and the saints have a "created and derived dignity," that "the Blessed Virgin and the saints have received a subordinate office of mediator."[62] Further, if Protestants were to be consistent, argues the writer, they could not give respect and veneration to a crucifix or to Christ.

It is obvious that the difference between most Protestants and Catholics on this issue could not easily be overcome. For Protestants generally, saints were out, for no other mediator than Christ was admitted. For Catholics, additional mediators expressed the fullness of God's available grace. Since much of the art represented the saints, many Protestants questioned the role of art. For Catholics, leaving out the saints was unthinkable.

In an article in the *Catholic World* entitled "Art and Religion," a second major difference emerges. The writer suggests that for Protestants, art is "purely material," while "religion is the worship of God in spirit and in truth."[63] But we are not only spiritual, for matter forms part of our nature. So we cannot express the spiritual without making use of the material. "We rise from the visible to the invisible, from the sensible to the supersensible. . . . Is not the Christian religion a system of things invisible, visibly manifested? The end of religion is spiritual, but in order to attain this end it must possess a visible and material element. This fact of itself gives to art a religious mission of the highest order . . . to proclaim to the world Jesus Christ and him crucified and glorified—by poetry, by song, by painting, by architecture, in a word, by every artistic creation of which genius is capable."[64]

Not surprisingly, the *Ecclesiastical Review*, a conservative Catholic periodical which began publication in 1889, is more cautious and circumscribed in its view of the arts than the *Catholic World*. While articles on the visual arts occur more frequently than in the *Catholic World*, they generally stress the appropriateness of art when its aims and those of religion are identified, when our souls

are lifted to the contemplation of God. True art and true Catholic religion coincide, each needing the other. That theme is repeated again and again, though it is not elaborated. Twice the church is counselled not to place the Sacred Heart in positions separated from Christ, since we are dealing with helps in devotion, Christ's role in its total scope demanding central attention.[65] Such articles disclose that emphasis on the Sacred Heart could be a problem.

The first volume of the *Ecclesiastical Review* in 1889 has a review article, "The Story of Christian Art," centering on Dore's *The Vale of Tears*. More important for our purposes than the comments on this painting are the views of art. The visual arts as sacred art must "unfold the living charity that speaks out of the mystery of revelation," which arouses us "to the love and practice of the Gospel precepts and the Evangelical counsels."[66] Art may, the reviewer continues, first of all, please us, and, second, "foster the public virtues of honor, loyalty, patriotism and the like," but, third, it is true art only when it ends in religion and carries that out "in the purest, loftiest, and most effectual manner."[67] In the *Ecclesiastical Review* of 1890 one reads "Christian art . . . teaches not only the fact of Christianity, but also aims at convincing the beholder of the *supernatural character* of that fact."[68]

The Catholic periodicals agree in declaring that the true home of art is in the church, and that its object is to help us in contemplation and its setting our hearts on eternal dimensions. P. Raphael, O.S.B., writing in the *Ecclesiastical Review* states that "the Christian artist who does not respect the laws of the church concerning Christian art, cannot claim to foster Christian art."[69] The object of true art is no less than faith itself. Hence, art which does not purvey such dimensions is, according to some of the writers, rightly to be circumscribed by the church. Only a believer engaged in creating art that urges us to be believers is sacred and legitimate.

5

The Religious Views of Artists

In the late eighteenth and the entire nineteenth centuries, art with religious subject matter was created and executed by young American artists, the first wave of whom received their training under Benjamin West in London. Most of these artists were Protestants, and their works were neither encouraged nor commissioned by churches. Religious subjects were commissioned or purchased by individual patrons for private or public spaces. Only in the late nineteenth century did the Anglican church join the Moravians and Roman Catholics as the patron of the arts.

The question inevitably arises: What was the religious faith of the painters or sculptors, and what role did it play in the artists' work, particularly when religious subjects were executed without the churchly context? In some instances, we know a considerable amount about the religious orientation of the artists; in others, very little.

We do know that many of the artists were of English descent, and in the first chapter it was noted how the visual arts had fallen out of English life. To that we now need to add that, from Quaker to Anglican, English Christianity was characterized by considerable distrust of the senses. God and God's relation to the world was considered so spiritual in character that the world was not a legitimate mode through which God might be perceived or apprehended. The world and all it symbolizes was the fallen matrix from which, through the resources of mind and spirit, humanity must be delivered. God was spirit and the locus of God's relation to humanity was thus essentially and directly spiritual. There was a connection between spirit, breath, sound and words, so that words, not things, became the particular medium appropriate to the mediation of God's presence. Hence, its dominant modality was verbal and auditory.

However, the picture is not totally consistent. While the Quakers emphasized the spirit and an anti-institutional orientation more than any of the other religious groups, the visual arts were not entirely absent for them. The story that Benjamin West's artistic gifts were encouraged by the Quakers because his very apparent gift shone in spite of the lack of artistic encouragement and environment may be apocryphal. At the time, West's parents were not in good standing in the Quaker community. Quakerism is the ethos from which West emerged, though he joined the Anglican establishment soon after he permanently settled in England. Indeed, West's mature religious outlook reflected the theology of the

Anglican bishops of his time, in which, through reason and revelation, the events of English life were related to the ultimate end of history.[1]

Edward Hicks remained an authentic Quaker, though his sympathies lay with the Hicksite group which stressed the direct dictates of the spirit rather than traditional views of Christ and the atonement. Today, Edwards Hicks is known as the most gifted folk artist in the East during the second, third, and fourth decades of the nineteenth century. Hicks came to Quakerism in his early manhood, and a decade later, at age thirty, his Quaker ministry began. While Quaker meetings stressed silence as the context in which the movings of the Spirit manifest themselves and become articulate, accent on the Spirit was supplemented by preachers and instructors on the meaning of the Inner Word. Such a ministry was carried out by Hicks as he traveled throughout the Eastern seaboard. But, since the Quaker ministry was carried out at one's own expense, he precariously eked out a living by doing sign and stage coach painting and, unsuccessfully, at one juncture by working as a farmer. Increasingly, his artistic drive won out, probably because of all the things he tried, only painting came easily, and through it, his financial situation, while always precarious, was at least made tolerable. Although he executed at least eighty *Peaceable Kingdoms* (see Plates 85–88), Hicks himself tells us that he never felt comfortable with his painting talent. Painting, after all, represented the imaginative faculty and the world of sense, against which Quakers set plain speaking and simplicity. And since this world was viewed as already representing the kingdom of Christ, what could art possibly add? In his *Memoirs*, Hicks wrote:

> If the Christian world was in the real spirit of Christ, I do not believe there would be such a thing as a fine painter in christendom. It appears clearly to me to be one of those trifling, insignificant arts, which has never been of any substantial advantage to mankind.[2]

Only late in life did Hicks wonder if he could not have pursued his art more vigorously.

Even more troubled by his artistic talent was the Presbyterian Samuel F. B. Morse. The few religious subjects that he did are views of scenes or events that include, rather than center on, religious subjects. For Morse, the issue was art itself.

Better known in our day as the inventor of the telegraph, Morse was in fact a painter whose works compared favorably with those of his contemporaries. S. F. B. Morse, called Finley, was the eldest son of the Reverend Jedediah Morse, the famed geographer and defender of Calvinist orthodoxy who was finally discharged from his parish in Charlestown, Massachusetts, under the liberal Unitarian impact, and then settled in New Haven, Connecticut. Apparently, Finley never rebelled from his double, Congregational-Presbyterian heritage, which was expressed in the plan of union operative between 1801 and 1847. Within the heritage he accepted, Morse was flexible and open, for he endowed a lectureship for the more liberal Union Theological Seminary in honor of his father, Jedediah. However, outside the norms

and traditions which he accepted, Morse was intolerant. He was opposed to abolitionists and Roman Catholics, and he was an active nativist. He was the personification of the white, Anglo-Saxon Protestant, a man sure of the ennobling virtues of his heritage and determined, along with many others of his day, to see to it that this heritage would not be lost among the hordes of immigrants, whose Catholic background, he was sure, strongly inclined them to the monarchical tendencies of the lands from which they came. Controversy was his lot, and even his behavior in connection with the invention of the telegraph was shrouded with accusations and counter-accusations.

Inclined to the role of artist throughout his life, but eventually seeing it as a love that had failed to sustain him, Morse understood each change in the fortunes of his life as the guiding hand of Providence. A regard for the overruling hand of Providence seemed to override his rebellious affections, and he understood the changes in his vocation as the directing hand of God. While feeling subservient to the Divine, he was sure in each instance that God had called him to make significant contributions to the economy of God in the world.

With such a self-conscious Protestant orientation throughout his life, Morse might be expected to have a propensity for religious, or Christian, art. But, as far as we know, Morse painted only three explicitly religious subjects, with an additional three or four paintings peripherally touching religious themes.

Morse did provide us with clues as to why this is the case. He was convinced that Art was dangerous for the Church. His attitude was reinforced by his experiences with nineteenth-century Roman Catholicism. The pious Morse attended Roman Catholic services in Italy, not as did his fellow artists, who saw it as part of a mysterious drama simultaneously attractive and repulsive, but as a Protestant trying to worship. He tried hard; but what he saw was limited by his Protestant eyes. He demanded clarity, purpose, and disciplined moral seriousness in the deportment of those who officiated. From such premises, a negative judgment on Italian Catholicism of the time followed as night follows day. For Morse, true religion was addressed to the mind; Catholicism and art were troublesome, for both seemed addressed to the senses.

After visiting the Milan Cathedral, he wrote in a letter that Catholicism is

> a religion of the imagination. . . . architecture, painting, sculpture, music have lent all the charm to enchant the senses and impose on the imagination by substituting for the solemn truths of God's Word, which are addressed to the understanding, the fictions of poetry and the delusion of feeling.[3]

In the public domain, art was acceptable as an instrument of refinement. But its capacity for refinement is called into question by dangers inherent in the fact of imagination itself. That tension Morse could not resolve, and he made it clear which side he would choose if he had to:

> I am sometimes even constrained to doubt the lawfulness of my own art when I perceive its prostitution, were I not fully persuaded that the art itself, when used for its legitimate purposes, is one of the greatest correctors of grossness

and promoters of refinement. I have been led, since I have been in Italy, to think much of the propriety of introducing pictures into churches in aid of devotion. I have certainly had every inducement to decide in favor of the practice did I consult alone the seeming interest of art. That pictures may and do have the effect upon some rightly to raise the affections, I have no doubt, and, abstractly considered, the practice would not really be harmless but useful; but, knowing that man is led astray by his imagination more than by any of his other faculties, I consider it so dangerous to his best interests that I had rather sacrifice the interests of the arts, if there is any collision, than run the risk of endangering those compared with which all others are not for a moment to be considered.[4]

That outlook had not kept him from thinking of a church commission earlier in his career. Anticipating his return to the states, he wrote to his parents on May 3, 1815, precisely about such a possibility.

If I could get a commission or two for some large pictures for a church or public hall, to the amount of two or three thousand dollars, I should feel much gratified. I do not despair of such an event, for, through your influence with the clergy and their influence with their people, I think some commission for a scripture subject for a church might be obtained; a Crucifixion, for instance.[5]

In the same letter he moralized that if one considered that an equal amount of money was frequently spent for entertainment in one year, his request was not out of order. Moreover, his ambition to "rival the genius of Raphael, or a Michael Angelo, or a Titian," he asserted, deserved support, and that if his aim was no higher than to be a portrait painter, he would never have chosen art.[6] But Morse, in order to eke out a living, was forced to do portraits; indeed, he did excellent portraits in Concord, New Hampshire; Charleston, South Carolina; and New York City. Each year, he had hoped to return to Europe, but, before he did so in 1829, Morse was married, had three children, had lost the wife he adored, and had become a moving spirit in the founding of the National Academy of Design, of which society he was also made president.[7] During this period, he also painted his historic picture, *The Old House of Representatives* (Corcoran Gallery), apparently in the hope that it would attract considerable attention.

On his return trip to the states in 1832, Morse worked out the principle of the electromagnetic telegraph. But, in 1834, he was actively pursuing a commission for one of the Rotunda paintings in the Capitol. It was logical that Morse would be asked to do one of these paintings. He was a distinguished painter, president of the National Academy of Design, who had the support of other artists, and he had been appointed professor of the literature and the arts of design at New York University in 1835. In 1837, a congressional committee revealed that Henry Inman, John Gadsby Chapman, John Vanderlyn, and Robert Weir had been chosen to do the paintings, and that Morse was not on the list. The blow was so keenly felt by Morse that, for all practical purposes, it ended his career as a painter, though he remained president of the National Academy until 1845. Allston and Cole urged him not to abandon art, as he had threatened, and his fellow artists raised funds for him to do a painting, in the

hope that a future vacancy for a rotunda painting would occur. Morse began *The Signing of the First Compact on Board the Mayflower*; but his heart was not in it, and the work was abandoned. The rejection had cut too deeply. Morse's hope temporarily revived in 1846, for a vacancy did occur with Inman's death. Morse's fellow artists, headed by Asher B. Durand, petitioned Congress to appoint Morse. In a letter to his brother, Sidney, on March 28, 1846, Morse invoked Providence again, implying that events had been so ordered for him first to do the telegraph, "an accomplished blessing for the world," and that now "he so orders events as again to turn my thought to my almost sacrificed Isaac." But, in 1847, he learned that enough political pressure had been brought for the appointment of the westerner, Powell, from Ohio.[8] On November 20, 1849, he wrote to James Fenimore Cooper:

> Alas! My dear Sir, the very name of *pictures* produces a sadness of heart I cannot describe. Painting has been a smiling mistress to many, but she has been a cruel jilt to me. I did not abandon her, she abandoned me. I have taken scarely any interest in painting for many years. Will you believe it? When last in Paris, in 1845, I did not go into the Louvre, nor did I visit a single picture gallery.[9]

Except for a few portraits, Morse now felt that it were better that his paintings be destroyed, that he had never been a painter.[10] While a politican himself, he could never accept that his rejection was entirely political.

Morse had not been tempted by the tradition of the sublime, that notion of transworldly dimensions being conveyed by the irregularities and sometimes ominous power of nature. In that tradition, nature is a veil through which forces and powers disclose themselves, a nature in which the majestic, the dread sublime, disclose terror as well as order, potential powers of good and evil, transworldly forces mirrored in terrestrial nature. Many artists, largely under the influence of the English tradition, who had direct exposure to it as students of Benjamin West, stand in that tradition. However, there were also artists who saw in nature a calm, ordered, whole, symbolic of the potential life of humankind in the new world. Sometimes, both strands are to be found in the work of a single artist, as in the Congregationalist, then Episcopalian, and possibly eventually Unitarian-oriented, John Trumbull. His *Joshua Attended by Death at the Battle of Ai* (Plate 32) is in the tradition of the sublime, heir to West's dread sublime paintings of *Death on a Pale Horse*. But Trumbull also painted *The Religion of Nature or Nature's God*. Irma B. Jaffe calls the painting, *And Look Thro' Nature* (Plate 33), since Trumbull inscribed on the back of the painting the lines from Alexander Pope's "Essay of Man," "and Look thro' Nature, up to Nature's God."[11] While Irma Jaffe accents the Burkean sublime as the context for this painting, it seems to me to be more Newtonian in its mood, indeed, in line with the inscription from Alexander Pope.

Charles Willson Peale could probably be characterized as a mild deist, for whom nature had a religious aura. Friend of many liberal clergy, Peale was

interested in the world of nature, particularly the animal kingdom.

Asher B. Durand found religious significance in nature as we see it, trees, woods, meadows, streams. Early in his career, he did religious paintings, but he did not wish them to survive—and they did not. The Durand family was originally French Hugenot, and Durand's mother was an orthodox Christian. During his youth, Durand was drilled in the Westminster Catechism, but he gradually moved to more liberal views. It is likely that his more liberal views were encouraged by his friend, fellow class member and working companion, the conservative Unitarian, William Cullen Bryant. Moreover, Durand and Bryant were close friends of the Unitarian clergyman, Orville Dewey, whose views on art were discussed in chapter three.[12] But this loose Unitarian association should not be overstressed. The most that one can draw from it is that a religion of nature was encouraged by the less evangelical strands of the Unitarian tradition. Durand was a mild nature mystic or pantheist, to whom nature spoke in fundamental terms apart from all creed or ritual.

For Peale and Durand, nature was viewed as a calm, quiet, natural, sympathetic realm, through which the orderliness and indeed friendliness of God appeared. The view of Peale and Durand reflects an orderly, tame, Popean view of the Newtonian world. Artists with such a viewpoint ignore the sublime.

Artists who reflect the sublime in nature may also echo the benign in nature. Certainly, the art of Washington Allston and Thomas Cole disclose both facets of nature. In the case of Allston, the dread sublime is more evident in his earlier rather than in his later paintings. Allston was an Episcopalian, though married to Ann Channing, the sister of the Unitarian, William Ellery Channing. After marrying his second wife, Martha Dana, Allston attended Shepherd Congregational Church in Cambridge. It may be surmised, but only surmised, that Allston could attend a Congregational church only after his loss of interest in the dread sublime and his fading association with that aspect of Coleridge's thought. But a thorough-going Transcendentalist Allston never became, for the forces of revelation were too much a part of his life.

In the case of Thomas Cole, some paintings convey one or the other aspect of nature and others convey both. The terror of nature is usually associated with biblical or historical events, and the calm of nature with a paradise lost or to be regained. But in the last decade of his life, religious, indeed specifically Christian views of the world, began to manifest themselves in much of his painting. Ellwood C. Parry III has provided a chronological account of Cole's relation to the Episcopal Church.[13] Originally, the Cole family had come from the dissenting tradition in England. But Cole's marriage to Maria Bartow late in his thirty-fifth year by the Reverend Joseph Phillips, rector of St. Luke's Episcopal Church, at the mansion of John Alexander Thomson of Catskill, New York, undoubtedly started an association with the Episcopal Church. In 1839, Cole drew up plans for a new St. Luke's Episcopal Church, for the old one had burned in September of that year.[14] Cole was also a member of the building committee. The structure was completed and consecrated in 1841. In the early period, it also had an illusionist window

painted on one wall by Cole, apparently "stone arched," having "columns and capitals," and, as if seen through the glass, painted "blue sky with . . . cumulus clouds."

Cole's further involvement with the rector and the church is evident, first, in the fact that the Reverend Joseph Phillips and Cole corresponded in 1840 on the direction of the stream in the *Voyage of Life* series, and second, in that Cole was designated as one of the delegates from St. Luke's to the annual Episcopal diocesan meeting at St. Paul's chapel of Trinity Church on September 30, 1840. Further, Cole was on a committee to procure an organ as well as funds for the church.

The previous details are important in the light of the impression that the Reverend Louis Legrand Noble, successor to Phillips at St. Luke's in 1844 and the biographer of Cole, gave to the effect that Cole became an Episcopalian in 1842 after his return from Europe.[15] The parish register for 1841–44 was destroyed by fire and the first entry for the new one for 1844 is that of the baptism of Mr. and Mrs. Thomas Cole on November 22, 1844. Noble was present at Cole's death and presided at his funeral in 1848.

While Noble enhanced his own role in relation to Cole, there is no reason to doubt the accuracy of the record of the baptism of Cole. The Bartow family had been members of St. Luke's at the time of Cole's marriage and thus Mrs. Cole's baptism at this late date appears more of a problem. If Cole was not baptized until 1844, it is still evident that he had an active association with the previous rector, Joseph Phillips, and was involved in the affairs of St. Luke's. Until the rise of the Tractarian movement in the 1840s, it would not be unusual for one who became an active Episcopalian not to have had the question of baptism raised. But in the tightening up of the 1840s—and in some areas before that time—the issue could and did arise. Hence, it is conceivable that Cole was encouraged to be baptized or himself sought baptism some eight years after his association with the Episcopal church had begun.[16]

It is clear that Cole's Episcopalianism was a deeply felt heritage. In 1846, two years before his death, Cole responded to an article in the Episcopalian *Churchman* on frescoes for churches. After correcting the writer on frescoes, Cole defended the role of art in the church. He wanted art to be genuine and significant, even if the result was that one still had to wait on the question of art in the church. Careful not to be associated with the papacy and art, Cole recalls the paintings in the catacombs as a longer heritage on which to draw. Mostly there is too much imitation of past art, particularly of the Middle Ages, a time when in fact, architecture was better than painting. The artist must work by analogy, hoping in one's own time, having learned from the past, to do work as distinguished as one's predecessors. Particularly, Cole is opposed to painting sculpture and columns on walls, even if the argument is that it will create a climate for doing paintings in the church. An authentic niche, even without sculpture for the time being, is preferred to the illusion of painting a sculpture on the wall.

Cole stressed the discipline and struggle of living life freed from all its distracting sensuous manifestations. His new Christianness involved the discipline and reality of the cross. He always prayed before he painted. On his bed-table at the time of his death, in addition to the Bible, was Thomas Wilson's *Sacra Privata*, a devotional tract full of pious directions and discipline, designed to free one from the distractions of the world. Cole's religious pilgrimage apparently led to a liturgical, sacramental ambience; but he never abandoned the general contours of his Puritan Protestant heritage, namely, that God called one to moral and purposeful activity in all that one did.

Thomas Cole's pupil, Frederic Edwin Church, who became one of the most important of the landscape painters, came from a conservative Congregational background in Hartford, Connecticut, but apparently adopted more liberal views in his more mature life. Except for a few religious paintings of Biblical subjects done under Cole's tutelage and some later with broad themes, such as Faith, Church's paintings centered in landscape. There is a somberness that inheres in his majestic scenes of nature, which could stem from his Puritan heritage. Church, however, remains silent about such issues.

It is interesting that Robert W. Weir, painting instructor at West Point, also responded to the article on frescoes in the December 5, 1846, issue of the *Churchman* and that the articles of Cole and Weir are printed next to each other. Like Cole, Weir lamented the illusion of sculpture in the ornamental paintings proposed by the writer against whom they wrote. Rather than having "'the twelve apostles painted in different canopied niches, in order to give an ornamental effect,' [pictures] should be illustrations of the doctrine and precepts taught."

Weir had apparently come from a Presbyterian heritage to the Episcopal Church and became interested in the emerging Neo-Gothic churches. While a tradition of Episcopal chaplains at West Point arose because the leadership had largely been Episcopal, in the 1830s a new superintendent appointed a Presbyterian chaplain, much to the chagrin of the Episcopalians at West Point. One can imagine Weir's own distress, since he was originally a Presbyterian. Apparently, an Episcopal mission to the community below West Point had previously been organized by the West Point Episcopalians, who in the light of the new developments, now made the mission their parish for approximately a decade. Upon restoration of the chaplaincy to the Episcopalians, the mission church continued to serve both the community and at least some from West Point, among whom was Weir.[17]

Weir's interest in the church, as in the case of Cole, was concrete. Like Cole, he had an interest in architecture and apparently traveled in England among Anglican parish churches before designing the Church of the Holy Innocents at Highland Falls, just south of West Point (Plate 34). While the church has been extensively renovated, the exterior walls, built of native stone, look much as they did originally when viewed from the South and Southeast.

Weir's identification with the Church of the Holy Innocents rests on several

grounds. In addition to being the architect and being active in its affairs, Weir painted at least two versions of the church, one of which was the basis of a print published in the popular *Home Book of the Picturesque* in 1854 (Plate 34). The first funeral in the new church was for his first wife, Louisa Ferguson Weir, and some of his children were also baptized and buried in the church.

Episcopalianism had become an attractive alternative for some literary artists, painters and sculptors. With a greater regard for mystery, expressed alike in liturgy and architecture, it offered an alternative to the moral nonsensuous character of Protestantism generally, or to the rigidity of thought of its more conservative groups.

Still others found religious dimensions for art in spiritualism and Swedenborgianism. The landscape and genre painter, William Sidney Mount, exhibited an interest in spiritualism, though his paintings themselves could hardly be so understood. Mount did two early, rather melodramatic paintings of religious subject matter—*Christ Raising the Daughter of Jarius* (1828, Suffolk Museum and Carriage House, Melville Collection, Stony Brook, Long Island) and *Saul and the Witch of Endor* (Plate 35). He must have known West's painting of the latter subject through an engraving. Could he also have seen Allston's version painted eight years earlier in Boston? Except for a sheet of sketches in March, 1867, which includes two Christ figures and probably an Eve,[18] we have no paintings or references to religious subject matter in his work. Alfred Frankenstein records Mount's distaste of the traditional, cold Presbyterianism he apparently knew and his regard for nature and conscience.[19] Frankenstein also records that Mount's interest in spiritualism included the attempt to relate it to traditional Christianity and that it made him reluctant to paint the dead, the latter having been a common nineteenth-century practice.[20]

For many artists, Swedenborgianism was the most viable alternative. Given the small number of Swedenborgians in the culture at large, the number of artists interested in Swedenborg's thought is impressive. One thinks immediately of Hiram Powers, George Inness, and William Page. Swedenborgianism was made to order for artists who had religious propensities. It posited that the ideal, spiritual world is disclosed through the senses in a non-sensuous way, that is, the senses transcended themselves for those who had eyes to see.

Hiram Powers had been a Swedenborgian since his early manhood in Cincinnati. While his father was unchurched and his mother was a Universalist, Powers was probably introduced to Swedenborg by Luman Watson in Cincinnati. Both Powers and his wife, in separate letters written from Florence to Cincinnati, refuted the accusation that their agent, Minor Kellogg, introduced them to Swedenborgianism long after they left Cincinnati. Both the Powers pointed to their early interest, and maintained that Kellogg had only brought interesting Swedenborgian literature with him to Florence. Moreover, both of them accused Mrs. Powers' sister, Abbey, of having blindly followed the attackers of Swedenborg, who usually had no firsthand knowledge of Swedenborg. Mrs. Powers particularly placed Lyman Beecher in that class.[21] Powers himself read Swedenborg

carefully enough to discuss it with Swedenborgian clergy, and engaged in correspondence with the Swedenborgian minister, Thomas Worcester, whose portrait bust he also executed.[22] Moreover, Worcester baptised the Powers children in Florence.[23]

Powers found in Swedenborg, he told H. W. Bellows, "Scripture made clear and the Trinity given an intelligible interpretation."[24] Indeed, coming from the Universalist background, in which the Trinity was anathema, Powers found the interpretation of the Trinity by Swedenborg to be a return to a form of intelligible orthodoxy. It is interesting to note that Powers also discovered that his neo-classical conviction of the elemental rightness of the nude form as a medium of artistic expression was reinforced by the Swedenborgian contention that good and evil resided in the way in which the physical is perceived, not in physicalness itself. In an undated letter to a Mr. Holland, Powers wrote:

> I claim that in all my work there is no impure thing or sentiment—I have always aimed at the pure image of God and they who shrink from beholding it and fear contamination should try to purify their own minds. . . . No pure heart can suffer while contemplating the noblest work of God unless when it is degraded to some false sentiment.

In a letter to Elizabeth Barrett Browning, August 7, 1853, he wrote, "a nude statue should be an unveiled soul and not a naked body." But beyond these statements, one cannot connect Swedenborg with the art of Powers.

Powers also had an interest in phrenology and spiritualism. The English medium, Home, spent a month with the Powers in Florence. Powers was in the Browning circle, but he was neither as believing as Mrs. Browning nor as disbelieving as Robert Browning. He found both quackery and incontrovertible truth in spiritualism. His conviction seems based more on a spiritual vision Powers once experienced than on the spiritual seances.[25] Moreover, he considered spiritual phenomena too serious a matter to be pursued in seances, and he consequently backed away from them. His piety knew the limits of what one may discern, as was indicated in his moving letter to his mother-in-law, Mrs. Gibson, on the death of the Powers' son in Florence (March 20, 1838) and his letter to Henry W. Bellows (December 1, 1869), upon the death of the latter's wife. Powers' conceptions may have been limited at many points, but his humanity also knew appropriate limits and was free of pretensions.

Horatio Greenough's religious views were complex, but very much a part of his life. Although he came from a Unitarian background and late in his life was associated with Emerson, his imagination certainly breaks the boundaries of both traditional Unitarianism and of Emersonian ideas.[26] His religious ideas follow no regular path and much of what he said was related to the currents of his time. So he went in many directions at once, regarding truth as indeed a two-edged sword: "But it is a sword whose handle burns as fiercely as its edge doth cut, and knowing men pass it more quickly than the bottle."[27]

Greenough continually protested against those who cover or subvert the

vitality of life and who try to hide the fact that life is incomplete. He was convinced that the inevitable tension between the ultimate destiny of humans and the bodily, concrete strivings of existence are usually arrested, covered up, and taken advantage of by institutions, secular and religious, including particularly those represented through architecture and church. For Greenough, death must be incorporated into life, accepted as a natural end, beyond which lies another domain. Death belongs sufficiently to life, so that death represents the grace of God.[28] So he rejected the churches and the clergy who use both eternal life and death as a club, masking transitoriness. Let a human being accept that he or she is incomplete, in transition; only God is complete. Humans try to hide the fact that at no point in life is there fullness and perfection. And religions want humans complete, safe, devoid of the vitalities that define their very being. So religions try to suppress much of God's creation. But they are not successful, for the suppressed person breaks out and does acts of evil, or seeks diversion on the side. Then humans taste the flesh as if it were not their life, but, instead, the forbidden fruit. For Greenough, there is no forbidden fruit, though for him humanity is not by nature good. Here he differs from Transcendentalists and Unitarians alike. It is, rather, that goodness should not be an issue. The vitalities of life, including those of the body, naturally express the dynamics of life as movement.

Greenough's strong rejection of chastity is to be understood in this context. Life is to be enjoyed in all its God-given dimensions, in all its wholesome possibilities. Life is a pilgrimage, never to be arrested as institutions, past and present, try to do. It is because creed, dogma, and institutions arrest life's dynamics that they must be opposed.

Humans must find themselves enabled to act; to make that possible, Greenough wants to take a page from "nature" to find "nature's author and finisher," and, if that path is followed, a human may discover "that he was made only a little lower than the angels—Beauty—Action—Character." And then he adds, "By beauty I mean the promise of function. By action I mean the presence of function. By character I mean the record of function."

For Greenough, the pilgrimage of life is of such a nature. He illustrated his meaning by talking of the history of a leaf, from its early budding to its November days. In each stage, as well as the end, appropriately there is beauty, action, and character, that is, the function appropriate to the manifold situations of life. To this he added that the glory of beauty was the faith in future action, in its continuous expression through multiform and multifold ways appropriate to the functions which are elicited. In this sense, form follows function, and variety is present and authentic. To so work is to have character, to have the courage and charity "that giveth itself to God, in sacrificing self to humanity."[29]

Such is the major thrust of Greenough's religious views. It is apparent that his conception of art, architecture, religion and life form a whole, though on a particular issue, Greenough may be tangential, and sometimes incoherent.

Roman Catholic artists had none of the problems with the visual arts which

Protestant artists had. Other-worldly dimensions had always been expressed in sensuous form in Catholicism, from sacramental to artistic creations, though the latter frequently were artistically so poor as to become reminders of faith rather than powerful expressions of it. However in the case of John LaFarge, Catholic substance was also mixed with Oriental interests, so that his paintings frequently also have a recognizable Eastern repose. In the latter part of the nineteenth century, Eastern art became a source of interest to many artists, both because it was relatively newly known and because it offered an alternative to the conventions of Western art.

The root convictions of artists find expression in the works of artists, for art mirrors perceptions rooted in the artist and the society of the artist. But seldom is there a direct correspondence between particular religious perceptions and the works of art. One could ask the question, do the particular works of art depend on the particular religious perception? The answer in most instances is in the negative. Given that such art with religious subject matter was mainly created outside the liturgical life of the church, and most works were not for the church at all, a social matrix, such as the medieval church exemplified, was absent. At best, the works of art then expressed the personal vision of the artist. That personal vision may have a religious ingredient, but it is in itself not the determinant. Hence, these artists exhibit the mix of their own personal views of life, in which religion, philosophy, views of nature, destiny, and morality are interwoven. Religious art is then not merely religious. Having no liturgical setting, it is fundamentally a cultural expression of the artist and his time. Nor does it express vital currents challenging to, or subject to, the baptism of the church. If art once reflected the social life of the church, in the nineteenth century, it reflects the personal conviction of artists whose professional life is largely unrelated to the church. Their art does not challenge the culture in which they live.

6

Theological Interpretations
of the Neo-Classical and the Neo-Gothic Styles

Because the nineteenth-century debate over the appropriateness of the Neo-Classical or the Neo-Gothic style for churches was more a theology of seeing art and architecture than an architectural debate as such, the subject belongs to our purview. Until that debate, architecture largely reflected, even if mostly in a simplified form, the national origins of those who settled what became the United States. The earliest extant buildings, even if modified through restoration, reflect that diversity. The walls of San Miguel in Santa Fe date from approximately 1610 and the San Esteban Del Rey Mission Church, Acoma, New Mexico, dates from 1629, the latter being the oldest church in the United States to survive essentially in its original form. San Miguel and Acoma are, of course, of adobe construction; St. Luke's Church (Historic St. Luke's National Shrine), Smithfield, Virginia, erected between 1632 to 1638, represents the early Gothic brick style of the English parish church. The Old Ship Meetinghouse (Church) in Hingham, just south of Boston, erected in 1681, reflects an earlier medieval tradition, one antedating what we know as colonial architecture and dedicated to creating a simple space useable alike for religious and secular activities informed by religious conviction. Thus, already in seventeenth-century America, the diversity of national styles was evident.

On the path to what became what we associate with New England architecture was St. Paul's Church (Old Narragansett Church), erected in 1707 in Wickford, Rhode Island. Patterned after Wren's parish churches designed after the 1666 fire in London, it is still a rectangular structure, ornamented with pilasters and Palladian windows. But the shape we associate with the New England meeting house is indicated in such buildings as the Old North Church, Boston (after Wren) and St. Stephen's, a Charles Bulfinch building nearby.[1] Such structures, as their prototypes in Cambridge, Massachusetts, and Alexandria and Williamsburg, Virginia, are auditory spaces, with white interiors and clear glass windows. They usually have high pulpits and modest sized tables or altars.

Indeed, until the middle of the nineteenth century, the diversity of national styles continues without question. In the first decade of the mid-eighteenth century, one can think of King's Chapel, Boston, and the Touro Synagogue, Newport, Rhode Island, both executed by Peter Harrison. At the same time, Mission

Concepcion, the oldest unrestored church, and San Jose are being built in San Antonio. In the next decade, St. Paul's chapel is being erected in New York City, and in the 70s and 80s, the Arizona missions were built and many of the California ones as well. In the first decade of the nineteenth century, buildings as diverse as the First Congregational Church, Old Barrington, Vermont, the Bulfinch Roman Catholic cathedral in Baltimore, and the San Francisco de Asis Church Ranchos de Taos are being erected. And the following decade sees many of the New England Congregational churches arising on village greens.

But in the early nineteenth century, as the nation developed, it was widely recognized that there was no new national architectural tradition, and that each immigrant group erected buildings that reflected its own national origins. The question arose, should not a new national spirit create a new national architecture, as, indeed, had been the case in other countries? In part, this was a legitimate existential question in its own right. It occurred, of course, at a time when the Eastern seaboard was becoming conscious for the first time of two realities, the Spanish Catholicism of the West, and the immigration of non-English into the new nation. The awareness of diversity became a conscious issue to those who had created the new nation. It was an issue that had to be met. Hence, the question of an appropriate architecture is mainly an issue among English descendents who, in their own mind, had created a Protestant country. They looked for precedents in the past, which turned out largely to be Neo-Classical with respect to public life, and increasingly Neo-Gothic, with respect to church life. Such a view is reflected in Thomas Cole's *The Architect's Dream* (Plate 36).

The suggestion, so pointedly made by Horatio Greenough, that Americans should follow Greek principles but not imitate the Greeks, was a hint that did not automatically translate itself into results.[2] Early nineteenth-century Eastern Americans, thinking of themselves as the heirs of Greece, believed that classical architecture was particularly appropriate to a republican or democratic society. Thomas Jefferson was the most outspoken and influential person promoting that view, largely through his designs for the University of Virginia, through his own home Monticello modeled after the Maison Carrée in Nîmes, and through his influence upon the architectural style of Washington, D.C. Ironically, Jefferson's initial interest in classical architecture came not from Greece, but from France, where he saw the classical mode connected with the ideals of the French Republic. When the French Republic turned sour, defenders of the classical tradition turned to Periclean Athens and to the idea that in architecture and in sculpture, the free liberties of the people were the soil out of which great architecture and sculpture were born.

It must immediately be added that the protagonists of the new Neo-Gothic style likewise used arguments from history to bolster their claims. The defenders of classicism and of the Gothic revival alike insisted that the moral spirit of a people combined with artistic competence dictated their respective styles. They saw a direct connection between the fabric of society and a particular architectural style. Hence, the defense of architectural style was more than preference; it

was a question of truth or falsity. Consequently, views of architecture were more dogmatically held than views in regard to sculpture or painting.

While Georgian and classical styles predominated on the Eastern Seaboard in the early period, the conscious espousal of both classical and Gothic models occurred in the early nineteenth century. Indeed, for those who were not doctrinaire in their choices, there was openness, sometimes ambivalence, as to the particular architectural choice. For example, in 1805, Benjamin Latrobe submitted both classical and Gothic designs for the proposed Catholic Cathedral in Baltimore.[3]

One of the earliest, relatively pure forms of the classical mode was Latrobe's bank in Philadelphia, which no longer exists. But one need only visit Washington and the capitols of most of the states, or county court houses, to be surrounded by classical architecture. Moreover, classical motifs are seen on buildings in many cities whose names echo Greek or Roman sources, particularly from New York State to the Mississippi.

In addition to the alleged historical reasons for the appropriateness of the classical style, such architecture had much to be said for it from a practical standpoint. If one stripped a classical building of the columns which often surrounded it, as in the case of the Greek temples, and placed columns only on the facade, extensive internal, useable space could be obtained in a building of relatively modest dimensions. The theoretical, indeed theological, justification for classical buildings was the simple way in which ample space and elegance were combined. Such architecture, it was affirmed, expressed the spirit of a people in whom expertise, industry, and devotion combined to produce artistic excellence.

The argument is familiar. Just as painting and sculpture were seen as emerging from the spirit of the Greek people and their republican government, so did architecture. Moreover, Americans, it was said, could be equally great in architecture, if Greek principles were appropriately adapted to the spirit of the new nation. This argument is extensively elaborated in 1830 in articles in *The American Journal of Science and Arts* by Benjamin Silliman,[4] prominent Yale chemist interested in natural history. But, while Silliman, like Greenough, argued for Greek principles over against a Greek style of building, the two usually coincided. For him, a Greek temple was "even more simple than a circle, when we consider that the subject is solid walls instead of lines."[5] Silliman deemed the Doric style as the highest form of art, that is, appropriate for churches, banks, government buildings, colleges, though not for private houses.[6]

On such a basis, Silliman obviously rejected the Gothic style and contrasted the Gothic and Greek styles as follows:

> The Gothic style creates and overcomes vast mechanical difficulties, that we may be astonished with the display of skill; but here [with the Grecian style] there is not one mechanical difficulty throughout the whole: the Gothic employs every variety of ornament to dazzle or distract the senses; the Grecian uses ornaments sparingly if it uses it at all; the former calls in every adventitious circumstance to heighten the effect—painted glass, music, obscurity; it awes us with its vastness, it overpowers and subdues the senses, and we gaze on it with wonder and with

> fear. The latter rejects everything foreign to itself; it never affects us with its size; it exerts itself chiefly on the outside, in the broad light of day; our senses grow clear and critical before it, it insinuates itself into our very soul, and we become filled with lively and almost bewildering admiration.[7]

Again:

> The latter [Grecian] aims only at gratifying the taste. . . . The Gothic operates on all our sensations. With the pleasures of taste are mingled astonishment, fear, wonder, awe. . . . A *simple Gothic* building is a contradiction of term. . . . The aim of the Grecian, let me say again, is to bring all the parts within the compass of the mind, subject them to its keenest perceptions: that of the Gothic is to confound the attention, and while the powers of the mind are thus weakened, to bring it completely under its control.[8]

Precisely the same arguments were used by the leader of the theological movement for Gothic architecture, the Englishman A. A. Pugin. At that point, architectural and theological issues became intertwined. Wrote Pugin in defense of the Gothic or Pointed Architecture:

> A pointed church is the masterpiece of masonry. . . . Grecian architecture is essentially wooden in its construction. . . . But is it not extraordinary that when the Greeks commenced building in stone, the *properties of this material did not suggest to them some different and improved mode of construction?* They set up stone pillars as they had set up trunks of wood; they laid stone lintels as they had laid wood ones, *flat across.* . . . The finest temple of the Greeks is constructed on the *same principle* as a large wooden cabin. . . . [By contrast] pointed architecture does *not conceal her construction, but beautifies it.* . . . A buttress in pointed architecture at once shews its purpose, and diminishes naturally as it rises and has less to resist.[9]

Indeed, Pugin goes on to claim that even the details of the Gothic are not ornamental, but functional and necessary to the purposes of the building.

In the last analysis, the debate is not about architecture, but about diverging views of worship. Protestants generally preferred the classical style because of its alleged simplicity and spaciousness.[10] When adapted to a church building, the classical style lent itself to an internal, spatial adaptation, congenial for preaching to congregations. Even in England, where the Gothic parish building deriving from the Middle Ages had to be used by Protestants for whom preaching was central, the interior of buildings underwent transformation. Balconies were installed and chancels closed, so that the congregation could gather round the pulpit as the focus of the worshipping congregation. Such newly built interiors are to be found to this day in the newly created colonial buildings of the Episcopal parishes of Christ Church, Cambridge; St. Paul's, New York; Christ Church, Alexandria; Bruton Parish, Williamsburg' and in the earlier King's chapel, Boston, originally Anglican, and then Unitarian (Plate 37). The American Episcopal Churches initially erected buildings appropriate to the Protestant Evangelical tradition of which Anglicanism was a part in the eighteenth century. The Anglican affinities with the general Protestant tradition prior to the high church Tractarian movement must not be forgotten.

It is for theological and liturgical reasons that Silliman and a writer in the *Christian Examiner* found Gothic architecture inappropriate for Protestant worship. Silliman wrote:

> The interior of our edifices for worship must not be broken up into parts. The best form for our Protestant church is a rectangular parallelogram, though I have seen the circle and other simple forms employed, seemingly, without any inconvenient results.[11]

The writer in the *Christian Examiner* expressed the general Protestant attitude:

> The "long-drawn aisles" and interminable vistas [of the Gothic style] were intended to give vast processions of worshippers opportunity of seeing the elevation of the host, and the splendid ceremonies of the mass. The "fretted vaults" resounded with the music of the majestic organ, and the mingled anthems of a thousand voices. The "garish light of day" was excluded by the rich stained glass of the windows, and replaced by a dim, religious twilight, which aided the solemn effect of the scene. Every thing was calculated to stimulate emotion and repress thought. But when we attempt to reproduce such a building for the Congregational form of worship, the effect is always inconvenient, often ridiculous. The preacher can hardly be seen at the end of one of the long aisles, and had he the voice of Stentor, he could hardly hope to penetrate the forest of columns and projections which intercept sight and sound. The stained glass of the windows usually makes it so dark, that it is with much ado that we can see to read our hymn books. . . . Perhaps a time will come, as some predict, when our form of worship will be modified, and we shall have less of "this immoderate desire for preaching," which is so strong now. Until then, however, we had better beware of cathedrals.[12]

In a previous issue, the *Christian Examiner* expressed dissatisfaction with the architectural scene in any form, saying that there are many new buildings in Boston and New York, which a few years ago, would have looked like a Greek temple. Now they are all Gothic, unsuitable for Protestant worship, with a "long nave, the lofty ceiling, the narrow window, admitting an imperfect light, the frequent pillars intercepting the view," but only appropriate for the mass.[13] Unfortunately, adds the writer, the "old Puritan meetinghouse had but one thing to recommend it,—its steeple, often unsightly, but always pointing to the heaven."[14] A building is needed, the author argues, that is appropriate to Protestant worship, and whoever succeeds in designing such will have his name immortalized. That hope, he adds, then as now is hardly realized.[15]

The general Protestant objections to Gothic church architecture involved a theological understanding in which the clarity of word and perceptions of the mind were central. George Washington Bethune, a reformed clergyman who was relatively sophisticated on matters concerning art and artists, as we have seen, expressed this traditional Protestant attitude toward the Gothic:

> The gloom of the dark ages, in which it arose, has passed away. Our churches are now the abodes of clear truth, not of oppressive mystery; places of lowly and glad worship, not of long processions and pompous display. The Grecian

styles suit our religion far better. The false poetry of a "dim religious light" does not agree with our faith in the God of Love, who lifts upon his people the smile of a father's countenance. . . . Our recent ecclesiastical buildings, after the Grecian models, promise a far better taste in propriety than the modern churches in our mother country. The high backed pews; the inconvenient and meaningless recesses by which the church is tortured into the shape of the cross; the gloomy windows, granting little light, and less air; the tub like pulpits, in which the preacher suffers like another Regulus, and the dizzy galleries, where the people look like swallows on the house-top, have given place to arrangements, which enable all to see and hear and worship without doing penance.[16]

For those so minded, the Gothic spirit, which antedates the resurgence of Gothic architecture, was no less a problem. Even as late as Sir Walter Scott, many Protestants had reservations about reading his so-called Gothic novels.

The Gothic spirit indirectly influenced the development of Gothic architecture. The new interests in the sublime and in the so-called Gothic novel created an atmosphere in which mystery and awe contrasted starkly with the verbal tradition of central Protestantism, and with the incipient rationalism and deism of much of Anglicanism. Indeed, the romantic tradition had a Gothic spirit and, for many romantics, both the medieval period and Roman Catholicism were attractive. This kind of spirit was expressed in Horace Walpole's writings and in his creation of Strawberry Hill, as well as in William Beckford's creation of Fonthill Abbey. The creations of Walpole and Beckford were at once a new spirit, extravagantly expressed, and a revival of a tradition of architecture which had always been a part of the English scene.

With the exception of the rebuilding of parts of London because of the fire, few church buildings were built in the English scene from the Middle Ages to the nineteenth century. Because of the rapid increase in population in the second decade of the nineteenth century, the government made money available for the building of new churches. Various styles were permitted, but the Gothic style was usually selected, although the interior frequently had little resemblance to the churches of the Gothic Middle Ages. Moreover, both the Gothic creations and restorations of this early period could as well be called Gothic destruction. The knowledge of what earlier Gothic had been like was not readily available, and, as a result, restorations were frequently outright transformations of the past.

Nevertheless, the Gothic revival was assisted by an increasing antiquarian interest. Furthermore, by the 1820s and 1830s this antiquarian interest was associated with a theological interest as well. There were those who felt a renewed interest in the centrality of the Eucharist and the appropriateness of Gothic architecture for the celebration of this mystery. While the writings of Pugin are associated with this development, the major thrust for a change came from two directions, the Tractarian movement at Oxford, and the Camden Ecclesiological Society at Cambridge. While Pugin and Newman both turned Roman Catholic and created problems for the two movements, they symbolized much of the new mood, namely, the concern for the Eucharist as equal, if not more important

than, the proclamation of the word. James F. White has conclusively demonstrated, however, that the Anglican Tractarian movement, while dedicated to a sacramental understanding, was not interested in architecture as a necessary accompaniment of the new understanding.[17] However, the movement did provide a theological understanding which could be used by those so inclined.

By contrast, it was the Camden Ecclesiological Society which saw the Eucharist, liturgy, architecture, and the contours of society as one ecclesiological problem. It considered the Middle Ages in non-Roman Catholic form to have been the ideal period. They meant, of course, the Middle Ages of England, in counter-distinction to the Continent. The program of the Society called for the rehabilitation of the parish church as they understood it to have existed in the thirteenth century; for the reintroduction of stained glass to create the appropriate mood; for the reintroduction of the chancel and the altar as the space in which the mystery is enacted; and for the removal of the pulpit from its central significance.

This same movement from the general Gothic spirit to a definite ecclesiological position is paralleled in the United States. The initial interest in the Gothic style had little to do with theological issues. Church buildings, externally Gothic, expressed little of the new Gothic spirit in the inside. Initially in the United States, the Gothic attitude meant embellishment and variety, and represented a matter of preference rather than theological insight.

John Henry Hopkins' *Essay on Gothic Architecture,* first published in the United States in 1836, was obviously influenced by developments in the English scene. It represented neither the most advanced Gothic view of the time, nor the doctrinaire views of the Camden Society. The book grew out of his own problems in finding adequate information for building a church in Pittsburgh. He wrote it with the hope that it would help clergy faced with similar problems. Hence, it has both text and illustrations. Hopkins knew that Gothic architecture was not inspired by forest groves and that it was not an English invention. The grounds for his own Gothic preference centered in the meaning of the structure of the building, not with what happens inside it.

> The distinguishing features of the Gothic style seem to consist in two particulars—the effect of the perpendicular line, and the terminating the various parts in a point. . . . In this . . . we find that all the upper horizontal lines are broken into battlements, while the multiplied perpendicular lines of the buttresses, crowned with pinnacles diminishing to a point, the mullioned windows, and the slender clustered pillars, lead the eye of the beholder upwards; causing, by a kind of physical association, an impression of sublimity more exalted than any other sort of architecture can produce.[18]

Hence, the Gothic style is superior to the Grecian for the church. Indeed, Hopkins recommends the Grecian style for secular purposes and the Gothic for ecclesiastical.

> . . . the Grecian, with its lengthened colonnades and its horizontal extension, running in lines parallel with the ground, seems suited, by its characteristic expression, to secular objects and pursuits. Hence, we should recommend the

> Grecian and Roman architecture for all buildings designed for legislative, judicial, commercial, civic, or merely scientific purposes; but wherever the spiritual interests of our race are to be the primary concern, the elevated sublimity of the Gothic style is far more appropriate.[19]

That viewpoint would have been shocking to the Camden Ecclesiological Society, since it objected to secular society as such. Moreover, the Camden Society, in the light of its liturgical interests, also focused upon the internal needs of buildings, while Hopkins, as we have seen, was interested in the external structure. Hopkins, too, as the Camden Society, is interested in recapturing antiquity and he is not averse to tracing the Gothic style back to Solomon, though not to the forest groves.[20]

Elaborating on the influence of the Bible on the arts, another writer in the *Christian Examiner* suggests that the most significant influence is in the direction of Gothic architecture, for we are "indebted to the religion and spirit of the Bible, probably for the origin, certainly for the perfection and perpetuity, of the most grand and impressive of the architectural order, the Gothic."[21] The familiar claims of pointed vaults and arches being derived from the great oaks is repeated, sublimity is stressed, and the gothic, in its very idea, is "aspiring, spiritual, Godward tending," while it is stated that France, in its atheistic period, tried to supplant the Gothic with the Grecian.[22]

While Hopkins, like the Camden Society, was interested in Gothic architecture, neither he nor the Camden Society was interested in painting and sculpture. Hopkins contended that, since the reading of the Bible belongs to the life of the church, it would seem to him that "the same events might lawfully be presented to the eye by pictures and statues." He further recalled "that statues of cherubim were sculptured all round the Temple of Jerusalem, and that the veil was covered with embroidery." But then he also remembered that "one of the early Councils of the Church expressly forbade pictures in churches," that statuary was opposed, and that "in neither temple nor synagogue was there anything else that could be called picture or statue." So, his conclusion was that

> on the whole . . . I should recommend the adorning the walls of Churches only with the appropriate architectural enrichments, and with judicious edifying selections from the Word of God. These last cannot be too abundant, and should be so disposed, that the wandering eye might be arrested, on every side of the sacred edifice, by some counsel or warning of Divine truth, calculated to enlighten the conscience and to mend the heart.[23]

We have already noted the preference for passages from Scripture on the walls of churches on the part of those who had historic negative memories of Roman Catholicism.

Hopkins was dependent on English sources, and he quotes from Pugin. But he meant his book to be a practical handbook rather than a technical or historical treatise or manual. The interest in what was going on in England was so pronounced that there were Americans who toured English churches. Bishop Doane of Burlington, New Jersey, and the painter Robert W. Weir were among

those who made such a tour. Weir's Gothic church in Highland Falls, New York (Plate 34), was influenced by his discoveries during this trip. Bishop Doane was also responsible for a Gothic church in New Jersey, which was severely criticized by the Camden purists.

The building of Trinity Church (Plate 38) in New York in Neo-Gothic style may serve as an illustration of the Gothic pilgrimage in the United States and its problems. The original Trinity building was traditionally English, with Gothic embellishments. The second building was more distinctly Gothic. It was demolished in turn when the architect, Richard Upjohn, convinced the trustees that the cost of new construction would not be more than the reconstruction of the old. This conclusion also served Upjohn's religious purposes. He stood in the theological tradition which demanded an extended chancel. However, the building was criticized by the Camden group and the New York Ecclesiological Society for not being adequately Gothic. This was ironic, for Upjohn's principles did not permit him to undertake a Unitarian Church for the Federal Street Society, Boston. He wrote that "after having anxiously and prayerfully considered the matter, he had come to the conclusion, that he could not conscientiously furnish a plan for a Unitarian Church, he being an Episcopalian."[24]

The kind of theological viewpoint represented by Upjohn became pervasive among many Episcopalians. At first they associated themselves with the English scene, but gradually they came to the conclusion that the Camden Society was too dictatorial and that the particular needs of the American scene demanded the creation of a separate institution. In 1848, the New York Ecclesiological Society was formed. Phoebe B. Stanton writes,

> Its founders were those clergymen most responsive to the Oxford Movement, architects intent upon and educated in English Gothic revival theories, and laymen of High Church inclinations who possessed an avocational interest in architecture.[25]

In the introduction to the report of the New York Ecclesiological Society for 1851, as well as in other publications, the Society announced its aim to be "to promote the knowledge of church architecture, and matters of ritual," and in order to do this, to collect

> a complete Ecclesiological Library, embracing all the publications of the Societies in England, all the best works on Church Architecture and Church Arrangements, and also those on Decorative Painting and Church Music, as well as any other works that bear on the general subject.

Further, the aims included "to furnish information on questions of Church Architecture and Arrangement, etc., to all that apply to it," and generally to disseminate information through papers and publications.

The presidential address at the third anniversary meeting of the New York Ecclesiological Society, May 12, 1851, provides us with the typical views of the Society. Should religion be addressed mainly to the understanding or to the senses? The obvious conclusion is that religion is

> to sanctify the whole Man; the shallows as well as the depths of his nature, his
> Imagination and his Senses, as well as his Reason and Understanding; and
> having sanctified them, to offer up the whole, a Holocaust on God's Altar, and
> even then acceptable only through the Beloved.[26]

It is apparent that the accent on the senses is more than an addition. It represents an alternative, sacramental view not envisaged in the initial Gothic interest, and one which raised a fresh spectre among Protestants. The members of the Ecclesiological Society felt that the re-emergence of Gothic architecture was nothing less than providential. In the presidential address previously quoted, we read:

> There is something holy as well as touching in this historic rise of Pointed, as
> we may safely term it, Christian architecture. It seems to connect the question
> with the great designs of God's providential government of his Church on
> earth, to note how that, when the fullness of time was come, and Christ's Gos-
> pel was to make of man a new creature, God should have prepared to that end
> a fresh and vigorous branch of the "wild olive tree," taken direct from the
> forest, to bring forth, "when grafted in," the Gospel's choicest fruits.[27]

The myth of the Gothic origins in the forest and in nature is repeated, in this instance to show that it is rooted in creation itself. Gothic architecture is not inherited as were all the other forms—Greek or Roman; it grew directly out of Christian faith. "With them [Greek-Roman], all their Architecture preceded their Religion and was accomodated to it, not an exponent of it."[28] Indeed, the writer of the address does not shrink from seeing Gothic architecture as representing Anglo-Saxon religious and cultural superiority.

> It belongs specifically to the Northern or Gothic race, and in their groves of
> arched and clustered elms we find alike its birthplace, its model, its home.
> Like good seed on a virgin soil, Christian faith brought forth in that native
> race a native Christian Architecture. Contemporaneously with their Creed, it
> grew up, step by step, through all the phases of Lombardic, Norman, Saxon,
> and Gothic forms; the growth of Christian teaching on the heart and intellect
> of a brave, generous, and undegenerated race.[29]

Thus, nativism was expressed both in the domain of religion and architecture.

The Neo-Gothic style was centered in a conception of architectural space with little attention to painting and sculpture, but this attitude changed in the latter part of the nineteenth century. Certainly one of the most persistent voices urging the use of the fine arts in the church was Morgan Dix, high church Episcopalian who was active in the New York Ecclesiological Society. Convinced that painting was an ally of religion, particularly of the Reformed Catholic faith, he addressed the question of its role. First, he deals with the issues raised by the Second Commandments' prohibition of images. Contrasting biblical directions for the construction of the Tabernacle with the prohibition of the second commandment, Dix concludes that "the making of a likeness or image, or visible representation of a specified object in the Creation, is only then prohibited when the said object is to be worshipped and adored,"[30] Positively, argues Dix, "God

sanctioned and sanctified to Himself the Fine Arts, by directing their employ-
ment in the erection of a suitable place of worship, and the arrangement of an
elaborate and imposing ritual system."[31] Aware that the church seemed to have
little art during the first centuries of its life, Dix concludes that the fact is under-
standable in view of the reality that paganism was associated with art in this
early period and that all things look different after the victory of the church in
313 A.D. The ancient liturgy is sacred, but the embellishment and refinements
associated with it differ for various periods of church history. After the early
period, the church could move from the abuse to the use of art in its devotional
life. Concludes Dix,

> The faculties which, through ignorance of the true God, produce the art of
> heathendom, cannot be stifled or eradicated. They are recognized by the wise
> as among the gifts of the Universal Father; and as therefore, owing Him trib-
> ute. Purified and filled with grace, they bring forth, in a helpful and legiti-
> mate production, the form of early Christian art.[32]

Dix believed that we now have enough safeguards for the proper use of art, that
is, knowledge of history, thorough instruction, and a good use of scripture.[33]
Hence, we can move ahead, not being bound by particular views of scripture or
church history, with the assumption that in "the House of God everything ought
to be collected and employed which can contribute to His greater honor, and to
the edification of those who worship there."[34] In that respect, the visual arts have
a kind of pre-eminence, for the mind can get a "clearer idea from one good
picture than it would from a dozen sermons."[35] Hence, the Neo-Gothic style is
completed by the introduction of painting, though it must be stated that its
architectural structure was more congenial to stained glass with its deliberately
subdued light, than to the luminosity suitable for paintings.

The vigorous introduction of the Neo-Gothic architectural style for churches
stemmed from the Tractarian theological and liturgical development. Roman
Catholics, of course, had frequently built in the Neo-Gothic style. But there was
little discussion of the Neo-Gothic as a religious style. The debates delineated in
this chapter are conspicuously absent. It was assumed, rather than debated,
among those Catholics for whom the national inheritance included the Gothic
style. Saint Patrick's Cathedral in New York City, begun in 1858, adapted this
catholic spirit to the building materials at hand.

The Neo-Gothic style caught on in American life beyond the Episcopal and
Roman Catholic churches. The early twentieth century found Baptists, Meth-
odists, and Presbyterians building Neo-Gothic structures, with chancels that had
no basis in their traditions. Riverside Church in New York City is but one of the
more conspicuous examples. The use of English Neo-Gothic in collegiate build-
ings, too, provided a public mind set in favor of the Neo-Gothic. The net result is
that the person on the street who may know nothing about art and architecture
knows that she or he likes Gothic buildings with vines. Such widely held percep-
tions are hard to understand. In part, but only in part, they are the result of

promotional efforts, what I would call one of the successful "con-jobs" of historic conditioning. It is the architects, rather than the populace, who today are moving us away from the Neo-Gothic.[36]

THREE

Nineteenth-Century Art in Private and Public Life

7

Nature and Nature's God

For a long time the association of William Cullen Bryant and Thomas Cole has been known. The painter, Asher B. Durand, painted Bryant and Cole in a Catskill setting and called the composition *Kindred Spirits* (Plate 39). The painting was actually commissioned as a gift to Bryant for having given the eulogy at Cole's funeral. So it is indeed fascinating that the nineteen Cole letters written to Daniel Wadsworth recently discovered at Trinity College, Hartford, Connecticut, were found attached to a copy of the eulogy delivered by Bryant at Cole's funeral.[1] Both events exhibit the identification of the two in the popular mind. Yet I think that the kindred spirits were not Bryant and Cole, but Bryant and the painter, Asher B. Durand.[2]

The issue is essentially whether nature, particularly American nature, is both the source and possibility of an independent, creative future; or whether nature is closely tied to historic events and therefore is in and of itself a false clue to life and to the destinies of a people. The former nineteenth-century viewpoint meant that howling nature had been left behind, and paradise regained seemed possible of attainment. The new, allegedly virgin, land was uncontaminated by the worn-out legacy and historic associations of Europe. Nature had its own momentum, determining meaning, possibilities, and religious attitudes freed of traditional historical associations. That new national feeling, celebrated in art and literature alike, was particularly evident in William Cullen Bryant, who, together with Emerson, called for a new national literature, based in the pure, unspoiled nature of America. That vision was shared by many of the landscape artists, from the Hudson River School painters to Albert Bierstadt.

However, that view was not shared by the artist credited as one of the founders, if not the most prominent painter of the Hudson River School, Thomas Cole. Cole shared neither the optimism of Bryant, nor that of painters such as Durand, Church, Cropsey, and Kensett. Two things made him see the world differently. First, he felt that nature and history were intertwined to such an extent that nature by itself could not carry the freight of humanity's hopes and failures. However great American scenery seemed to be—and he extolled its virtues and delights—it was not enough. Second, Cole's moral and religious conception of the world did not permit the optimistic course of Bryant or Emerson, even when he looked at nature virtually in and of itself, with slight relation to humanity. Already in his teens, and for all of his life, Cole sensed a relation

between the nature he loved and the humanity to which he belonged. While music and poetry provided the link between nature and humanity for many, painting became Cole's major linkage between the two.

Only months after his arrival in Philadelphia from England, Cole went with his roommate from Philadelphia to St. Eustatius in the West Indies. This early visit is of considerable significance, as his writings resulting from this trip provide us with information about Cole's early views of nature and humanity. Though not published until 1825, Cole's novel, *Emma Moreton*, is based on this trip. A mountain in the West Indies that rises directly out of the sea made a tremendous impact upon the young Cole. Neither in England nor in the United States to this point had he seen such a phenomenon, and it led him to reflect in *Emma Moreton* as follows:

> There is a grandeur and sublimity in the work of nature, whether it is sought within the icy bounds of the frigid, or in the melting brightness of the torrid zone. When man in his wandering sees the rocky towers of a mighty mountain springing in awful dignity from the bosom of a wide and unfathomable ocean, he acknowledges the majesty of nature—and when his venturous eye penetrates the gloom of some deep and secluded valley, over whose secret depths the twilight spreads a veil of dim obscurity, he ponders upon the silence and secrecy of her workings. There are spots on this earth, where the sublime and the beautiful are united—when the heart of man feels its own nothingness or rises with the most ecstatic emotions—when the lips are sealed in reverence, but the soul feels unutterably. Such a spot is St. Eustatius.[3]

Here already are all the ingredients found in the work of the mature Cole: the mystery of nature in relation to the silent mystery of humans and the inextricable mixture of the sublime and the beautiful. Cole's melodramatic tale taken as a whole reflects humanity's relation to nature, and a majestic moral sadness pervades the whole. For example, every event in the courtship of Edward Vivian and Emma Moreton is associated with obvious moral conclusions and the reluctant acceptance that that is the way things are. When Emma's father decisively says no to Edward's and Emma's hopes to be married, Cole writes, "Strange as this may seem, of such hardness of heart, mankind are daily witnesses"; of Edward's hopes for Vivian, "But hopes ofttimes grow up in the most scanty soil, only to wither in the noonday drought"; of the death of Emma's mother, "The death of Mrs. Moreton was felt severely by her husband, but the chastisement of heaven only rendered more pungent the effect of the naturally unkind disposition." The inevitable conclusion is that life is a veil of tears:

> A commencement is often bright and sunshiny but as the pilgrim advances cloud and fog darken his path, and the sun which shone so cheeringly when he first started is hid, or only gleams through the darkness, at distant and uncertain intervals.

This is a view of the world which Cole never abandoned, and it is evident throughout his painting career. If one examines *St. John in the Wilderness* (Plate 40) or the *Expulsion of Adam and Eve* (Plate 41), nature is dominant, and

humans, small in size. But the interrelation between the two is inescapable; they participate in each other's life. The sublimity of nature echoes the sublimity of an historic event, or vice versa. In the *St. John*, the scene is not peaceful, and its impact is inescapable. The forceful and threatening aspects of nature match the message of John the Baptist. Nature is ominous as well as peaceful, harbinger of powers both good and evil. In theological terms, one could call this a theology of nature.

While Cole was the critic of much that he found in Europe, his trip impressed him deeply, particularly his Italian experience. He did not find the English scene promising, and he did not care for French art, but Italy was different. He considered the galleries of Florence to be paradise, and the antiquities of Rome impressed him even more than did the great masters of painting. St. Peters did not move him, but the Coliseum and Pantheon did. Raphaels' *Transfiguration*, Domenichino's *Communion of St. Jerome*, Caravaggio's *Entombment*, and Michelangelo's *Moses* he considered to be the greatest works of the past. He thought Salvator Rosa to be "the greatest of all landscape painters."

In Italian art he saw a high regard for the beauty of nature, and that the beauty of nature impressed and informed Italian artists. They did not, he said, sit down, as the modern artist too often does, "with a preconceived notion of what is or ought to be beautiful. . . . They loved the beauty which they saw around them, and painted."[4] Their proper regard for beauty pushed every theory of the beautiful aside.

More importantly, Italy impressed upon him the ancient and historic associations of humans and nature. In his previous American work, nature and the human were indeed correlative; but his American experience had been loaded on the side of a new humanity and a *new* nature. In Italy, however, he realized that triumphs and defeats, rises and falls, strengths and weaknesses alike characterize humanity's existence, and might be true of the American experience as well as of previous civilizations. Historic associations now took on a new prominence in Cole's work.

Cole was fascinated by ruins and decay. The Italian landscape, strewn with classical fragments, had for him a paradoxical, eschatological character, marking both the travail of life and the peace that comes after struggle. Both seemed fated and inextricably bound. For Cole, the vitalities of nature are generally double-edged. Sometimes these occur within a single painting, as in the *Expulsion of Adam and Eve* (Plate 41), exhibiting alike the peace and violence of nature, or by a series such as *The Course of Empire* (New York Historical Society) and *The Voyage of Life* (National Gallery of Art, Washington, and Munson-Williams-Proctor Institute, Utica) or by a series of one-to-one antitheses, such as *The Past* and *The Present* (Amherst), *The Departure* and *The Return* (Cororan). When the context justifies it, however, the peaceful aspects of nature are predominant. *The Garden of Eden* (ca. 1828, unlocated), known by a print and described by Cole, is luxuriant and free of nature's threats.[5] *The Subsiding of the Waters of the Deluge* (Plate 42), painted in 1829, conveys a scene in

which the rains have stopped and the water is peaceful with mountain peaks protruding. The ark is in the foreground, but more prominently, the sun is rising and light radiates throughout. It is like a hopeful new beginning. Similarly, though not totally so, is Cole's largest painting, the *Angel Appearing to the Shepherds* (Plate 43). The peaceful is dominant, obviously in accord with the fundamental message. On the left is the angel, appearing light in a dark setting; on the right, a bright star; and the shepherds in the lower center.[6]

The Course of Empire (Plate 44), commissioned in 1834 by Luman Reed, consists of five paintings depicting the course of humanity in integral relation to nature. Cole was impressed by the beauty of unspoiled nature and he mourned the changes wrought by the axe and the railroad on the American scene. *The Course of Empire*, reflecting what he learned in Europe, suggests a cyclical pattern that affects humans as well as nature adversely. Cole himself wrote, as he contemplated doing the series:

> A series of pictures might be painted that should illustrate the history of a natural scene, as well as be an epitome of Man,—showing the natural changes of landscape, and those effected by man in his progress from barbarism to civilization—to luxury—to the vicious state, or state of destruction—and to the state of ruin and desolation.[7]

The completed paintings include: (1) A Wilderness Day Emerging With the Savage State of Man; (2) A Pastoral State: The Day Well Begun With Peasants, Flocks, and Village; (3) A Great City: Noonday With Humanity Exhibiting All the Accoutrements of Civilization; (4) A Tempest, A Battle, and A Burning of the City; (5) A Desolate Place, Ruins, No Human Figures. While the paintings convey the change in nature as well as the human state, the same solitary mountain in each painting conveys to us that the changes take place in the same geographical area.

This is not the optimistic theology of nature conveyed in Bryant or Emerson. In Cole's next series, *The Voyage of Life*,[8] ranging from childhood through youth and manhood to old age, the personal pilgrimage is given meaning through a natural, though troublesome, passage to an immortal destiny, envisaged as the end of humanity's journey. In the meantime, a guardian angel who acts as guiding spirit hovers near, accompanying the pilgrim on earth's journey. The first painting, *Childhood* (Plate 45), like the first in *The Course of Empire*, has a rising sun; nature is pristine here, too, analogous to the infant in the boat, piloted on the stream by an angelic form. In *Youth* (Plate 46), the guardian angel is now on the bank of the stream, for the youth guides the boat himself while gazing expectantly at a vision of celestial architecture and luxurious nature. In *Manhood* (Plate 47), the apogee of hope has been passed, the rudder of the boat is gone, and the man looks toward heaven, as if imploring help, while the guardian angel now sits on the clouds. Nature is now ominous, the precipices abound, and the water is turbulent. In *Old Age* (Plate 48), nature is quiescent. The guardian angel has taken over and the man gazes toward an opening in the

clouds where a light glows and angels seem ready to welcome the traveler, who no longer has an interest in the things of the earth.

The idea of the stages of life's journey was, of course, not newly minted by Cole. In American folk art of the twenties and thirties of the nineteenth century, the pilgrimage was spelled out by depicting humans, sometimes woman alone, sometimes man alone, and sometimes both, in a pyramid arrangement, the center of which is life at its maturity. The figures are usually surrounded by events in life's pilgrimage, such as baptism (christening), marriage (marrying), death (dying), burial (burying). In mood they are not dissimilar to the many mourning pictures, which sometimes have a picture of the mourner or the mourned in a setting of nature with cemetery and chapel-like building. These pictures are somber reminders of the grim pilgrimage of life. By contrast, Cole's series ends on an optimistic note, the confident hope of glory at the end of life's journey.[9]

The Course of Empire depicts a social historical drama, the end of which is desolation. *The Voyage of Life* depicts the personal journey of humanity in which the historical hopes are no greater than in *The Course of Empire*, but in which there is a generalized hope of immortality at the end. Humanity can be glad and hopeful, for the natural end is immortality, that is, being welcomed to life in another realm. Theologically, this is known as a theology of glory, a destiny unrelated to the struggles and decisions of humanity, but rather as the natural outcome of humanity's journey.

The Voyage of Life series, made readily available through James Smilie's engraved copies of the paintings, was promoted by artists and clergy alike because of their high moral and Christian content. But Cole himself, while never departing from the moral stance of his previous work, became more explicit about his theological views. His painting must more directly reflect his Christain views. In that respect, Noble may be correct in what he sensed to be Cole's conversion.[10]

In most of the explicitly Christian paintings, the cross enters as the central organizing emblem. But in the instance of *Angels Ministering to Christ after the Temptation* (Plate 49), the Christ figure is now central. While originally a large painting with the tempter visible in a mountainous setting, Cole himself cut that part away. Whether that was because the painting, as executed, would not fit over the mantel in Cole's house, or because a friend suggested that the vast landscape made the figures appear as an accessory, it is doubtful that Cole would have cut the painting prior to his particular Christian sensibilities.

The emblem of the cross appears almost as a centering device in a sketch, probably in 1845, now in the National Gallery, and in the finished round painting, *Cross in the Wilderness*, now in the Louvre. Based on a poem by Felicia Hemans, the sketch and painting disclose a rather thick, low cross and a figure, both in the foreground, but both set in an expanse of nature. Another painting with the cross at the right, a ruin at the left, with mountains in the distance and streams of light above them, has been designated the *Cross at Sunset* (Thyssen-Bornemisza Collection) by Ellwood C. Parry III.

But Cole's most ambitious attempt to create an art of explicitly Christian subject matter was *The Cross and the World* series (Plates 50–52), begun in 1846, but uncompleted at his death. In this series, there is no natural destiny for the soul of man; rather, destiny depends on making choices and decisions. In Cole's first phase, when he painted *St. John*, and the *Expulsion*, nature and humans are glorious and ambiguous; in the second, humanity has a natural destiny beyond this world, as in *The Voyage of Life*. But in the third phase, man confronts either-or choices: either one lives in the discipline of the cross, or one forfeits initial grace by following the allurements of the world. As a result, Cole needed to change from a series of events in which the movement was from beginning to end, as in *The Course of Empire* and *The Voyage of Life*, to one in which choices and alternatives were paramount. Hence, in *The Cross and the World* series, one painting (Plate 50), apparently a center one, according to his own sketch (Detroit Institute of Arts), anchors the two alternatives, while a series of two on each side of the center one discloses the respective paths of the pilgrim of the cross and the pilgrim of the world. In one sense, Cole had already used that format in his proposed hanging scheme for *The Course of Empire* (Plate 44), where the central and larger painting on the *Consummation of Empire* was to hang over Luman Reed's mantel, with two each over each other on the side of the mantel. As Ellwood C. Parry III has pointed out, this scheme unifies the whole, light coming from the appropriate directions. Apparently, too, above these paintings were to be three paintings, sunrise, noonday,and sunset, "as a kind of celestial commentary or gloss, enclosing the rise and fall of an ancient seaport civilization within the classic dramatic unity of a single day."[11]

But if the hanging format is similar, the effect is different. In the one, one sees the rise and fall; in the other, alternative choices which we cannot escape. The proposed paintings were: the center one, *Two Youths Enter Upon a Pilgrimage, One to the Cross, the Other to the World* (Plate 50); to the left, *The Pilgrim of the Cross on His Journey*; to the right, *The Pilgrim of the World on His Journey* (Plate 51); and, *The Pilgrim of the Cross at the End of His Journey* (Plate 52); and, *The Pilgrim of the World at the End of His Journey*.[12]

The first sketch, *Two Youths Enter Upon a Pilgrimage*, is reminiscent of the *Expulsion from the Garden of Eden*, inasmuch as the same painting shows both the peaceful and terrifying aspects of nature. But in this sketch they are related not to one pair of figures, Adam and Eve, but to two individuals, each of which has a choice. The Evangelist, with open Gospel, urges both on the right course.

The Pilgrim of the Cross sets out toward the left of the painting, uphill against cragged mountains and obstacles with the cross in view in the distance. The Pilgrim of the World, however, in spite of the urging of the Evangelist, sets out toward the right through a valley that is alluring and full of vistas of opulence and ease. The Pilgrim of the Cross valiantly fights his battle with nature and, by implication, with history, while the Pilgrim of the World forfeits what has been given him by succumbing to allurements and the pleasures which the world provides.

This painting is the centerpiece, around which are arranged, on the one side, the two additional episodes of *The Pilgrim of the Cross* and on the other, *The Pilgrim of the World*. *The Pilgrim of the World* is eventually defeated, the vision of the cross finally fleeing from his sight, while *The Pilgrim of the Cross* safely ends his journey in clear sight of the cross. In *The Pilgrim of the Cross at the End of His Journey*, the pilgrim has overcome the last obstacles of nature and is met by angelic hosts; but more particularly he is in sight of the cross, the prize which he has sought. The major difference between the last painting in the series of *The Voyage of Life: Old Age*, and *The Pilgrim of the Cross at the End of His Journey* is that in the former one has the angelic vision; in the latter, one has the cross.

Cole's works belong to a didactic, moral, religious view of the world, far from the sensibilities of our own time. Hence, issues of the quality of his art and our lack of sympathy with his outlook intertwine, making it difficult to make just assessments. Nevertheless, one can say that the more specifically religious he became, the more difficulty he had finding adequate and appropriate artistic expression. Surely, the conclusion is not that religious orientations create undue difficulties for art. For Cole, it was rather that his particular religious sensibilities and thoughts became confining, rather than emancipating. As a result, he could not transform his newly-appropriated traditional religious vision into new artistic possibilities. At best, his painting is illustrative of what he believed but what he could not religiously or artistically transform.[13]

A more optimistic religious view of the world is expressed in the developing American landscape tradition of which Asher B. Durand, friend of both Cole and Bryant, is an early representative figure. Initially, Durand was an engraver, and among his early paintings were religious subjects belonging to the standard repertoire.[14] His own religious views were unorthodox in the sense of being unrelated to the church in scope or practice. His was a religious outlook deeply associated with nature, a kind of mild nature pantheism. In his journal written in 1840 en route by sea to England, one finds this entry:

> Today again is Sunday. I do not attend the church service, the better to indulge reflection unrestrained under the high canopy of heaven, amidst the expanse of waters. This mode of passing the Sabbath became habitual with me in early life—then 'midst other scenes than here, it is true; yet if more conso- nant with my feelings (as the world of the woods, plains, and mountains ever is), certainly not less impressive.[15]

But if he usually did not attend church or associate himself with a religious denomination, he did not reject revelation. In his *Letters on Landscape Paint- ing*, nature is "only surpassed by the light of Revelation."[16] The statement is undoubtedly more than cant, but what revelation meant to him in disassociation from a religious body is not clear.

Like other artists, too, Durand made the pilgrimage to Europe, though in his case, it was at the relatively advanced age of forty-four. He went to England,

Paris, Switzerland, and Italy, spending the winter of 1840–41 mainly in Rome. Much, of course, impressed him, and he did sketches both of old master paintings and of the countryside, which sketches he later turned into paintings. But of those artists who went to Europe, he was least enamoured by what he saw. Even the paintings of the landscape artist Claude Lorrain did not meet his expectations, and he wrote back that the rocks, trees, and great meadows of Hoboken (New Jersey) had a charm not even Switzerland could boast. Such judgments tell us less of Durand's critical eye than of his confirmed disposition toward, and preference for, the American landscape. From boyhood on, nature had held a fascination for him, a place for restoring the soul, for meditation, and for feeling at home in the world. By the time he went to Europe, the art of landscape painting was for him a major, consciously-held program to be carried out without deflection. Had he gone to Europe before this self-conscious aim, he might, as he wrote, "have become a painter—but not of landscapes!"[17] For him, European landscape painting did not have the excellence which he acknowledged in other categories of continental painting. He wrote to Thomas Cole,

> But the result of my observations thus far is the conviction that the glorious field of landscape-painting has never yet been so successfully, so fully cultivated, not even by Claude, as have other branches of art depicting the action and passions of men.[18]

While some of the paintings done upon Durand's return to the States reflected what he had seen and the sketches that he had made in Europe, Durand soon centered all his energies in painting the American landscape. Indeed, Bryant, who was interested in having American artists devoting themselves to American scenery rather than the European tradition, had in Durand rather than Cole his exemplar.

Durand's views on landscape painting were written for *The Crayon* in 1855, at the invitation of its then joint editor, Durand's son, John. The *Letters on Landscape Painting*[19] do provide both his views of Nature and of Art. Nor can there be any doubt that for Durand, art had a religious character. Art and gain do not mix, indeed, seem alien to each other, wrote Durand, so that we have no choice but to serve God or Mammon.

> And it is only through the religious integrity of motive by which all real Artists have ever been actuated, that it [art] still preserves its original purity, impressing the mind through the visible forms of material beauty, with a deep sense of the invisible and immaterial, for which end all this world's beauty and significance, beyond the few requirements of our animal nature, seems to be expressly given.[20]

Moreover, Durand added, great art has always subordinated "the more sensuous qualities with which material beauty is invested,"[21] but it is by sense that art conveys what is not sensual. The aim of the artist must be to use sense wisely, so that the means do not become ends. Durand illustrates this problem in writing of the work of Raphael.[22] Too many artists have tried to add to reality by the use

of the sensuous. Reality is disclosed by the appropriate use of the sensual. Genuine art is true to nature, neither overdone nor contaminated.

Durand had a passion to see nature unalloyed, either by humans or by human conceptions of what nature portends. For him his landscape paintings depict quintessential nature standing before us independent of humans.

> When I asserted . . . that the great landscape is always representative of nature, and that it owes its greatness primarily to this fact, it was on the ground previously assumed, that the true province of Landscape Art is the representation of the work of God in the visible creation, independent of man, or not dependent on human action, further than as an accessory or an auxiliary.[23]

Nature is a direct mirror of God, and art a special agent of disclosure, but that disclosure must be true to nature (Plate 53). Once the elementary rudiments of art are known, the Studio of Nature, not the Studio of Men, is to teach us. Concentration on the work and techniques of the painters of the past leads to mannerism, that is, being influenced by works of art rather than by nature as the source of art. But to follow nature rather than the old masters still required training as an artist. Durand incessantly stressed practice and discipline, to the end that the competence of the artist should become so great that it was hidden in the grandeur of the painting itself. True training meant the representation, not the imitation, of nature.

The representation of nature also meant that the picturesque had to be abandoned. The picturesque was not how nature presented itself, but how humans thought nature should present itself, to the point of "giving preference to scenes in which man supplants his Creator."[24] In the picturesque, we possess nature; in a true painting, it is we who are possessed and drawn into its orbit and atmosphere. True landscape painting represents nature in that role.

By truth to nature, Durand did not mean true in the sense of a literal detailing of nature. The expression, "truth to nature," used extensively by Durand, reminds one of John Ruskin. One of the aims of *The Crayon* had been the promotion of Ruskin's views, and it is likely that Durand knew Ruskin's ideas and had read his writings. Nevertheless, Durand's views of nature were certainly not formed by Ruskin. His views of nature antedated Ruskin and were independently formed. Ruskin was confirmatory of what Durand already declared to be true.

Durand rejected the oft-debated alternatives of idealism and realism, the former being too removed from the realities of nature and the latter too imitative. The ideal was found in the actual world of nature; that real world that the artist depicted was not a copy of nature, but a vision based on its truth. The painter must select from nature; its beauty and harmony can be more directly conveyed in a painting than nature unedited permits. Selectivity is the task of the artist. Durand assumed that selectivity would never distort nature but be truthful to it; selectivity was predicated on exhibiting the beauty of nature, and

therefore of nature's God, more readily and more immediately than did nature to the untutored eye. The true artist had distilled the truth of nature for a painting. A true landscape was a shortcut to the essence of nature.

Still another religious view of nature occurs in Frederic E. Church's paintings, what one might call a majestic mode of painting nature. As a student of Cole, Church did some early religious subjects—*Moses Viewing the Promised Land*; *The Deluge*; and scenes from *Pilgrim's Progress*—but moved on to his own unique perception and style of painting nature. Like Cole and Durand, painting nature was not an exercise in depicitng what the eye obviously saw. For Church, the task was to paint nature as he thought it to be, the vehicle or book by which God's awful creative power was discerned, sometimes in itself and possibly on occasion also as an analogue to God's role in historical events. In any case, the lineaments of his Congregational Puritan heritage brought a somber, though still vibrant, cast to his painting, whether he is dealing with waterfalls, volcanos, or icebergs. Louis Legrand Noble sensed this in his trip to the North Atlantic with Church in 1859, when he found it all like a vision of St. John, a transfigured realtiy.

But this is as Noble and others viewed Church. Church himself used the words *strange, supernatural*, but not the traditional religious language. That he understood his work as religious or even in a Christian sense need not be doubted. But some of his contemporaries saw more of the American religious drama in his paintings than we see today, or for that matter, than Church may have intended.[25]

Church had picked grand, exotic nature (Plate 54). Grandness was increasingly accented as the Western Rockies and the Sierras entered American consciousness. The Eastern Mountains and valleys, or the gentle Trenton Falls of upper New York, visited by most European travelers and painted by American artists in mid-century, were replaced in travel and in art by the Rockies and the Sierras. The Western scale is vast and impressive, as everyone experiences who travels back and forth between east and west. Such nature painting was not a return to the grand sublime of the eighteenth and nineteenth centuries; it was instead focused on the literal grandeur of God's handiwork in nature that seems to make humankind insignificant when viewed only from the scale of nature (Plate 55).

From Thomas Cole to Albert Bierstadt, the play of light and dark, whatever the color, is a major device for disclosing the majestic, whether of God or nature or both. In the case of Cole, angelic messengers, and later the cross, are found in the area of light. In the painters after Cole, the tradition of light stands without props or aids, utilizing the background of a fairly traditional history. For the most part, light conveys the grandeur of a positive force or reality, a sign frequently of another reality. Among a few painters in the third quarter of the nineteenth century, particularly John F. Kensett, Martin Johnson Heade, Fitz Hugh Lane and Sanford Gifford, a particular use of light is central to the painting. Hence, they have been called the Luminists. Barbara Novak states that "luminous light tends to be cool, not

hot, hard not soft, palpable rather than fluid, planar rather than atmospherically diffuse. Luminist light (Plate 56) radiates, gleams, and suffuses on a different frequency than atmospheric light."[26]

If there may be said to be a suggestion of transcendence, frequently related to the sublime, in the work of Cole or Church, immanence is the key religious category for the luminists. If there is a counterpoint in art to Emerson's religious/philosophical views, it surely centers in the luminists. One sees through to a presence, and Emerson's eyeball is an apt metaphor.

A totally different use of light, suffusion rather than clarity, is evident in the work of George Inness. For Inness, it was the softening of contours and the blurring of details which showed underlying structures that directly mirrored the divine, as in *September Afternoon* (Plate 57). This indistinctness of form is particularly true of Inness's late landscapes, painted when he was influenced by Swedenborgian ideas. Coming from a Baptist and a Methodist background, Inness temporarily became a Baptist; but when hellfire was vividly preached by the Baptists, he forsook the traditional historic faith and became interested in Swedenborg, largely through the influence of his neighbor, the painter William Page. Inness continued to be interested in theology, but his new faith had no liturgical or worship form. He was a friend of the Swedenborgian minister, J. C. Ager, and of Brooklyn's famous preacher, Henry Ward Beecher.[27]

It would, however, be a mistake to overstress the Swedenborgian influence on his painting. It reinforced, rather than determined, his view of the role of the artist in painting nature. More accurately, Inness can be called a nature mystic, one who painted nature as he saw it, not realistically, but in terms of the way in which it gave itself to be seen, with its transworldly, spiritual aspects visibly present.

Given his painting style, some called Inness an Impressionist. However, for Inness, impressions represent the total linkage between the artist and the nature he conveys, and are not to be confused with Impressionism, which he considered to be a technical, rather than a spiritual, rendering of nature.

For Inness, art is a perception in which an appeal is made to the mind through the senses. Like theology, it is a way of seeing a world whole. It is therefore not the same as the moral or the scientific, though it may give rise to both. It is certainly more than either and therefore neither to be derived from, nor interpreted by, the moral or the scientific. The senses and their accompanying passions are not to be denied. They are primordial. We must learn how to use them, lest they overflow in all the wrong directions.[28]

It is ironic that Inness did only a few religious subjects, though he talked about theology and God incessantly. Among his religious subjects is *The Valley of the Shadow of Death* (Plate 58), in which explicit Christian subject matter, the Cross, is combined with his particular rendering of nature. Nature was a reality, which when properly seen, expressed religious dimensions in this-worldly form. That reality was to be conveyed by the artist.

In spite of the diversity, a religious view of nature is intended by the artists

we have discussed. How much of that is particularly American is an issue for debate. Many of the artists did think American nature was unique, but probably less so than the literary figures of the time. These particular artists, largely Eastern and living in the ambiance of a new national consciousness and during a time the nation was being torn apart by Civil War, did share in the feeling of the special destiny of this nation. Such perceptions made both nature and history appear special, purposeful, as if God had saved this nation for this time. Perhaps, it was felt, nature and history both moved from East to West. How much the artists consciously share such views is ambiguous with respect to the landscape artists. But there were artists who combined nature and history in a self-conscious way, namely, in the expressions of civil religion to which we now turn.

8

Civil Religion in the Visual Arts[1]

The consciousness of the new nation cried out for symbolic expression. The concern for a national literature and the celebration of the new land in landscape painting has been commented on. But the symbolic celebration of the new country in terms of its political experiment found no new symbols, since it was largely dependent on the inherited tradition of Europe, about which the nation was ambiguous. The schizophrenia is evident in that the institutional forms of the new nation were conceived to be unique, developed over against a decaying Europe; but simultaneously it was felt that no Americans, for example, were competent to do the sculptural work for the nation's new Capitol building.

When the State of Virginia wished to honor George Washington in 1784 for his role in the War of Independence, Jefferson and Franklin were consulted on a sculptural commission and they recommended the Frenchman, Jean-Antoine Houdon, whose life-mask of Washington was used for the features of Washington in the early statues. While it was true at the time of Houdon's sculpture of George Washington, still to be seen in the Rotunda of the Capitol building in Virginia, that no competent marble workers were to be found in the Colonies, the declaration continued long after the facts so warranted. In connection with selecting artists for the Rotunda of the nation's Capitol, former President John Quincy Adams "expressed a doubt whether four native artists could be found who were fully competent to the execution of the task to be assigned to them."[2] American artists were naturally incensed at such statements, and an anonymous article in the New York *Evening Post* provided an able but indignant reply, which was attributed to Samuel F. B. Morse mainly because of Morse's facile, sarcastic pen and because he was identified, partly through the National Academy, which he headed, as the promoter of American art and artists. All too late it was discovered that James Fenimore Cooper had written the reply and that Morse had not seen the Adams resolution. As a consequence of this confusion, Morse did not receive a commission and was so dissappointed that he gradually withdrew from the profession of art. Actually, Adams, who had sounded off on the issue, had little interest in art. In her book on William Morris Hunt, Mary Helen Knowlton reports:

> President John Quincy Adams once asserted that he "would not give fifty cents
> for all the works of Phidias or Praxiteles," adding that he "hoped that America

would not think of sculpture for two centuries to come." On hearing of this, Hunt dryly inquired: "Does that sum of money really represent Mr. Adams' estimate of the sculpture of those artists, or the value which he placed on fifty cents?"[3]

Such schizophrenia was also evident on the role of religion in the understanding of the nation. Religion had played a large role in the history of the settlements of the new country and, in many instances, in the Revolution itself. In the new nation, however, no religious establishment or preference was permitted. This had the result of encouraging private associations of religion for the sake of a positive, public, political ethos, while denying the legitimacy of national symbols expressed in terms of a concrete religious tradition. It encouraged a religious spirit, but not a specific religion. Given the competing claims for allegiance and dominance among religious bodies, no other solution may have been possible. Such disassociation between the religious spirit and institutions of religion led to the schizophrenic situation in which there was an uneasiness between proponent and opponent alike about the role of religion in national life. The issue did not arise when the subject matter was that of depicting actual historical events in the American drama, as, for example, in the case of John Trumbull, whose *Declaration of Independence* (Plate 59) was extensively circulated through an engraving by Asher B. Durand. Moreover, four of his major renderings of the Revolution were painted in enlarged versions and placed in the Rotunda of the United States Capitol, where they can still be seen.[4]

The issue surfaced in connection with a plan for Washington Allston to do a painting for the rotunda of the new Capitol. Gulian Verplanck, Chairman of the Committee of the House of Representatives on Public Buildings, obtained an order from Congress for Allston to paint two of the panels. But Allston had difficulties with the request, for he doubted that he could meet the stipulation, namely that the subject matter be "limited to American history." He stated that he was second to none in love for his country and for what it stands, yet he maintained that battles or the history of the country were not, as such, matters for "high art." Allston implied that only a subject which moved his very being would justify his undertaking such a demanding and significant project. But he immediately added that he would love to do something from Scripture but feared that this was not possible. Then he added, why should it be a forlorn hope; "This is a Christian land, and the Scriptures belong to no country, but to man. . . . Should the Government allow me to select a subject from them, I need not say with what delight I should accept a commission." In his own mind, he already thought of the "Three Marys at the Tomb," and Gerdts points out that the Belshazzar theme might also have been a possible subject in Allston's own mind, since the size was exactly right. Verplanck replied on March 9, 1830, suggesting that he is convinced that there should be at least "one specimen of high art," implying that that is what Allston would produce. He immediately added,

By American history mere revolutionary history is not meant. To Scripture I fear we cannot go in the present state of the public opinion and taste. But does

our ante-revolutionary history present no subject? The "Landing of the Pilgrims," a threadbare subject in some respects, has never been viewed with a poet's and painter's eye. What think you of that, or of any similar subject in our early history?[5]

In a reply about three weeks later, Allston turned down the "Landing of the Pilgrims" and also rejected a proposed subject of the "Leave-taking of Washington," but then added that he could think of another in which he might be interested, "'The First Interview of Columbus with Ferdinand and Isabella' at court after the discovery of America, accompanied by natives, and so forth, exhibited in evidence of his success."[6] Allston immediately added that the story was found in Washington Irving and would therefore also introduce an American subject; but then he asked, "Could not a commission also be given to Vanderlyn?" and in the next paragraph he also adds the names of Morse and Sully. Two months later, Verplanck replied that under other pressing business before Congress, the matter of the painting had not yet been considered. In February, 1832, Verplanck wrote that Vanderlyn had been commissioned to do a painting for the Rotunda and that Allston's friend Horatio Greenough had been given an order for "a pedestrian marble statue of Washington, limiting him only to the Houdon face."[7] In later correspondence with his friend Leonard Jarvis, a former college classmate who was now a member of Congress, Allston had to defend Greenough's right to do the Washington statue as he saw fit, even though Allston himself said he would not have chosen to represent Washington with raised hand nor with bare chest.

In 1836, the Rotunda request to Allston was renewed. In the light of his commitments to completing the Belshazzar painting (see pages 136ff.), he decided that he could not accept the offer. Whatever the theories about art and the nation, it is doubtful that Allston's "Three Marys" would have been appropriate, unless one declares that in great art, the subject matter is irrelevant, even when one is concerned with national symbols. Religious subject matter was, however, considered appropriate when it dealt with the life of the nation, as, for example, John Gadsby Chapman's *Baptism of Pocahontas* and Robert W. Weir's *Embarkation of the Pilgrims*.

John Gadsby Chapman, known for his melodramatic religious paintings, his more than 1400 book illustrations for *Harper's Illuminated Bible*, and for his *American Drawing Books*, actively campaigned for a commission for the Capitol Rotunda. Between 1837 and 1840, he executed the *Baptism of Pocahontas* (Plate 60). A document published at the time of its unveiling is explicit about its religious significance. No one, says the writer, can look at our history and to the writings and documents contemporaneous with the event, and not be impressed that the "sincere and fervent desire to propagate the blessings of Christianity among the heathen savages mingled deeply with the alloy of more worldly considerations."[8] Pocahontas, it was said, was the first benefactress of that mission. Her baptism was thus a momentous event, anticipated and now made real. Captain Smith refers to Pocahontas on the cover of a pamphlet of the *Baptism*

of Pocahontas as the "first Christian ever of that nation," and the Reverend Alexander Whitaker stated, "She ultimately renounced her country, idolatry, professed the faith of Jesus Christ and was baptised." Hence, the pamphlet can and does state:

> She stands foremost in the train of those wandering children of the forest who have at different times—few, indeed and far between—been snatched from the fangs of the barbarous idolatry, to become lambs in the fold of the Divine Shepherd. She therefore appeals to our religious as well as our patriotic sympathies, and is equally associated with the rise and progress of the Christian church, as with the political destinies of the United States.[9]

This glorious beginning of the nation, it was felt, had been purveyed by Chapman, to the point of being faithful in every detail, as, for example, the closed *Book of Common Prayer*, since at that time the Book did not include a service of baptism for adult converts.

But the painting was criticized. The Indian figure did not meet the standards of the ideal in art. More important, some did not consider the religious subject to be appropriate for a national painting. A writer, who feigns to have no religious orientation himself, vigorously replied:

> The first barbarian brought to the knowledge of the living God! . . . I am far from being a religious man; but my nature is bowed down when that consecrated scene is presented to me. I see that through the lapse of time the rude old church of Jamestown—the soldiers on guard—the graceful Indians wandering beyond their nature—the solemn nights, the pious governor, all assembled to witness a scene that God Himself, turning from the rotten pomp of the Old World, must have blessed with His peculiar notice. Thus, she knelt before Whitaker, the clergyman, and God's eye was upon that small band.[10]

The theme of the Indians being awakened to Christianity was also executed in marble, though not as a national commission. In 1854, Erastus Dow Palmer completed the full-length sculpture, *Indian Girl*, or *Dawn of Christianity* (Plate 61). The half nude, thus allegedly innocent Indian, has just discovered a cross, upon which she is gazing. Wrote Henry Tuckerman in a passage that both gives the context for the sculpture and the piety of the time:

> An aboriginal maiden is supposed to be wandering in the forest in search of stray feathers to decorate her person, when she discovers one of the little crosses placed here and there in the wilderness, by the early missionaries, as symbols of the faith to which they endeavored to convert the savage tribes. As she looks upon the hallowed emblem, the divine story of Jesus recurs to her mind, and awakens emotions of awe and tenderness; the religious sentiment thus accidently aroused, lures her into a reverie; the crucifix is held before her downcast eyes in the palm of her hand. It is a single figure, but it tells a comprehensive story—the dawn of Christianity upon savage life—the first glimmer of divine truth upon an untamed and ignorant, but thoroughly human soul.[11]

In 1877, Joseph Mozier returned to the Pocahontas theme in his sculpture of

that title, in which Pocahontas has discovered a cross as she wandered in the wilderness accompanied by a deer.[12]

In 1857, Erastus Dow Palmer also had proposed a sculptural group for the pediment of the House Wing of the capitol on the landing of the Pilgrims at Plymouth. The proposal was rejected because the topic was considered to be of local interest, thus not a truly national subject. Approximately two decades previously, Robert W. Weir (as well as Chapman, John Vanderlyn, and Henry Inman) was commissioned to do a painting for the Rotunda of the Capitol, and at that time, the *Embarkation of the Pilgrims from Delft* (Plate 62), completed 1843, had neither the question of provincialism nor religion raised against it. It was considered an historic episode of the American nation. Weir, pursuing his studies for the picture, became more religious as a result of his research, and he was confirmed and became, not a descendent of the Puritans, but an active Episcopalian.

There was, of course, much art which did not directly raise religious issues, as the commemoration of the Revolution in the Rotunda paintings by John Trumbull, or *Armed Freedom*, by Crawford, on top of the Capitol dome, or the figures in Sculpture Hall. Sculpture Hall was originally the old House of Representatives, which was so vividly painted by S. F. B. Morse.[13]

The numerous representations of Washington are in this category as well; the fascination with Washington held two elements in uneasy tension, his concrete humanity and his symbolic role as father of his country. That double conception was deep in the psyche of Americans.

Washington was at once a person of means and station, who yet preached the democratic impulses and processes. His virtues, modesty and general democratic tendencies, were prized; but as the first person of the new independent nation, deifying tendencies could not be avoided. Hence, paintings and prints began to draw the traditional conclusion, depicted in *The Apotheosis of Washington*, as in Constantino Brumidi's painting at the eye of the Capitol dome.[14] Indeed, Americans generally and the artists in particular experienced a double pull, the humanity of the man and the religious, symbolic figure of the leader. Painters generally seem to convey one or the other aspect. Portraits by Stuart and the Peales, to mention only a few of the prominent artists, essentially glorify the human figure, showing him in full military regalia. The religious aspect was foremost in the apotheosis theme paintings. Sculptors, on the other hand, seemed to encompass nuances of meaning. For the important commissions, Washington is generally shown neither as a leader in battle nor in the form of a portrait bust. Some of the commissions were for equestrian groups, showing Washington as a leader without reference to concrete situations. Henry Kirke Brown's equestrian *Washington* (1856, Union Square, New York City) was enthusiastically received. Thomas Crawford's *Washington*, erected in 1858 on the capital grounds of Richmond, Virginia, shows Washington confidently pointing to the future while the horse stands somewhat uneasily on its high base.

Two early sculptural versions of a seated Washington were intended as presiding symbolic figures under the domes of two capitols, that at Raleigh,

North Carolina, and the national capital, Washington, D.C. In 1821, Canova's seated *Washington* (Plate 63) was installed under the capitol dome in Raleigh, North Carolina. The face was modelled after a bust of Washington by Ceracchi, and the apparel was that of a Roman general with a Roman toga, sandalled feet, and Roman hair style. He gazes at a tablet held in the left hand and quill in the right. In spite of protests that it bore no resemblance to the real Washington, it remained in its location until 1831, when it was destroyed by fire, and in 1971, it was remade and installed again.

The most extensive criticism however was reserved for Horatio Greenough's *Washington* (Plate 64), designed for the United States Capitol building. Greenough depicted Washington seated in a chair, right arm pointing upward, left arm extended holding a sword with the handle extended toward us, feet sandalled, toga fully covering his legs, but his body naked from the navel up, except for a draped cloth hanging on his right arm between elbow and armpit.

Greenough had spent more than three years in the creation of the sculpture, which was placed in the Rotunda in 1841. He looked upon the commission as the opportunity for an American artist, using his best talent and ideas, to show the meaning of Washington and the nation and, in the process, to successfully wed art and the country. For those who knew the European tradition of art and for most of his fellow artists, Greenough accomplished precisely that. But for the public at large, including congressional critics, the statue was a disgraceful creation, and was mercilessly ridiculed and criticized. Situated today in the low-ceilinged National Museum of American History, it is now largely ignored.[15]

The sculptural conception tells us much about art and the nation at the time. We know that Greenough had the fifth century B.C. Athenian sculptor Phidias in mind. Phidias had supervised the carving of the sculptures of the Parthenon and had been responsible for the most revered but lost statue of the Greek god Zeus. Phidias' Zeus was considered one of the seven wonders of the world, even though it had not existed since the fifth century, B.C. In 1800, a Frenchman by the name of Quatremere de Quincy attempted a pictorial reconstruction of the Phidian Zeus, based on literary sources and coins, in a book entitled *Jupiter*.[16] The interest in Phidias was more than an antiquarian one. First, Americans of the time compared themselves to ancient Greece and to Rome, and particularly to the Age of Pericles, a time when democratic traditions and great art had flourished. Indeed, the American experiment did not go back to England or to France, or to Italy; it went behind all of these to the "glory that was Greece and the grandeur that was Rome." America was at once the youngest and the oldest nation on earth, combining the vitality of the new with the genuine heritage of the old against its more recent decadent corruptions.

The second reason for interest in Phidias' Zeus was the role of Zeus himself. Zeus, like the gods of antiquity, took human form. Emphasis was given to the manly qualities which disclosed god-like qualities. It is not that Washington was thought to be a god-like Zeus, but that he functioned in a god-like role and therefore had godly qualities ascribed to him. Brumidi's *Apotheosis of Washington*,

executed two decades later on the apex of the Capitol dome, still reflected such an outlook.

Since a god-like man represents enduring qualities that transcend the present and become object lessons for the future, Greenough had no interest in representing Washington as he appeared visually to his contemporaries. Indeed, he felt that such portraits had been done by other sculptors. In a letter to Samuel F. B. Morse, May 24, 1834, he wrote:

> Three statues have been made of Washington: one by Houdon, representing the General, made with every advantage, and with an accuracy of detail that will ensure it, in its way, the first place among the representatives of the man; one by Canova representing a Roman in the act of thinking what he shall write; one by Chantrey, representing him holding a scroll in one hand and a piece of his cloak in the other. . . . I find nothing in the interest they excite to tempt me to follow either. I choose to make another experiment. If it fails, the next sculptor who attempts the subject will have another beacon in this difficult navigation.[17]

In a letter to Lady Rosina Wheeler Bulwer-Lytton, some time before May 8, 1841, he described his own conception:

> Being intended to fill a central position in the Capitol of the U.S. I have thought fit to address my Statue of Washington to a distant posterity and to make it rather a poetical abstract of his whole career than the embodying of any one deed or any one leading feature of his life—I have made him *seated* as *first magistrate* and he extends with his left hand the emblem of his military command toward the people as the sovereign—He points heavenward with his right hand. By this double gesture my wish was to convey the idea of an entire abnegation of Self and to make my hero as it were a *conductor* between God and man—Though the Presidential chair is very like any other chair, I have thought it my duty to make that in which Washington is seated mean something with reverence to the country. . . . By the figure of Columbus who leans against the back of the chair on the left side I wished to connect our history with that of Europe—By that of the Indian chief on the right, to shew what state our country was in when civilization first raised her standard there.[18]

Greenough elaborated further in a letter to Edward Livingston, January 28, 1834:

> I have not represented any one action of the man, but have given him a moment which seems to me characteristic of his whole life. I wish while I impress the beholder with the idea of Washington, to remind him that Washington was an agent. I have chosen the seated posture as giving a repose not incompatible with expression. To have represented any one action would have been difficult from the nature of our art, its limits and the unity of person described by the subject.[19]

Visitors to Greenough's studio had seen the emerging statue and he carried on an extensive correspondence about it. He forwarded sketches to Washington, and soon reactions began to filter back to him. Artist friends who would have

done the statue differently defended Greenough's right to his own conceptions. Greenough's friend Edward Everett praised the designs, but then changed his mind and asked Greenough to do something that the people would understand. Indeed, Greenough was sufficiently aware of adverse reactions to propose that a plaster cast be placed in the Rotunda for a period of time in order to test reactions. But Congress did not vote the required fifteen hundred dollars to facilitate this. Some objected to Washington's being seated; many were unhappy that his right hand pointed upward; most disliked his bare chest, with drapery only from his lower waist down. When Greenough so easily suggested that the elevation of the statue should be such "that at the distance of 30 feet from the Pedestal in front, the *fold of the skin above the navel* may be *visible* and not *hidden by the knees*,"[20] he did not realize that a Washington with exposed navel and chest was unthinkable; indeed, it was easier to believe that Washington never took off his clothes than that he ever exposed his bare chest.

In assessing Greenough's role, we should remember that the neoclassical style called for the nude when dealing with ideal form and expression. Indeed, for Greenough, as for Powers, the nude as such was not an issue. On April 12, 1831, Greenough wrote to Robert Gilmor, Jr., "It belongs to our artists to shew that the arts of the imagination may charm without seducing and refine without corrupting a great people."[21] Danger in the eye of the beholder does not justify suppression.

In addition, Greenough, as did many of his contemporaries, considered eighteenth and nineteenth century dress to be extremely ugly and unaesthetic, a transitory fashion that would later appear dated and would thus interfere with proper seeing. This he did not want to happen to Washington, as it had, for example, with statues of French kings. In a letter to Secretary of State Edward Livingston, January 28, 1834, Greenough wrote,

> In looking at the portraits of some of the kings of France, we forget the man
> in wonder at the size and structure of the wig. And when we remark the vol-
> ume and weight of the robes, the inconvenient and uncouth forms given to
> every portion of the attire, it is not our taste only that is shocked, our sense
> also suffers. Such in kind if not in degree must be the sensations of posterity in
> looking at a literal representation of the dress of Washington's time.[22]

Those who thought he had merely substituted Roman costume for contemporary dress misunderstood him, wrote Greenough to Samuel F. B. Morse.[23] We must understand that the awkwardness of the full dress of the time is foreign to the embodiment of the ideal, or universal, or to the moral impact of the figure. The role of the sculptor was to take attention away from dress to form, in one sense, to undress. Whatever dress there was must not call attention to itself, but be an inconspicuous part of the whole. In this sense, says Greenough, the sculptor

> avoids *small facts* that he may fasten your idea upon *great truth*. To be true
> to fact the figure of Laocoön should be clothed in a priest's dress—clothe him
> thus and the subject is for a painter. The first postulate of sculpture in its
> essence is that the veil of convention be rent. Dress the fighting gladiator and
> you might as well sculpture a house and tell me that a fighting hero is inside

thereof; or say, as Michelangelo playfully said, that perfection lies in every rock that rolls from a quarry. True it is that perfect beauty is in every rock; the art lies in stripping therefrom the dress of chips that disguise it.[24]

Greenough does not deny that contemporary dress is appropriate on occasion. But there is a difference between what is appropriately conveyed for a person who improved upon the human scene and one whose greatness so transcended his time, as in the case of Washington.

> In a statue of Howard, or Fulton, or Watt, or any other simple improver of the arts or institutions of society, I should think it very proper then to mark the date of his career, by exhibiting him in that circle of usages where he merely served. But the man who overthrew a tyranny, and founded a Republic, was a hero. When he sits down in marble immortality in the Hall of the Capitol, his dress should have reference to the future rather than the past; there should be about him nothing mean or trifling, or above all, ridiculous; which latter adjective, I hope to apply in its full extent, to the modern dress generally, and to that of Washington's time particularly.[25]

But if Greenough found the dress of Washington's time ridiculous, that is exactly the word most of the populace found to describe Greenough's statue. For the Reformed clergyman, George W. Bethune, who defended Powers' *Greek Slave*, it was not a matter of ridicule but of failure on the part of an artist of whom he was appreciative:

> WASHINGTON in a *toga* is an affront to our common sense; and he who cannot give us the foremost man of modern times in his own garb, should confess a genius unequal to the portraiture. An artist is not obliged to copy all the fantastic caprices of fashion, but his invention is very weak if, like a country tailor, he can work only after obsolete patterns. He has the right of contrivance in costume, but imagination must be ruled by propriety.[26]

But in spite of the ridicule and criticism, Greenough never varied in his conviction that he had done the best he could and that the future would be a more adequate judge.

The removal of the statue from the Rotunda of the Capitol had to do, not with the criticism, but with Greenough's own dissatisfaction with its placement and lighting. The mid-nineteenth century was not the age of flood-lighting, and the dome for the Rotunda was the earlier low dome. Since the changes necessary to provide an adequate viewing of the statue were so extensive that they were not approved, Greenough himself petitioned that the statue be placed on Capitol grounds, covered by an appropriate building. This location proved to be no more satisfactory. For a time the statue was exposed to the elements, a most destructive factor in that the concave areas of the sculpture had been designed for an interior setting. For a while, the statue was in the chapel of the Smithsonian building, but for most of its history it was in storage. However, it now can be seen again by the general public in the National Museum of American History, where it is unfortunately placed alongside an escalator.

In one sense, Greenough's *Washington* as a work of art was too sophisticated

for its time. It actually expressed what many Americans, who considered themselves the heirs of Greece and Rome, said in their speeches and believed to be true about themselves. When they saw what they believed, they could not accept it; but they were not cognizant of the contradiction.[27] A disjunction between seeing and believing is not unusual. More germane to the failure of Greenough's statue to find acceptance is that the traditional American conception of portraiture as a genuine likeness made it impossible for people to think of historic figures in a way other than that in which they were known. Greenough meant Washington to be a representative and symbolic figure, but an acceptable representation of Washington had to have familiar American features.[28]

The concern with expressing what Washington meant to the nation occurred before Abraham Lincoln emerged on the scene of history. There are, of course, many statues and portraits of Lincoln, including photographs. Among the prominent representations in sculpture are the seated figure of Lincoln in the Lincoln Memorial in Washington, D.C., executed from designs by Daniel Chester French late in his career, and the standing Lincoln figure by Vinnie Ream in the Capitol Rotunda, Washington, D.C. The artist George C. Bingham has caught the spirit of Vinnie Ream herself in a painting showing her standing before her sculpture of Lincoln, entitled *Vinnie Ream with Lincoln Bust* (Plate 65). Vinnie Ream, it should also be mentioned, had three marbles exhibited in the Woman's Building of the Columbian Exposition, *America*, *The West*, and *Miriam*. Edmonia Lewis did a Lincoln bust, owned by the San Jose, California, library. Of Indian and black descent, Edmonia Lewis was also known for her variations on the Hiawatha theme. Harriet Hosmer began, but never completed, a design for an extensive Lincoln memorial. For Chicago's Lincoln Park, Augustus Saint-Gaudens executed a large standing Lincoln, though in the popular mind, his stereotypical sombre *Puritan* (Springfield, Massachusetts) may be better known. In all the Lincoln sculptures, as contrasted to Washington, the humanity is central, reflecting the person and the time. Lincoln was not the founder of a nation, though he represented its preservation in a time of severe testing.

Turning from sculpture again to paintings, another work of Robert Weir, whose Rotunda painting has been commented on, is *War and Peace* (Plate 66), in the lunette formed by the curved ceiling of the old West Point chapel. Kent Ahrens describes the painting as follows:

> In the center of the mural are seen the allegorical figures of War and Peace, flanking a dias on which rests a half globe representing the northern hemisphere and a bald eagle with his attributes symbolic of the United States. Following neo classical precedent, Weir freely combines secular and Christian symbolism. Thus it is that the idealized figure of Peace, clad in classical garb, carries the Christian attributes of a Bible and an olive branch (the traditional symbols of peace), while War, represented as Mars in Roman armor, looks broodingly at the fasces and the full American flag in the lower right corner of the mural. In his left hand he holds the sword and laurel wreath, pagan symbols of power and victory, but on the dias between the two figures is an inscription from the Book of Proverbs: "Righteousness exalted a Nation but Sin

is a Reproach to any People!"[29]

Ahrens interprets the whole as meaning that a peaceful and Christian United States will prosper while a warring Europe will continue to be corrupt. Whether the painting needs to be so interpreted, the viewpoint is a dominant one for the time.[30]

The most self-conscious attempt to unite the religious tradition and the American nation occurred in Erastus Salisbury Field's astonishing *Historical Monument to the American Republic* (Plate 67) done for the hundreth anniversary of American independence. In this wall-size canvas, made available to the general public by engravings, one sees an immense architectural structure with towers joined by bridges and cables at their top. Near the top of each tower, one finds the initials, T.T.B., meaning The True Base, on which columns are based, each representing a state then in the Union. The towers are decorated with reliefs and sculpture which, taken together, depict a history of America as viewed by this eccentric artist. Field was against slavery and governmental corruption, and for temperance, and he believed scripture to be the real foundation of American destiny. Painstakingly lettered across the facade of the lower right building is a long sermon on the Bible. Indeed, didacticism pervades every facet of the painting, and it is saved only as a work of art by the fantasy and imagination inherent in Field's composition.[31]

The mood of the latter half of the nineteenth century can be conveyed through two paintings by Emmanuel Leutze, and by the American Renaissance creation, the Chicago Columbian Exposition of 1893. Leutze's two paintings are: *Washington Crossing the Delaware* (Metropolitan Museum of Art) and *Westward the Course of Empire Takes Its Way*, known popularly as *Westward Ho!* (Plate 68). While *Washington Crossing the Delaware* was originally executed by Leutze when he was disappointed with the European Revolution of 1848, it celebrated what he believed can be done if freedom is vigorously grasped and pursued. The painting, featuring Washington in a literal and symbolic forward-looking stance, also recalled to Americans the significance of that event in turning the fortunes of war from adversity to hope. Today, that painting is probably more in the consciousness of Americans than *Westward Ho!*, possibly because it celebrates an accepted past.

Westward Ho!, however, spelled out what Americans were thinking of themselves in terms of the present and future. While focused on the immigrants to the United States, it points their arrival toward the westward destiny of America. Leutze built upon the inherited conviction, spelled out already in the eighteenth century, that civilization moved from east to west. The title of the painting itself echoes the poetic refrain of Bishop George Berkeley, who lived in Newport, Rhode Island, awaiting preparations for the abortive school he was to head in the Caribbean. Even Benjamin West repeated the familiar refrain of civilization moving from east to west. Evidence of the centrality of that motif consists in that, while the main focus of the painting includes the hunter, farmer,

missionary, the displaced Indian, border vignettes include illustrations of historic linkages of emigration and Providence, "Arion on a dolphin, the Hebrews bringing fruits from Eshcol, the raven of Elijah, Jason and the Golden Fleece."[32] Only now in America these prefigurations had come to fulfillment. Providentially considered, the westward movement in the New World was but the final development in that pre-ordained chain. Many of those who thought in such terms were Anglo-Saxon and assumed or hoped that the wave of immigrants would come no faster than they could be assimilated into that English mode. It was all part of one grand scheme, an application of energy which was acting out the manifest destiny of America. It was a secular religious version of the older Puritan idea of applying oneself to Providence.

If *Westward Ho!* is the later nineteenth century painting version of civil religion, the Chicago Columbian Exposition of 1893 was the summation of all that Americans believed their experiment had accomplished. A nation had been developed to the point that a frontier no longer existed. Surely symbolic of what happened is that Frederick Jackson Turner gave his classic address on the impact of the frontier on American life at the Congress of Historians at the Columbian Exposition. The westward movement was now behind us. America now had, and could continue to stress, the cultural achievements of its new place in the world. The Columbian Exposition was its visible embodiment. It represented the unity of art and architecture, of commerce and of politics, of religion and the role of women in the world's affairs. In everything it touched, the Exposition expressed what Americans had achieved, but in a world context. America no longer needed to feel inferior. In all areas of life, it had come into its own.

Stylistically, the buildings and their decoration were the epitome of the American Renaissance, that late nineteenth century revitalization of artistic style, which, instead of returning to the Classical or Gothic worlds, built itself consciously on that of the Renaissance. A close affinity to that period was felt by the new architects and artists, for in the Renaissance, entrepreneurs representing both wealth and political power worked closely with architects and artists to create total environments expressing the spirit of the times. The unity which they sought to express was no less total than our conception of the Middle Ages, but it was based on a rediscovery of the classical world as mediated by the Renaissance, and forged by its own analogous use of that inheritance. Henry Adams, who had been so distressed by the disappearance of unity from the medieval world on, was temporarily, though only temporarily, impressed by what the Exposition exemplified. In Chicago, architect and artist had apparently "leaped directly from Corinth and Syracuse and Venice, over the heads of London and New York, to impose classical standards on plastic Chicago. . . . Chicago was the first expression of American thought as a unity."[33]

The site on Lake Michigan, a modified version of Olmsted's plan, was spectacular and it created a kind of Renaissance landscape where water and architecture combined to form an oasis in the midwestern prairie. All of the major architects and sculptors of the time were involved.

Prominent among the architects were McKim, Mead, and White, who orchestrated much of the architectural conception and who themselves designed the Agricultural Building, and Richard Morris Hunt, who did the Administration Building. Among the sculptors were Daniel Chester French, whose raised colossus, *Republic*, vied for visibility across the lagoon with Frederick MacMonnies' boat-fountain, the *Triumph of Columbia* (Plate 69). The latter symbolically identified the boat of Columbus with the current "Barge of State," led by allegorical figures represented in the form of maidens, with Fame at the prow, Music, Architecture, Sculpture, Painting, Agriculture, Science, Industry, Commerce following, with Columbia holding a torch, perched high above the rest. Both the *Republic* and *Barge of State* were idealized, allegorical representations of the creativity and industry of humanity. For the public, it felt good to identify with them, for they represented so much of themselves.

Predominantly, the American Renaissance tradition centered in architecture, sculpture, and mural painting. While important in its own right, mural painting was a part of the architectural ambience and in effect the same was true of sculpture. The paintings assembled from across the world had their place in the Art Gallery but the painters represented are hardly known today except by historians of the period. The subjects were wide-ranging, but when religion was represented, it largely centered, not in the religious meaning, but in a religious scene, such as a group at a baptism or attending a service of worship, or the commemoration of an event.

One of the most widely acclaimed spaces at the Exposition was the Tiffany Chapel (Plate 70), a monument exhibiting the varieties of techniques of this master's unique use and control of glass. The chapel had mosaic sheathed walls and stained glass windows, including a *Field of Lilies* (angels and landscapes) in the baptistry, *The Entombment, Christ, Ruler of the Universe*, and *Jesus Blessing St. John*. But aside from these iconographic subjects, the chapel centered in the decorative use of glass for the liturgical artifacts. The altar, the front of which was glass mosaic, was set under triple mosaic arches, with a floor and chancel steps sheathed in glass mosaic as well. The columns under the arch and along the sides were of iridescent mosaic, as was the lectern and font. A three-dimensional glass mosaic cross hung over the chancel area and the altar cross was jewelled. The tall candlesticks were of marble.

So impressive was the chapel that it received more than fifty awards. Granted that the chapel, which was located in the Manufacturers and Liberal Arts Buildings, had to be abandoned, as is the case with most fair buildings, the chapel itself consisted of material which survived the immediate occasion. After being exhibited in New York City, it was given to the Cathedral of St. John the Divine, where the installation in a Romanesque chapel survived until 1911, when the Cathedral went Neo-Gothic. Then the chapel was erected in the Tiffany Villa, Laurelton Hall. Because of financial difficulties in 1946, the Tiffany Foundation disposed of the altar, the furnishings, and most of the windows. Fortunately, after the fire at Laurelton Hall in 1957, efforts were made to pull

together the major remains of the chapel from many sources.[34]

The Exposition was but one in a series of world fairs originating in the 1850s. In the United States, the Sanitary Fairs, which emerged in the Civil War period, were an early manifestation. The Philadelphia Centennial of 1876 was particularly notable. But the Columbian Exposition, in another sense, was the pinnacle of previous and succeeding world fairs, for no other fair represented so thoroughly the American view of itself in relation to the rest of the world. America had arrived, its fulfilled promise evident in the architecture, art, and technology on every side. The mantle had fallen on America, and the country had risen to the occasion. Confident of its own future in the light of what it had accomplished, it had a sense of its role in relation to past history and to the contemporary world. Hence, the new so-called American Renaissance was the successor of the Renaissance, which, it was believed, had itself encapsulated all that was good and creative in past world histories. Americans were suddenly also the preservers of that history through the myriad libraries and museums they had created, and they now also had the self-confidence to expose themselves to the widening interests in world culture. The Exposition included a world parliament of religion in which world religious leaders participated, representing the major traditions of the world. The diversity of world culture was not yet seen in a fully pluralistic sense, but rather in terms of the unity that would emerge in the future. That unity of course was seen incipiently in America's new role as the inheritor and extender of a world tradition in which western values were secure, and personified in sculptural creations, but open to stimulation by the unfamiliar and exotic elements of the east.

That mixture of nationalism, idealism, and self-serving historical judgment is not uncharacteristic of nations, but it did not become full-blown in the United States until the late nineteenth century. Earlier, the Trumbull paintings of the War of Independence and Daniel Clark French's *Minuteman* celebrated the birth of a nation. The Civil War produced little significant art, but, in its aftermath, monuments in profusion emerged in both north and south, of which Memorial Hall at Harvard and the Shaw monument by St. Gaudens at the edge of the Boston Common are among the better known examples. If the Revolution was an initial victory that spawned the new nation, the Civil War had saved it. In the late nineteenth century, it was felt that the major victories had been won and that the fruits could be enjoyed, including the virtue and genius that had created them.

By the latter half of the twentieth century, however, that confirmation of idealism and conviction of achievement has been devastatingly challenged. Two world wars, the Vietnam War, and the conflicts of the 80s are sobering realities. We confront the pluralism of our culture, wondering if there are cohesive cultural bonds in our society at all, wondering if an element of civil religion is not necessary for a culture to survive.

9

Old Testament Themes

As a young man Benjamin West had spent almost a year in New York City as a portrait painter without much professional success. His departure to Italy soon thereafter, in 1760, for a three-year period, was the occasion for the development of his talents. His resultant artistic style so impressed English bishops and George III that, what was to be a temporary visit to England, became instead a permanent residence and a distinguished career in England until his death more than a half-century later. While West grew up in Pennsylvania and many of his paintings are now to be found in the United States, his mature work belongs to the English orbit.[1] Still his influence on the American scene was great, for many of the American artists of the late eighteenth and early ninteenth centuries studied with him or received help and encouragement from him in his studio in London. Moreover, his promotion of history painting, which included a repertoire of religious, classical and contemporary subjects of his time, provided a spur to those American painters who were trying to find patronage for subjects other than portraits.

Because of this role, and because he is the first in the sudden emergence of talented artists from American soil, West is the primal figure symbolizing the beginning of a significant artistic tradition. This is true, despite the fact that few of his students showed the influence of his style and that subsequent major nineteenth century developments stem from sources other than West.

While the period from 1620 to 1760 in the colonies is marked by the relative paucity of the visual arts apart from portraiture, the period from the late eighteenth century throughout the nineteenth is characterized by more vigorous artistic pursuits than is usually recognized. Moreover, the number of paintings with religious subject matter is impressive, though it needs to be added that until the latter half of the nineteenth century, such paintings were not done for churches. Paintings with religious subject matter were done as private commissions, or by the artist with the intention of exhibiting the works and offering them for sale.

Late eighteenth and nineteenth century art with religious subjects or subjects with religious implications will be dealt with here in terms of allied themes, roughly chronologically developed. No attempt will be made to provide a history of art of the period or even a history of religious art. Rather, the intention is to provide a picture of the range, scope, and place of such works in the American cultural scene.

For traditional iconographic reasons, it is appropriate to begin with Adam and Eve. Immediately one is confronted with the fact that Eve, rather than Adam, is the conspicuous figure in American art. There does not appear to be a major instance in American art of Adam represented alone. The prominence of the Adamic theme in American literature has been noted by R. W. B. Lewis and David W. Noble.[2] Thus one is confronted with an interesting contrast between the fields of the visual arts and literature, the reasons for which are not immediately evident.

In some instances the attention given to Eve in Salomon Gessner's popular bathetic poem *The Death of Abel*[3] may account for her prominence. In about 1830, Mrs. H. Weed executed an embroidery and painting, probably based on an engraving, entitled the *Death of Abel* (Plate 71), which is in fact Adam and Eve discovering the body of Abel, with the wives of Cain and Abel also present. Surely this work is based on Gessner, for in *Genesis*, it is the Lord who confronts Cain about his deed.

Abel is also the subject of a painting by the Hudson River artist, Thomas Cole. While in Florence, he did a painting of the *Dead Abel* (1832, Albany Institute of History and Art), in which Abel lies stretched out before us, while Cain disappears behind a craggy rock as he heads toward a threatening wilderness. The painting was meant to be a study for a large picture in which Adam and Eve found the body of Abel, according to a letter Cole wrote to William Dunlap.[4] That it is a study for a painting undoubtedly accounts for the fact that the body of Abel is so large in scale. Ordinarily, Cole's artistic strength was not in the draftsmanship of the human figure; indeed, his figures are usually small and set in vast landscapes.

Also in about 1830, an unknown folk artist depicted *Adam and Eve* (Plate 72) in a paradisal setting in which the human figures and nature form a quiet, congenial, untroubled scene. An *Adam and Eve*, attributed to Rafael Aragón, was probably executed prior to 1834. As a tableau with three distinct scenes, it is reminiscent of similar European iconographic programs, but it is the only Adam and Eve of which we have knowledge in New Mexican art of the time. Between 1860 and 1870, Erastus Salisbury Field, a self-taught artist, painted *The Garden of Eden* (Plate 73) in which Adam has his back to us, and Eve is reaching for the apple, a clump of bushes hiding her body from the waist down (Museum of Fine Arts, Boston. A second version is in the Shelburne Museum, Vermont.) In both of these paintings, the panorama and the details of nature seem more interesting than the figures, but one cannot escape the harmony between nature and humanity.

The marble sculpture of *Adam and Eve* (Plate 74), executed by Thomas Crawford in Italy, shows the guilty pair after the Fall, and the figures exhibit a kind of melodramatic regret. Paradise has been left behind. Behind the standing figures is a tree trunk, and at its base is an apple with teeth marks clearly visible. Adam, looking soulfully to the heavens, has his hands clasped above his head, and Eve has her right hand cupping her forehead, her left holding on to Adam, who, after the Fall, is appropriately and abundantly fig-leafed. The figures are

less than five feet in height, though Crawford originally conceived of the group as nine feet in height. The gestures of this pair of adolescent sinners seems sentimentally shallow as an interpretation of the great biblical myth.[5]

Crawford, who, together with Horatio Greenough and Hiram Powers, constitute the most significant mid-nineteenth century sculptors, is most known for his public commissions: the pediment sculptures on the northern end of the east side of the United States Capitol, the colossal *Armed Freedom* above the Capitol dome, and the reliefs on the Senate doors. Many of the works from his Rome studio were lost in a New York City fire, and among them were seventeen statues with religious subject matter, including a Christ figure.[6] Had these sculptures survived, we would have a more adequate assessment of his religious work than we have with the nude *Adam and Eve* and a clothed *Christian Pilgrim* (1857, Boston Athenaeum). Crawford suffered an untimely death. Although he was an Episcopalian, we do not know the role his religious outlook played in his sculpture; nor do we have any knowledge about the context or uses to which his religious sculpture would have been put.

Though Adam is not represented alone in painting and sculpture, but together with Eve, Eve, particularly in sculpture, has been repeatedly modelled without Adam. Most noted, and the subject of controversy because she was sculptured in the nude, was Hiram Powers' *Eve Tempted* (Plate 75). Powers was born in Woodstock, Vermont, but his early artistic influences stemmed from Cincinnati, where his mechanical and sculptural ingenuity was discovered and where he was encouraged by Nicholas Longworth and Frances Trollope. Mrs. Trollope was in Cincinnati at the time in an attempt to recoup the family fortunes.

Powers spent some time in Washington, D.C., but his long, active sculptural life was spent in Florence, Italy. Because of Powers' extensive correspondence and contact with a wide-range of Americans who visited Florence, we know a good deal about his conception for his *Eve Tempted*. Like others, he began his rumination with the work of Salomon Gessner. In a letter to Nicholas Longworth, dated April 22, 1839,[7] Powers wrote:

> I shall begin a statue of a female figure in a few days. I think it will be an illustration of Gessner's Eve at the moment when she is looking at a dove, which lies dead at her feet and which calls up disagreeable reflections in her mind, on the consequences of her transgression. I think I shall call it "Eve Reflecting on Death."

And, in a letter in May of the same year to one Ryder, also in Cincinnati, he wrote,

> It will be an attempt to illustrate Gessner's Eve and the scene, her reflections on death, as one of the consequences of her transgression. If you have ever read the book, you will remember it—a dove lies dead at her feet which she supposing at first to sleep tries to awaken—but is at last convinced of the true state and meaning of it all and this is the moment which I have chosen.

But Powers abandoned this conception in favor of Eve before the fall, or of Eve being tempted. While the reason for the change cannot be totally reconstructed, we do know that Powers consulted others and engaged in spirited debates about the subject. A letter to Powers from the artist W. J. Hubard in the fall of 1839, written from Gloucester, Virginia, upon his return from Florence where the two of them had debated the issue, suggests that the original conception was wrong. Hubard stated that Powers' conception made Eve too much of a heroine, too much of a rational being, in whom knowledge is related to sin. For Hubard, mind as active knowledge did not exist before Cain. Therefore,

> Eve could not have had a mental horror or comprehension of the nature of death even when she beheld it. It was rather combined sensations of wonder and apprehensions arising from a melancholy sensitiveness produced by their expulsion and fear of coming wrath or evil.

For Hubard, Eve was suspended between a "loving, entirely confiding and relying upon a divine source for every wish and act"[8] and the characteristics of any being we know, since death actually entered the world. Hubard despaired of the possibility that art was capable of portraying a conception vitiated for all of us by the act of death. However, Powers' sculptural image, when finally executed, corresponded more to Hubard's conception than to that represented in Gessner.

A second indication of a change in the conception of Eve comes from the Unitarian clergyman, Orville Dewey, who had apparently seen the Eve during a time when Powers was making changes. Describing the finished model in 1842, Dewey wrote:

> She is represented in this work as standing, and her left hand hangs negligently by her side; her right holds the apple, and upon this, with the head a little inclined, her countenance is fixed—and in this countenance there are beautifully blended, a meditation, a sadness, and an eagerness. When I first saw this statue, or model rather, the last of these expressions was not given. I said to the artist: "I see here two things; she meditates upon the point before her, and she is sad at the thought of erring." He said: "Yes, that is what I would express but I must add another trait." I feared to have him touch it; but when I next saw the work that expression of eager desire was added, which doubtless fills up the true ideal of the character.[9]

Meditation and sadness are characteristic of Eve in Gessner's account; eagerness is a new ingredient, marking a major transformation. In a letter to the Reverend Philip Slaughter, April 21, 1852, Powers confirms such a mood, for Eve has "taken the forbidden fruit, but she has not yet consummated the act—she has not yet eaten of it."

The modeling of Eve occurred between 1839 and 1842, and it was probably put into marble in 1843.[10] During the time the first *Eve Tempted* was being completed, Powers had also begun the *Greek Slave*. While an historical rather than a Biblical subject, comments on this sculpture are in order, for it was *Eve* and the *Greek Slave* (Plate 76) which raised the question of the nude for the

clergy and laity alike. Twenty-five years after the initial work, Powers wrote to Stoughton (November 26, 1869) about the context of the *Greek Slave*:

> It was several years after being in this city and while thinking about some new work to be commenced that I remembered reading an account of the atrocities committed by the Turks on the Greeks during the Greek revolution (1821), which were finally put an end to by the destruction of the Turkish fleet by Admiral Codrington and the Russian Naval Commander, whose name I do not now remember. During the struggle, the Turks took many prisoners—male and female and among the latter were beautiful girls who were sold on the slave market in Turkey and even Egypt. These were Christian women and it is not difficult to imagine the distress and even despair of the sufferers while exposed to be sold to the highest bidder. But as there should be a moral in every work of art, I have given to the expression of the Greek Slave what trust there would still be in a Divine Providence for a future state of existence with utter despair for the present mingled with somewhat of scorn for all around her. She is too deeply concerned to be aware of her nakedness. It is not her person but her spirit that stands exposed and she bears it all as only Christians can.

In the passage, Powers reflects the reasoning which had been employed for the defense of the *Greek Slave* and *Eve Tempted*. Since Horatio Greenough's *Chanting Cherubs* and his *George Washington* (Plate 64) had already been attacked for their nudity prior to the *Greek Slave's* tour of the States in 1847, every effort was made to provide a correct interpretation. With considerable humor, Powers himself recalls the reactions of Henry Ward Beecher in a letter to a friend in Cincinnati, April 15, 1850, written when Powers believed that his *Eve* had been irretrievably lost in a shipwreck.

> Why in a fit of mortification and shame brought on partly by some of Mr. Beecher's remarks upon the nudity of the [Greek] Slave, and mostly by a sense of superior modesty and innocence of her grand-daughter, she [Eve] forgets her gratitude to me for all my pains, and plunged overboard. . . . Dr. Beecher and others no doubt will see in this a Judgment for making two such statues, but accidents happen sometimes even to churches.

Powers and his agent, Minor Kellogg, generally successfully prepared the ground with a brochure which extolled the virtues of the statue. The publication was mainly a collection of previous newspaper accounts of the statue, including Edward Everett's "American Sculptors in Italy," first published in 1841; G. H. Calvert's material on Powers from "Scenes and Thoughts in Europe"; and, of course, the Reverend Orville Dewey's comments were reprinted from the *Union Magazine* for October, 1847.

While Orville Dewey is largely quoted by those who write on Powers, the full context of his comments must be more fully reported than is usually the case. While we may scoff at some of the things he said, he was acquainted with the artistic tradition and represented widely-held artistic and religious views. Dewey admitted that the *Venus de Medici*, in terms of beauty of form alone, was superior to *Eve* and to the *Greek Slave*. But beauty as "that complex

character . . . which embraces, with muscular form, the moral sentiment of the work" gives the prize to both Powers' *Eve* and his *Greek Slave*. There is, says Dewey, no sentiment in the *Venus de Medici*, for

> she is not in a situation to express any sentiment—or any other sentiment. She has neither done anything, nor is going to do anything, nor is she in a situation to awaken in herself, or in others, any moral emotion. There she stands and says, if she says anything, "I am all beautiful, and I shrink a little from the exposure of my charms." Well she may. There ought to be some reason for exposure *besides* beauty; like fidelity to history, as in the Eve, or helpless constraint, as in the Greek girl.[11]

There one has it. The nude is not justified as beauty, but only when the setting or moral sentiment permits or requires it. That is the setting for Dewey's oft-quoted remark, "Brocades of cloth of gold could not be a more complete protection than the vesture of holiness in which she stands." Indeed, in the *Greek Slave*, wrote Dewey, Powers had reached the highest point in art, "to make the spiritual reign over the corporeal; to sink form in ideality." For this reason, Dewey can conclude:

> There stands the Greek girl in the slave market, with a charm as winning as the eye ever beheld, and every sympathy of the beholder is enlisted for the preservation of her sanctity.[12]

The sculptor, Erastus Dow Palmer, executed the *White Captive* (Metropolitan Museum of Art, 1857) as an American analogue to Power's *Greek Slave*. The theme is the same, but here the totally nude figure is to represent the innocence and purity of the American woman as a captive of the Indians, instead of the Turks and Greeks. Moreover, the defense of her nudity parallels that used for the *Greek Slave*.

Such an approach was the context from which art was both defended and encouraged by the church in the next half-century. The thought that sheer beauty could legitimately excite physical sensibilities was rejected. Indeed, when Dewey so prominently injected the moral setting and purposes for art, he was but expressing that the moral stance was the prevailing category by which religious people understood every facet of life and thought.

While Powers fought for his conception of the *Greek Slave*, criticism of the nude did lead him to discourage the public showing of the second version of *Eve Tempted*, destined for John Preston of South Carolina. In a letter to Sidney Brooks, December 14, 1849, Powers stated,

> The expenses of exhibition are so great and the results so uncertain that I do not think it advisable to attempt it at all—and besides, Eve might shock the sensibilities of many who found the Slave quite as much as their moral feelings could bear—for Eve is quite "naked"—and she does not appear in the least 'ashamed.'[13]

Powers had a genuine sense of humor. He readily accepted the human form, and never recognized that others might see erotic elements in his art. Had he himself accepted that, he would have been troubled. Powers was a Swedenborgian,

who believed, perhaps more simply than a careful reading of Swedenborg's thought allows, that that which comes from the creator's activity is a direct manifestation of the divine, and that there is a direct correspondence between the celestial and the terrestrial. Hence, the nude, direct from the hand of God, is an earthly correspondent to the beauty of God. From the standpoint of religion, the nude is not a problem. When a problem arises, it stems from the eye of the beholder.[14]

We know less about the conception of Eve as embodied by other sculptors than we do in the case of Powers. Edward S. Bartholomew sculpted *Eve Repentant* (Plate 77), seated with head bowed and serpent and bitten apple visibly present.[15] We know that Thomas Ball's unlocated *Eve* was an Eve awakening to the wonders of creation in paradisal terms. But of other lost works we know less, such as the *Eve* by Randolph Rogers, or the *Eve with the Dead Abel*, by John Adams Jackson.[16]

John La Farge painted an *Eve* still in paradise, a nude red haired woman sitting on an embankment and surrounded by the blossoms of an apple tree. Also called *The Golden Age* (Plate 78), the painting combines the innocent, the religious, and the secular in a mood reminiscent of what now is only a distant echo, a nostalgia for a lost good.

It would be hard to imagine the sculptures and paintings discussed in this chapter as part of a liturgical setting. At best, such works might be placed in an alcove or along a wall area. The fact is that these works were not done with liturgical settings in mind, for they were not commissioned by the church. They belonged to the historic repertoire and had a life of their own apart from all contexts. They were judged in and of themselves. These nineteenth century American sculptures and paintings suffered an eclipse in popularity in the early nineteenth century and only recently have been re-evaluated.

No other Old Testament subject seems to have received the same degree of attention as did Eve. Moses and the events associated with him in the theological category of the Mosaic dispensation comprise one-half of the Windsor chapel scheme Benjamin West did for George III. That scheme, associated with the English Anglican outlook, played no part in the American scene. The most extensive attention to the Moses theme occurs in the work of the naive artist, Erastus Salisbury Field, whose series on the Israelites in Egypt, included *He Turned Their Water Into Blood* (Plate 79), the *Death of the First-Born* (ca. 1870, Metropolitan Museum), *Burial of the First-Born* (ca. 1880, Museum of Fine Arts, Springfield, Massachusetts), *Pharaoh's Army Marching* (ca. 1865–80, Garbisch Collection), and the *Israelites Crossing the Red Sea* (ca. 1865–80, private collection). But in only one of these is Moses visibly present, for the paintings center in the narrative event. Moses is depicted in Page's *Moses, Aaron, and Hur at Mount Horab*, in Palmer's bust, *Moses* (1857, Wells College, Aurora, New York) and in Francis Lathrop's *Moses Finding the Law* (Bowdoin College). But considering the role of Moses in Old Testament history and the proclivity of New England clerics for Old Testament themes, the number of portrayals is few

indeed. Biblical figures such as the feminine heroines of the Old Testament, *Hagar and Ishmael*,[17] *Jephthah's Daughter*,[18] *Ruth, Ruth Gleaning, or Ruth and Naomi*,[19] *Esther*,[20] *Rebecca*,[21] *Delilah*,[22] *Miriam*,[23] and the New Testament *Salome*[24] are frequently executed by more than one artist, and many of them occur in the art of the forties and fifties of the nineteenth century. William Wetmore Story's *Delilah* and *Salome* (Plate 80) were created in the sixties and seventies. This prominence of women from the Old and New Testaments probably derives from several factors. First, there is an interest in the sentimental in Victorian culture generally and in religion particularly, which is personified in Woman; second, Woman is also viewed as a heroine and therefore singled out; third, this is a period for considerable advance on the part of women in American culture, an advance which is reversed in the post-Civil War period.[25] Male figures from the Old Testament are prominent after the 1860s, such as Story's *Saul* done in 1881 (Plate 81), Rogers's *Isaac* (1858 and 1863), Emma Stebbins's *Samuel* and *Joseph*, Ball's *David* (1885), Ryder's *Jonah* (1890).

While sculpture was largely confined to the human figure, painters dealt with themes, events, and human figures in environmental settings. The Deluge and Noah's Ark were favored themes. In 1786, John Trumbull did a study for *The Last Family Who Perished in the Deluge* (Fordham University Library), which was executed in oil (Plate 82) over a half-century later in 1838–39. Joshua Shaw's *Deluge* of 1805 (Plate 83) may also be mentioned. It exemplifies the late eighteenth and early nineteenth century preoccupation with the dread sublime in art. Ominous forces of nature are everywhere, all humans are already dead, while the animals await their fate.

Charles Willson Peale's *Noah's Ark* (Plate 84), while based on a composition of another artist, shows Peale's deep regard for the animal world.[26] Peale was a naturalist, having created, in Philadelphia, the first natural history museum in the nation. This museum was the result of more than curiosity made attractive by biological and geological discoveries. The specimens in his museum illustrated the glory and the majesty of God's creation. Charles Willson Peale revelled in the grandeur of nature, with a worshipful stance more intense than that exhibited by many in orthodox churches. Indeed, Peale had many liberal clergy friends and he exhibited a piety more intense than any of the deists. In *Noah's Ark*, Peale substituted the American buffalo for the elk which was in the original painting he was copying and he added as ass next to the horse, citing stylistic reasons for the changes. Noah looks benign, at home and secure with the animals, in spite of the flood. The flood does not appear threatening but mirrors the goodness of creation, and a positive, American view of nature.

Edward Hicks, Quaker sign and stagecoach painter sympathetic to the Hicksite views of his cousin Elias Hicks, is known mainly for his many paintings of the *Peaceable Kingdom*.[27] While these are based on an 1813 engraving of the *Peaceable Kingdom of the Branch* by the English artist, Richard Westall, scholars have been intrigued by the changes Hicks made over the years in his compositions of the same subject. The Westall painting stands in the orthodox Christian

tradition, with the branch representing either the grapevine symbolizing the Eucharist, or simply the root of Jesse, which was symbolic of the Messiah. When Hicks became aware that such symbols did not correspond to the Quaker inner light, he changed the grapevine to an olive branch, the branch of peace, or dropped it out altogether. Already in the early *Peaceable Kingdoms* from the 1820s, Hicks provided a non-traditional interpretation of Isaiah 11. The dream of the new age, symbolized in the harmony among the animals, was not a future eschatological event, but a reality already present in the world, that is, wherever God's spirit now reigns. Penn's Treaty with the Indians, added by Hicks to the background of most versions of his *Peaceable Kingdom*, was its visible embodiment, the beginning seed of the new kingdom already present. While modeled on West's painting of an alleged historic event, Hicks' own vision (Plate 85) tied the vision of Isaiah to contemporary Quaker life in Pennsylvania.

But, in 1827, tension and separation had taken the place of peace and harmony among the Quakers. In that split, Edward Hicks was sympathetic to his cousin Elias Hicks, who stood for a tradition of the inner light freed from traditional views of Christ and the atonement. The Philadelphia society, which had moved toward more orthodox Christian views, would not tolerate the views or presence of Elias. The result was two Quaker groups.

The *Peaceable Kingdom with Quakers Bearing Banners* (Plate 86), of which several versions are extant, represents Hicks' way of declaring that those who now are in the spirit stand in a continuous association with the Eternal Spirit.[28] Christ and the Apostles, at the top of the pyramid of people, and Elias Hicks, at the bottom, with Edward Hicks' hero, George Washington, next to Cousin Elias (Plate 87), are symbolically and artistically tied together by banners in the Gospel of peace; they are all dependent on the same Spirit, without resort to views of Christ or the atonement. The painting represents a universal claim of Christian peace and liberty. It is a Hicksite manifesto, free of traditional Christian claims.

The struggle between the two Quaker groups was a troubling time for Hicks. Interpreters have seen a change from the more placid versions of the *Peaceable Kingdom* to ones fraught with tension, exemplified in a rougher, eroded terrain, and a fierceness in the faces of animals (Plate 88). But Hicks himself, following an older tradition, indicated that the animals represented mankind in four temperaments: melancholy, sanguine, phlegmatic, and choleric.[29] He considered the leopard to be the "most subtle, cruel, restless creature and at the same time the most beautiful of all the carnivorous animals of the cat kind."[30] Hardly visible in the earlier *Peaceable Kingdoms*, the leopard now stretches benignly before us in later versions, all its cruelty gone and only its beauty left. But, it was with the lion that Hicks identified himself. The lion's face reflects his own changing contours, anxieties, frustrations and hopes. But in the later paintings, the lion, too, has found its peace and, being no longer carnivorous, the Hicks lion, like Isaiah, "shall eat straw like the ox" (Isaiah 11:7), or, to use Hicks' own paraphrase, "While the old lion, thwarting nature's law, Shall eat beside the ox the

barley straw." Indeed, Eleanor Price Mather has convincingly shown that Hicks' final vision of peace is symbolized by the lion eating straw with the ox, rather than by the vines and olive branches of the earlier versions.[31]

In the *Peaceable Kingdom*, the child leads the animals, either with a gentle arm about the beast's neck or, in the later versions, by a slender, slack ribbon. But the particular animal associated with the child varies between the leopard and the lion.

The various *Peaceable Kingdoms* roughly parallel the sequence of Hicks' own pilgrimage. The first ones represent a more earthly hope, that the kingdom is present, working its way in the world, represented particularly by the inclusion of Penn's treaty. The second group represents the new universal claims of the efficacy of the spirit in the light of the Hicksite development. The third and final development represents the vision born afresh—secure, peaceful, but eschatologically in the future.

If the *Peaceable Kingdoms* of Hicks have eschatological overtones, so does the battle scene in John Trumbull's *Joshua Attended by Death at the Battle of Ai* (Plate 32), also known as *The Conquest of Canaan* (sepia and wash, Fordham University Library, 1786; oil, Yale University Art Gallery, 1839–40). While the Joshua saga has to do with the conquest of the land of Canaan, the particular reference here, as Professor Jaffe of Fordham has pointed out, refers to Timothy Dwight's 1785 poetic version of the events, *The Conquest of Canaan*. Patricia Mullen Burnham also connects Joshua with Trumbull's hero, George Washington, to whom Dwight dedicated his poem.[32] On the back of the sketch are found the four middle lines from the following, more extensive quotation from Dwight's poem:

> So, loud and furious, Israel throng'd the fight,
> And their blue armour flash'd a dreadful light;
> O'er the pale rear tremendous Joshua hung;
> Their gloomy knell his voice terrific rung;
> From glowing eyeballs flash'd his wrath severe,
> Grim Death before him hurl'd his murdering spear;
> Heads, sever'd from their necks, bestrew'd his way,
> And gushing bodies round his footsteps lay.[33]

Timothy Dwight (Plate 26), Trumbull's cousin, was a a theologian, president of Yale, writer, traveler, preacher, poet, and a proponent of revivals against the so-called "infidelity" represented by rationalists and deists. His poetry, popular though not universally appreciated even in his own time, dealt with moral themes and contemporary issues. He considered *The Conquest of Canaan* to be a Miltonic epic, and, like the *Iliad* and the *Aeneid*, it transcended historic boundaries, providing opportunites of exhibiting the agreeable, the novel, the moral, the pathetic, and the sublime. The poem, while dealing with the conquest of Canaan, also provides occasion for moving from creation to the fulfillment of history, in which America will play a final, definite role. There is an analogy between Canaan and the new world. Moreover, Dwight quotes Longinus' *A*

Dissertation on the History, Eloquence and Poetry of the Bible, and consciously models his work on the criteria set out in Lord Kames' *Elements of Criticism*, a modified version of Burke. Hence, grandeur and sublimity are featured. The fury evident in Nature and in warfare demand a poetic prowess, so that the poet John Trumbull, cousin of the painter, suggested that Dwight "should have supplied his poem with a lightning rod."[34] Indeed, the passages quoted above are preceded by a delineation of the fury of nature, to which the fury of Israel and Joshua are compared. While the figure of Death is not a part of the Joshua story, it is a part of the artistic tradition. It is surely not by accident that Trumbull, who had studied with West, chose this passage featuring "Grim Death." As in West's *Death on a Pale Horse*, Death actively hurls a spear, the horses and human figures exhibit terror at Death, and destruction is everywhere. But in Trumbull's version, Joshua defiantly and confidently walks in the midst of destruction, a noble figure in the heat of battle.

The figure of Death, while in this instance not based directly on an Old Testament theme, is delineated also in Rembrandt Peale's *The Court of Death* (Plate 89). This painting, too, is based on a poem, a popular poetical essay on death by the evangelist, Anglican bishop and friend of George III, Beilby Porteus. *The Court of Death* illustrates these lines:

> Deep in a murky cave's recess,
> Lav'd by oblivion's listless stream, and fenc'd
> By shelving rocks, and intermingled horrors
> Of yew and cypres' shade, from all intrusion
> Of busy noontide beam, the Monarch sits
> In insubstantial majesty enthron'd[35]

Death, the central figure, is draped in the classical manner and is powerful in form and intent on judgment. Before Death lies a corpse, and on each side are figures representing the baleful destiny none can escape. The poem in its entirety includes the "minister" of death represented in old age, and allegorical figures representing fever, consumption, palsy, gout, rheum, dropsy, asthma, etc. But the warrior may be more a concession to Peale's memory of West's *Death on a Pale Horse*, upon which he felt he had improved, rather than a reference to Porteus' poem. Theologically, Porteus' poem is traditional, centering in the sin of man and the conditions of redemption, while Peale accents in the painting the plight of humanity in the hope that humans might apply their own remedy: if one flees both war and intemperance, representing the two foci of all evils, one can, like the old man, approach death in utter trust.

Peale's *Court of Death* had a moral message, bordering on the religious, while Porteus' poem had a religious message, bordering on the moral. Peale sidetracked the traditional Christian content and, indeed, felt that he had created an approach to such subjects not heretofore known in history. His approach, he said, while based on the ancients, avoided traditional allegory and mythology in favor of "embodying thought, principle and character."[36] He wanted to affect

the heart without doing violence to the understanding. A pamphlet accompanying the exhibition of the immense painting said it represented "painting applied to its noblest purpose,—the expression of moral sentiment."

Rembrandt Peale felt he had succeeded in *The Court of Death*. He was not only moved by his own creation; he discovered that it was understood "by the unlearned and the learned." The success of the painting is evident in that during its thirteen-month tour, the painting earned more than nine thousand dollars.[37]

The extensive production of mourning pictures, alluded to previously, also belongs to the category of sentimental art. Evangelical religion appealed to the emotions, trying to influence conduct and induce conversion through keeping the thought of death and its consequences before individuals. It is interesting that the dread of death, the silent presence of its reality, was preferred by evangelical groups to explicit Christian subject matter, such as the Crucifixion. In part, such subjects as the Crucifixion had been rejected as part of the Roman Catholic tradition. But more importantly revival religion, whether in the evangelical sense or the more revivalistic form, stressed, not the objective events in the Christian drama, but the states of soul to which the Christ-event was addressed.[38]

Alternations between the sublimely violent and the sublimely peaceful are evident in Washington Allston's paintings of Old Testament themes. Allston was reared on a plantation in South Carolina from which experience he recalled tales of eerie happenings; he prepared for college in Newport, Rhode Island, went to Harvard, where he carried on a vigorous social life and where he wrote poetry and also painted. In 1801, Allston studied painting in England. In 1803 he visited Paris and from 1804 to 1806, he visited Italy, where he had many associations, including the beginning of his lifelong friendship with Coleridge. The years 1808 to 1811 were spent in the Boston area; 1811 to 1818, in England; and the remainder of his life, until 1843, in the Boston area, particularly Cambridge.

Allston's first major painting was *The Dead Man Revived* (Plate 90), based on II Kings 13:20–21. In art, the subject is rare, to be found only occasionally as for example in a late medieval, moralized Bible. The story itself is brief:

> So Elisha died, and they buried him. Now bands of Moabites used to invade the land in the spring of the year. And as a man was being buried, lo, a marauding band was seen and the man was cast into the grave of Elisha; and as soon as the man touched the bones of Elisha, he revived, and stood on his feet.

Short as the passage is, it provided a dramatic possibility for Allston of interrelating the actions of the witnesses to a drama, each of whom responds differently. Indeed, Allston vividly describes his own conception.

> The sepulchre of Elisha is supposed to be in a cavern among the mountains, such places, in those early ages, being used for the interment of the dead. In the foreground is the man at the moment of reanimation, in which the artist has attempted, both in action and color, to express the gradual recoiling of life upon death. Behind him, in a dark recess, are the bones of the prophet, the skull of which is peculiarized by a preternatural light. At his head and feet are

two slaves, bearers of the body, the ropes still in their hands, by which they
have let it down, indicating the act that moment performed; the emotion
attempted in the figure at the feet is that of astonishment and fear, modified
by doubt, as if still requiring further confirmation of the miracle before him;
while in the figure at the head, is that of unqualified, immovable terror. In the
most prominent group above is a soldier in the act of rushing from the scene.
The violent and terrified action of this figure was chosen to illustrate the mira-
cle by the contrast which it exhibits to that habitual firmness supposed to pro-
ceed from no mortal cause. The figure grasping the soldier's arm, and pressing
forward to look at the body, is expressive of terror overcome by curiosity. The
group on the left, or rather behind the soldier, is composed of two men of two
different ages, earnestly listening to the explanation of a priest, who is direct-
ing their thoughts to heaven as the source of the miraculous change; the boy
clinging to the young man is too young to comprehend the nature of the mira-
cle, but, like children of his age, unconsciously partakes of the general
impulse. The group on the right forms an episode consisting of the wife and
daughter of the reviving man. The wife, unable to withstand the conflicting
emotions of the past and the present, has fainted; and whatever joy and aston-
ishment may have been excited in the daughter by the sudden revival of her
father is wholly absorbed in distress and solicitude for her mother. The young
man, with outstretched arms, actuated by impulse (not motive), announces to
the wife by a sudden exclamation the revival of her husband; the other youth,
of a mild and devotional character, is still in the attitude of one conversing—
the conversation being abruptly broken off by his impetuous companion. The
sentinels in the distance, at the entrance of the cavern, mark the depth of the
picture and indicate the alarm which had occasioned this tumultary burial.[39]

The painting is large and is replete with dramatic action. Leslie records that
Allston "modelled in clay (of small size) the principal figure, over which he cast
wetted drapery; and he also modelled the head very finely, of the size of life."[40]

This was Allston's first major painting. He had woven many of his memories
into the work. Among them were the childhood memories of stories which
terrified and attracted him; the vision of nature exhibited in the paintings of
Salvator Rosa and Claude Lorrain, in which one found both the terror and the
peace of nature; the theory of the sublime, that was expressed in Burke's famous
eighteenth-century essay and was illustrated in such works as Benjamin West's
Death on a Pale Horse. Then there was the memory of associations with
Germans of a religious and romantic bent in Italy, a knowledge of German
romantic writings, and a close association with Coleridge. Finally, there was the
classical notion of the ideal, in which a trans-worldly concept is given this-
worldly expression, transcending all its known individual manifestations.

Partly as a result of over-exertion in painting *The Dead Man Revived*,
Allston's health failed and he was advised to leave London. Indeed, so frail and
uncertain was his health that Morse, Leslie, and Coleridge tried to give what
help they could. After his recovery and the return of the Allstons to London,
Mrs. Allston became ill and died early in 1815. In the agony of those months,
Coleridge played a significant role in Allston's life, giving encouragement and
advice. It was apparently in this setting and under Coleridge's influence that

Allston became an Episcopalian. Moreover, Allston's sensibilities were closer to the Episcopal Church of the time than to the Protestant heritage generally. Later, however, when Allston married Martha Dana, he joined and became active in the Shepherd Congregational Church in Cambridge, at which time he also did a design for its building.

In the period from 1816 to 1820, Allston executed several religious subjects of a diverse nature. Reference has already been made to his *Rebecca at the Well* (1816, Fogg Museum of Art). This was followed by *Jacob's Dream* (1817, Petworth, England), the next year, and *Elijah in the Desert* (1818, Museum of Fine Arts, Boston) in the succeeding year. There is also reference to an unlocated painting from the same period entitled *The Repose in Egypt*. In 1820, Allston did two religious subjects, *Jeremiah Dictating His Prophecy of the Destruction of Jerusalem to Baruch the Scribe* (Plate 91), done in a massive classical style; and *Saul and the Witch of Endor* (Mead Art Gallery, Amherst), more in the tradition of the sublime. In 1821, he did a painting entitled *Miriam the Prophetess* and, in 1835, the *Evening Hymn* (Montclair Art Museum), a painting that is more Italian and romantic in mood than iconographically religious.

In 1817, Allston began a painting that was to preoccupy, if not haunt, him until his death in 1843. He began the sketches for *Belshazzar's Feast* in 1817, and, in 1818, he began the canvas itself. We have Allston's own excited account of his early work on the *Belshazzar's Feast* in his letter to Washington Irving, May 8, 1817.

> Your sudden resolution of embarking for America has quite thrown me, to use a sea phrase, all aback. I have so many things to tell you of. . . . One of these subjects (and the most important) is the large picture I talked of soon beginning; the Prophet Daniel interpreting the handwriting on the wall before Belshazzar. I have made a highly finished sketch of it, and wished much to have your remarks on it. But as your sudden departure will deprive me of this advantage, I must beg, should any hints on the subject occur to you during your voyage, that you will favor me with them, at the same time you let me know that you are again safe in our good country. I think the composition the best I ever made. It contains a multitude of figures, and (if I may be allowed to say it) they are without confusion. Don't you think it a fine subject? I know not any that so happily unites the magnificent and the awful. A mighty sovereign surrounded by his whole court, intoxicated with his own state, in the midst of his revellings, palsied in a moment under the spell of a preternatural hand suddenly tracing his doom on the wall before him; his powerless limbs like a wounded spider's shrunk up to his body, while his heart, compressed to a point, is only kept from vanishing by the terrified suspense that animates it during the interpretation of his mysterious sentence. His less guilty, but scarcely less agitated, queen, the panic-struck courtiers and concubines, the splendid and deserted banquet-table, the half-arrogant, half-astounded magicians, the holy vessels of the temple (shining, as it were, in triumph through the gloom), and the calm, solemn contrast of the prophet, standing like an animated pillar in the midst, breathing forth the oracular destruction of the Empire! The picture will be twelve feet high by seventeen feet long. Should I succeed in it to my wishes, I know not what may be its fate; but I leave the

future to Providence. Perhaps I may send it to America.[41]

The painting (Plate 92), still unfinished at the time of Allston's death in 1843, became, as William H. Gerdts has suggested, both Allston's "holy grail and albatross for more than a quarter of a century."[42]

Gerdts calls attention to the many painters who were fascinated with Belshazzar since the Renaissance, and notes Handel's 1745 Oratorio with its Belshazzar theme. Nor should the significance of Rembrandt's *Belshazzar's Feast* be forgotten, even though, as we have previously mentioned in connection with Benjamin West, Rembrandt stressed the feast itself rather than the moral significance of the event, which was so central to eighteenth and nineteenth century painters. In the eighteenth century, Benjamin West did a *Belshazzar's Feast* (Berkshire Museum, Massachusetts), exhibiting the painting in 1776. Allston's choice may have been partially dictated by the hope of outdoing his master, Benjamin West. Moreover, Allston, with his literary interests, would certainly have been aware of the new interest by writers in the Belshazzar theme, of which Lord Byron's 1815 "Vision of Belshazzar" is an example. According to Gerdts, general fascination with the theme may also stem from the conviction that "Belshazzar's fate was recalled as a warning to future Napoleons."

In 1820, John Martin, an English friend of Allston's, exhibited his melodramatic and highly successful *Belshazzar's Feast*. Indeed, so successful was Martin's exhibition that West's painting of the same subject was exhibited again, along with Martin's at the British Institution. A brochure circulated at the time included a major part of the Reverend Thomas S. Hughes' poem on Belshazzar. All of these occurrences Allston followed with great interest from the United States, to which he had returned in 1818.

Allston's English friends regretted his return to the United States. Allston had left England precisely at the height of his success. Many believed that he would have successfully completed *Belshazzar's Feast* in the congenial atmosphere of artist friends in England. There are also those who feel that his productivity diminished in the isolation of Boston and Cambridge, but E. P Richardson has documented his extensive productivity quite apart from his trials over *Belshazzar*. We shall not review here the problems caused by his financial need to do other paintings, the necessity for a studio large enough to work on *Belshazzar*, the pain caused by the criticism of the elderly and successful Gilbert Stuart, who told Allston that his perspective in the *Belshazzar* was wrong. To these problems was added the psychic pressure of indebtedness to the group of Bostonians who contributed funds so that Allston could work full time on this large painting.

By the time *Belshazzar* could be worked on without other restraints, Allston found it nigh impossible to complete it. Increasingly, too, at this time, Allston turned to literary matters. The events surrounding *Belshazzar* remain confusing. From 1817, when he began the painting, to 1843, the year of his death, is a long period of time. While artists frequently return to earlier themes or finish earlier work, Allston was almost continually preoccupied with the Belshazzar problem.

The simplest explanation is that by the time Allston found solutions to the problems already noted, his own orientation and interests in painting had changed so much that the melodramatic, complex scenes of wonder and terror no longer had an interest for him. Gone was the day of his own interest in subjects such as his own *The Dead Man Revived* or Benjamin West's *Death on a Pale Horse*.

But Allston continued working on his *Belshazzar* unto the very end, and when friends entered his studio after his death, they discovered that he had just painted out the central figure of Daniel. After a consultation, it was decided to remove this layer of paint, thereby again exposing the full expanse of the painting, even though various parts are not in consistent scale with each other. Nonetheless, in its incomplete state it is still an imposing painting.

Allston had a cosmopolitan spirit, but his return to this country when his recognition was at its height in England seemed to confine that spirit to a Boston environment with limited horizons. He was a thoughtful, reflective person, interested in literature and in his own writing—lectures, poems, novels—as well as in his painting. All who visited with him testified to his genial, somewhat pious spirit, and, above all, to his charm as a *raconteur* and conversationalist. He loved good food and cigars; he was a late worker and a late riser and was considered lazy by those whose habits and piety did not like turning night into day. But a tone of awe and gratitude resonates in the accounts of his friends. He must have possessed an unusual degree of what we now call presence.

Central to Allston's conception was the conviction that art was a vehicle of religious expression in which other-worldly powers and realities were given sensuous form without becoming this-worldly. His was a unique romantic vision, but he rejected traditional conceptions of the sublime. The beautiful in and of itself, if it represented more than transitory particularity and had the character of ultimacy, partook of sublimity. His art, whether signifying the terror or peace in nature, the Greek ideal, the rebirth of nature, or eerie or romantic stories, reflected dimensions not encompassed by abstract reason, pious sentimentalism, or Transcendentalism. Indeed, Allston's orientation must be sharply distinguished from Transcendentalism. Allston's vision centered in the operation of trans-worldly powers, whether expressed in the revival of the dead man, the eerie presence of ghosts, or the inspiration of Jeremiah. Transcendentalists were idealists, who posited a reality of spirit, symbolized definitively in the immortality of the soul, alongside the world of sense and materiality. For them it was not, as for Allston, that powers invaded this world; for Transcendentalists, the dimensions of another world were affirmed to be synonymous with the ideal, with the spirit in man.

Allston's vision is akin to that of Coleridge, with whom he spent time in both Italy and England. Both associations with Coleridge antedate the New England Transcendentalist movement. Moreover, the Coleridge Allston knew was also a churchman and an interpreter of the romantic tradition through the eyes of Schelling. Both of these elements were absent from American Transcendentalism, which was less philosophical, less traditionally religious, and more literary in

orientation. Moreover, Coleridge's work was not introduced to New England until 1825 and then only in the form of Coleridge's *Aids to Reflections*. In short, Allston is not to be seen through the eyes of our associations with his brother-in-law, William Ellery Channing, the great Unitarian preacher, or of the sage of Concord, Ralph Waldo Emerson.

Further, Allston did not share the optimism of the Transcendentalists. He had his own ideas of the world. The Transcendentalist stirrings left him cold, and he retreated from stirrings he did not believe in. Transcendentalists used Allston, but Allston had his reservations and ignored them. It was impossible to reconcile the Transcendentalist idea that nature revealed another realm with Allston's conviction that the other realms invaded and revealed themselves in and through nature.[43]

Allston had a religious temperament and did religious subjects. Yet his directly religious subjects numerically are less than a sixth of his work. But some of them are his most important paintings, both in his own eyes and in those of modern critics. In another sense, most of his paintings are religious. He might well be called the painter of the mysteries, in which diverse transworldly factors inhabit and touch upon human existence. His paintings do not tell us of the grandeur of God or man; rather, they alternate between the forces which dramatically affect life, as in the more secular *Flight of Florimell* (Detroit Art Institute), based on Spenser's *Faerie Queene* or the more specifically religious subject, *Saul and the Witch of Endor*, and affirmations of the quiet mystery present in our existence, as in *Moonlight Landscape* or the *Evening Hymn*. Even his portraits are the bearer of a respectful regard for the mystery of life, and were undertaken only when he had a positive view of the sitter.

Allston's specifically religious subject matter was mainly taken from the Old Testament. His romantic vision was undoubtedly served better by its dramatic possibilities. Moreover, his hesitations over the painting of the Christ figure, which will be discussed in a later chapter, may have had an inhibiting effect. His few New Testament subjects, such as the *Angel Releasing St. Peter from Prison*, and the proposed *Three Marys at the Tomb*, studiously avoid the Christ figure. He did sketches for *Christ Healing the Sick* (Plate 93), but he never did a painting from the sketches.

While many of Thomas Cole's late religious works center in the New Testament, he did do a number of paintings of Old Testament subjects. Although his *Garden of Eden* is either not extant or unlocated, the *Expulsion From the Garden of Eden* (Plate 41) represents a significant Old Testament subject in which nature and humanity are inextricably linked.

In the *Expulsion from the Garden of Eden*, the right side of the painting discloses an orderly, radiant nature, while on the left, nature itself shows the scars of the Fall, as if it participated in humanity's act. The loneliness of the figures is not unlike the barren, unfruitful nature. Both seem to mourn a lost God. It is as if creation and fall were delineated in the same painting. In the New Testament subject, *John the Baptist Preaching in the Wilderness* (Plate

40), the flaying arms of John the Baptist are not unlike the diagonal precipices and angular thrusts of nature.

Too much has been made of the puniness and irrelevance of human figures in the vastness of nature in Cole's paintings. Humanity and nature participate in a common destiny, for which nature provides a dramatic and more pronounced vehicle than the figures themselves. Nature represents the theater, not the stage of humans. Cole represents a religion of nature, but it is not the orderly nature on whose basis philosophers and natural theologians posit the nature and reality of God. Rather, it is a dynamic, historic nature, mirroring the drama of humanity's destiny and fate.

Two artists whose major works lie in the second half of the century did significant paintings of Old Testament subjects. William Rimmer, who in his early life painted New Testament themes and whose *Massacre of the Innocents* (n.d., Amherst) is extant, did the *Coronation of Esther* (1847, Amherst), which is actually based on an eighteenth-century tapestry, which can be seen at Windsor Castle. Interesting in our day, and as a composition, is *Flight and Pursuit* (Plate 94), or as it is also called, *Oh, For the Horns of the Altar*. Based on the story of Solomon and Adonijah, in which the latter seeks safety in clutching the horns of the altar (I Kings: 1:49–53; Exodus 27:2), the painting probably reflects the Rimmer family history of believing that they could become the victims of political pursuit. In our time, the issue of seeking sanctuary in temple or church has taken on a new urgency.[44]

Imaginative and powerful in conception and execution are *Evening: Fall of Day* (Plate 121) and the drawing of *God the Father Creating the Sun and the Moon* (Plate 95). Jane Dillenberger has identified the former as based on the passage of Ezekiel, "How art thou fallen from heaven, O Lucifer, son of the morning! How art thou cut down to the ground!" Hence, the painting might also be called *The Fall of Lucifer. God the Father Creating the Sun and the Moon* is dominated by a Michelangelesque God figure, surrounded by the symbolism of sun, moon, Trinity. Albert Pinkham Ryder's *Jonah* (Plate 96) draws attention alike to the plight of Jonah, and to God the father. Ryder's God gives the traditional gesture of blessing, but, oddly enough, with his left, rather than his right hand. This dynamic figure of God hovering above the turbulent waters of the deep and William Rimmer's *God the Father Creating the Sun and the Moon* are two of the rare representations of deity by mainstream American artists of the nineteenth century.

10

The Christ Figure and New Commissions

Some American artists had no difficulty in dealing with the Christ figure; some found it impossible to do so; some, one might add, should have had more restraint in dealing with it.

We noted that the Moravian, John Valentine Haidt, had no hesitation in painting the Christ figure, and, of course, the figure is central to the Lord's Supper in the painting attributed by some to Hesselius. Moreover, Benjamin West repeatedly painted the Christ figure, as is evident in his several versions of the *Lord's Supper*, various paintings on the theme of *Suffer the Little Children*, *Christ Healing the Sick*, the *Messiah* and the *Ascension* for the proposed chapel of the History of Revealed Religion for George III's private chapel. John Singleton Copley, too, had painted the Christ figure in his *The Ascension* (Museum of Fine Arts, Boston), a painting done soon after he left the Colonies for England for the rest of his life. Known more for such paintings as *Watson and the Shark* and the *Death of Chatham*, Copley nevertheless did a few religious subjects, of which *The Ascension*, executed under the influence of a trip to Italy, is undoubtedly the most significant. In this painting, Christ's Ascension and the disciples who witness the event are in two separate zones. Copley tells us that he meant to accent both aspects, the event itself and the reaction of the disciples, in accord with the Book of Acts.[1] John Trumbull, too, provides a figure of Christ in *The Woman Taken in Adultery* (Plate 97) and in *Our Saviour and Little Children* (1812, Yale University Art Gallery). The Christ figures are obviously in the tradition of West.

It was precisely the facile representations of the Christ figure, such as those of West, which contributed to Allston's refusal to paint the figure. Allston did two sketches for *Christ Healing the Sick*, now in the Fogg Art Museum (Plate 93) and in the Worcester Art Museum, a theme which had so engaged West. However, in a letter dated June 13, 1816, Allston turned down a request from James McMurtrie of Philadelphia to do a painting from the sketches.

> Upon considering the sketch some months since (though still pleased with the general arrangement), I found the principal incident so faulty and inefficient, and myself, at the same time unable to suggest any one better, that I was forced to come to a resolution of relinquishing it altogether; or, at least, to lay it by for some future and more propitious period, in the hope that my imagination might then supply a more suitable incident. I may here observe that the

universal failure of all painters, ancient and modern, in their attempts to give even a tolerable idea of the Saviour, has now determined me never to attempt it. Besides, I think His character too holy and sacred to be attempted by the pencil.[2]

In a letter to the artist John F. Cogdell a decade later, December 21, 1828, Allston returns to the question of portraying the figure of Christ:

Your account of Mr. West's picture, as well as I recollect it, seems to me very just; and I perfectly agree with you in your criticism of the figure of the Saviour. Yet Mr. West has only added one to the uniform failures of all his predecessors. It is, indeed, as you have truly said, "a face no mortal has ever or can ever portray." And it is one which I have long since resolved never to attempt.[3]

But if he found the execution of the Christ head too difficult to do, he found his 1814 *Agony of Judas*, though the best he had done, so dreadful that he destroyed it. R. H. Dana, Jr., records Allston saying:

The finest head I ever painted, and for effect the best thing I ever did, or ever expect to do, was the agony of Judas, which I painted in Bristol, England. I showed it to a few friends who said that its effect upon them was as dreadful as it was upon me; but I destroyed it in a few days, and for reasons which perhaps I could not make others understand as I felt them. It was not merely the distress I felt at looking on it, for I might have disposed of it and never seen it again, but I could not endure the thought of deriving an intellectual gratification or professional reputation and pleasure from what I believe to be so dreadful a reality.[4]

In his new Christian consciousness, Allston found the Christ figure too holy to paint and the Judas too dreadfully sublime to permit its actual existence. While such an attitude has a limited theological cogency, it is doubtful that it ought to have an artistic one.

Allston's hesitation to do the Christ figure was shared by Robert W. Weir, instructor in painting at West Point, and instrumental agent in the erection of the Episcopal Church of the Holy Innocents, just south of West Point. In a letter to C. S. Henry, reprinted by Henry in an article in *The Crayon*, Weir tells us why. He remarks that in the early Church, to which all now want to conform, symbols were used to convey Christ's meaning, such as a cross, an anchor, or a ship. Moreover, he recalls the use of Old Testament events to signify the New.

When the mysteries of His birth, action, sufferings, resurrection and ascension were represented, it was done by depicting the corresponding events in the Jewish prophecies, which of course, only intimated the ideas they contained; as Moses striking the rock—the spiritual Rock from which they drank; Abraham sacrificing his son—the Crucifixion; Daniel in the lions' den, or Jonah—the passage through the Valley of Death; Elijah ascending to heaven—the Ascension of Christ, etc.[5]

In contrast to such hesitations in the early Church, Weir comments on the current lack of restraint in depicting the "Lamb of God, our awful Judge." For

himself, he cannot eradicate "a degree of dread arising from the awful character of Him, who bought us by His blood and is our Judge."[6] In a later interview for *Harper's*, he demurred again, but this time the sympathy and tenderness of Christ is stressed in contradistinction to his dread power. In that context, he wrote: "I painted the *Two Marys at the Tomb*, but left the figure of Christ to be imagined. I have often so left it. One feels a delicacy in even attempting the delineation."[7] Nevertheless, Weir did several paintings, now lost, which did include the Christ figure.

For Allston and Weir, the sublimity and religious significance of the Christ figure placed it beyond successful portrayal. But Weir, as did Samuel F. B. Morse, had additional reasons for being suspicious of art in relation to the Church. Weir, too, was troubled by Catholic life as he saw it in Italy. He was sure that an unbridled imagination, as contrasted with the moral purpose art must serve, was responsible for excesses that must be curbed. So art in the Church must be discreet and limited in scope, even though it represents a universal language as contrasted with the more concrete language of speech.[8]

It is interesting, if not ironic, that the reservations about Catholicism on the part of Morse and Weir is counterbalanced by a fascination that resulted in an exquisite painting by each of a Catholic subject. In the instance of Morse, it was the *Chapel of the Virgin at Subiaco* (Plate 98), and in the case of Weir, *Taking the Veil* (Plate 99). Weir had sketched the scene in 1826, when he observed the consecration of Carlotta Lorenzana in the church of San Guiseppe, Rome. While he exhibited a sketch of the scene in 1836 at the National Academy, the final painting was completed in 1863, some thirty seven years after witnessing the event.

Weir had clear ideas about the nature and placement of art in the church, which was harmonious with the spirit of the English Neo-Gothic churches that interested him. Wrote Weir:

> Let the symbol of the Crucifixion, the Altar of the atonement, the Record of the price, be our grand altarpiece; and the side-walls convey the precepts of Him who bought us; those acts of mercy—feed the hungry, clothe the naked, heal the sick, comfort the afflicted, etc., which would compel us to remember our duty as pledged followers of our Master.[9]

It is not clear, however, in Weir's statements whether he means that paintings on the walls that convey central affirmations and precepts are acceptable, or whether he prefers that the verbal precepts be painted on the wall. Weir used the expression, "pictorial thoughts." Certainly, the Anglican tradition in which Weir stood had a preference for the latter direction.[10] Gothic Revival churches frequently have scriptural quotations framed in decorative panels. Though the Middle Ages conveyed biblical subject matter by pictorial representation, the Gothic revival churches conveyed biblical subject matter by inscribed passages in accord with its verbal preoccupations. The Gothic Revival proponents had little appreciation of the place of painting and sculpture within a liturgical context.

Perhaps, when artists were not concerned with working within a liturgical setting, the problem was less acute. At least several additional painters can be said to have had no hesitation in representing the Christ figure, though in some instances their paintings have greater value as documents than as works of art. Among these are John Landis, *Jesus and the Apostles Reproving Thomas*, *Jesus in the Upper Room* (1836 version, Philadelphia Museum of Art); William Dunlap, *Christ Rejected*, *The Bearing of the Cross*, and *Calvary*; and John Quidor, *Christ Healing the Sick* (1849, not extant), and *Christ Raising Lazarus From the Dead* (1849, not extant). John Landis' Christ has the simplicity and the directness of the naive folk art tradition; William Dunlap showed no inhibitions in his melodramatic creations; in the case of John Quidor, we can only surmise what he did, since the paintings are lost. His *Two Marys at the Tomb* (Purchase, New York) leaves out the Christ figure.[11]

In the area of sculpture, both Horatio Greenough and Hiram Powers did Christ busts. Horatio Greenough thought the subject difficult, and recognized that it had been avoided in the American scene, but insisted that one must try to do it. He was unaware, it seems, as the following letter, apparently written in 1846, indicates, that William Page had painted a Christ figure in 1843, or that William Rimmer was doing several religious subjects, with the Christ figure, including the *Infant Saviour*, in 1845. Greenough wrote:

> I am not aware that any American has, until now, risked the placing before his countrymen a representation of Our Saviour. The strong prejudice, or rather conviction of the Protestant mind has, perhaps, deterred many. Not behind the most jealous in deprecating the abuse of images in places in public worship, I think, nevertheless, that the person and face of Our Saviour is a legitimate subject of art, because, although our conception must fall short of what the heart of the Christian looks for, yet you will allow that we may offer to many an imperfect instead of the mean or grovelling idea which they have drawn from other sources. The prayers and hymns of the most pious are as far unworthy the perfection to which they are addressed, as the lights and shadows of the artist; yet both may be accepted as fervent aspirations after the good and the beautiful. It is a mistake to suppose that the artist, because he stops working, thinks his task perfect; he says only—behold, the subject proposed to me as the art which is in me can give it.[12]

Greenough modeled at least two *Christ* busts, one of which, done in 1846 (Plate 100), became a companion piece to the *Lucifer* of 1842.[13] In this pair, the *Lucifer* has the handsome dynamism of a Byronic hero, and the *Christ*, by contrast, a quiet composure that verges on sadness. Indeed, the Lucifer is the more interesting conception and conjures up reminders of Allston's destroyed Judas. Neither the artists nor the theologians have apparently incorporated into their own thinking that the image of evil is generally more convincingly delineated than the good.

About the base of the Christ and Lucifer busts, a serpent coils prominently, the phallic heads differing in their position and expression. Under Christ, the serpent's head falls relaxed over its own coils, eyes and mouth shut. In the case of the

Lucifer, the mouth is open, fangs visible, and tongue extended as the serpent is about to strike. In the light of the prominence of the serpents, Greenough's observations about the famous classical Laocoön group are all the more interesting.

> In the group of Laocoön we never weary of admiring the palpitating agony of the father, the helpless struggles of the sons. The serpents, which are the causes of this pain and despair, are scarce noted; why? because the artist wished to chain our attention upon the human portion of the spectacle. He had no means of veiling the snakes in shadow; but he has veiled them in the mode of treatment. There is more imitation, undercutting, illusion, in one of the gray locks of the old man than in the serpents' whole form. Even their heads as they strike are made vague and indistinct. Do we suppose that the sculptor who made those limbs throb, and that marble mouth hot with pain, was blind to the beauty of the bossed hide and abdominal rings of a snake? This is impossible. He gave only enough of the snakes to tell the story, because the snakes were not subjects of his chisel, but the men. This is art; nay, this is pure art.[14]

If Greenough was at all true to his theory that the subject demands prominence, the striking presence of the serpent in both the Lucifer and Christ figures, in contrast to the Laocoön group, must be significant. Moreover, the fangs of the serpent beneath *Lucifer* are sufficiently exposed to indicate its striking power (made even more prominent now because part of the head was broken), while the head of the serpent beneath the bust of Christ, is relaxed in slumber or in having been strangled. Certainly the intention behind the serpent in the Christ figure is that the fangs have lost their power. The strangulation, or at least making the serpent benign, is specifically indicated in a written fragment of Greenough's that clearly corresponds to the actual execution of the serpent beneath the Christ figure. Speaking of the circle created by the serpent having its tail in its mouth as a standard, symbolic form, Greenough also points to another version of the circle, which he so clearly illustrated in his sculpture. "The circle is sometimes sought by giving the tail a double turn round the neck; thanks to God! the tail loses its power when the brain is isolated by the hug."[15] This assumes, of course, that the real power of the snake is in the tail. The eighteenth-century English Bishop Thomas Newton reports that the political figure, Mr. Pulteney, stated that the "heads of parties were somewhat like the heads of snakes which were urged on by the tail." Hence, Greenough represents a living tradition.[16]

The second Christ bust executed by Greenough (Fogg Museum) is more classical in form and lacks any additional iconographic detail.

Hiram Powers, too, was interested in the Christ figure. In a letter to the Reverend Philip Slaughter, July 7, 1852, Powers refers to a proposed group statue to be called the "Rose of Sharon." (Song of Solomon 2:1; Isaiah 35:2) While the extant copy of Power's letter has deteriorated precisely where one wants concrete information, it is clear from what remains that the Rose of Sharon, as a female figure, represents the Church, which is blessed by Christ, and both figures were to be included. Since this conception expressed a view probably associated

with Roman Catholicism, and contrasts sharply with the individual, non-Church orientation of Powers, it is a matter of regret that no more is known. While Powers thought the Pope ill-advised on specific issues, his letters show a warm regard over the years for the Roman Catholic Bishop John Purcell of Cincinnati, who had visited the Powers in Florence.

Powers did a Christ bust, of which the two marble versions are lost. The National Museum of Amercian Art owns three plaster busts, two fully modelled of the head and upper torso, and one with just the face and neck (Plate 101). These busts are interesting in the light of the correspondence between the patron, William H. Aspinwall, and Powers. Indeed, the full plaster models are significantly different at the points mentioned in the correspondence.[17]

Apparently on the basis of having seen the model, Aspinwall wrote to Powers from Milan on April 10, 1865, asking that the haughtiness and voluptuousness of the lower half of the face be changed by diminishing its fullness, thereby bringing it in line with the "benignity and sorrowful serenity of the upper features."[18] Aspinwall approved of the upper portion of the face because it corresponds to no other, that is, it is unique to the Saviour. But the bottom part, he adds, was consistent with an Apollo or victorious warrior, not the merciful Saviour. Powers' concern to show that "in reproof [Christ] was terrible," Aspinwall rejected, for he considered that to be an exceptional emotion and, therefore, not appropriate for an ideal bust. Aspinwall is interested in "gentle reproof." So he adds, with the authority of a patron, "I think you will either work the moustache very thin or diminish it in size."

But Powers did not readily accept Aspinwall's views. Two days later, he sent a reply, in which he stated that Aspinwall had understood him correctly. Powers said he was pleased that Aspinwall had

> found in the expression of the mouth a certain fullness indicative of the passions of men, though subdued, and under the restraint of the intellectual power shown in the upper part of the face, you have found precisely that I wished to reveal, and I regard your criticism as at least a high compliment to my design. Your remark that the mouth might be that of a warrior "who would strike back" or words to that effect pleased me much—not that I intended He would strike back, but that it was in Him to do so if He would, but as you have seemed to admit—the upper part of his face forbids—and here permit me to say a few words in regard to the province of the eyes and the mouth.

Powers then goes into a discussion of the respective significance of the eyes, that is the seat of mind and intelligence, and the mouth, that is, the arena where will is operative. In short, the top of the face is thus capable of expressing a serenity that the mouth is not. By implication, too, it is obvious that the mouth is the place where temptation is manifest. So Powers continued:

> It was not the Divine nature that was tempted for that is impossible, but the human nature—and this nature I have endeavoured to give in the mouth, while I have been vain enough—presumptuous I should say, to attempt a

Divine expression above the mouth.

The question is—shall I remove—far as my feeble ability can do—the human nature from the face? I can easily make a change. I do indeed know how to soften the mouth down to entire submission. But then how are we to conceive of an expression which made His reproof terrible? The dove cannot be terrible, nor can the lamb. We must have something of the eagle with the lion—that can and will strike back—as Christ Himself did on all just and proper occasions. He did not indeed strike with His arm, but His "words" smote His enemies, as enemies never man smite.

Powers then concludes by stating that the delineation of the mouth was not accidental, and, as far as he is concerned, he would prefer not to change it.

In June 7, 1865, Aspinwall replies, restating essentially his former position, on the basis of photographs of the bust:

What I wish to obviate is any voluptuous expression—or one which might indicate the indulgence instead of the repression of any sinful emotion. When we look at a man's face we are apt to impute to him the characteristics marked on the countenance—and unfortunately many a man is therefore misjudged—but this can be avoided in an ideal bust. Now as our Saviour never fared luxuriously, and was often badly lodged, we cannot expect him to have the fullness of a well fed man—but rather the reverse—and I think that you could take away a little of the fullness of the mouth without interfering with the firmness of expression of a man who could at times be terrible in reproof.

While Powers replied, April 7, 1866, that he was satisfied with the changes, he also made it clear that he

had the plaster cast of the bust moulded so that I might try some further experiments in a duplicate view to improvement for I feared to axe the model, [that] I might not satisfy myself so well, and regret that I had tampered with it.

While Powers expressed satisfaction with the changes, it does not necessarily follow that the final changes expressed his preference.

At the same time that Powers was laboring over his conception, William Wetmore Story was working on a white marble, standing, draped, seven-foot tall Christ figure (Museum of Fine Arts, Boston 1866-67), with the inscription in the base, "Come unto me all ye that are heavy laden and I will give you rest." The face is somber, but the countenance inviting, as is the gesture of the hand. Nothing is known about the genesis of the work, but it has been suggested that it may emerge from a personal religious interest on Story's part in later life.[19]

Moses Jacob Ezekiel, a Jewish artist conscious of being a Jew but believing that art transcended such designations, did several large religious subjects, in one of which, which was entitled *Israel*, the figure of Christ is incorporated, for the concept of the suffering Messiah refers for him both to Israel and to Christ. Most powerful is his Christ, *Ecce Homo* (Plate 102), a bronze upper torso with bowed head, bearded face and with a crown of thorns. Less impressive, because the full-length figure of Christ standing behind Phillips Brooks and his pulpit seems an

auxiliary to the figure of Brooks, is the statue outside Trinity Church, executed by Augustus St. Gaudens in 1910. The face of Christ is shadowed by a heavy hood, reminding one of the famous Clover Adams Memorial by St. Gaudens in Rock Creek Cemetery, Washington, D.C.[20]

The painter, William Page, did a bust of *Christ* (Plate 103), which was unlocated for some time and was recently discovered in a private collection. Like Powers, Page had a definite conception of what he wanted to convey. The painting, originally commissioned by Theodore Tilton, a poet and literary figure who was interested in Swedenborg and one-time editor of the Brooklyn *Independent*, was to convey the trans-wordly dimensions in this worldly form on the basis of the Swedenborgian notion of correspondences between the celestial and the terrestrial. Physical beauty and fullness of humanity were thought to be analogues and expressive of the divine. Anything less than full humanity would not have adequately expressed divinity. Hence, in this painting the concrete Jewish character of the Jesus gives way to an allegedly ideal physiognomy modeled on the Greek notion of beauty. Color abounds. Page's *Christ* has red hair, full red lips, beard of red, yellow, and green.

Such a conception was obviously criticized, but Tilton came to the defense of Page, suggesting that red lips meant they were full of love and red hair was the most beautiful of all. Indeed, flesh conveyed spirit, without the additional accompaniments of halo, dove, etc. According to the late Joshua Taylor, Page's interpreter, the theory of art expressed by Page meant that the sensitive portrait expressed the spiritual nature of the person. Hence, Page's *Christ* has its adequacy from the standpoint of the Swedenborgian understanding—though only then.[21]

The Christ figure and associated events were painted by Robert Loftin Newman, an artist relatively unknown in his own time. Paintings such as *Christ and Peter on the Sea of Galilee* (n.d., Portland Art Museum, Portland, Oregon), *Madonna and Child in a Landscape* (n.d., Tennessee Fine Art Center), and the *Good Samaritan* (Plate 104) are vivid in color, with the figure and landscape somewhat indistinct; but they are poetic and evocative in their effect. It should also be noted that the theme of the Good Samaritan, while executed by only a few professional artists, was much more popular in the folk art tradition.

Henry Ossawa Tanner did many religious subjects. Tanner, who was black, American Indian, and white, spent much of his artistic life abroad, where in the late nineteenth and early twentieth centuries there was relative freedom from race prejudice. Tanner's dedication to quality in art, as somehow above race and subject matter, kept him from being sidetracked by what he considered wrong and irrelevant questions. Tanner's biblical works are powerful in that they combine the aura of biblical lands, strong figural form, and a soft palette. His *Saviour* (Plate 105) and *The Annunciation* (Plate 106) evoke our sentiment without being sentimental.[22] It is interesting to note that both black and Jewish artists have created works of art with religious themes, without sentimental self-consciousness or secularization.

A transformation and, to varying degrees, secularization did happen in the work of some artists. In Abbot Thayer's *Virgin Enthroned* (Plate 107), we see the secularization of the inherited tradition, for in this painting a family group is arranged in a traditional religious iconographical format. In the instance of Elihu Vedder, the transformation tends toward new perceptions. His *Lazarus* (Plate 108) paintings (Museum of Fine Arts, Boston; J. B. Speed Art Museum) are powerful portrayals in which the psychic stress is more dominant than would be the case in more traditional interpretations. Vedder's *Star of Bethlehem* (n.d., J. B. Speed Art Museum, Louisville, Kentucky) is a visionary piece, ambiguous as to whether its religious or landscape aspects dominate. The *Soul Between Doubt and Faith* (The Baltimore Museum of Art) shows the ambiguity of faith itself. At the same time, as Jane Dillenberger has shown, the series of drawings accompanying Fitzgerald's *Rubiayat* reflects a Christianizing of the poem.[23]

This transformation of the tradition with its ambiguous nuances is surely evident also in William Page's *Christ* (Plate 103), previously discussed. In an arresting way, it is evident, too, in Thomas Eakins' life-sized *Crucifixion* (Plate 109), a subject that had been largely absent in the American scene. In Roman Catholic, Lutheran, and to a lesser extent in Anglican churches, one found, to be sure, crosses with a corpus, but one did not find significant works of art on this theme. There are a few exceptions in folk art, but these lie outside the main English painting tradition. Both Elihu Vedder and A. P. Ryder essayed the crucifixion theme, but in both instances it is events associated with the central event rather than the Crucifixion itself that have become the theme of the painting. Vedder's *Ninth Hour: Crucifixion* (Plate 110), of which there are additional versions, center on the people leaving, not on the crucifixion event. Ryder's *Way of the Cross* or *Story of the Cross* evokes associations with the event but not the event itself. But Ryder was not hesitant about the figure of Christ, as is seen in two versions of the *Resurrection* in which one sees Christ and the Magdalene in the garden, namely the *Resurrection* (Plate 111) and *Christ Appearing to Mary* (Plate 112). We also know that William Rimmer executed a traditional Crucifixion, but it is not known to be extant.

In Protestantism generally and among the artists who loosely belong to that tradition, the Crucifixion theme is absent from their art. American Christianity in the eighteenth and nineteenth centuries, first, was interested in creating sentiment and experience and second, it was too optimistic for the Crucifixion to have symbolic centrality. It is interesting, if not ironic, that the Crucifixion should reemerge in the art of the skeptics, Thomas Eakins and John Singer Sargent, and that neither delineation has a church setting.

While the subject matter of the Crucifixion is unique in Eakins' oeuvre, it is treated in a vein similar to that of his portraits. Accuracy of delineation was his intention, and he had his student and friend, John Laurie Wallace, strapped to a cross erected on the roof of Eakins' third-floor studio in order to study the muscular and anatomical detail of his body in the outdoor light and sun. The human form in all its dignity, its grandeur and fragility, discloses a depth beyond all

realism. Eakins' *Crucifixion* profoundly touches religious depths.

Like most of the works of art with religious subject matter, Eakins' *Crucifixion* stands outside a liturgical setting. There were efforts, however, to reintroduce paintings into Episcopal churches in the last three decades of the nineteenth century. Unfortunately, Robert W. Weir's *Evening After the Crucifixion*, an altar piece in a church in Troy, New York was destroyed in a fire in 1895. The major reintroduction of religious paintings, including the Christ figure, emerged through the work of the Roman Catholic artist, John LaFarge, for Trinity Church, Boston, and for churches, mainly Episcopal, in New York City. An interesting, but slightly incongruous note, is that LaFarge also did extensive decorative, non-representational work for a Congregational church in Newport, Rhode Island.

LaFarge was a literate, sensitive person, who first studied in Couture's studio in Paris and then with William Morris Hunt in Newport, Rhode Island. Friend of William and Henry James, he also became a traveling companion of Henry Adams, first to Japan in 1866, to the South Seas in 1890-91, and then to Chartres in 1899. While not necessarily believing in art for art's sake, LaFarge was clear that no practicing artist could accept Ruskin's views on morality and art.[24] Influenced by Japanese prints he had seen early in his life and by subsequent travel to the East, LaFarge was impressed by the diverse, yet related, modalities in both life and art.

LaFarge's work can be divided among his easel paintings, mural paintings, and stained glass. While now known more for his stained glass (partly because of his discovery of an intensely opalescent glass), LaFarge's paintings of still life and flowers and his non-religious subjects, such as his Japanese and Samoan paintings, are greatly valued by critics today.

An interesting example of his easel paintings is the *Halt of the Wise Men* (Plate 113). It shows us both the style and type of subject matter that became so important in his mural paintings for Episcopal churches.

Mural designs by LaFarge may be seen at Bowdoin College, Maine; the Baltimore Courthouse; and the Supreme Court room in the St. Paul Capitol building, St. Paul, Minnesota. The latter two exhibit the vision of LaFarge, in which the East and Greece are united. Eastern and Greek figures and themes are both present, and, in the scheme for the Supreme Court room, St. Paul, Minnesota, Moral and Divine Law (Moses) are included along with the Recording of Precedents (Eastern Religion) and the Relation of the Individual to the State (Greece).

Prior to his exposure to the East, LaFarge was chosen by the architect, Henry Hobson Richardson, and the rector Phillips Brooks, to do major work for the new Trinity Church building in Boston. Based on Romanesque buildings in Europe but adapted to the requirements of the plot of land, the building was designed to fit the views of Phillips Brooks, that is, of a Catholic tradition of word and sacrament which existed prior to the Medieval development.

Romanesque buildings generally provided better space and light for painting

and decorative motifs than did Gothic churches. Trinity which was Romanesque in style was no exception.

LaFarge was given responsibility for the artistic development of the inside of the new Trinity, and he provided not only paintings, but also the gold leaf decorative motifs, which surrounded and integrated the decorative scheme. The haste with which the work had to be done may account for the fact that there is no consistent scheme and that the subjects and their placement at best make decorative and architectural sense. There is no religious scheme, as for example, in West's *History of Revealed Religion* or in Sargent's scheme for the Boston Public Library across the street. Subjects are taken from the Old and New Testaments; but the basis for the selection is not known. Moreover, the quality of the painting is uneven, for, while LaFarge is responsible for the whole, assistants did much of the work. However, the paintings in Trinity Church are important, for there is no nineteenth-century American church in which works of art are so pervasively present in a church of comparable distinction.

Confining our consideration to the work done by LaFarge, we see above the high windows of the central tower twelve lunettes whose subjects are: over the east windows—*Journey Into Egypt, Madonna and Child, The Resurrection*; over the south windows—*Samson and the Lion, The Good Shepherd, Jonah and the Whale*; over the west windows—*Morning, An Allegory, Jewelled Cross, Evening, An Allegory*; over the north windows—*The Garden of Eden, The Peaceable Kingdom, Abraham and Isaac*. For each of the series of three, one could venture tenuous reasons for the association of those figures with each other; but no total plan would emerge. Alongside the high windows are painted crosses and biblical texts—a particularly prominent feature in Anglican churches even when there was no visual art—and the symbols of the evangelists: angel (St. Matthew), eagle (St. John), ox (St. Luke), and lion (St. Mark). On the wall spaces created where the arches form the tower are large figures: on the east wall—*St. Peter* and *St. Paul*; on the south—*Isaiah* and *Jeremiah*; and over the north wall—*David* and *Moses*. These large figures form a unity: David and Moses are associated with each other in the Anglican and Reformed traditions, for both figures represent the embodiment of the religion of Israel in the law and the nation, that is, a total religious society. The prophets Isaiah and Jeremiah are traditionally linked.

Moving from the tower of the crossing to the nave, we find a painting of *Christ and the Woman of Samaria at the Well*, between the clerestory windows of the north wall, and *Christ and Nicodemus* (Plate 114) on the south wall, both subjects suggested by Phillips Brooks. Both paintings are so high on the walls that viewing them is difficult. Even when the lights are on, there is a dimness, caused also in part by the low tonality of the paintings. There are no clues as to why Brooks should have selected them, but they are obviously related to each other in that each records a conversation based on water and the spirit. LaFarge designed several stained glass windows in Trinity Church, notably the large window on the west end, *Jesus Holding the Book*, particularly designed with Phillips

Brooks's preaching in mind.[25]

LaFarge did three mural commissions in New York City for Episcopal churches. The first, in 1877, for St. Thomas, destroyed by fire in 1905, consisted of two paintings of the Resurrection placed on each side of a reredos modelled by St. Gaudens. To the left of the reredos was the *Angel Appearing at the Sepulchre*; to the right, the *Three Marys at the Tomb*.

In 1885, he did two mural paintings for the Church of the Incarnation (Plate 115), centering on the *Nativity* on the one side of the reredos and on the *Arrival of the Magi* on the other. After his trip to Japan, LaFarge painted the *Ascension* on the wall above the altar for the Church of the Ascension in New York City in 1887. Partially sketched in Japan, this mural shows the influence of the East on LaFarge. Mount Fuji is included in the composition. More significant is the subtle oriental integration of landscape and figural painting.[26]

Trinity Church, Boston, with its total decorative scheme, and the above-mentioned New York City Episcopal Churches, with the apse decorated with mural paintings, were unique in the late nineteenth century. While exhibiting no single or coherent scheme, they represented significant instances of the reintroduction of the art of painting into the church.

Ironically, the most comprehensive religious painting scheme in the late nineteenth century was conceived, not for a church, but for the new Boston Public Library. Spurred by the new interest in mural painting, the architects McKim, Mead, and White, who shared the American Renaissance architectural notion of nobility of architecture appropriately decorated, worked now with sculptors and painters. Indeed, the Boston Public Library was considered a splendid example of the American Renaissance. Correspondence at the time conveys the excitement of architects and artists in common planning for such projects.[27] Given this setting, it was not surprising that the building committee, the architect, and the artist, John Singer Sargent, together discussed mural paintings for a long gallery at the head of the stairs on the third floor.

There are many unanswered questions about this commission for which Sargent was authorized to select the subject matter. Sargent was originally interested in scenes from Spanish literature, and his reasons for changing to a religious scheme are unknown. Moreover, Sargent, an American who spent most of his time abroad and did the paintings for the library while in England, was not known for any religious propensities of his own. The evidence suggests that Sargent had historic high points in mind, and that he wanted to depict cultural periods of the past for our illumination or thoughtful appropriation. The notion was obviously appropriate for a library, for it utilized religious episodes in a celebratory, rather than promotional way. Sargent himself gave the title of the series as "The Triumph of Religion. A Mural Celebrating Certain Stages of Jewish and Christian Religious History." He further suggests that he gave the work a title in order to avoid such names as "Religions of the World and others that are too comprehensive,"[28] and when he refers to the first completed north end wall, he states the subjects to be polytheism, monotheism, and the Law and the Prophets.

Given this explicit title, it is interesting that the biographers of Sargent, respectively, Ormond and Charteris, refer to the title as "the development of religious thought from paganism, through Judaism, to Christianity."[29] While that is probably not Sargent's own title, it is understandable that in the evolutionary mood of the turn of the century, Sargent's work would be interpreted in a progressive evolutionary manner, even though the development would end in a Catholic view rather than the dominating view of a Protestant America.

One end of the wall is a celebration of the dogma of redemption understood in the medieval and therefore Roman Catholic mode. Protestants could more easily claim, as they did, the frieze of the prophets, circulating reproductions freely of the segment of the mural at the opposite end of the hall.

The subjects for the original commission of the two ends of the hall are as follows: For the north end of the building the prophet Moses is at the center of the lowest frieze, flanked by eight prophets (Plate 116). The attractive and destructive aspects of the pagan deities—Neith, Mother of the Universe; Moloch, God of material things; Astarte, beautiful but soul-less sensuality—are shown in an upper barrel-vaulted ceiling zone, while between—that is, between paganism and the prophets—is Israel under the oppression of the Egyptian Pharoah and the Assyrian king. Viewed as a whole, this north end of the room exhibits both the misfortunes and foundations of Israel's history. Temporarily seduced by the pagan deities and oppressed by the political powers, the foundations of its own life are clearly revealed in the law, summarized in the Decalogue, and its prophetic interpretation.

On the south end is the *Dogma of the Redemption* (Plate 117), which has a lower frieze of angels who hold the instruments of the passion, in the place corresponding to that of Moses and the prophets on the north end. The ceiling vault has the Annunciation, the Coronation of the Virgin, the Crucifixion and the Madonna. Between the two is undoubtedly the most interesting part of the total composition, the Crucifixion, in which Adam and Eve are bound to Christ and hold chalices to receive the blood of Christ. The nail driven through the feet of Christ also nails the serpent's head to the cross, and, beneath the Crucifixion, is the pelican feeding its young with blood from its own breast, an ancient symbol of the Crucifixion.[30] Written on the frieze below the Crucifixion is the following in Latin: "I, God in the flesh, man's maker and redeemer, myself made man, redeem both body and soul." This quotation was based on an inscription in a twelfth-century mosaic of the Cathedral of Cefalù in Sicily, but Sargent changed "judge both body and soul" to "redeem both body and soul." Above the Crucifixion are three figures, representing the Trinity, each person identified by attribute, but the figures enveloped by a single robe. Byzantine in character, the trinitarian composition hardly escapes tritheism through the device of the encompassing robe.

It is obvious that in this original commission, Sargent achieved considerable unity. Paganism, Judaism, and medieval Christianity were represented as the triumph of religion, medieval Christianity being an end product in no other way than historical sequence and perhaps for Sargent, intriguing, because more complex. For

both the Judaic and Christian materials, Sargent traveled extensively, visiting and sketching in Palestine and in Roman Catholic churches throughout Europe.

The entire project turned out to be an extended one. The oral agreement to do the two ends of the hall, originally made in 1890, was put into writing in 1893. The second contract, executed in 1895, called for three panels on the east wall, with three lunettes above, and, as a donation from Sargent, probably three lunettes on the west wall. The north end was not put into position until 1895 and the south end, the *Dogma of the Redemption* until 1903. The project stretched out from 1890 until 1919. Perhaps the prolonged period of time adversely affected the conception for the side walls.

Originally, Sargent had thought of doing the Sermon on the Mount along the east wall, but then he decided that the hall was too narrow for any individual visually to take in the whole as a single composition. That statement is doubly significant. First, it indicates that the original conception for the two end walls was a complete one, for, iconographically, the Sermon on the Mount would not have related to the original scheme. Secondly, given the narrow hall and the fact that the side wall was a poor location above a staircase, Sargent decided to use only a part of the wall, and to phase in subjects from both sides of the end walls. That change, however, turned out not to be an addition to the scheme, but a distortion that disclosed a prejudicial handling of the materials. Sargent slipped from the original thematic historian to the nineteenth-century interpreter. The negative subjects were placed near the pagan, Hebraic end, and the positive ones, near the *Dogma of the Redemption*. Hence, a figure representing the *Synagogue* with a lunette above of *Gog and Magog*, both on the east wall, are placed near the north wall, and those cast into hell on the west wall are also placed near the north end. Conversely, the *Virgin Enthroned* and the lunette above the *Messianic Era* (Plate 118) on the east wall are near the *Dogma of the Redemption*, and, on the west wall, the *Passing of the Souls into Heaven*, is also near the *Dogma of the Redemption*. In the center of the east wall, the panel, which was to be the *Sermon on the Mount*, was not completed. Above the empty panel is an allegorical representation of *The Law*, and on the center west wall, *The Last Judgment*.

The representation of the *Synagogue* (Plate 119) as an aging, blindfolded woman, who crouches fearfully amid scenes of chaos and destruction, created a stir among Boston Jews. Under Jewish influence, an act was passed by the state Legislature in 1922, authorizing the seizure of the painting "By Right of Eminent Domain for Educational Purposes in Teaching Art or the History of Art," but it was repealed in 1924, the attorney general having indicated that the act was unconstitutional. In a letter to Evan Charteris, Sargent stated:

> I am in hot water here with the Jews, who resent my "Synagogue" and want to have it removed—and tomorrow a prominent member of the Jewish colony is coming to bully me about it and ask me to explain myself—I can only refer him to Rheims, Notre Dame, Strasburg, and other cathedrals. . . . Fortunately, the Library Trustees do not object, and propose to allow this painful work to stay.[31]

While the Trustees rightly responded that they had given freedom of subject matter to the artist, Sargent himself could hardly hide behind "Rheims, Notre Dame, Strasburg and other cathedrals." In these, and other medieval cathedrals, the *Synagogue* is represented, in contrast to the *Church*, by a blind-folded woman. It is negative to suggest that the synagogue is blinded, that is, does not see the full truth. But the theology and art of the time makes this to be the one difference, namely, that the truth is yet veiled to the Jew. Historically, the bodies of the *Synagogue* and the *Church* are alike, that is, bodies of beauty, while *Synagogue* wears a blindfold. Only in Rheims is the crown on the *Synagogue* akimbo. But in Sargent's composition the *Synagogue* (Plate 119) is not merely blindfolded; her body is old and worn, whereas the *Church* (Plate 120) has the body and face of a young woman. Sargent had in fact changed the history he claimed for himself.[32]

Today, the murals can be seen by entering the new wing of the library and working ones way to the third floor over what used to be the main entrance, directly across from Trinity Church. The lighting is poor and few find their way to this part of the library. Adequate lighting would certainly bring attention to the murals. Sargent's own letters in which he directed that the light not be too intense had reference, I think, to wanting less light than he had in his own London studio, hardly the dusk which usually surrounds the paintings today.

FOUR
The Visual Arts in the Twentieth Century

11

Views of the Visual Arts

Nineteenth- and Twentieth-Century Approaches

The paintings and sculpture discussed thus far take us into the first three decades of the twentieth century. Prevailing nineteenth-century views are hardly challenged, either in theory or by the works of the artists themselves, until the 1940s. Before entering the distinctive twentieth-century world, summary remarks about the nineteenth are in order as a way of making clear the decisive shifts that began to emerge in the forties of this century.

Nineteenth-century visual art reflected the reigning views of the culture. That culture was complete in and of itself; it did not need the visual arts. Hence, the visual arts were an epi-phenomenon. The essential fiber of the culture could be expressed without them.

In what is usually considered to be the ideal relation, the visual arts and the culture may be said to be congruent, that is, the various facets form a whole without tensions among them. Though we know that the so-called Middle Ages were not as coherent and monolithic as was once believed, nevertheless, social, political, and cultural forms occurred in a common context of faith. They were focused in the single conviction of expressing God's redemption of the world through God's visible agency, the Church. Differences then occurred within a common framework of intentions. The result was that artists were neither singled out for special attention nor were they neglected. They belonged to the commonly accepted fabric of the time. Hence, the visual arts could be expert or crude in execution, pleasing or shocking. But this was an issue of appropriateness, not of violating faith or the shape of the culture as a whole or of challenging the place of art.

If nineteenth-century thinkers, too, thought of culture as a whole, it was unlike that of the Middle Ages, for the sensual forms of culture were either sidetracked or had to serve the non-sensual. Except for the Spanish Catholic development of the Southwest, which can be said to represent a residual form of the medieval world, the art with which we have dealt thus far represents the visual arts severed from a natural and formative role in the culture. The dominance of English Christianity and English culture in the forming of American life and institutions had direct consequences for the visual arts. The absence of the latter from English life generally and from the churches in particular, as a matter of social and religious principle, created an uneasy void. The reemergence of a painting and sculptural tradition in this country

in the late eighteenth and early nineteenth centuries thus was largely independent of other cultural forms and occurred outside the church. In the struggle to find a place, the visual arts were forced to accept an ancillary role of expressing what the culture already believed and depicted in existing cultural forms, which were essentially verbal. The visual arts did not have, but had to contend for, a cultural role.

This cultural issue was to some extent as characteristic of Catholicism on the Eastern Seaboard as it was among descendents of the Puritan tradition. For Catholics generally, the interest centered in the visual arts as liturgical objects, with the result that in many instances sentimental plaster statues were installed rather than sculptures. Such plaster statues served as a reminder, not as a source of power related in part to their artistic integrity. At issue between Protestants and Catholics was the use of art, good or bad in the church, and this had to do with the question of images quite apart from their quality.

Hence, even when art belonged to the life of the church, its presence there did not translate into a general interest in the visual arts. The artists had to win that battle on their own, with only occasional help from prominent clergy. They received the help of clergy insofar as their creations could be incorporated into the reigning views of morality and religion which shaped the culture. In that sense, the ideal of a unified culture was at work, just as in the Middle Ages. The horizons, however, had shrunk. In many areas of cultural life, the parameters were shaped by ideas of a moral, purposeful history. The country was seen as a new Israel in which many vitalities were considered suspect. The sensual in art must clearly be in the service of non-sensual ends. Hence, the cultural and religious role of art was circumscribed. The visual arts conveyed what one already knew.

The nineteenth century was one in which the leading perceptions were formed by religious and secular thinkers, directed toward forming an appropriate body politic. In this the artists played no significant role, following rather than leading. Even the attempts to feature the social conceptions, as in the instance of civil religion, were celebratory and modelled on historic prototypes. When they were too sophisticated or ran against current mores, as in the case of Greenough's *Washington* (Plate 64), they were ridiculed. Only in depictions of nature were they close to helping form perceptions. Thus, in American history, the visual arts are an extra in a culture already defined.

That the visual arts developed mainly outside the church but nevertheless in a religious culture, did not affect the subject matter and style of the works of art. This is, of course, more true of Protestantism and of the general religious culture than of Roman Catholicism. For Catholicism, the repertoire of subjects was fairly standard, featuring first Christ and the Virgin Mary, and then the saints, appropriate to particular churches. In the culture at large, shaped as it was by Protestant and non-church religious conceptions, the repertoire of subjects and the function of art were affected. The Crucifixion, except for Catholic and Lutheran groups, and some German fracturs, was usually conspicuously absent, except for the work by two major American artists of no religious persuasion in the late nineteenth century, Thomas Eakins and John Singer Sargent. Eakins's *Crucifixion* (Plate 109) with its veracious anatomical rendering and shadowed face is an impressive painting but ambiguous in terms of content.

Though loaned by the artist to St. Charles Borromeo Seminary, it was never hung in the chapel. Sargent's handsome *Crucifixion* (Plate 117) is liturgical in concept but is embedded in a didactic and decorative cycle of paintings in the Boston Public Library.

Among artists who themselves belong to traditional religious bodies, the question of whether to paint or sculpt, and if so, how to represent the Christ figure was of major concern. The hesitation about doing the Christ figure suggests an uneasiness in regard to his role, rather than the question of how art can convey his meaning. Some artists resolved the problem of his meaning by centering on Christ in relation to some other Biblical figures, thus painting events rather than centering on the meaning of the central figure.

Though the visual arts did not emerge within the church, the church created the culture which is reflected in the artistic traditions which followed. Moreover, the then dominant Congregational, Presbyterian, Methodist, Baptist, Quaker, and Episcopal groups, for all their differences, reflected a consistent English history in relation to the visual. At first, the visual arts had dropped out. Then they emerged in relation to an existing cultural approach, which limited the role of the visual. Finally, the topics of the artists reflected the content and style of that English Protestantism as filtered through and transformed in the American scene. Stress on the Crucifixion, on Christ's divine nature and mission, and on sacrifical themes, such as Abraham and Isaac, belonged to more Catholic traditions and to a liturgical ambience closely related to these themes. The Protestantism of the American scene was largely non-liturgical, but interested in the effects which the Gospel could create, whether in the form of the cure and care of souls, the creation of the conviction of sin and the acceptance of Christ, or the more liberal notion of the emulation of Christ's mission in our world. Such different theological views, running throughout American history, exhibited an interest in the results of faith rather than in what the faith and its broader ambience meant. The result was an accent on the difference that faith makes, rather than that faith makes a difference. This theological bias stressed sanctification more than justification.

The art with religious subject matter which emerged reflects that orientation. Accent falls, not on the suffering of Christ, in the light of which we see ourselves, but on how we experience ourselves, confronted by actual sins. The dynamics are always the direct confrontation with ourselves, whether it is the Puritan "heart prepared" or the revivalist hellfire. With such stress on the experience of the human pysche, and on creating the crisis of damnation and deliverance, as contrasted, for instance, with incorporation into the wider scope of God's purpose in more liturgical traditions, we readily find understandable the fact that a mourning picture may be considered more influential than a picture of the Crucifixion in creating faith.

The Biblical subjects selected by the artists stress events with which we can directly identify, or events which affect our experience, which touch or create our sentiments. Thus, for example, the Finding of Moses is more central than Moses Striking the Rock; the Deluge is more central than the Creation or the Crucifixion. The predicament of Adam and Eve takes precedence over the mythic event of their creation.

The contrast is most clear when one focuses on Catholic art in which ecstasy is conspicuously present. In the art of Spanish Catholicism, the emotional elements do not center in, or on, us, but are integral to the event itself. In the Holy Week self-scourgings of the Pentitentes, the aim is not to touch our emotion, but to emulate the event itself. Nineteenth-century American art by Protestants is meant to affect us directly, to make us feel the impact of the event. The emotion is less integral to the event than to how the event affects us.

Differences also exist among Catholic bodies and their national origins. From the beginning, the Spanish churches in the new world imported and created paintings and sculptures in numbers exceeding that required for specific liturgical usage. The visual was everywhere, creating an ambience in which the eye was never out of sight of a religious symbol or artifact of one kind or another. Catholic churches in the East, largely from the north of Europe, apparently utilized standard items of available paintings or sculpture, and then only to the extent required for their liturgical life. Only after the middle of the nineteenth century did the quantity of artistic objects increase in Eastern Catholicism. These differences within Catholicism stemmed as much from ethnic differences, such as north and south of the Alps, and the continental versus the English and Irish settings of Catholicism.

We do have a clearer picture of early architectural and artistic developments among Spanish and Pacific Northwest Catholic churches than we do in the East and Midwest. The abandonment of the California missions and the absence of an early impulse to modernize in New Mexico and the Northwest have meant that conservation has brought the missions close to the older and original tradition. In the East and Midwest, where churches continued an active, uninterrupted living tradition, renovations were regularly carried out. The result is that original works and settings have largely disappeared. One need only compare El Santuario in Chimayo (Plates 14 and 15) and Santa Cruz (Plate 12), both in New Mexico, with the old Baltimore cathedral or Weir's Episcopal Church of the Holy Innocents (Plate 34) in Highland Falls, New York. In the first group, careful conservation is from recent decades; in the latter, restorations have occurred so often that the original ambience has largely disappeared, though in the old Baltimore cathedral, the changes have preserved the basic Latrobe plan.

It must also be noted that American art throughout the nineteenth century is uneven in quality. There are notable art critics who do not find the quality of American art before the forties of this century, as contrasted with European and Asian art, worthy of serious note. There is partial truth in such observations, though the comparison is somewhat specious. The fact is that eighteenth- and nineteenth-century art, which is the period of which we are speaking, suffers in Europe, too, when compared with the high points of Western history.

While we are beginning to look more favorably on such art in our own time, we find ourselves still out of phase with what has been represented. Hence, taste as well as technical judgments influence our perceptions. Today we hardly notice the nineteenth-century bronze sculptures in our parks or the white marble ones in museums, but we do notice, either with approval or disapproval, the public sculptures from our own time. It is hard for us to believe that the unveiling of nineteenth-

century sculptures attracted thousands of people, and that people paid to see special exhibitions of sculptures, such as Powers's *Eve* (Plate 75) or *The Greek Slave* (Plate 76), much as they do for the blockbuster exhibitions today.[1]

Questions of quality and taste are hard to disentangle when judgments about the visual arts are believed legitimate without the comparable training and discipline we require for judgments in other areas of knowledge and life. Nevertheless, judgments may and need to be made. It is widely believed that, in the forties and fifties of this century, both the vitality and quality of art began to center in the United States as contrasted with Europe. Never before had the United States been in that position, a position which it still shares today in the international scene. But just as that position was attained, the experiences of the sixties pulled into the opposite direction, one in which distinctions about quality were considered conditioned by an elitist society. In that setting, folk art of all kinds was considered positive, while suspicions about professional art increased. Before that time, there was little consciousness of the need to choose between folk and professional art. Folk art, with its penchant for direct and immediate experiences in which one affirms life without the need to be stretched by formative events, however, was particularly congenial to the American temperament. The charm of folk art can be directly experienced, since it requires no context of wider meanings. Think, for example, of Protestant and secular individuals who like the folk art of the Southwest, but who know little of how it functioned or the context in which it arose.

At the same time, New Mexican folk art, seen in its total setting, stretches the imagination and suggests transcending associations that are matched by its artistic style. We are invited to live in a new realm of being, in accord with an ancient tradition, but given a new style appropriate to its own time and materials at hand. This is quite different from the folk art of Puritan New England, which consists of samplers, embroideries, or quilts. Here we do not have an ancient artistic and iconographic tradition made new, but a limited repertoire of a craft tradition. This is neither historic nor contemporary transcendence.

Even traditional scholars have generally come to appreciate folk or naive art and high or professional art. As a result, criteria for distinguishing among works of folk art are being developed. It may well be that the difference between one end of the folk art spectrum and the other may be greater than between folk art nourished by tradition and professional art. Indeed, sometimes folk art formed by a living tradition is better than professional art of lesser quality. One need only compare episodes from *A Panorama of Mormon History* (Plate 122),[2] which includes the trek from Nauvoo, Illinois, to what became Salt Lake City, executed by Carl Christian Anton Christensen between 1869 and 1890, with the professional but sleek, banal sculpture and paintings in the Visitors Center in Salt Lake City and in many of the Latter-day Saints temples. So, the choice is not between folk and professional art, but between living, vital, competent work in both.

The new power of the visual arts, manifest already in part through works created in the thirties but mainly during the late forties and fifties of the twentieth century, accented perceptions of its own, frequently at odds with the prevailing ethos of the

culture at large. Hence, as was indicated previously, there was a movement in the visual arts from being an epi-phenomenon in the culture, as in the nineteenth century, to the creation of leading motifs that challenged the inherited culture. Since neither the nineteenth nor twentieth centuries exhibited a cohesive unity, the arts did not share in a common culture. In both, the arts had no single center or focus. Hence, in the nineteenth century, the arts stood alongside a dominant culture, irrelevant to its main motifs. In the twentieth century, however, the arts, through their own creative power, formed perceptions that could not be ignored, that demanded attention in and of themselves. While there were parallel developments in the visual arts, literature, music, philosophy, and theology, the most radical revisioning occurred in the visual arts, particularly in the form of abstract expressionism and its aftermath, which will be discussed in the next chapter.

While the new perceptions expressed a wider and deeper conception of humanity through acknowledgments both of grandeur and of tragic alienation, they also suggested that the visual arts could not be laid aside, that they provided nuances of perception, which, while congruent with others, were also unique. Hence, it began to be realized that the visual provided us with aspects of our existence which were unique to seeing itself. In an editorial as early as September 4, 1924, in the *Christian Century,* a Protestant interdenominational journal hardly known for its interest in the arts, occurs this statement: "for if the work of art has any justification at all, it is that it gives expression to something which cannot be otherwise expressed."[3]

Journals and the Visual Arts

Twentieth-century journals provide views of the visual arts that are in sharp contrast to those of the nineteenth century. Gone are articles that speak of the arts in terms of refinement or decoration. More fundamental roles are assigned to the arts, roles that are essential to life and to the church. Moreover, there is a concern with quality. Article after article berates the poor quality of art objects in churches, indeed of the architecture itself. Attention is given to pioneering developments in art and architecture, with the hope that they may influence the future.

Most of the major secular journals, such as *Time, Newsweek,* the *Saturday Review of Literature, New York,* the *New Yorker, House and Garden,* or art journals, such as *Art News,* the *American Artist,* the *Art Bulletin,* the *Magazine of Art,* at some time or other give attention to the visual arts and the church. Religious journals do so too. The *Christian Century* has already been mentioned. Usually it published one issue a year on the arts, of which the visual arts were one ingredient. In addition, most years include a major article or two on the visual arts, and particularly on architecture.[4] The more conservative journal *Christianity Today* also has occasional articles and short pieces on the visual arts. In recent years, it has joined in the protest against illustrative art, making reference to the work of Cynthia Pearl Maus, whose writings mixed good and bad without discrimination. In this article, Mark Marchak

also contends that painting dare not be propaganda, whether communist or Christian.[5] In a later article, Marchak defends abstract painting in a period when the printing press has made didactic art unnecessary, thus allowing art to become "purer, less literary."[6]

As one would expect, Catholic journals generally give more attention to the visual arts, including the more liberal journals such as *Commonweal* and *America*, the more centrist Paulist publication the *Catholic World* (succeeded by the *New Catholic World*), and the more conservative journal the *Catholic Art Quarterly* (which in 1960 became *Good Work*), which with its sponsor the Catholic Art Association subsequently went out of existence.[7]

New, however, is a number of journals and movements in which the central or allied purpose is the promotion of good art and architecture for the church. It is generally accepted that good art is now assured in the public domain. Insofar as art has returned to the churches, however, the quality is considered low. Only in France, it seemed, had the avant-garde in art returned to the churches, such as Ronchamp, Audincourt, Assy, and Vence. Indeed, it seemed ironic that while the center of the art world had moved to New York City from Paris, as far as the churches were concerned, important developments had happened in France, though to be sure, the movement represented by these French churches was short-lived.

From 1931 to 1972, a forty-one-year period, the Liturgical Arts Society, itself founded in 1926, published *Liturgical Arts*,[8] a journal exclusively devoted to improving art and architecture in the Catholic church. In an editorial for the November, 1946, issue, Otto Lucien Spaeth, then president of the society, wrote that the aim of the society, "the betterment of the arts which are an integral part of Catholic liturgy and culture" was sound. But he added that

> it was unfortunate that those artists whose work has been illustrated in the pages of *Liturgical Arts* have found little encouragement in the way of commissions [from the church]. However, it is also true that if we would rid ourselves of the blight of mediocre and indifferent work, it is to these artists we must of necessity turn. . . . We may hope . . . eventually to create an atmosphere in which the work of top-flight artists can enhance the beauty of the House of God.[9]

Such themes and others are repeated throughout the years of the journal, both in editorials and articles. Frequently, the use by churches of mail-order catalogues and their inferior liturgical objects are lamented. Interest in the Neo-Gothic as the rightful tradition in church architecture is rejected, reminding readers that everything which is now traditional was done by artists who originally represented their own time. Hence, we must commission contemporary artists and architects, who use the idiom and materials of our time. Only in that way will the arts serve this time and be as competent and right as was the older art for its time. Hence, it is necessary that we get rid of the fear of the modern, for the modern, like the past, comprises both good and bad.

It must be noted that such ideas stemmed not from wild-eyed believers, but from individuals solidly in the mainstream of the Catholic tradition. In addition to

such figures as Otto Spaeth, one must add Maurice Lavanoux, a lay Catholic, who alone edited the journal for most of its history, or the Jesuit Father John LaFarge, chaplain of the society and son of the painter John LaFarge, or his fellow Jesuit Clement McNaspy, who succeeded Father LaFarge as chaplain on the latter's death.

Throughout its history, *Liturgical Arts* had financial problems, though there were always those who came to its help. Through a special foundation, which surely involved Otto and Eloise Spaeth, funds were secured to enable the editor, Maurice Lavanoux, to travel both in this country and abroad. The result was that the journal, while concerned to improve the arts in relation to the church in the United States, provided a picture of the church and the arts throughout the world. Hence, significant developments are reported from Europe, Asia, South America, and Africa, as well as from every segment of the United States. Some of the earliest and best reports on important developments appeared first in *Liturgical Arts*, including the artists at Assy, Leger at Audincourt, Matisse at Vence (all under the instigation of Father Couturier), Le Corbusier at Ronchamp, Graham Sutherland and Sir Herbert Spence at Coventry, Henry Moore at Northampton, and, in this country particularly, the commissioning of Marcel Breuer for St. John's Abbey (Plate 123), Collegeville, Minnesota. The churches to which attention was given by *Liturgical Arts* in the United States are too many to mention, with few of them of the distinction of St. John's. The same is true with respect to individual artists. Hardly any of the major artists of our time are not mentioned, though there seems to be a particular pathos felt for the art of Rouault, a competent artist and devout Catholic, whose first church commission was at Assy.

Though the events of Vatican II occurred during the latter years of the journal's existence, it is surprising how little, rather than how much, attention it receives. In part, that is surely because many of the concerns for art in relation to the life of the church transcends, and in many instances, anticipates Vatican II. It is simply a fact that Vatican II was less of a surprise to *Liturgical Arts* than to most Catholic groups.

Liturgical Arts too had to face the question of whether or not artists who worked for the Catholic church needed to be believers. Essentially, the writers subscribe to the views of Father Alain Couturier, the French Dominican who had secured his secular artist friends to work at Assy and who believed that the divorce between the artists and the church had to come to an end. Hence, he was willing to accept the requisite risk of using nonbelievers, maintaining that to use less than artists with genius would never produce a miracle of art in relation to the church. Wrote Couturier:

> The majority of these artists having until that moment been strangers to the life of the Church, we faced this problem: what explicitly "religious" values could we expect from work born during a very first contact with Christian realities? We faced a risk, but we deemed it best to accept it. All that we knew of those great spirits sufficed to assure us of the gravity and respect with which they would treat the sacred mysteries. And it is a joy to be able to say that, even in this, they exceeded our expectations. The Spirit breathes where it will.[10]

In his "Credo," prepared specifically for *Liturgical Arts*, Salvador Dali states that he agrees with his friend, Father Couturier, that in this moment of the decadence of religious art, "it is more advisable to call upon unbelieving geniuses than upon believers without talent." But he considers this a lesser evil. "The ideal is, undisputable, that religious art, as in the era of the divine renaissance, be executed by geniuses who, at the same time, will be animated by faith, as were Zurbaran, El Greco, Leonardo da Vinci, and Rafael."[11] For this reason Dali too believes that it is important that Christians who are equally competent (and in his mind that includes himself, though even Catholic writers have been critical of his religious works) be given commissions.[12] In that attitude, he was joined by the artist William Congdon, a convert to Catholicism.[13] In *Liturgical Arts*, however, it is clear that while some wished that what Dali said was true, they found Couturier closer to the realities with which they had to deal.[14]

A similar problem presented itself with respect to abstract art, and particularly, abstract expressionism. Recalling his own visit to the Rothko Chapel in Houston, Texas, at the time of its dedication, Lavanoux expressed his reservations as a Christian. He stated that he was puzzled by the pervading sense of spiritual vacuum.

> I could not overcome the feeling that the desire to become everyone's brother led to abandoning one's identity. And the large, one color (dark) Rothko panels heightened in me that sense of being in a spiritual no man's land. Although I can appreciate manifestations of non-figurative art, I found it difficult to sense even a modicum feeling of dialogue with the artist. I felt a void.[15]

Two decades earlier Dali had already gone further, seeing abstract art as the expression of artists who believe in nothing, making it possible to use their art only for decoration.[16] But on the opposite sides are strong articles in support of abstract art even for the church, particularly in our time. These include such authors as Roman J. Verostko, O.S.B., Angelico Surchamp, O.S.B., and Thomas Mathews, S.J.[17] They are aware that in contemporary art, the faith which we bring is particularly significant, indeed as it has always been. But gone is the day when the visual arts are needed for didactic teaching purposes. Now the visual arts can serve in their special way, freed of verbal and liturgical necessities. It is also clear that had the journal continued to be published after the early seventies, the debate on abstract art would have continued, indeed, as it has to this day.

While *Liturgical Arts* represented the views of the Liturgical Arts Society, it was essentially a journal edited and held together by one person, Maurice Lavanoux. While encouraged to seek assistants, Lavanoux never found them, perhaps for financial reasons, but also because his disposition was that of doing things by himself. In fact, the journal abruptly came to an end with the May issue, 1972, with Lavanoux citing dwindling subscription renewals, a 50 percent loss of advertising revenue, printing bills, and delinquent membership dues, with the wry comment about the latter that we would be surprised by the names on that list.[18] Hope that the journal would be renewed under the auspices of the Society for the Renewal of Christian Art, which

also sponsored the Contemporary Christian Art Gallery, did not materialize as these institutions themselves floundered and went out of existence.

Started ten years later than *Liturgical Arts*, *Motive*, the magazine of the Methodist Student Movement, with the support of the Board of Higher Education of the United Methodist Church, served three decades of student generations before its controversial end in 1972. Hence, for most of their histories, the two journals were contemporaneous, though they served different constituencies. Given its independence from control of a church body, *Liturgical Arts* could withstand the barbs of its critics easier than could *Motive*. From its very beginning, the critics of *Motive* found it too "arty," and too liberal in its outlook, but the journal survived its early years through the support of some of the most powerful Methodist bishops.

Motive was served well by a series of superb editors, Harold Ehrensperger, Roger Ortmayer, Jameson Jones, and B. J. Stiles, as well as a series of art editors, chief of whom was Margaret Rigg, herself an artist with an eye for style in publishing. The place of the arts was evident both in the articles which covered all of the arts and in the visual format of the journal. Its very appearance spoke as loudly as did its words.

But if the journal appeared "arty" to some, it was because most journals did not have the style or attention to art that one found in *Motive*. Actually, *Motive* addressed all the social and theological problems of its time, always with a perspective that lifted the issues beyond partisan positions. Its articles were instructive and educational, written by the major theological and cultural interpreters of the time. Working one's way through the decades of the journal, one confronts a veritable Who's Who of the period.

The rationale for art in *Motive* was simple, namely, that the arts were a part of life. When students encountered them, they provided special clues to the understanding of our culture and our time. They belonged to the fullness of life, and style and quality were prized both in the visual and in the verbal arts. In the early issues, special sections were assigned to the arts—radio, TV, jazz, music, drama, and so on. But in later issues, the special sections were mainly abandoned in favor of articles on the arts that were interspersed with writings on the major issues of the period. Plates representing art and architecture, drawings, and special covers were featured in each issue. Indeed, it is impossible to overestimate the style of the journal.

While *Motive* was not an art journal, it did give considerable space to the visual arts. In its pages one found plates and brief articles on the major artists of the time, as well as a featuring of younger artists whose works, it was hoped and believed, would be widely accepted. It is not a criticism as such to note that there is hardly a name in the latter category which one would recognize today. Corita Kent is the one prominent exception, though today one would hardly give her the acclaim she then had. Only occasionally was a work of art not worthy of the journal. By contrast, the articles and plates on the leading artists introduced students and the university community to such figures long before they became part of our common universe of discourse. To use but one example, the issues for the academic year 1949–50 had articles and plates on Käthe Kollwitz, Rouault, Picasso (particularly on *Guernica*), Orozco, Chagall, and from the past, El Greco and Grünewald. In the same volume,

Marion Junkin is critical of Sallman, Hofmann, and Christy, though the latter had been used in a previous issue. Moreover, Richard A. Florsheim writes discerningly on Picasso's *Guernica*,[19] as does John F. Hayward in a subsequent volume.[20] In both instances, not only do they see *Guernica* through the eyes of destruction but also they delineate how the art of Picasso gives form and substance to humanity in spite of or through the subject matter. In the next year, Margaret Rigg provides a similar interpretation of Pollock.[21]

In the latter half of the sixties, there was a pronounced change in the character of *Motive*. Its articles no longer had an overarching perspective on issues. Instead, articles centered on social agendas. Major artists were no longer featured. Rather, there was a turn to prints, drawings, and engravings, art forms considered more in line with the predilections of the underprivileged. What color remained in the journal became increasingly psychedelic.

Throughout its history, *Motive* had an uneasy relation with the Methodist church. It represented the student movement, with all its concerns and its pronounced ecumenical character. In the light of the developments just indicated, it was inevitable that the tension with the Methodist church would increase. An agreement was reached that the journal would become independent of the church, but misunderstandings about the phasing out of funds from the church accelerated its demise. After the resignation of B. J. Stiles as editor, for reasons largely independent of *Motive*, and the subsequent disaffiliation with the Board of Higher Education of the United Methodist Church, a more collective editorial arrangement emerged. In the letter to subscribers which signalled the end of publication, it was affirmed that

> the staff and editorial board were committed to allowing the majority of our pages to be used by the undiluted voices of the oppressed and alienated. . . . We understood our commitment to the Christian faith to put us on the side of the poor, the disenchanted, the disenfranchised and the oppressed in their struggles. We also committed ourselves as a staff to work collectively, feeling that this would be the best way to curtail elitism, egoism and their unChristian virtues.[22]

The letter goes on to note that these commitments did not work out, that *Motive*, as a magazine that cut across social constituencies, was now an unneeded extra, that individuals in liberation movements had their own journals and that when they had difficulty working together, they preferred, rightly so, to rejoin their own movements rather than spend time saving such a journal as *Motive*. Hence, for financial reasons and the non-viability of a collective editorship, it was decided to suspend publication after two additional issues, one on Women's Gay Liberation and one on Men's Gay Liberation. Hence, a journal which had served the student movement, indeed reflecting the issues with which students were concerned, found itself the victim of the very fragmentation of that movement at the end of the sixties and the beginning of the seventies.[23]

In 1968, the Guild for Religious Architecture, itself organized in 1940 under another name but now affiliated with the American Institute of Architects, founded the journal *Faith and Form* "to provide the most current information available on

problems of design and liturgy as related to religious architecture and art." In 1978, *Faith and Form* became the journal of the Interfaith Forum on Religion, Art, and Architecture (IFRAA), a merger of the American Society for Church Architecture, the Commission on Church Planning and Architecture, and the Guild for Religious Architecture. It is thus obvious that the constituency of *Faith and Form* consists of architects, designers of objects for church and synagogue, and clergy and rabbis. Given that membership, it is perhaps inevitable that the magazine is partly a trade journal, partly one that explores issues in art, architecture, and religion. IFRAA itself sponsors regional and national conferences, architectural and ecclesiastical object competitions, all of which are reported in *Faith and Form*. The first editor, Dorothy S. Adler, working in association with a committee headed by the architect Edward Sovik, was succeeded in 1980 by Betty Herndon Meyer. Meyer, still the current editor, has succeeded in broadening the scope of the journal, so that articles on major issues now predominate over items of trade interest, making it one of the significant journals of our time.

Although a popular journal, the *Bible Review*, founded in 1985, publishes works by sound scholars. While most of its articles deal with Biblical materials, they are frequently accompanied by plates, mostly in color and of high quality. Occasionally, there are articles on art that deal with Biblical materials. The cover invariably has a distinguished work of art that relates to the content of a particular issue. Further, two professional journals are also known for the quality of the plates they include: *Church Teachers* frequently includes articles and plates on contemporary artists, as does the *Stained Glass Quarterly*.

Individuals on Religion and the Visual Arts

In the nineteenth century, as was noted in chapter 3, clergy had a good deal to say on religion and the visual arts in speeches, major journals, and in the pulpit. In the twentieth century, this would hardly be characteristic of clergy serving in parishes. Their interest was primarily in literature, drama, cinema, and dance. Perhaps the change also reflects that more widely learned discourses were expected from nineteenth-century clergy than is now the case. There are exceptions, of course, in the role of the clergy, particularly in instances in which they were directly responsible for significant developments in art and architecture. With respect to the latter, two figures stand out—Ralph Peterson's leadership in the creation of St. Peter's Lutheran Church in New York City, as well as the Erol Beker Chapel of the Good Shepherd (Plate 124) with the Nevelson sculpture defining its interior, and Robert Schuller's work, first with Richard Neutra, and then with Philip Johnson in the creation of the Crystal Cathedral (Plate 125) in Garden Grove, California. The beauty of the latter structure stands, however, in marked contrast to the mediocre art in and around the building itself.

Many of those active in speaking, writing on, and promoting significant developments in the visual arts were clergy, but since they did not function as parish clergy, they were otherwise identified, mostly in teaching positions and other profes-

sional activities. Such figures worked easily with lay individuals who frequently were responsible for significant developments beyond the spoken or written word. In the latter category, mention has already been made of the late Otto L. Spaeth and his association with the Liturgical Arts Society and its journal. In addition to the promotion of better art and architecture for the church, he encouraged exhibitions in museums that touched on religious themes, and was among the pioneers of corporations exhibiting and owning works of art. In 1953, on the occasion of the opening of a new office building of the Meta-Mold Aluminum Company, of which Speath was the board chair, there was an exhibition of works of art as well as the announced policy of acquiring works for the various offices. At the time, Spaeth stated:

> It seemed a shame to leave the walls bare. . . . It also seemed appropriate to
> demonstrate at once that the first exhibition was not an isolated instance, but
> the first application of Meta-Mold's art policy: that industry as the bone and
> flesh of society has a direct and continuing responsibility to the soul of society,
> the humanizing things in life—in this case, art.[24]

J. Irwin Miller, also an industrialist, has had a role similar in many ways to that of the Catholic Otto Spaeth. Miller, a member of the Disciples of Christ, was largely responsible for the campus buildings of Christian Theological Seminary in Indianapolis by Edward Larrabee Barnes, the chapel (Plate 126) and final building of the central complex having been completed in 1987. But Miller also, through an imaginative grant policy for the selection of architects, made Columbus, Indiana, into a city noted for its distinguished architecture, covering churches, schools, and civic buildings by the prominent architects of our time, frequently supplemented by distinguished sculpture.

Eloise Spaeth, Otto Spaeth's widow, who was active with him in promoting better art for the Catholic church, made her impact particularly on institutions of art in relation to the church and religious questions. The first exhibition featuring modern art in relation to religion was undertaken by Eloise Spaeth for the Dayton Art Institute,[25] where she was given responsibility for the development of exhibitions for the modern section of the museum. While attention will be given to this exhibition in the next section, as well as to two additional exhibitions she initiated, it is important to note here that the list of artists represented in 1944 featured figures who have stood the test of time. Recognizing artists and their works in 1944 that became important in the eighties discloses the perceptive eye of Eloise Spaeth. Her concern with quality was also evident in her work with the American Federation of Arts and her formative influence in the revitalization of the Guild Hall Museum in Easthampton, Long Island. Ever a devout Catholic, she also used whatever leverage she could to improve the quality of art in the church with expectably uneven results. She has also been a leading figure in the Archives of American Arts, where her knowledge of art and artists has frequently been instrumental in bringing their papers to this depository. Moreover, her tours throughout the world, visiting museums and private collections, have been a source of education and funds for the Archives. Her guide to U.S. museums, now out of print, was for years standard.

Jane Owen has been mainly responsible for the restoration and revitalization of

New Harmony, Indiana, where her imagination has made a vital, living community in the midst of the old Owenite buildings of that early nineteenth-century utopian community. The older buildings have been preserved, many old houses restored, and the best of modern architecture added, such as the Roofless Church (Plate 127) by Philip Johnson, the Tillich Park with its bust of Tillich, the Visitors Center and Potting Shed by Richard Meier, the addition to the Inn by Evans Woolen, the sculpture by Stephen De Staebler (Plate 128). In New Harmony, the old buildings, the new ones, and the town itself form a unity. The result is that it is not merely a place to visit for historic reasons; it is also a place where conferences, both secular and religious, take place that deal with the significant issues of our day. In addition to her role in New Harmony, Jane Owen has also been active in the art life of Houston, particularly in relation to the Blaffer Trust and its travelling exhibitions, including work with religious subject matter.

John and Dominique de Menil, sensing the religious aura of Mark Rothko's work, were responsible for the Rothko Chapel (Plate 129) in Houston, Texas. When Barnett Newman's *Broken Obelisk* (Plate 130) was rejected by the city of Houston, for which it was intended, because it did not at the time like its dedication to the memory of Martin Luther King, Jr., the de Menils purchased it and placed it near the chapel. Dominique de Menil, a French Protestant who converted to Catholicism, was particularly influenced by the French Dominican Alain Couturier, whose work in France in connection with Assy, Audincourt, and Vence has already been mentioned. Hence, it did not seem strange to her to create a chapel, utilizing the work of a great artist with spiritual sensitivity, even if devoid of specific religious subject matter. The Menil collection of art, both distinguished and wide ranging, was opened in 1987 in a new building, which is also near the Rothko Chapel. It is another of her and her late husband's gifts to the public.

Otto Spaeth, J. Irwin Miller, Eloise Spaeth, Jane Owen, Dominique de Menil represent lay individuals of vision, who also had sufficient means and influence to make some of their dreams become real. In different degrees, all of them were also collectors of art, not because it was an investment, but because such works were loved and formed a vital part of their own lives. Finally, all of them moved easily in both the secular and religious world, trying to benefit the public at large through their particular activities.

During the same period, particularly from the late forties on, there were also individuals who began to make an impact through their teaching and writing in the areas of religion and the arts. First, although Paul Tillich never made the visual arts a systematic concern in the sense of writing books in the area, he continually made reference to the visual arts in classes and, as the volume of collected speeches and articles entitled on *Art and Architecure*[26] indicates, the visual arts and architecture influenced his thinking and were of paramount interest throughout his life. The writings of the Roman Catholic Jacques Maritain and the Eastern Orthodox Georges Florovsky disclosed a scholarly knowledge of the the visual arts, both historically and for the contemporary period.[27] Their works were read widely in the fifties among Protestants, Catholics, and Orthodox alike.

The first of the professionals in the area was undoubtedly Wolfgang Stechow at Oberlin College, followed by Joseph Gutmann, John Dixon, and Jane Dillenberger. While Joseph Gutmann's work has been mainly in the arts in relation to Judaism, his writings and competent research have greatly influenced art historical developments in Christianity.[28] John Dixon has written extensively on Christian faith and the visual arts, and taught under a joint appointment in religion and art history at the University of North Carolina until his retirement in 1987. Many of the major contours and issues in the field were first explored by Dixon with passion and scholarship.[29]

Jane Dillenberger, among the first in the field of religion and the visual arts to teach in a theological school, convinced Drew University's theological and graduate schools in 1950 of the place of art history in theological education. She pointed out that the history of the church could hardly be understood without that component, and that there was a special need for clergy to be sufficiently trained in areas of art and architecture to enable them to know how to proceed with building programs. She taught courses in art and religion, but equally important, worked with faculty in their own disciplines in ways that brought the visual arts into association with their subjects. In 1962, she taught at the San Francisco Theological Seminary, and subsequently was involved in establishing the doctoral program in religion and the arts in the Graduate Theological Union, in association with the University of California at Berkeley. Being academically and museum trained, she involved her students in both traditional academic work and in exposing them visually to works of art. Her writing, too, has followed that pattern, that is, both books and exhibition catalogues associated with exhibitions she initiated.[30]

In 1951, John F. Hayward taught in the area of theology and painting in the Federated Theological Faculty, University of Chicago, until its demise in 1958, when he taught in the same area at the Meadville Theological School for another decade prior to his going to the University of Illinois. At the time, Chicago developed an extensive program in the arts, which, after Hayward's departure, centered mainly in literature.

From the sixties on, the number of individuals specifically giving attention to the visual arts in relation to religion in theological schools gradually increased, so that while the visual arts do not receive attention in most theological schools, there is a considerable cadre of individuals in the field in the eighties. In 1968, Jane Dillenberger did a survey of instruction in the visual arts in the United States for the Society for the Arts, Religion, and Contemporary Culture.[31] In 1988, Wilson Yates published a volume delineating the situation in the arts today in theological education, prepared in the light of his own extensive survey sponsored by the Lilly Endowment.[32] While the first report is bleak, the second is indeed encouraging. While the Pacific School of Religion reported in 1968 that "there is no program in visual arts here because of a thoroughly Calvinistic theological orientation on the part of the administration and a hostility to art as being unworthy of religious consideration," in the mid-seventies it became a supporter of the arts, appointing Doug Adams full-time to the visual arts and dance, serving both the Pacific School of Religion and the Graduate Theological Union. In the early survey, Yale Divinity School reported that

"disciplined appreciation and study of the visual arts is considered a luxury by most faculty and students due to an already overloaded schedule." Two decades later, John Cook, an architectural and art historian, has developed a program in the visual arts for those in the basic theological degree, as well as broadened the scope of the arts through his heading of the School of Music at the Divinity School. Indeed, in 1988, at least a dozen individuals, trained in the visual arts and religion, are spending a major part of their teaching and research time in the area of the visual arts.[33]

Exhibitions[34] and Societies in Religion and Art

While a particular work of art was frequently exhibited by itself in the nineteenth century, as was the case with Benjamin West's *Christ Healing the Sick* (Plate 131), in the twentieth, exhibitions representing themes and the works of individual artists increasingly emerged. Frequently, these were accompanied by a listing of the works, sometimes with a few plates. It was not until the fifties of this decade that scholarly catalogues began to be a regular part of a museum's agenda in presenting an exhibition.

Exhibitions of religious art, as contrasted with the showing of individual objects, began surprisingly early. In 1931, there was an *Exhibition of Religious Art by Artists of Chicago and Environs*, arranged by the Renaissance Society of the University of Chicago, with an introduction by Daniel Catton Rich, director of the Art Institute of Chicago. Today, few of the artists exhibited are names one recognizes. In 1933, at the International Exposition in Chicago, there was an exhibition, entitled *Modern Ecclesiastical Art*, consisting of art from Germany, both Catholic and Protestant. Among the artists represented were Nolde and Barlach. In 1941, the Parzinger Gallery in New York City exhibited seventy-three objects under the title *Exhibition of Religious Art*. The only work in this exhibition readily recognizable today is Zorach's *Head of Christ*. In the following year, the Puma Gallery, also in New York, did an exhibition, entitled *Modern Christs*. Among the two dozen items represented were works by Max Weber, Max Beckmann, and Adolf Gottlieb.

Of major significance were two exhibitions in 1944, that by Eloise Spaeth for the Dayton Art Museum, and the second, by the Institute of Modern Art, Chicago, *Religious Art of Today*. Both of these exhibitions were extensive in scope and consisted of the works of the significant artists of the period. The Dayton exhibition included paintings, drawings, sculpture (these three categories comprising over eighty of the almost one hundred items), liturgical objects, and photographs of modern churches. Among the major American painters represented were Max Beckmann, Hyman Bloom, Marsden Hartley, Horace Pippin, Abraham Rattner, Joseph Stella, Max Weber; among the European painters were Marc Chagall, Salvador Dali, André Derain, Pablo Picasso, Georges Rouault. Among the sculptors, both European and American, were Ernst Barlach, Jose de Creeft, Jacob Epstein, William Zorach; among the American architects, Eliel and Aero Saarinen and Frank Lloyd Wright. The editors of the *Magazine of Art*, in reviewing the exhibition, pointed out that except for materials from the Jewish Theological Seminary and the Portsmouth Priory, the ob-

jects came from individuals and secular institutions, not religious institutions, thus confirming the problem Eloise Spaeth saw and was concerned to correct.[35]

Interestingly, *An Exhibition of Religious Art Today*, by the Institute of Modern Art, Boston, also in 1944, had virtually an identical list of artists. Hence, in Dayton and Boston, there was major agreement on both the artists to be included and their significance for religious subject matter.

Also in that year, an interesting catalogue by Charlton Fortune, entitled *Notes on Art for Catholics*,[36] based on the Collection of the William Rockhill Nelson Gallery of Art, Kansas City, Missouri, appeared. While designed for the guidance of Catholics visiting the museum, it was obviously appropriate also for those interested in such subjects, particularly since the museum has a superb collection in this area. In retrospect, it is surprising that such an approach to museums has not been more widely followed by churches.

In 1945, the Philbrook Art Center, Tulsa, Oklahoma, had an exhibition of painting and sculpture, including both older and contemporary artists, ranging from El Greco to Thomas Eakins. In 1946, the Durand-Ruel Galleries in New York City exhibited *Modern Religious Paintings*, including the significant artists of the time, borrowing from galleries, museums, and collectors, such as the Spaeths. In 1948, the Museum of Modern Art in New York City entered the scene with a travelling exhibition, *Modern Church Art*, which was shown at thirteen museums throughout the country, but not at the Museum of Modern Art itself. While the exhibition included only eleven works and fifteen enlarged photographs of additional works, it did introduce the works of major European artists to a wide public in this country, such as Henry Moore, Graham Sutherland, Fernand Leger, Jean Lurcat, before their religious works were widely known either in Europe or the United States.

For 1952, three exhibitions deserve mention: the first, a regional one; the second, a European travelling exhibition; the third, by a theological school. On the West Coast, there was an *Exhibition of Contemporary Religious Art by California Artists* at the M. H. De Young Memorial Museum, San Francisco, with most of the works selected by a jury.[37] Among the artists, who together exhibited 186 works, were such nationally known American figures in paintings and drawings as Beniamino Bufano, D. Faralla, André Girard, Rico Lebrun, Millard Sheets; among sculptors and ceramists, Ruth Cravath, Micaela Martinez Ducasse; among mosaicists, Louisa Jenkins; in weaving, Mark Adams; among seriographers, Sister Mary Corita (later known as Corita Kent); and among architects, Mario Campi and Lloyd Wright.

The second exhibition, which circulated throughout the United States, involved the collaboration of several groups. *Art Sacre: An Exhibition of French Modern Religious Art and Architecture*[38] was sponsored by the Direction Generale des Relations Culturelles, Paris, and the Cultural division of the French Embassy, New York; initiated by the Yale University Art Gallery; presented in the United States under the auspices of the Liturgical Arts Society; and circulated by the American Federation of Arts. Among the almost one hundred works done by French artists were such well-known artists as Marc Chagall, Maurice Denis, Albert Gleizes, Fernand Leger, Jacques Lipchitz, André Marchand, Alfred Manessier, and Georges Rouault.

The third exhibition, *Contemporary Religious Art*,[39] was presented by Union Theological Seminary in New York City. The materials were selected and presented by the Student Religious Art Committee, with the advice of an outside selection committee comprising Lloyd Goodrich of the Whitney Museum of Art, Meyer Shapiro of the fine arts faculty, Columbia University, and Eloise Spaeth, then representing the American Federation of Arts, together with Hannah and Paul Tillich, representing the Union faculty. For the back cover of the catalogue, Tillich provided a brief statement on the relation of religion and art.[40] A review of the exhibition by Aline B. Louchheim in the *New York Times*, December 14, 1952, spoke of the exhibition in these terms:

> No *Bondieuseries* here. No sweetly sentimental or slickly streamlined version of religious themes. Instead, the show divides primarily into two parts—works which give bold, expressionist treatment to religious subjects and works which, with abstract or even secular themes, suggest a style, a way of seeing and saying, that might lend itself to religious purposes or in itself have religious significance.

In any case, among the notable artists and architects included in the almost ninety works are Marc Chagall, Pietro Belluschi, Lyonel Feininger, Adolf Gottlieb, Morris Graves, Ibram Lassaw, Rico Lebrun, Jacques Lipchitz, Richard Lippold, Henry Moore, Alfonso Ossorio, Richard Pousette-Dart, Abraham Rattner, Ad Reinhart, Georges Rouault, Eliel Saarinen, Edward Sovik, Theodore Stamos, Graham Sutherland, Mark Tobey, Max Weber, Frank Lloyd Wright, and his son, Lloyd Wright.

While the San Francisco exhibition was limited to California artists, the 1944 Dayton, Ohio, exhibition, the exhibition of French modern art, and the contemporary art exhibition at Union Theological Seminary, the latter two both in 1952, included many of the same artists. A growing consensus was beginning to emerge about the artists both in Europe and the United States who were doing works related to spiritual and religious traditions. Except for the Union exhibition, which was confined to paintings, drawings, and sculpture, the others also included liturgical objects appropriate to the life of church or synagogue.

In 1956, Eloise Spaeth was responsible for another exhibition, *Contemporary Religious Art*, consisting of paintings, sculpture, architecture, ceramics, metal, and glass, for the Guild Hall, East Hampton, Long Island. In 1958, she also undertook the exhibition *God and Man in Art*, circulated by the American Federation of Arts. With a forward by Eloise Spaeth and some observations by Marvin Halverson, the catalogue lists 175 items, including religious art, craft, and architecture. Again, the major artists of the period are included.

Two additional exhibitions in 1958 deserve attention, *The Patron Church*, initiated by the Museum of Contemporary Crafts and centering in architecture and crafts rather than painting or sculpture, and *Religious Art of the Western World*, sponsored by the Dallas Museum of Fine Arts, centering in painting and architecture. The Dallas exhibition included both works from early periods and the contemporary scene.

While it has been noted that the exhibitions began to include the same artists,

which, given the quality of their work, was a positive factor, the same constancy obtains with respect to the reproductions of plans and photos of architecture. Saarinen's Stephens College Chapel (Plate 132) at Columbia, Missouri, his Kresge Chapel (Plate 133) at the Massachusetts Institute of Technology, Lloyd Wright's Wayfarer's Chapel (Plate 134), Palos Verdes, California, and Anshen and Allen's Chapel of the Holy Cross (Plate 135) at Sedona, Arizona, were on everyone's list.

In the sixties, as in the fifties, exhibitions of religious art continued to be mounted by museums and galleries. In 1960, the Brooks Memorial Art Gallery, Memphis, featured sixty-two pieces. Mention should also be made of the 1963 exhibit, *Sacred Art in America Since 1900*, at the Art Gallery of the University of Notre Dame, and the 1954, 1959, and 1968 shows, *Twentieth Century Biblical and Religious Prints*, at the Cincinnati Art Museum. Further, one can add, the Brooklyn Museum exhibition, *Religious Painting 15-19th century*, of 1956, the 1965 *Religious Art from Byzantine to Chagall* exhibition at the Buffalo Fine Arts Academy, the 1974 exhibition *Contemporary Religious Imagery in American Art*, Ringling Museum of Art, or the *Art and the Sacred* catalogue, a history of religious perspective on art exhibited by University of Vermont religion students, in 1975. Then there are the regular exhibitions at the Cranbrook Academy of Art, Bloomfield Hills, Michigan.

While the fifties and sixties disclosed the emergence of exhibitions in which first-level artists and religious themes were featured, in the seventies such exhibitions began to take on the proportions and characteristics of developments that had begun already in the museum world in the fifties, namely, the emergence of catalogues that served as scholarly records, including major interpretative essays, entries for each work, and relevant information about the artists. Probably the first exhibition in this category in the field of religion was the 1972 venture by Jane Dillenberger and Joshua Taylor, *The Hand and the Spirit: Religious Art in America 1700-1900*.[41] This exhibition was unique both in its coverage and in the fact that it was shown at four museums, the University Art Museum, Berkeley, California, the National Museum of American Art, Washington, D.C. (then known as the National Collection of Fine Arts), the Dallas Museum of Fine Arts, and the Indianapolis Museum of Art. In addition, it was among the first exhibitions on the subject of religion and the visual arts with an extensive catalogue that included many plates, both in color and in black and white, as well as a scholarly introduction and extensive entry materials on the works. Similar in the nature of the catalogue and also exhibiting at four major museums was the sequel, *Perceptions of the Spirit in Twentieth-Century American Art*, done by Jane Dillenberger and John Dillenberger in 1977.[42]

The most extensive exhibition, covering both Europe and the United States, occurred in 1986, *The Spiritual in Art: Abstract Painting 1890-1985*,[43] the opening show for the newly renovated Los Angeles County Museum of Art. Over five hundred works were included, with a catalogue of over four hundred pages, and the exhibition was subsequently shown in Chicago and in the Netherlands. While many of the works featured in *Perceptions of the Spirit in Twentieth-Century American Art* were also included in the Los Angeles exhibition, the organization, viewpoint, and scale of this exhibition made it unique. While we have all known of the background of

theosophy, anthroposophy, and the occult in the emergence of abstraction, this volume dramatically demonstrated how extensive the influence of those movements was in the European and American artistic communities.

This development is further underscored in the eighties by the number of exhibitions featuring the spiritual, ranging from a mystical orientation through historic reappropriations, transformed, to be sure, into a new idiom. Over forty such exhibitions have been noted, most of them shown in museums and galleries in which quality is a sine qua non.[44] Indeed, the number of exhibitions concerning the spiritual between the forties and the eighties are probably less than those that have appeared in the eighties alone.

It will have been noted that some of the journals, exhibitions, and catalogues grew out of the work of institutions or societies which had an interest in the arts. Already in the forties, some of the churches had divisions that included concern for the arts, though this usually meant drama, dance, music, architecture, with less attention to the visual arts. The National Council of Churches of Christ in the U.S.A., created in 1950, successor to the Federal Council of Churches and a number of other entities, professed an interest in the total range, creating separate commissions for each art form. For these commissions, included under the Department of Worship and the Arts in the Division of Christian Life and Work, Marvin Halverson served as executive director in the period from 1952 to 1962, and Truman B. Douglass as chair from 1955 to 1962.

Halverson particularly had extensive contacts in the arts, and an imaginative vision as to how religion and artists were to be brought into relation with each other. In a 1955 brochure,"The Church, the Arts, and Contemporary Culture," authored by Amos Wilder under the instigation of Halverson, it was affirmed that while the church had pragmatic reasons for encouraging the arts in relation to its function as a worshipping community, more fundamental issues, such as the nature of the culture, needed to be addressed.

> What the Social Sciences can tell us about the contemporary scene needs to be completed by the deeper revelations mediated by the arts. . . . The contemporary arts have moved toward wholeness and have the virtue therefore of disclosing the fuller picture of man and society.The character of our civilization is such that its real inwardness is most fully grasped through the sensitive recorders we know as the artist, the poet, the novelist, the architect, the musician and the dramatist.

On that basis the document sets forth five specific tasks: (1) to know contemporary culture and its expressions and through them to know our time more fully; (2) to assess the arts in terms of Christian criteria (considered to be both negative and positive); (3) to contribute to the health and vitality of the arts and the proper understanding of the vocation of the artists; (4) to heal the breach between religious institutions and the arts, and (5) finally, to bear witness to the common ground to which both religion and the arts refer. Moreover, it is affirmed that such an agenda can only be carried out in an active partnership between those in the church and the artists themselves.[45]

In a small brochure, the founding document of a network of arts associates, serving both as interested individuals and supporters, the aim of the department in functional terms is declared to be to "set up exhibits, encourage creative work in music, drama, writing and other art forms, publish surveys, news and studies (in the newsletter and various pamphlets), organize workshops in worship and the arts, promote a living exchange of knowledge and experience, and maintain a cooperating relationship with denominational boards and agencies. A noteworthy example of its publications at the time is the special issuue, "Art in Christian Education," *International Journal of Religious Education.*[46]

It soon became apparent to Halverson and to Douglass that the National Council would not be a place where either clear thinking about the arts or financial support would be adequate. Hence, in 1962, Halverson left the National Council to form the independent group which eventually became known as the Society for Arts, Religion, and Contemporary Culture. Shortly thereafter, Truman Douglass also resigned as chair of the Department of Worship and the Arts, expressing his disappointment with the lack of support, but that he would continue to support the National Council in other areas. Apparently this development was enough of a shock to encourage another attempt on the part of the National Council to deal with the arts. In October, 1963, the council received a report from a committee appointed by J. Irwin Miller, then president of the council. The "Report of the Special Committee on the Council's Role in the Field of Religion and the Arts," chaired by Joseph Sittler, Jr., and including such well-known members as Roger Hazelton, Roger Ortmayer, Robert Seaver, and Amos Wilder, provided a new introduction to the arts, but in the body of the report repeated the former document, "The Church, the Arts, and Contemporary Culture."

New to the document are the conclusions, which are obviously an attempt to deal with the problems that had led to Halverson's departure. Fundamental to the proposals is that the issues stated in the document be the agenda for the arts; that money must be committed for adequate staffing; that the arts must be pulled together under one agency, a department of the arts, rather than scattered throughout other groups and commissions as heretofore. Pointedly, the committee states that the arts are an area in which the "usual commission, study conference, group report method of implementing this particular concern cannot be the characteristic method. . . . We have much to gain through listening with intent and sensitive ears to the artist and to artistic modes of interpreting both the faith and the world. We must overcome the tyranny of procedures, which sometimes loses ends in fascination with means." It further suggests that the perception of meanings in art in their translation into meanings related to Christians takes time, pondering, probing. Such events can be encouraged; they cannot be produced.[47]

While the report of the Special Committee was adopted in June of 1963, a Department of Church and Culture was created in 1966; yet the Commission on Church Building and Architecture continued its separate existence. In 1972, the Commission on Church and Culture, under the direction of Roger Ortmayer, was abolished, in part because of lack of money and in part because of the polarization of outlook manifest in the early seventies. While some exhibits were circulated by the National

Council and participation in conferences continued, neither Halverson's early vision nor that of the Special Committee made much of an impact on the council. More successful, in terms which the council could easily understand, was its involvement in church architecture. While the *National Council Outlook*, the official organ of the council from 1950 to 1962, followed by the *Religious Newsweekly* from 1963 to 1970, published an address by Douglass on art, these publications confined themselves to analyses of architectural meetings, lamenting sterile buildings, encouraging modern but not modernistic styles, and reporting on progress made here and there.[48]

The irony of the National Council's concern with art and architecture is evident in the building of the Inter-Church Center on Riverside Drive, near the Riverside Church. The land, the gift of John D. Rockefeller, Jr., was an ideal site, but sufficiently near the Riverside Church to tempt the architects, perhaps with encouragement from church bodies, to propose a building which harmonized with the imitation Gothic of Riverside Church. When the Gothic frills of the proposed building were exposed through the press, a more chaste building was planned, which the *National Council Outlook* of December, 1957, described as follows:

> The exterior of the Interchurch Center will have a dignified, distinguished character that blends harmoniously in appearance, materials and mass with the buildings of its important neighbors. Of conservative modern design, its uncluttered, functional lines will take full advantage of the commanding site. Its inviting limestone exterior, and the wide expanse of glass framing its imposing Riverside Drive entrance, conform perfectly with the spirit of the building's purpose.

Given the criticism which the plans for the rather undistinguished building brought forth, an advisory committee to the architects was established, this time to deal with the interior of the building. While various themes were proposed for sculpture and painting, it became obvious that the will to employ distinguished artists was not present, in spite of the encouragement of such figures as Alfred Barr of the Museum of Modern Art and the eminent theologian Paul Tillich. Moreover, the chair of the Building Committee held the view that the architect had the right to select the artists, which, in more favorable circumstances, might have worked. The Biblical theme from Ephesians 4:4, proposed as the theme for the first floor by Jane Karlin (Dillenberger), was accepted. But instead of commissioning an artist to execute a work of art in the light of the theme, as she had proposed, the passage from Ephesians was carved on a block of marble in the entranceway.

Dissatisfaction with the National Council on the issue of the arts was translated into action on the part of Douglass, Halverson, and a number of additional individuals. One of the original partners to the conversation was Paul Tillich, with whom Halverson had repeated conversations about both the National Council and alternative possibilities. In a letter written by Tillich to Halverson, dated October 21, 1961, preparatory to a meeting the same day, he indicated steps he had already taken.

> I want you to know that I have retained a lawyer who is drawing up the legal papers for the establishment of a non-profit corporation to be called the Foun-

dation for Religion and Culture. Many of us have talked about the wisdom of setting up such a foundation to carry out projects which an increasingly bureaucratic church organization finds impossible. But I want you to know that your suggestion on seeing you at Harvard last April that we proceed served as the catalyst and prompted me to go ahead. Needless to say this has been discussed in a small circle thus far but it seems the KAIROS has arrived.[49]

Among others in the discussions, according to the letter, was Denis de Rougemont, who later gave a commemorative lecture on Tillich for the society, and who at this time symbolized the anticipated international dimensions. Ten days after the Tillich letter, a group met at the Century Club for lunch, including in addition to Tillich, Halverson, Douglass, and de Rougemont, Alfred Barr, Jr., Robert Penn Warren, Stanley Hopper, Tom Driver, Marcel Breuer, Alexander Schmemann, Howard Spragg and William Stringfellow. At a further organizational meeting, held on May 10, 1962, such additional figures as Nathan Scott, Jr., Wilhelm Pauck, and Robert Motherwell were present. Hence, it is obvious that the initial group consisted of individuals prominent as architects, artists, literary figures, and theologians. At the same organizational meeting, in which Barr was elected president, Tillich, de Rougemont, and Wilder as vice-presidents, Douglass as chair of the board, and Halverson as secretary, an additional eighty-four individuals were elected members of the newly founded group, then known as the Foundation for the Arts, Religion, and Culture, Inc.

While the name was changed in 1968 to the Society for Arts, Religion, and Contemporary Culture, and was increasingly referred to as ARC, the designation "foundation" was appropriate for the original purpose, one which included the commissioning of artists, major publication projects, a house for conferences, visiting scholars, and a library. Plans called for a staff of at least five individuals, and hence a budget of considerable size. Ironically, in spite of the efforts of Barr, Halverson, and Elizabeth Bradley, to name but three of the most active in the attempt to raise funds, the same lack of financial support plagued the new group as had been the case with the National Council of Churches. Within three years of its founding, ARC could not afford a full-time director, much less a larger staff. In the meantime, Halverson, who had been executive director, became ill and never returned to a full-time position. ARC survived financially mainly through the interest of Douglass (active until his death in 1967) and Spragg, who through their roles in the United Church of Christ, saw to it that financial support came from that body from the sixties into the eighties. Aside from a $50,000 grant from the Luce Foundation and the support of the United Church of Christ, ARC has relied on the contributions of members, the efforts of underpaid part-time executives, and donated or modestly rented space.

While Tillich was a moving spirit in the start of ARC, there is no evidence that he was ever active in the organization or attended a meeting after its initiation. After three years, Barr and Pauck resigned respectively as president and chair of the executive committee, and within a few years, many of those initially active resigned or simply drifted away. At the same time, it is impressive how many individuals continued to see in ARC a place for conversations across boundaries that had separated

religion and art, once so closely intertwined. Robert Motherwell and Ad Reinhardt, avant-garde artists of their time, and Alfred Barr, Jr., whose perceptive eye created the core collection of the Museum of Modern Art, were active in the early years. From the early days into the eighties, the literary critics Stanley Romaine Hopper and Amos Wilder, the psychiatrist Rollo May, and the mythologist Joseph Campbell were active. From its inception until the present, William Conklin, the architect and authority on Pre-Columbian art, and Emery Valyi, industrial engineer and inventor, have been active in its affairs. In more recent decades, David Miller, Howard Hunter, Betty Meyer, Roger Hazelton, John Hayward, Theodore A. Gill, Howard Fish, and Jane Dillenberger have played an important role.

From the beginning, publications were considered important to the life of the society. At first, ARC *Directions,* dealing with various issues of the time, was published, followed by *Seedbed,* a newsletter for the members conceived and edited by Betty Meyer for most of its history. Equally important, several volumes emerged from the activities and programs of the society. *Myth, Dreams, and Religion,* edited by Joseph Campbell, is clearly the product of ARC, as is the forthcoming volume on the grotesque, edited by James Luther Adams and Wilson Yates.

During its quarter-century history, different accents have manifested themselves in ARC. Given its origin in the context of the National Council of Churches, it was perhaps inevitable, as Amos Wilder noted, that the original concerns dealt with religious institutions and the artists, then moved to symbolism and the dynamics of culture; or from aesthetic critiques of traditional religious art to art in general, whether or not specifically religious. In its early period, the aim was to put artists and the church in contact with each other; in a middle period, it was to bridge religion and art through studies and methodologies which cut across them, as in forms of psychology and mythology; in more recent years, to reinstate an active dialogue between those in religion and the arts.

While the National Council was bureaucratic, ARC was loose in its structure and operations. While the National Council was unwilling to commit significant funds for the arts, ARC never succeeded in raising sufficient funds to carry out the agendas it has set for itself. In short, it was always at the brink of collapse for financial reasons. Yet, it continues to exist, currently centering its activities in three all-day symposiums per year in New York City. These meetings are among the most significant and interesting in the field of religion and the arts. Surely, the idea behind the original vision, namely, of conversations that involved people in the fields of religion and the arts, is vindicated in that the society has continued to function in spite of financial and staffing problems.

Christians in the Visual Arts (CIVA), founded in 1982, is also an independent organization, sponsoring a national conference every other year and editing a regular newsletter. The newsletter serves both as a means of disclosing what is going on in the arts and as a medium of communication among its members. As the title of the organization suggests, CIVA, in contrast to ARC, has a distinctive viewpoint, assessing the arts in the light of specific Christian criteria. Given its brief, though active history, it is too early to make an adequate assessment of its work and its future.

12

New Forms of Christian and Religious Art

The search for the depths of humanity is at the heart of modern art, and with it a turning away from all conceptions of humanity and God that cover up the wide ranging facets of who we are and how we act. Since the eighteenth century it was widely accepted that figural and religious subjects no longer conveyed either the dynamics of humanity or of God's loving holy wrestling with the world. While this transition has often been discussed in terms of a developing secularism, it is more instructive to talk of the loss of a broad understanding of the range of sensibilities that make up who we are.

While the Renaissance, with the help of the recovery of classical Greece, gave us both a tradition of technical excellence and models from antiquity, as the basis for a concept of human beauty that personified all that we might be and become, it also opened the door for imitations of the human figure that had neither the power nor facility possessed by classical Greece or the Renaissance. It was only in these two brief periods that the human figure as ideally beautiful could convey the grand dynamics of humanity. The continuation of that ideal, when the circumstances changed, turned art into imitation, virtuosity and sentimentality. Precisely that happened with Christian art, as both inside and outside the church the post-Renaissance figural tradition was continued. The regionalist painting by Thomas Hart Benton, *The Lord is My Shepherd* (Plate 136), is perhaps intended to be ironic, but it is in fact superficial and banal. Warner Sallmann's or Heinrich Hofmann's *Jesus* is slick and sentimental, disclosing what happens to art with religious subject matter by the thirties and forties of this century. Such works manifest the dead end of religious subject matter for the church.

Since religious art had continued in the Renaissance tradition, the church had no awareness that, except for classical Greece and the Renaissance, the visual arts always had elements of distortion or abstraction, even when dealing with the human figure. Hence, it has been ill prepared for the emergence of either partially or totally abstract art, even though facets of abstraction have characterized the visual arts more often than not. In addition to that stylistic difficulty, the distortion or absence of the human figure seemed to imply that Christian substance had disappeared and that, at best, a general religiousness had set in. Living in the aftermath of a Christian understanding of the Renaissance, the church has not been aware of the extent to which the Renaissance itself involved a baptism and transformation of art forms into its own idiom. Nothing less than a similar problem challenges the church today, as

it faces art forms that are abstract, and figural creations that deliberately have canons of beauty different from the inherited Renaissance tradition.

The task before us then is to show how art forms that are in an abstract tradition, either totally abstract or figural in the context of a preceding abstract tradition, are the very vehicles by which the modern world has recaptured a fuller range of human sensibilities, and thereby also the possibilities of a visual tradition that can serve the church.

This shift toward abstraction is already evident in how nature and civil religion, both themes in the nineteenth century, are transformed in the twentieth. This is followed by the total abstraction of abstract expressionism, and then by the emergence again of the human figure under the impact of abstraction rather than the Renaissance.

Before turning to each of these developments, we should also note that such art currents no longer reflected the culture out of which they emerged, but instead formed perceptions that challenged and transformed the inherited culture. In the process, attention in the art scene shifted for the first time from Europe to the United States, accounting, too, for the fact that American art of this period cannot be discussed without reference to European figures who continued to be part of the dialogue, whether from Europe or as expatriates.

In the eighties, of course, we live in a period in which the artistic currents, like other currents of thought, are increasingly worldwide. The result has been a widening of horizons for many artists, though the dizzying project of coming to terms with a pluralistic time has led some to resurrect motifs from the past, a vertical rather than horizontal broadening of horizons. This has been described as the shift from the modern to the postmodern, and is characteristic of some of the art of the late seventies and of the eighties.

Nature and Art

The paintings of the Hudson River School could be seen in a Christian context, the manifestation of how the created world was perceived with Christian eyes. In such nineteenth-century views of nature, the sublimity is evident in the grandness of the depiction, with the forces of nature evident in the pictorial portrayal, either through an arcadian pastoral scene with its harmonies or through other scenes in which the disharmonies are evident in craggedness, storminess, and sometimes vastness of scale. In the work of artists such as Thomas Cole, both poles are evident in paintings with religious subject matter, as in the *Expulsion* (Plate 41), or more secular subjects, as the *Oxbow*. In such paintings, the harmonies and the disharmonies are natural, that is, not produced by humans.[1] Nature, seen in these paintings with Christian eyes, is the direct handiwork of God.

Already in the second decade of the twentieth century, a shift was occurring in the depiction and perception of nature, largely under the influence of a circle of artists associated with Alfred Stieglitz. In terms of his own art, Stieglitz will always be remembered for his photographs, which he understood as a combination of the

representational and the abstract. But his role in relation to other artists is equally important. In the first and second decades of this century, he exhibited works of Rodin, Matisse, Rousseau, Cézanne, Picasso, and Toulouse-Lautrec in his own gallery in New York. In the 1913 Armory Show, under the organizational leadership of the artist, Arthur B. Davies, the avant-garde of Europe was even more dramatically brought to the attention of the American public. The negative reaction to this show indicated the barriers that had to be broken in order for new forms of art, which included distortions of the human figure and abstraction, to be accepted. Over a decade later, Constantin Brancusi, who exhibited in the Armory Show, was involved in lengthy litigation with the U.S. customs office, for they considered his *Bird in Space* (Plate 137) to be a manufactured object instead of a work of art.[2]

Stieglitz encouraged a group of American artists to expose themselves precisely to such modern art, both here and abroad, and then provided them with space in which to exhibit their own work. In this group were such artists as Charles Demuth, Arthur Dove, Marsden Hartley, John Marin, Georgia O'Keefe, Charles Sheeler, Abram Walkowitz, and Max Weber. Diverse as these individuals were, they were concerned to create a new American art, and their works seemed to represent both the forces of nature and the dynamics of the new industrial scene, though the latter seemed to them as extensions of the power of nature. While nature had been a subject for art from the seventeenth century on in art, its place in American art was pervasive.

For the artists just mentioned, the objective was not to purvey the forces and mysteries of nature through forms of direct depiction. Rather, forms of abstraction became the way in which the forces and vitalities of nature were set before us as positive mysteries, echoing something about nature and about ourselves. Elsewhere I have dealt with these artists.[3] Here, Georgia O'Keeffe, both because of the quality of her work and her long productive life, has been chosen to represent this new American direction in art.[4]

O'Keeffe, who went to Europe only after her career was well established, was brought to the attention of the art world by Stieglitz. While influenced by the teaching of Arthur Dow, with its overtones of oriental painting, O'Keeffe soon developed her own unique style, a style which led Stieglitz to declare that she was the "first real woman painter."[5] Her works of the twenties disclose the serenity and internal forms of nature, forms of energy that, while contained, are perceived as full of power. Her paintings of the thirties and forties have haunting undertones, whether expressed through somber New Mexican experiences or the more lighthearted encounters with eastern Canada. Her works of the sixties reflect new and joyful experiences, such as her extraordinary vision of rivers or clouds seen from the air.

In all of them, the mystery of nature, to which we humans bear an affinity, is the subject of the paintings. This is true even when the obvious subject of a painting is one of her abstract versions of the Ranchos Church, or one of her crosses placed against a Mexican sky, as in *Black Cross: New Mexico* (Plate 138), or her Canadian version of the same subject, *Cross by the Sea, Canada* (Plate 139). In the Church paintings, the elemental forces of the adobe materials form and sustain the structure

of the building. In the New Mexican Cross paintings, it is the power of the sky and the hills that override a cross, even when the latter is placed dominantly in the foreground and shares in the attracting, threatening pulse of nature. In her Canadian versions, it is the wide vista of the sea that makes the small wayside cross an ironic if not incongruous intruder on the scene.

O'Keeffe's paintings of her patio door, of cow skulls in which one cannot miss the cross forms (Plate 140), and of pelvic bones through whose sockets the blue of the sky is seen, too form a passionate fascination with the mystery of nature, and with it, an affirmation of humanity. Her nature mysticism is not one in which the self is lost; rather, our affinities with the forces and structures of nature are affirmed. Nature appears as the elemental grounding of everything, including our humanity. A profound reverence pervades the whole.

For the artists in the Stieglitz circle, nature was seen in its many moods. It had an echo of mystery, of elemental forces and structures, that lay at the heart of both nature and humanity. For these artists, such affirmations, expressed in nature, were substantive and real, in contrast to what had happened to traditional conceptions of God. It was as if one had to leave the God question before it could be taken up again.

The shift from the Hudson River School to that represented by O'Keeffe and her fellow artists involved a transition in the art itself from form and pictorial structure to concentration on forces expressed through abstraction. As art, the former was less religious in spirit, but easily acceptable to a Christian understanding. O'Keeffe, whose paintings breathe spiritual and religious sensibilities, at one level is considered antithetical to Christian understanding, perhaps because her outlook demands no further context than itself. But at another level, her perceptions could easily be brought into or baptized into a Christian understanding. Such an approach, however, requires abandoning the directly pictorial mode and accepting forms of abstraction as appropriate to Christian comprehension.

Public Municipal Sculpture

In contrast to nineteenth-century public sculpure, which was mainly figural in style, twentieth-century sculpture in the public domain is either abstract or shows the influence of abstraction with respect to the human figure. However, instead of centering on public sculptures by such figures as Calder, Dubuffet, Picasso, or Serra, whose works are placed next to corporate offices or in public squares, our focus will be on sculpture that relates to specific events in the body politic, that correspond in some sense to the civil religion of the nineteenth centuury.

The Vietnam Veterans Memorial (Plate 141) by Maya Lin on the mall in Washington, D.C., is a symbol of twentieth-century civil religion expressed in abstract forms. A sloping landscape ends before a walk along a wall that reaches just to the top of the normal terrain, a wall upon which are inscribed the names of those who lost their lives in connection with Vietnam. The simple, almost stark black marble

wall is the backdrop for the thousands upon thousands of lighter inscribed names. Watching the crowds scan the wall, one sees some who are curious, others looking for a name they know, brother, sister, daughter, son, but all caught up in the conjunction of object and the event it signfies. It is a perfect illustration of contemporary art which compels us into its orbit.

Nevertheless, the disquiet of some with abstract art led to the commissioning of a figural sculptural group by Frederick Hart (Plate 142). The abstract work by Maya Lin and the figural sculpture of Frederick are far enough apart so that one does not need to see both at the same time. While competent enough as figural work, Hart's figures are commemorative, as in nineteenth-century Civil War sculpture or even the Iwo Jima monument of World War II. But since World War II, something has happened to the psyche of Americans. Many of them no longer see the world in terms of victory or defeat, but instead have become aware of the ambiguity of human events. The Civil War and Iwo Jima monuments celebrated costly victories and veritable turning points in the fortunes of the two wars, which are seen through the eyes of the victors. But the Vietnam Memorial reflects not only the loss of countless lives; it also binds together those who died, who thought the cause just, with those who saw it as folly and tragedy. The wall could do what nothing else could, namely, bring a people symbolically together in the ambiguity of suffering. It is what Hart's figural work cannot do.[6] The artist Stephen De Staebler has said, the function of art is to restructure reality so that we can live with the suffering.[7]

The large folk art quilt commemorating victims of AIDS also symbolizes the commonality of suffering beyond censure, blame, rhyme, or reason. It is made up of pieces the size of a grave (three by six feet), each commemorating a specific victim of AIDS; in each of the large cities where it was exhibited as it toured the country, squares were added on which the names of additional victims were inscribed. Here the beauty of art visually articulates the range of humanity's glory beyond what discourse and sheer passion can articulate or convey.[8]

The Holocaust memorials in this country and abroad present special problems. The enormity of that event is without ambiguity. Precisely because that is the case, some memorials, as the one on the Île Saint-Louis in Paris, appear as tombs rather than as works of art. They convey nothing but death. Is that, one wonders, why the Paris memorial is widely regarded as the best commemorative work on the Holocaust?

In contrast to such works is the Holocaust memorial by George Segal, consisting of ten bronze, partially abstract figures, at first sight dead figures randomly strewn on a concrete block, enclosed on three sides by a wall, and fronted on the fourth by a barbed-wire fence with a standing, survival figure between the fence and the dead figures, who looks beyond the fence, toward the outside world. We, the living, now decades after the tragedy, can walk around and in the total sculpture, experiencing, to be sure, from a distance, the burden of that event.[9]

For years, Segal avoided doing that sculptural ensemble. Distance, he believed, was a dividing line between depicting an event and creating a work of art. But distance is not merely time; it is a way of seeing. Segal exposed himself to thousands of photographs of the Holocaust and to accounts of the happenings. But he also pondered

the events, asking himself how to convey that horror with the transcending strands of human dignity that every work of art requires.

The result is one of studied ambiguity and heightened tensions. Placed deliberately in one of the most beautiful vistas that nature can provide, namely, looking at the sea and coastline as it forms the Golden Gate leading to San Francisco Bay, the juxtaposition of beauty and monumental horror is unavoidable and part of the experience. The lonely survivor looks out, as if the memory of survival can never be erased by what lies beyond. The sprawling figures, on examination, form deliberate configurations. Some seem to form a star, perhaps the star of David. Then there is Adam and Eve (Plate 143), the latter with a partially eaten apple, and Abraham and Isaac (Plate 144), those figures that haunted Segal, as Kierkegaard before him, and which he had sculpted twice before. Here Abraham seems not only to shield Isaac's face from the terrible deed he is about to undertake; it is also as if Isaac's face was being hidden from the horrors of the world and of this particular event.

Segal's *Holocaust* has received mixed reactions. Some find its placement in such a beautiful spot a negation of its power. Others see the connection with past history, as exemplified in Adam and Eve, and Abraham and Isaac, as blunting the horrendous events of the Holocaust, which, for them, cannot be compared with anything else in history. Still others see the strewn figures as appearing too peaceful, though, for Segal, they deliberately appear peaceful and now are at peace. For Segal, the horror of the Holocaust is real. But its reality, too, belongs to the agony of history, in which the cruelty humans inflict on each other does not wipe out the dignity of humanity, even in death.

The Vietnam Memorial, the AIDS Quilt, and Segal's *Holocaust* represent three contemporary public works of art in which elements of abstraction have replaced traditional figures. They also deal with ambiguity—the irrational, the cruel, and the absurd. In these works, ugliness and beauty have touched each other in ways only art can instantly purvey. For this reason, too, these works represent the reemergence of symbols in our time, works of art that are powerful because they mirror the tensions, fears, cruelty, and hopes within us. For those who believe that symbols have died, that there are no signs of their being reborn, these works of art testify precisely to the opposite.

The Context and Nature of Abstract Expressionism

In twentieth-century theology and culture, many have tried to mark out new departures. For the church, the problem arose when religious subject matter no longer carried power, because its literal form, which had once pointed to trans-literal meanings, had become literalistic. Then attention shifted to the forms themselves, which were considered equivalent to subject matter and meaning. In theology and the visual arts, the problem of demythologizing arose, namely, the question of how to start over again in the light of a world view that, in its pictured exactness, had sapped imagination.

The New York City abstract expressionists, in whose paintings the manipulation of color and the format of the canvas were both the medium and the message, were among the most self-conscious repudiators of the past in their attempt to start over, indeed, to create a new art tradition.[10] And for the most part they succeeded, for just as postmodern is dependent on modern, so the visual arts are different in the aftermath of abstract expressionism, even among those who are now forging diverging paths.

The abstract expressionists centered in New York City. To some degree, that was the result of the temporary (in some cases, the permanent) influx of artists from Europe to the United States during World War II. But mostly it was the coming together in New York City of a remarkable group of artists, both expatriates and Americans. Given that mix, it is understandable that their consciousness encompassed both developments in Europe and the United States. New York City was thus the setting in which yeasty currents of Western art were engaged in marking out the future in a situation in which many believed that the visual arts and sculpture had come to a dead end. In this respect, their convictions were similar to those of the earlier Stieglitz circle. While Georgia O'Keeffe and Arthur Dove, undoubtedly the two major figures in the Stieglitz group, centered their new departure in delineating the forces of nature, the abstract expressionists, such as Barnett Newman, were interested in an art which rehabilitated the human being as grand and heroic, even if tragic.

Moreover, in both instances, abstraction was the key to a new form of art. When the visible world in and of itself no longer conveys meaning beyond the visible, that is, when the visible itself has become banal and shallow, the erasure of the visible may be the only expedient. In that context, an affinity may be said to exist between the abstract and the spiritual, an outlook classically expressed in Wassily Kandinsky's *Concerning the Spiritual in Art*. Originally published in German in 1912, it was already available in English translation two years later.[11] While the volume expresses what became an accepted outlook among a considerable number of artists, it is difficult to document a direct influence, particularly among the abstract expressionists.

While the abstract expressionists found European art of recent decades more important to their concerns than American art, particularly the work of regionalists such as Thomas Hart Benton or Grant Wood, their psyches were formed in an American ambience. Their responses thus involved both worlds, an active conversation with the art and spirit of each. But if the abstract expressionists knew the sources of abstraction, they also believed, with justification, that they had carried abstraction to levels that made it a new reality.

Elsewhere I have sketched angles of vision unique to the various figures in the abstract expressionist movement.[12] In summary form these can be expressed as follows. Barnett Newman (Plate 145) accented the grand and the sublime in an art that demands much of us, and Jackson Pollock (Plate 146) glimpsed new realities, as if of a promised land he could not enter himself, having seen the depths of hell. Helen Frankenthaler (Plate 147) centered on color that suggests cosmic dimensions; Adolf Gottlieb (Plate 148), scrawlings and bursting circles that echo creation; Lee Krasner (Plate 149), the unity of inner and outer worlds, reflecting the self in all its mystery;

Joan Mitchell (Plate 150), the hieroglyphic structures of the world; Robert Motherwell (Plate 151), the grand classical tradition of humanity; Ad Reinhardt, a somber perfection that asks nothing more; Mark Rothko (Plate 129), the mysticism that is echoed in colors that evoke and entice us into new, unexpected modes and moods.

Of these artists, Newman, Rothko, and, to some extent, Pollock are publicly associated with religious themes. In Newman's case, the titles of many of his works, such as *Abraham, Covenant, Jericho,* and the fourteen *Stations of the Cross,* disclose an affinity between his works and the issues of religious perception. For Rothko, the connection is most vivid in the Rothko Chapel in Houston, though similar areas of contemplation are created in museums which occasionally bring several of his paintings together in one room, as at the Phillips Collection, Washington, D.C., or the Tate Gallery in London. While Pollock's name is associated with an aborted chapel project, it is essentially his paintings, as indeed is the case also with Newman and Rothko, that raises the religious questions. In the case of Newman and Rothko, the connection is merely more explicit than in the instance of Pollock. Moreover, given that Newman was both the most articulate and rigorous in making claims for the abstract expressionists, attention will be given particularly to his role.

In the broadest sense, the issue of what to paint or sculpt, particularly at a time when painting and sculpture seemed to have no future in a figural sense, is a religious question. Hence, the interest in abstraction, so alien to many, comes naturally to the foreground among artists, for whom it has always been an issue. The abstract expressionists were aware that there were traces of abstraction in impressionist paintings, such as the various forms of Monet's water lilies, where the light plays on the surfaces of nature and is expressed in such translations onto canvas. Yet, in spite of the beauty of such creations, the abstract expressionists sensed a lack of depth in such creations. Matisse was more interesting, for in him color expressed both form and content. While Matisse's feeling for color, which so focused the content that it provided the form, suggests an analogy to abstract expressionism, it never reached the radical focus that in abstract expressionism separated recognizable form and reality.

There are, however, several theories about the direct lineage of abstract expressionism, each of which supplies us with particular and appropriate angles of vision. While none of them satisfactorily explains the radical newness of the movement, taken together they disclose the magnitude of the issues which these artists had to address.

For years the accepted lineage of abstract expressionism ran from Cézanne through cubism to abstraction. Visually, the case is compelling, as one moves from Cézanne's *Five Bathers,* so familiarly clear, to Picasso's *Les Demoiselles,* more disturbing in its time by its aggressive angles than by its shocking pinks, to Picasso's cubist *Nude Woman,* hardly plausible as that without title. This breaking of figures into angles and planes, and the replacing of parts and facets in new configurations shattering what we have known, nevertheless makes the familiar but unfamiliar into a new creation, calling for new responses, which, with time, go beyond liking and disliking, to seeing anew, taking us knowingly into unknown realms.

In 1975, Robert Rosenblum, in *Modern Painting and the Northern Romantic Tradition, Friedrich to Rothko*,[13] marked out another lineage for total abstraction. Caspar David Friedrich, painting in Germany in the first decades of the nineteenth century, turned to the mystery of nature as an arena of transparency, in which nature in its presence discloses echoes of transcendence. Frequently, in line with the fascination of the romantics with the Gothic past, crosses and churches appear in the midst of his paintings of nature, as if, indeed, the heaven-aspiring trees and the Gothic thrusts coinhered in form and meaning.

In his own time, the theological world was not without interest in Friedrich's work. The theologian Friedrich Schleiermacher recognized a kinship with Friedrich, went to Dresden to visit him, and invited him to exhibit his paintings in Berlin.[14] At this time, both in Europe and the United States, nature was an alternative, collateral area of delineating mystery in a world in which orthodox theological mysteries had been over-clarified to the point where their clarity, originally so tantalizing, had become repulsive to many.

Rosenblum particularly points to the color of the sea to evoke mystery, with its indistinct horizons and misty vapors. Visually, then, he shows how Friedrich's *Monk by the Sea* (Plate 152), with its eerie lights and dark, can be linked with a painting by Mark Rothko, in which there are similar modulations of color, with the boundaries between them fluctuating between distinctness and indistinctness. Lest the alleged affinity between nineteenth-century Friedrich and twentieth-century Rothko be considered merely an oddity, one could add such paintings as *Luminous Sea* by Emil Nolde, to whose religious subjects we have already alluded. Most importantly, Rosenblum points to Piet Mondrian, in whom one sees the progression from the inchoate abstraction characteristic of Friedrich to a form of abstraction more akin to the total abstraction of abstract expressionism. The *Church at Domburg* combines the interest in nature with the Gothic impulse. But in *Pier and Ocean* (Plate 153), all traces of recognizable nature have disappeared, and the gridlike lines bear some affinity to cubism, a movement with which Mondrian is also associated.

Rosenblum is also aware that the relation of nature to abstraction can be found closer to home, that is, in the American scene. From our discussion of the nineteenth century, we know that Japanese works depicting nature, with their abstract forms, influenced painters in the United States, such as John LaFarge or, later, Augustus Vincent Tack. Earlier in this chapter, we noted that already in the thirties of this century, Georgia O'Keeffe was painting nature in abstract forms as a medium through which the human psyche was expressed without the presence of the human figure. Writing of O'Keeffe in a *New York Times* article, November 8, 1987, Michael Brenson stated: "Her belief . . . that the purity and grandeur of nature could be expressed most purely and grandly in an abstract or stripped-down pictorial language, helped her create images that point toward Abstract Expressionist painters such as Clyfford Still, Mark Rothko and Barnett Newman."[15] Giles Gunn reinforces this American source in describing a moral geography, an Adamic impulse, in which the thrust of starting over is found to be deep in the American psyche.[16] Barnett Newman was

interested in Emerson and Thoreau for precisely this reason and made a pilgrimage to New England sites associated with their lives.[17] Hence, this side of Rosenblum's thesis is supported from many quarters.

Recently, too, a third path toward abstraction has been vigorously documented in the 1986 exhibition and catalogue, *The Spiritual in Art: Abstract Painting 1890–1985*,[18] the opening exhibition of the Los Angeles County Museum of Art for the inauguration of its new wing. While we have known for a long time that a considerable number of artists had contact with theosophical and allied movements, the alleged influence of such movements is here documented (both in the exhibition and catalogue) through the juxtaposition of books on the subjects alongside works of art, together with biographical information that discloses membership in or associations with such movements and concepts as alchemy, the occult, theosophy, anthroposophy, cabala, hermeticism, spiritualism, native American arts, Rosicrucianism, Taoism, and Zen Buddhism.

In some of these movements, such as theosophy and anthroposophy, there were definite speculations and theories about color and its meaning in art. It was assumed that states of understanding could be induced and expressed by various colors and their modulations. The theories of Annie Besant and Charles W. Leadbeater were widely known, and Rudolf Steiner, himself a painter, was responsible for artistic and architectural developments at his institute in Dornach, not far from Basel.[19] Moreover, we know that Kandinsky and Mondrian were involved in both theosophy and anthroposophy. Hence, there was an atmosphere in which spiritual affirmations, theories of color, and forms of abstraction came together.

But the most that one can say is that these movements did provide an ambience in which artists laid claim to dimensions that, in one form or another, may be said to belong to the full range of human perceptions about themselves and their world. Hence, *The Spiritual in Art: Abstract Painting* was a fascinating exhibit, with an interesting thesis that can neither be proved or disproved. It leaves us disquieted in its quest of undergirding abstract art with spiritual movements, as if one now substituted cultic movements for traditional religious subjects that had become banal.

More convincing as part of the initial background for abstract art than the occult movements, it seems to me, are traditions of various North American Indian tribes. Richard Pousette-Dart, Jackson Pollock, Adolf Gottlieb, and, to a lesser extent, Barnett Newman confessed to an interest in and exposure to such arts. Indian arts were of interest for several reasons. First, they were outside the mainstream of Western history, and thereby free of the conditioned history that had made recent phases of Western art moribund for many. Second, as W. Jackson Rushing has remarked in an essay in *The Spiritual in Art: Abstract Painting*, American Indian art reflected "a universal stage of primordial consciousness that still existed in the unconscious mind," for, unlike many other primitive arts, "it had continued unbroken from ancient times to the present."[20] Here the affinity with Jung and the surreal in art is clearly evident. Third, from Pre-Columbian art to the art of the Pacific Northwest, this art had elements of abstraction in its motifs and figuration. Pousette-Dart's *The Magnificent* (Plate 154) suggests a relationship with the totem figures of the Pacific Northwest.

In Jackson Pollock's *Guardians of the Secret* (Plate 146), Indian motifs are evident, first in the center rectangle, full of pictographs, forms which are on the border between writing and painting, and which are found both in American Indian tribal cultures and other early cultures. On both sides of the pictographic center, Pollock placed two columnar forms, possibly male and female, which are influenced by Egyptian motifs, or are a transformation of the totems of the Pacific Northwest Indians. In the upper part of the painting, just to the left of center, is a white mask of the mythical Tsonoqua of these Indians. Just to the right of the white mask, indeed, top center of the painting, is a black, fetal-formed insect, found, this time, not in the Northwest, but among Indians of the Southwest.[21] Such Indian motifs, which Pollock and others knew mainly from the Museum of Natural History, from the Museum of the American Indian, and from exhibitions of Indian art, are however transformed into artistic creations of their own. But the Indian motifs, including readily recognizable masks, a mixture of geometrical and organic forms, as well as ritual patterns, seemed to have placed one nearer to original humanity than the artifacts of Western European culture.

Barnett Newman, too, saw Indian arts in that way. In 1944, he organized a Pre-Columbian stone sculpture exhibition for the Wakefield Gallery; in 1946, an exhibition of Northwest Coast Indian painting for the Betty Parsons Gallery. In 1949, Newman visited the Indian mounds in Ohio, which endlessly fascinated him. Writing the introduction to the catalogue of Northwest Coast Indian paintings, he pointed to the ritual character of the Indian paintings, and their expression of mythological beliefs. He was particularly fascinated by the fact that even their representation of forms in nature took on abstract shapes. Newman concluded that abstraction was not the creation of a snobbish elite, but it was instead the normal well-understood dominant tradition of such so-called primitive people. Is it instead, he asked, we who have lost the ability to think on the high level of these simple people?[22]

Unlike Pollock, Newman's own paintings bore no direct trace of Indian art. His early works, among which was *Genetic Moment* (Plate 155), had biomorphic forms and mythological images, related perhaps to his study of ornithology, botany, and geology. It was such study, too, that set him at odds with many of its scientific interpreters, who seemed always to ask who the first human was in terms of function, such as hunter, tool-maker, priest, when in fact, says Newman, the first human was an artist. "The God image, not pottery, was the first manual act," declared Newman, and the Fall in Genesis was not from utopia to struggle, but from the good in creation. The Fall is our inability to live the life of a creator, and it is the artists who are concerned with original humanity. The first human cry, like his painting *The Voice* (Plate 156), declared a song, not a request for a drink of water. Myth came before the hunt, and speech first was an address to the unknowable, not the desire to define the unknown. The human in language, he declared, is literature, not communication. In such language, Newman is searching for and affirming that humanity is first and foremost a mystery to be affirmed in its creative springs lest humanity is understood primarily through such questions as what for and what with.[23]

For Newman, what is fundamental to humanity had been lost and this meant the end of painting. In a symposium in 1967, Newman said: "In 1940, some of us

woke up to find ourselves without hope—to find that painting really did not exist. Or to coin a modern phrase, painting, a quarter of a century before it happened to God—was dead."[24] In short, painting, to be born again, meant first of all the rebirth of that which comprises humanity in its original emergence or creation, an indispensible prelude to the rebirth of painting or of God.

The struggle for humanity, in Newman as in the theologian Karl Barth,[25] meant overcoming even those who were helpers on the way. For Newman, nature as depicted by Monet in his water lilies, American Indian culture, surrealism as depicted in Gorky's *Diary of a Seducer*, and finally the geometrical abstraction of Mondrian, needed to be pushed aside, for in all of them, the recognizable traces of what we know still characterize painting. Instead of the traces of the world, however reshaped, slanted, skewed in order to avoid what Tillich called "beautifying naturalism,"[26] painting as painting itself, not what painting still discloses about a visible world, must itself be the reality from which we start. A painting can no longer be about something; it must itself be the something. There was no world to be painted; only a world to be made in painting. Painting then was an act of being, a metaphysical act, a venture of and into the unknown.

It is precisely here that Newman parts from Mondrian, for in Mondrian geometrical forms are still static elements of design, facets of the world as we knew it in the past. Newman wrote of Mondrian, "geometry swallows up his metaphysics," to which Harold Rosenberg added, perfection swallows up exaltation.[27] For Newman, a square or a circle was "a living thing, a vehicle for an abstract thought-complex, a carrier of awesome feelings." Abstraction in that sense dealt with humanity, not with the world in and of itself. One is reminded, of course, of Leonardo's version of *The Proportions of the Human Figure, after Vitruvius* (Plate 157), in which the standing figure touches the square and the outstretched one, the circle, as if there was a harmony between the geometry of the square, the circle, and the human body, a signification of a deeper affinity. Whether consciously or not, and I know of no evidence on the issue, Newman's paintings take on such forms. Jane Dillenberger has pointed out how the *Stations*[28] are in the range of the dimensions of the human figure, and Harold Rosenberg has noted how the zip, that electrifying thrust which marks and divides areas and gives them life, is related to the square. Visually, this is most evident when one compares Mondrian's *Composition with Red, Yellow and Blue* to Newman's *Who's Afraid of Red, Yellow and Blue.*

Newman was not alone in seeing the connection of the circle and the square, both abstract forms, with the human. Doug Adams has pointed out that Jasper Johns's work (Plate 158) too is to be understood in the context of the human as the measure of all things, surely visible with the hand in the circle.[29] The artist Frank Stella, in his Harvard lectures (1983-84) said, "abstraction—or better, perhaps, abstract figuration—is bound to be tied to human figuration."[30]

Because in abstraction it is the painting that is the reality that discloses the unknown, color is not a matter of mood, but an active ontology which operates as an actor in a drama. It is why the painter and the canvas are joined in what, in one frame of reference, is known as action painting, that enterprise in which both the

painter and we, the eventual viewers, also enter into the painting as those who act within it, who are surrounded by it, who recognize in our foundations that we participate in grandeur, sublimity, and the tragic. Such painting is, as Rosenberg puts it, a celebration, an event, an evocation of the unknown.[31] It is metaphysics as epiphany, but it does not pay off without effort and orientation of our own, our total involvement. That is why abstract art does not come easy and is easily dismissable, though its power is perhaps also evident in the fury it can create. But how else than as an epiphany of ourselves are we to see a painting such as *Vir Heroicus Sublimis!*.[32]

In this fundamental sense, abstract expressionism was a new event in the art scene, as important by analogy as the Renaissance focus on perspective. It has changed the landscape, the humanscape of painting in our time. Only now can we see that it had predecessors. But anticipations and intimations are not the same as the painting that emerged, a radical departure from the previous tradition of art, one in which the evocation of the world we know as the arena of perception was changed to the painting itself being the subject through which new perceptions arise. While the Los Angeles County Museum exhibition, *The Spiritual in Art: Abstract Painting*, provided us with background hints and evocations that few had suspected, it was wrong in interpreting the major works of abstract artists, such as Pollock and Newman, in such terms. While one can speak of a ritualistic, even almost magical character, to the way in which their act of painting and the painting itself coinhere, that is not the ritual or magic of predecessors, ancient or more contemporary.

In Pollock's work, too, the human is present, for the lines and contours are neither chaotic nor tightly structured, but are as random and patterned as life itself. Indeed, the abstract expressionists, with diverging accents, had taken on the task of the rehabilitation of the human. How ironic, one might conclude, that the recovery of the human in art should occur without the visual presence of the human, or the world, or religious subject matter. It arose from the perceptions of the artists themselves, working over against the visual depictions that no longer were adequate for defining humanity.

The Human Figure

The human figure has returned in modern and contemporary art, and in some quarters it had never disappeared. For the most part, the depiction of the human figure is different in the aftermath of the abstract expressionist movement, for such figuration has moved beyond sentiment and banal depiction of the human scene—though in pop art the banal was used in order to overcome banality—to visions that confront us in the sense that our humanity is challenged, possibly by surprise, even shock, but always with respect for the mystery of ourselves. George Segal's sculpture of the art dealer Sydney Janis with a painting of Mondrian (Plate 159) discloses his awareness of the thrust of abstract expressionism, particularly the art of Barnett Newman. While his own works stand over against the abstract expressionist movement, as is evident in the *Holocaust* (discussed earlier in this chapter), his own figural

creations, with their elements of abstraction, attest to the influence of the abstract expressionists. More recently, an additional shift has taken place in Segal's work. His 1987 sculpture *Abraham's Farewell to Ishmael* (Plate 160) has substituted a dark gray for the white plaster. More importantly, story or narrative has been given new vitality in the visual arts.

In Stephen De Staebler's *Standing Man and Woman* (Plate 161), clay, the fundament of the world, evokes the tragic dignity of humanity, sometimes by the artful distortion of parts, as in man and woman, or by parts which suggest the whole. Even when the works are in bronze, the fragility, vulnerability, and dignity of humanity are evoked in forms that defy ordinary beauty. In Nathan Oliveira's painting, *Spirit II* (Plate 162), humanity is emerging again, as if coming from the mists of the sea, like creatures freshly born again, awaiting the taking on of life in a new way. In Alfred Leslie's *Raising of Lazarus* the literal depiction of the human figure has returned, but the very effrontery of it makes it impossible to be literalistic in our viewing, thus giving us new possibilities of seeing. Even in Andy Warhol, whose human antics amused and sometimes shocked the world, but whose artistic talent surmounted it all, created an art in which the human figure sometimes has dignity, grandeur, even encompassing the tragic, as in Jacqueline Kennedy (Plate 163).

Principally in Jewish art and black art, the human figure did convey the drama of religious meaning with power and considerable artistic quality, but with little, if any influence from the abstract expressionist movement. The figures, nevertheless, have elements of abstraction and depart from the ordinary canons of beauty. In that category of Jewish artists are Jack Levine and his *David* (Plate 164) figures, or Abraham Rattner, with the colorful shapes and forms of *Crucifixion* (Plate 165), or of David Aronson with his series of bronze doors. All of these are images born of love, joy, or pathos, in which the range of humanity's fears and hopes are delineated. Powerful human content seems to stretch the artistic medium beyond its ordinary limits, making one wonder, without deprecating art that merely delights us, if great subject matter is not essential to art that reaches to the center of our being. The deep-seated human dimensions, so characteristic within the Jewish tradition, seemed to keep its art from the banality of Protestantism and Catholicism, where forms of belief or doctrine were sometimes at odds with the deeply human.

Similarly, but in a decidedly different context, black art too kept a vibrant figural tradition. William H. Johnson's *Mount Calvary* (Plate 166) follows both the content and iconography of that traditional subject; yet, there is a power in the depiction that takes us beyond literal subject matter. One could say the same of Bob Thompson's *St. Matthew's Description of the End of the World* (Plate 167), or the series of paintings executed either by Jacob Lawrence, like *Catholic New Orleans*, or Romare Bearden, like *The Prevalence of Ritual: Baptism* (Plate 168). It is surely obvious that, even in this figuration, considerable abstraction is present, as if confirming that forms of abstraction and spirituality do have affinities.

Why has black religion been able to use the human figure in religious art while others slipped into banality? Perhaps the answer lies in that the black artist belongs to a community which has known so much suffering that the human body becomes

the vehicle for a range of experience unknown to white liberal Protestants, liberal and conservative Catholics, or fundamentalists. Out of a milieu of suffering and loss, such artists are often able to represent the human figure with genuine pathos rather than bathos, drama instead of melodrama, thereby bringing new life and immediacy to the ancient Biblical themes. Yet, the haunting question remains, can black religion, as it becomes more related to the broader cultural milieu, make a transition into new forms of imagination without going through a literal and banal phase?

Religion and Art in the 1980s

The central significance of the abstract expressionist movement has been affirmed throughout as a clue to understanding modern and contemporary art. Its heyday was the fifties. However, it is only in the last decade that abstract expressionism has been approached as a religious, spiritual phenomenon by curators, museums, and critics. While the 1977 exhibition *Perceptions of the Spirit in Twentieth-Century American Art*[33] seemed outside the mainstream of museum subjects, almost ten years later the Los Angeles exhibit, *The Spiritual in Art: Abstract Painting 1890–1985*,[34] was readily accepted in that world.

Likewise, if the artists previously discussed in this chapter in the aftermath of abstract expressionism occasionally centered in specifically religious subject matter, or religious dimensions, it could not be said to be their central or consciously consuming interest. Among many of the artists of the eighties, however, the spiritual or religious is pursued as a conscious and central concern. If the sixties of this century brought a new accent on experience and participation, the eighties have defined experience in spiritual terms.

As we indicated in the previous chapter, over forty exhibitions with spiritual themes have occurred in the eighties. Centering on two such exhibitions, the *Precious*[35] show at the Grey Art Gallery and Study Center, New York University, and *Concerning the Spiritual: The Eighties*[36] at the San Francisco Art Institute, both in 1985, one notes such artists as Lita Alberquerque, Craig Antrim, Barry X. Ball, Eva Bovenzi, Adrian Kellard, Jim Morphesis, James Rosen, and Michael Tracy. While it is too early to tell which of these artists will, with time, maintain a national reputation, much of the work is exquisite and of first-level quality. In all of them, concern with the spiritual is pervasive.

In many of their works, these artists include historic allusions in a contemporary idiom, that is, reappropriations which do not repeat the past but provide analogous perceptions, newly minted and now seen afresh in the comingling of past and present. Two different but interesting examples utilizing the early sixteenth-century *Isenheim Altarpiece* (Plate 169) by Matthias Grünewald in Colmar, France, are Jim Morphesis's *Colmar Variations* (Plate 170) and James Rosen's *Homage to Grunewald, The Isenheim Altarpiece* (Plate 171). Morphesis has created an abstract tableau, filling the shape of the winged altarpiece with vibrant color, at once enticing and confronting us with the pulsating strands of our mortality. Rosen has chosen the Crucifixion scene, with the Christ figure, Mary, Mary Magdalene, John the Evangelist, John the Baptist,

and the lamb, in a configuration based on the original. But Rosen has built up his painting through layers of paint that seem both to veil and unveil the figures and the event. The result is that while we are not as directly confronted with the scene as we are in the original, we are psychically drawn into it in a way the original does not and cannot do. Rosen's painting is a genuine reappropriation of the past projected into the dynamics of our time.

In 1984, Escobar Marisol (Plate 172), and in 1986, Andy Warhol (Plate 173), both related to the pop tradition, did works based on Leonardo's *Last Supper*. In both Warhol and Marisol, figuration, abstraction, and historic allusions form the contours and ambience of the works. Pointedly, Marisol has placed her own figure opposite her *Last Supper*, the two confronting each other. In Frederick Brown's *Last Supper* (Plate 174), based on his travels in Europe, including his seeing Leonardo's painting, this black artist has brought the past and the present, figuration and abstraction, into a remarkable unity. Of Rosen, Marisol, Warhol, and Brown it can be said that they have not tried to bring old realities to life, but that new realities have been created out of the deposit of the old. Such a dialogue between the past and the present transcends either the repristination of the old or efforts at newness that lack depth.

Three factors may be said to be characteristic of the art of the eighties with respect to spiritual and religious themes. First, the artists working in the eighties incorporate into their works allusions to the past, and signs and symbols from history, and thus their work may be called postmodern. The perceptions are modern and unique to the artists; yet they see their work tenuously related to diverse facets of the past. Second, they alternate between abstraction and figuration, though even the latter is far from the Renaissance tradition of accenting the beauty of the human form. Third, readers who paid attention to the names of the artists in the eighties will have noticed that women artists are conspicuously present, as contrasted, for example, with the nineteenth century. As significant as the number, if not more so, is the fact that women no longer have to paint under the domination of men. In the contemporary scene, the possibility of creating paintings that express the inner dynamics of one's own being is affirmed. Hence, there is a new openess to distinctive perceptions among women and men. The problem for both women and men is compounded when new iconographic depictions are devoid of quality, as in the sculpture *Christa* by Edwina Sandys, a cruciform woman on a cross. Here the issue is not the subject matter, but a weak figural sculpture imitative of artists like Giacometti and Richier but without their astringency or power.[37]

The oscillation between a mixture of abstraction and figuration precisely defines the art of the last decades. That history is vividly illustrated in the career of the Connecticut artist, Cleve Gray, whose works span the decades of the fifties into our own time. While he associates his early abstract paintings more with an interest in the art of the East than with abstract expressionism, his paintings of the period still bear some affinity to the latter. In the early seventies, with Vietnam in the background, he did his *Threnody* (Plate 175) series, with colorful, abstract forms, which still suggest but never convey concrete figures. The whole is a veritable dance of life and death

that throbs before one, with echoes of hope. It is unfortunate that these paintings can only be seen on those occasions when they are installed in the room for which they were first executed in the Neuberger Museum, State University of New York at Purchase. His subsequent *Roman Walls* (Plate 176), growing out of time spent in Rome at the American Academy, too, are abstract, but full of color reminiscent of the light on Roman walls. His 1984 Prague paintings, growing out of his visit to the Jewish cemetery, are also abstract but hint at human lives dead beneath the grave markers (Plate 177). While the subsequent Holocaust paintings disclose dead bodies, a canvas which Gray considers a continuation of the series, called *Sleepers Awake (after Bach)* (Plate 178), hints at what is to come. In the subsequent *Resurrection* (Plate 179) paintings, the figures, he states, have come back to life. However, in 1987 he returned to abstract painting, acknowledging its special power. Surely his history represents an epitome of the last decades.

13

Observations on Contemporary Issues

At the fundamental level, we still need to come to terms with the fact that the modality of sight also gives us forms of perception unique to that sensibility, which, like other sensibilities, comprises a part of our humanity. That is why the sidetracking of art within the major sections of Protestantism, the use of plaster saints in Catholicism as reminders rather than objects that express the power of art, and the pronounced neglect of the visual arts on the part of most scholars of religion even when dealing with Eastern religions, have obliterated too much of what belongs to the world's humanity. Hence, we need a more pronounced reversal than we have seen thus far.

In order to come to terms with this problem, two specific issues have to be faced: first, as already indicated, the place of abstraction in the visual arts; second, the role of the visual arts in relation to the worshipping community of the Christian church, namely, its liturgy. From the most primitive cultures to our own, abstraction has been a part of the modality of art. Only in the classical period of Greece and in the Renaissance did the human figure stand before us with nobility and grandeur without the utilization of abstraction. But the loss of the particular perceptions of those traditions were followed by periods of decay and banality in the arts which were rescued only by a return to forms of abstraction, forms, which, in our century, are as radical as was the developed naturalism of classical Greece and the Renaissance.

But the public generally still lives with the feeling that the human figure, recognizable in some form akin to the Renaissance figures of the past, is what painting and sculpture are about. Hence, it does not clearly see the difference between Michelangelo and Sallman on the one hand, and Sallman and abstract expressionism on the other. That situation presents a major educational problem, namely, of recognizing both the validity of forms of abstraction and the validity of the human figure, the latter freed from Renaissance norms that we can admire but which can no longer be the basis for our own understanding of the visual arts. The art of our day must have characteristics commensurate with our time, for the art of the Renaissance, too, was modern in its day. To be like the Renaissance in this sense means abandoning its imitation.

Already in 1950, the avant-garde connoisseur and critic James Thrall Soby sensed the problem of living in the aftermath of the Renaissance and the place which abstraction could and perhaps needed to play in relation to the church. Apologizing that he intended no "irreverence whatever," he added that the "so-called 'abstract' art of our time might in certain instances quite properly and effectively be used as

an adjunct of church architecture. We tend to forget that religious symbolism was often extremely abstract until, at last, Renaissance humanism engulfed the world." While he was not convinced that a cubist Picasso would rival a Raphael in Christian consciousness, a view which he found Father Couturier propounding, he believed that abstraction, as seen in Matisse's chapel at Vence, was the road that must be taken. Occasionally there is a Manzu, who in his doors for St. Peter's does something interesting with the "established vernacular." Then Soby adds:

> Yet on the whole it appears to me that modern abstraction more frequently approaches a valid transcendentalism of which the various churches might well avail themselves. Could there be a more appropriate decoration for a chapel niche than Brancusi's "Bird in Space"? And what would happen if Mark Rothko's remarkable new paintings, shimmering with a quite unphysical radiance, were hung in a church? The story of Christianity is conveyed today by the spoken or written word, and only secondarily by the visual image. We should at least be willing to discover whether modern art is really antipathetic to religion or whether, in this as in many particulars, it sometimes penetrates to the core of the human spirit. In any case, the only alternative, with rare exceptions, is calculated revivalism. The history of religious art is strewn with its arthritic bones.[1]

Surely, Soby's was a perceptive, perhaps even prophetic voice. Continuing in the Renaissance tradition will be arthritic, though one could just as well say anemic. Given the centrality of the verbal in our culture, abstraction is a viable alternative to the figural, one in accord with much of Western history. Hence, over a decade before the Rothko Chapel, Soby was thinking in such terms.

In 1947, Philip Adams, then director of the Cincinnati Art Museum, also had made a case for thinking of new directions, perhaps less radical than Soby, but centered in the role of beauty. He wrote:

> It seems daring to think of Georges Rouault being employed by a provincial church in a midwestern city to paint the Stations of the Cross, but in another generation it might not seem strange at all. To expect the same church to put a van Gogh above an altar would stagger the imagination and yet, that too is not altogether inconceivable. I remember, in student days, being delighted with the Hispano-Moresque ivory boxes, designed as cosmetic containers for the concubines of Moorish emirs. They became reliquaries for the altars of the Catholic Church in Spain, not because the priests of the reconquest could not read their inscriptions or did not know their previous use, but because they were beautiful works of art, and anything so beautiful must proclaim the greater glory of God. On the altars of Rhenish churches were draped Persian textiles, on early Christian altars glowered the chimera. Why? The pagan origin, the pagan subjects of those textiles were perfectly apparent to the priests who used them, but they were gloriously beautiful things, and nothing so completely, so sublimely beautiful could but glorify a Christian God, or shall we say, a God seen through Christian eyes.[2]

While there is little question now about the appropriateness of speaking of the visual arts in spiritual or religious terms, the question of the relation of the visual to the worship life of a congregation persists, Soby and Adams notwithstanding. For

some, it is clear that twentieth-century art is not appropriate in a church or synagogue. In part, that is because twentieth-century artistic perceptions are formed from many sources, including East and West, but filtered through the special alchemy of being an artist. We live in a time when artists find themselves creating realities in which we do not naturally participate. Rather, they are forming human perceptions apart from a commonly shared outlook. It is a time when artists and religious institutions, at best, provide related but differing perceptions.

Moreover, from the visual standpoint, most of the paintings and sculpture discussed in the previous chapter would be considered inappropriate for church or synagogue. But we need to remind ourselves that they were not commissioned for such purposes, that they represent the vision of artists who continue to see the world in spiritual and/or religious terms, though religious institutions have not sought them out. In the instance of the church at Assy, we can see what can happen when artists who themselves are not believers nevertheless find their way into the spirit and function of a particular space. In the instance of the Rothko Chapel, one sees the results of the de Menil's vision of the appropriateness of Rothko paintings for a chapel. Stephen De Staebler's frontal Christ figure (Plate 180), and the liturgical objects, including chairs, altar, lectern, form a unity in harmony with Mario Campi's concrete building for the Newman Center (Plate 181), Berkeley, California, particularly when banners and coverings do not intrude. Lippold's shimmering baldachino (Plate 182) over the altar of St. Mary's, San Francisco, is in harmony with the hyperbolic paraboloids of this building. Hence, there are significant precedents for believing that when artists and patrons work together, the issue of the appropriateness of an art form takes care of itself.

There are instances, too, when promising ventures do not come to fruition. Two such plans date from 1950 to 1951, perhaps too early in time to secure approval for such new departures. The artist André Girard and the architect Jean Labatut, both of whom received considerable attention in *Liturgical Arts*, exhibited models and plans for a church at the Carstairs Gallery in New York City, in which paintings and the architectural forms presented a unity.[3] Surprising, perhaps, are the discussions among Jackson Pollock, Alfonso Ossorio, both painters, and Tony Smith, then still an architect, about the erection of a proposed Catholic chapel. While Tony Smith's architectural plans consisted of mathematical hexagonal units, together with a dome, Pollock's paintings were to surround the dome as well as the walls, particularly at the altar area. Fundamental to the plan was that the paintings and the architecture would require each other, so that the works of art could in no sense be considered decoration for a building. While the project was proposed to a group of prominent Catholics, it was not well received. Only minimal plans remain, and there is a difference of opinion as to whether Pollock's black paintings of the period were related to Crucifixion themes intended for the church.[4]

When it comes to the liturgy, the patron, of course, is the church. Here, in the light of Vatican II, changes have taken place both in Roman Catholicism and indirectly in Protestantism. There is a new consciousness of the assembled people, the congregation of God, among whom Word and sacrament are central. In one sense, this is a welcome departure in which Protestants have moved from the singular emphasis

on the preached word, and Catholics, from the singular emphasis on the sacraments in and of themselves. Centering on the people of God, however, also presents issues that need to be addressed. Granted that in such an approach, both architecture and the visual arts rightfully serve what is appropriate to the action of the congregation, the question arises as to whether or not there is an additional role for architecture and the visual arts. While many of the church buildings of the late fifties in Protestantism and also in the sixties in Catholicism reflect the attitude of providing space for the people, frequently inexpensively, the resultant spaces are mostly banal and trite. If liturgical action alone is central, it seems that space need be no more than a shell. Even if one accepted the liturgy as the one and only reason for the assembly, should there not be congruence between the space and the action. Indeed, if all of our sensibilities are to be touched and utilized, then such congruence is essential. The same can be said with respect to the visual arts.

The implications of the new accent on the liturgy are spelled out in Vatican II documents with respect to architecture and the visual arts. Architecturally, the building should permit the main altar to be central, though central is not defined in terms of a mathematical center, but as functional and psychological. The space is "to facilitate the celebration of the liturgy and the active participation of the faithful." Side altars, decreased in numbers, are preferred to be placed in separate spaces, in no cases in places where they interfere with the celebration at the main altar. With respect to the visual arts, particularly the placing of pictures and statues for veneration, "their number should be moderate and their relative positions should exemplify right order." The Christ figure should have the central place, with no saints elevated to a similar position; nor should the number of saints be unduly multiplied. Works which do not accord with "faith, morals, and Christian piety, and which offend true religious sense either by depraved forms or by lack of artistic worth, mediocrity and pretense" are to be removed. At the same time, no particular style is forbidden, though a balance is to be sought between the decorative and the iconographic, as well as between "the realistic and the abstract, so that in all things the splendor of order might shine forth."[5]

In principle, one could hardly quarrel with the desire for balance. Yet, the fact remains that the final control rests in clergy who may or may not be competent in architecture and art, and capable of informed decisions. Though the document asks for seminary training in the arts, this part of the document is not widely followed. Part of the psychology seems to be that since the center of the life of the church is liturgical action, anything that serves the liturgy is acceptable. Hence, the need for the voice of the architect and the artist along with the clergy or congregation is undercut by the final authority of the clergy. Time and again, architects complain that their space is violated by the tawdry liturgical items that finally intrude into the space, though, to be sure there have been notable exceptions, remarkable instances in which mutual education has taken place.

In collaboration among architects, artists, and patrons, one should not expect that all will be easy. Visions that issue in notable results have usually come only when all the parties are stretched beyond where they started, or perhaps beyond

where they thought they wanted to go. Moreover, conflicts over such issues are frequently related to other issues as well. Another reference to St. Peter's Lutheran Church in New York City illustrates the problem. Building the church under the Citicorp Center in mid Manhattan was itself a daring decision, particularly at a time when churches in such locations wondered about their future. From the very beginning, St. Peter's saw its mission in relation to the arts, having had a long history of association with music, particularly jazz. The form of the church itself, the Erol Beker Chapel of the Good Shepherd with the Nevelson sculpture, the outdoor Pomodoro cross (Plate 183) all tesify to that concern. It is perhaps all too human to find that such pronounced departures from the usual also left some dissatisifed to the point of saying, enough is enough. Moreover, independent committees on worship and on art acquisitions (though the approval of the former was necessary to place a work in the church) led to major differences of perception. Certainly such factors were a part of the issue when the possibility emerged of Willem de Kooning's doing a triptych (Plate 184) for placement behind the altar. De Kooning himself referred to the painting as his thanksgiving in recognition that, as a young man, the art that had made the difference in his life in Italy was found in the churches.[6]

The work itself is abstract, with sinuous lines and lyrical color. While the artist himself allegedly referred to the right wing of the tryptych as a Crucifixion theme, it is perhaps best to accept it as abstract. The issue, in any case, was its appropriateness for worship. In a letter of March 16, 1985, from the chair of the Worship Committee to the Art and Architecture Review Committee, we read: "We in the Worship Committee agree with most liturgists that seldom in the history of Christendom has a church been improved as worship space by the addition of a great piece of art. In fact, the finer the art piece, the less likely that the art can serve the assembly in its attention to the liturgy." At the request of the chair of the Art and Architecture Review Committee for a response to the actual de Kooning painting, the chair of the Worship Committee, a nationally known liturgist, responded for herself, the committee not yet having seen the triptych. In the letter of June 7, 1985, we read in part:

> A Christian worship space is a place for the assembly around word and sacraments. The primary symbols for the worship of Christians are the book, the font, the table, the bread, the wine, and the people. Contemporary liturgical thought urges against introducing into liturgical space images which do not assist the liturgical action of the baptized assembly. Christians must judge whether a piece of art, whether secular or religious, representational or abstract, contributes to the assembly's focus on Christ in word and sacrament. Even some uncontestably great pieces of Christian art are not good choices for liturgical art since, perhaps because of their very greatness, they cannot serve the liturgy.[7]

The intention here is not to single out St. Peter's or the particular liturgist. In fact, the statements here quoted do represent the thought of a good number of present-day liturgists. However, they do illustrate one of the problems which some of us see with respect to the visual arts and the liturgy, namely, that all space and related

objects must directly be subsumed to the liturgical action. In the light of Vatican II, and liturgical renewal in most churches, we have moved from the overaccenting of the Word on the one hand and priestly centered sacramental liturgy on the other. But in the process, it seems that the new liturgical ordering so stresses the assembly in liturgical action, that all modalities must serve that allegedly central form. Perhaps the arts represent collateral perceptions that do not need to center on the liturgical action as the one, single event.

Architecture is not merely functional space that works well for the liturgy, though it had better be that. It is also a space that forms us, affects us, apart from the liturgical functioning. The same is true with the best of the visual arts. They supplement as well as conform to the liturgy. They bring a wider range of sensibilities into the picture. When I was present for a service in St. Peter's when the triptych was behind the altar, I felt that all my sensibilities had been claimed, hearing, smelling, tasting, seeing. The joyous painting riveted my eyes on it and on the liturgical action, while in previous services my eyes usually wandered through the window to the New York cityscape. Of course, we are present for the liturgical action. But such action involves environment and participation, private and public psychic involvement, indeed, all the sensibilities that at any time make up who we are. Should anything less than that be claimed in a total worship experience? It is thus a delight to report that the de Kooning triptych was recently given to St. Peter's and that, in spite of the earlier controversy, it will become part of the ambiance and worship life of the church.

An analogous problem exists when one is asked to indicate how one distinguishes art that is appropriate for Christians and art that is not, or art that is spiritual or religious from art that is not. To some extent, that will differ for various individuals and communities. Art that is merely seductive or trite hardly matters, for either the church or life generally. Art that stretches us, that brings new perceptions helping form our full humanity, may be considered appropriate, for surely our humanity is part of what the faiths of the church and synagogue are about.

Precisely the question of criteria has been raised by Leonard Sweet, when he writes:

> This is my only argument with Dillenberger: he lets art be whatever an artist says is art, celebrates any hand with a chisel, and sees all works of art that express feeling weighted with religious meaning. But if all art is religious, nothing is religious and there can be little ground for discussion. If all art is not freighted with religious insight, then another problem arises—by what criteria do we decide what is a visual slum and what is a visual epiphany?[8]

Criteria do present problems with respect to the arts, as they undoubtedly do with other disciplines. Hence, one can understand that the problem is still more complex when one deals with the interrelation between two disciplines. One criterion for the arts that is indispensable is a discerning eye. This will require, as Sweet himself suggests, training clergy in new ways. When the discerning and trained eye, and a discerning theological sense are both present, then the convergences and differences between the two areas take on vitality, to the enrichment of our humanity.

Precisely because in our being there is a rent between our senses and sensibilities, including the structural inability to reunite them except tenuously, it is best, I think, to resist criteria from one side or the other, settling rather for the uneasy but exciting exposure of each to the other. In music, it seems to me, we have learned both the congruence and difference that artistic form brings to perceptions of Word and sacrament. Surely, the same is true of the visual arts. Hence, the task is both to affirm the place of the visual arts and, at the same time, not let its power be subsumed under particular conceptions of Word, sacrament, or community.

Hence, a work of art or the architecture itself provides more than a neutral place. In and of itself, it, too, has a reality that is communicated. That reality, even when identical with the function, is a differing, unique modality, one that presents the common reality in another way. Hence, the arts reach out to claim more of us than the liturgy does in and of itself. While art can be be said to provide a specific context, that ambience, at best, is congruent in a double sense with the total worshipping matrix. In one sense, art and architecture provide an ambience that carries perceptions apart from any activity of the assembly. In another sense, art and architecture relate to all functions that take place, even to the point of transforming the function. Is that, perhaps, what bothers the liturgists? Art and architecture do and should supply a "more" to the liturgy.

Already in 1956, Sister Mary Magdalen of the College of the Immaculate Heart, Los Angeles, stated the issue pointedly. "Religious art objects are not placed in churches to remind people to pray, since that is a utilitarian purpose insulting both to God and to humankind. Religious art is intended rather to honor God and His Saints, to bring a gift measured not by its efficiency but by love."[9] In and of itself, that statement may be too stark. But it articulates the integrity of an art form in relation to functions, their settings, transformations. It makes clear, indeed, that art does add something. Hence, the issue is not what serves the liturgy. Rather, it is what makes the liturgy different because it is there. The "thereness" of art and architecture is a reality that affects everything.

Notes

Preface

[1] Among earlier articles on parts of the history, see the following: "New York Church Architecture," *Putnam's Monthly* II (September 1853), pp. 223–48; *Great Exhibition of Religious Paintings, By the Pennsylvania Academy of the Fine Arts* (Philadelphia, December, 1843) (West, Allston, Huntington, Sully featured); and Clara Erskine Clement, "Early Religious Painting in America," *New England Magazine* 11, no. 4, new series (1894), pp. 387–402, and "Later Religious Painting in America," *New England Magazine* 12, no. 2, new series (1895), pp. 131–54. Some attention to religious subjects is included in the three articles by S. G. W. Benjamin, "Fifty Years of American Art 1828–1878," *Harper's New Monthly Magazine* 59 (1879), pp. 241–57; 481–96; 673–88.

[2] Of the thirteen chapters in this volume, this is the only one for which I have drawn on materials previously published by me, namely, "English Christianity and the Visual Arts in the Colonies," *Semeia* 13 (Society of Biblical Literature, 1978), pp. 9-27.

[3] The pioneering book on New England gravestones is Harriette Merrifield Forbes, *Gravestones of Early New England and the Men Who Made Them, 1653–1800* (Boston, 1927). A more recent, beautiful book, with extensive coverage and interpretive insights, is that by Allan I. Ludwig, *Graven Images: New England Stonecarving and Its Symbols, 1650–1815* (Middletown, Connecticut, 1966). The most recent book, covering many gravestones in detail, is that of Dickran and Ann Tashjian, *Memorials for Children of Change: The Art of Early New England Stonecarving* (Middletown, Connecticut, 1974). The Tashjians also relate the plain Puritan style and Ramist logic to the style of stonecarving. But the parallels they see have not convinced me that there is a connection.

A useful volume simply as a series of rubbings without text is that by Edmund Vincent Gillon, Jr., *Early New England Gravestone Rubbings* (New York, 1966).

Chapter 1

1 Extensive documentation of this point is to be found in Leonard J. Trinterud, "The Origins of Puritanism," *Church History* 20, I (1951), pp. 37–57; "A Reappraisal of William Tyndale's Debt to Martin Luther," *Church History* 31, I (1962), pp. 24–25; *Elizabethan Puritanism* (New York, 1971), and William Clebsch, *England's Earliest Protestants, 1520–1535* (New Haven, 1964). James Edward McGoldrick in his volume, *Luther's English Connection: The Reformation Thought of Robert Barnes and William Tyndale* (Milwaukee, 1979), challenges the interpretations of Trinterud and Clebsch at critical points, but I have not found his evidence or arguments convincing.

Having read the Continental Reformers first and then the English Puritans, I was impressed by the differences in the fundamental orientation toward life, which no attempt to show mutual influences overcame. Encouragement to think along these lines came first in reading Thomas Cumming Hall, *The Religious Background of American Culture* (Boston, 1930) and G. R. Owst, *Literature and Pulpit in Medieval England* (Cambridge, 1933).

2 William Clebsch, *op.cit.*, p. 314.

3 W. R. Jones, "Lollards and Images: The Defense of Religious Art in late Medieval England," *Journal of the History of Ideas* 34 (1973), p. 36.

4 For the history of the destruction of images from Henry VIII to the Restoration, see David Knowles, *The Religious Orders in England*, Vol. 3: *The Tudor Age* (Cambridge, 1959), or the abridged version, *Bare Ruined Choirs: The Dissolution of the English Monasteries* (Cambridge, 1976), and John Phillips, *The Reformation of Images: Destruction of Art in England, 1535–1660* (Berkeley, 1973).

5 While Henry VIII had many of the paintings and sculptures of monasteries and churches destroyed, he himself had a gallery of art. Charles I had a more extensive collection, secured from the collection of the Dukes of Mantua. Major collections were also held by the Earl of Arundel and the Duke of Buckingham. The cartoons of Raphael were purchased for the nation from the collection of Charles I on the order of Cromwell, though Parliament had ordered the collection sold. See "Statistics of Some of the Collections of the Fine Arts in Great Britain," *Bulletin of the American Art Union* II, 4 (1849), p. 11.

6 Charles Garside, Jr., *Zwingli and the Arts* (New Haven, 1966), p. 160.

7 A. Caiger-Smith, *English Medieval Mural Paintings* (Oxford, 1963), p. 113.

8 *Ibid.*, p. 115.

9 C. R. Leslie and Tom Taylor, *Autobiographical Recollections* (Boston, 1860), p. 48.

[10] Adolf Michaelis, *Ancient Marbles in Great Britain* (Cambridge, 1882), pp. 1–2. Petworth House, however, has considerable antique sculpture.

[11] William T. Whitley, *Art in England, 1800–1820* (Cambridge, 1928), p. 1.

[12] C. Kurt Dewhurst, Betty MacDowell, and Marsha MacDowell in their volume, *Religious Folk Art in America: Reflections of Faith* (New York, 1983), stress that the Puritans did have articles that indicated an interest in the visual arts. These writers state that such objects were useful and had a plain style, for adornment in and of itself was considered wrong. At best, I think it is a limited, folk art tradition, far removed from the usual canons of art.

[13] John Phillips, *op. cit.*, pp. 159–60.

[14] Robert Beverly Hale, *100 American Painters of the Twentieth Century* (New York, 1950), pp. v, vi.

[15] James Thomas Flexner, *History of American Painting*, I, *First Flowers of Our Wilderness* (New York, 1947, 1969), p. xvi.

[16] Reginald Howard Wilenski, *English Painting* (London, 1933), p. 46.

[17] Roy C. Strong, *The English Icon: Elizabethan and Jacobean Portraiture* (London and New Haven, 1969), p. 46.

[18] *Ibid.*, p. 50.

[19] Samuel M. Green, "English Origins of Seventeenth Century Painting in New England," *American Painting to 1776: A Reappraisal*, ed. Ian M. G. Quimby (Charlottesville, Virginia, 1971), pp. 15–69.

[20] Clergy portraits of note include the following: John Smibert: *Benjamin Colman* of the Brattle Street Church, Boston, and *James McSparran*, Presbyterian and later Anglican, of Rhode Island; Robert Feke: *Thomas Hiscox* and *John Callender*, both in 1745 and in Newport, Rhode Island; Nathaniel Smibert: *Samson Occom*, a Mohican converted during the Great Awakening.
　　Engravings of clergy portraits were widely distributed, and many of them were executed by Peter Pelham. In instances when portrait paintings were at hand, he utilized the portraits of others. Among them are three from John Smibert: *Benjamin Colman*, mentioned above; *William Cooper*, new light divine, also of the Brattle Street Church; and *Joseph Sewall*, minister of South Church, Boston, known as the weeping prophet. From an unknown painting, he did a print of *John Moorhead*, a Presbyterian. In 1750, Pelham did a mezzotint of John Greenwood's painting of *Thomas Prince*, a prominent historian of his day and minister of the Old South Church. Pelham himself painted and then made prints of *Cotton Mather* and *Mather Byles*. Pelham, an active Episcopalian, also painted and engraved the four leading Boston Episcopal clergy: *Henry Caner*, *Charles Brockwell*, both of Kings Chapel; *Timothy Cutler* of Christ Church; and *William Hooper*, dissenting minister who took Anglican orders and

became the first rector of Trinity Church.

Among portraits of American clergy done by John Singleton Copley are the Congregationalists—*Nathaniel Appleton, Edward Barnard, Mather Byles, Thomas Cary, Samuel Cooper, Edward Holyoke*; the Anglicans—*Arthur Browne, Myles Cooper, Samuel Fayerweather, John Ogilvie*; and the Presbyterian, *Alexander MacWhorter.*

21 Quoted by Jane Dillenberger and Joshua C. Taylor, in *The Hand and the Spirit: Religious Art in America, 1700–1900* (Berkeley, 1972), p. 46.

> This day Mr. King finished my Picture. He began it last year—but went over the face again now, & added Emblems &c. The Piece is made up thus. The Effigies sitting in a Green-Elbow Chair, in a Teaching Attitude, with the right hand on the Breast, and the Left holding a preaching Bible. Behind & on his left side is a part of a Library—two Shelves of Books—a Folio shelf with *Eusebij Hist. Ecc.*, Livy, Du Halde's Histy of China, and one inscribed Talmud B., Aben Ezra, Rabbi Selomoh Jarchi in Hebrew Letters, and a little below R. Moses Ben Maimon Norch Nevochim. . . .

> On the other Shelf are Newton's Principia, Plato, Watts, Doddridge, Cudworths Intellectual System; & also the New Engld primaeval Divines Hooker, Chauncy, Mather, Cotton.

> At my Right hand stands a Pillar. On the Shaft is one Circle and one Trajectory around a solar point, as an emblem of the Newtonian or Pythagorean System of the Sun & Plants & Comets. . . . At the Top of the visible part of the Pillar & on the side of the Wall is an Emblem of the Universe or intellectual World. It is as it were one sheet of Omniscience. In a central Glory is the name [Hebrew letters for "God"] surrounded with white Spots on a Field of azure, from each Spot ascend three hair Lines denoting the Tendencies of Minds to Diety & Communion with the Trinity in the divine Light: These Spots denote (*Innocency,*) a Spirit, a World, Clusters of Systems of Worlds, & their Tendencies to the eternal central yet universal omnipresent Light. This world is represented by a Cluster of Minds whose central Tendencies are turned off from God to Earth, self & created good—and also in a state of Redemption. Intervening is the Crucifixion of Christ between two Thieves—both Tendencies going off, but one turned back to the Light. Denotes also a converted & an unconverted Man.

> At a little Distance on the Left hand is a black Spot—the Receptacle of fallen Angels & the finally wicked. . . . And the collection of moral Evil & Misery, in comparison with the moral Perfection & Happiness of the immense Universe, is but a small Spot. . . . So that under this small minutesimal Exception of the Misery of all the fallen Angels & even most of the Posterity of Adam, . . . we may say ALL HAPPY IN GOD.

> These Emblems are more descriptive of my Mind, than the Effigies of my Face. . . .

22 See *A Remnant in the Wilderness: New York Dutch Scripture History Paintings of the Early Eighteenth Century* (Produced for the Bard College Center by the Albany Institute of History and Art, 1980) and the earlier *Hudson Valley Paintings, 1700–1750* in the Albany Institute of History and Art (1959).

23 The title, *The Naming of John the Baptist*, is not self-evident. It is conjectured by Ruth Piwonka and Roderic H. Blackburn that the source may be an Italian Renaissance painting of *The Birth of the Virgin*, a non-Scriptural subject hardly in the repertoire of a Biblically conscious community. But the Dutch Bibles do not illustrate *The Naming of John the Baptist* either. One problem persists; the male seated figure is not present in paintings of *The Birth of the Virgin* nor in renderings of *The Naming of John the Baptist*.

24 *A Remnant in the Wilderness*, p. 21.

25 Ruth Piwonka and Roderic H. Blackburn try to correlate the events of Dutch life in the Hudson Valley, including cultural, theological, and church issues, with the selection of particular subjects for the paintings. I have not found that exercise convincing. The repertoire is certainly not unique.

26 During the academic year 1973–74, the painting was deposited with the National Museum of American Art, while the church was being restored. There it was compared with known works of Hesselius by several specialists in the field, and paint samples were taken for analysis. E. P. Richardson suggested a Spanish source or background for the painting. No further information is available at this time.

Chapter 2

1 *The French in America, 1520–1880*. Exhibition catalog of the Detroit Institute of Arts (1951), pp. 48–49.

2 William Corner, *Facsimile Reproduction of San Antonio de Bexar* (1890; Graphic Arts, 1977). Facsimile reproduction with index added, by Mary Ann Noonan Guerra, p. 16.

3 Leland M. Roth, *A Concise History of America in Architecture* (New York, 1979), p. 52.

4 Mary Ann Noonan Guerra, *The Missions of San Antonio* (San Antonio, 1982), p. 11. This is one of the author's recent publications on the mission churches. They are well illustrated, very readable and carefully researched. In depth work has been done by Marion Habig, O.F.M. (*Alamo Chain of Missions*, Chicago, 1968; *San Antonio's Mission San Jose*, Chicago, 1968) and by Benedict Leutenegger, O.F.M., the latter editing and translating Spanish manuscript sources, with Habig providing annotations on the text.

5 For more on Kino, see Charles Polzer, S.J., *A Kino Guide* (Tucson, 1974). In addition to references to San Xavier del Bac in the footnotes of this volume, see Celestine Chinn, O.F.M., *Mission San Xavier del Bac* (Tucson, 1951).

6 Report of Francisco Iturralde, excerpt printed in *The Smoke Signal*, published by the Tucson Corral of the Westerners (Spring 1961, no. 3; reprinted 1971), p. 9.

7 Statuary in San Xavier Del Bac

Front External Facade

Francis of Assisi
Barbara (?)
Cecilia
Catherine of Siena (?)
Lucy

West Internal Side Wall

Matthew (?)
Barnabas (?)
Philip (?)

Front End of Chancel

Bartholomew (?)
Angel
James the Greater
Lion
Lion
Matthias
Angel
Ignatius Loyola

East Internal Side Wall

Judas Thaddeus
Empty niche
James the Less

West Transept

Collette of Corbie
Peter Regalatus
Francis of Assisi
Peter of Alcantara
Dominic Guzman
James of the March (?)
Jesus the Nazarene
"Francis Xavier," entombed
Bonaventure
Joseph
Gertrude the Great
Theresa of Avila
Scholastica (?)

Chancel Retablo

Cain
God the Father
Abel
Immaculate Conception
Peter
Paul

Simon (?) or John (?)
Francis Xavier
Andrew

East Transept

Agnes of Prague (?)
Elizabeth of Portugal
Clare of Assisi
Elizabeth of Hungary
Benedict the Moor
Bernard of Feltre
Recessed Cross
Fidelis Sigmaringen
Immaculate Conception
James of Alcala
Sorrowing Mother
Anthony of Padua
Crucifix
Crucifix (in sacristy), Sorrowing Mother

Statuary formerly in San Xavier Museum now to be found at the Tumacacori National Monument: Cajetan, Anthony of Padua, Bonaventure (?), Francis of Assisi, and Peter of Alcantara. Tumacacori, located between San Xavier and the Mexican border, was completed about 1820, but is mainly in ruins today.

The above list and locations are reproduced from Richard E. Ahlborn, *The Sculpted Saints of a Borderland Mission: Los Bultos de San Xavier del Bac* (Tucson, Arizona, 1974), p. 34, but are organized here according to location, since his visual scheme is not included in this volume.

8 Bolton, *Kino's Historical Memoir*, 1:122–23, quoted from Robert C. Goss, *The San Xavier Altarpiece* (Tucson, Arizona, 1974), p. 76.

9 E. Boyd, *Popular Arts of Spanish New Mexico* (Santa Fe, 1974), pp. 130–43. Anyone working in the New Mexican scene is largely dependent on Boyd's pioneering work. In addition to the present volume, I should like to mention *The New Mexican Santero* (Santa Fe, 1969).

10 *Ibid.*, p. 50.

11 Francisco Atanasio Dominguez, *The Missions of New Mexico, 1776* (Albuquerque, 1956), p. 104.

12 E. Boyd, *op. cit.*, p. 162.

13 William Wroth, *Christian Images in Hispanic New Mexico* (Colorado Springs, 1982), pp. 69–72.

14 One of the early adobe missions, Laguna Pueblo, still retains its flat roof (many of the early churches have since had metal pitched roofs added, altering the original distinctive contours) and hardpacked mud and straw floor. The church interior is in the process of extensive restoration, and presents a case-history for all

the problems of art and the Church. When visited in October, 1983, five Indians were seen on ladders propped against the central altar reredos, holding styrofoam cups of paint in their left hands as they dabbed away with paint brushes, converting the earth colors of the original santeros into highly saturated, sharply contrasting acrylic paints of our day. The side walls, which had a decorative border, had already been repainted and now jumped with undulant forms in matte black, sienna, and ochre. Wall paintings on the side at the altar end had disappeared as the result of roof leaks over a period of time; these sections had been replastered.

The church belongs to the Pueblo Indians and is being repainted by Indians. The long and costly procedure of conserving the church by having experts, who would remove later accretions of dirt and candle smoke deposits, and in-paint with the original pigments, could only take place with forceful leadership of the church hierarchy. The church is aware of a Wall Street Journal article (July 30, 1983) which is critical of much of the restoration work. In the Laguna Catholic Indian Mission Bulletin, October 16, 1983, one reads:

> LAGUNA CHURCH: Repair & Restoration. I would like to say, in spite of the Wall Street Journal article some of you may have seen, that this work has been and is being done very conscientiously and beautifully. Folk art is not a dead museum piece but is alive—vibrant—in the heart and souls of the people who produce it. The restoration of Laguna Church is proof that the religious folk art of Laguna is alive and well, in spite of what "Art critics", "art historians", and other keepers of tombs may have to say.

The church owns one of the early hide paintings of St. Joseph and the Christ child, and also a melodramatic academic painting of souls in purgatory being led into the heavens, which in 1983 was still rolled up in the sacristy but was to be displayed in the church when the renovation was complete.

On the basis of research done by E. Boyd and Marsha Bol, the altar screens for the following churches, some still in position, can safely be attributed to the Laguna santero: San Miguel de Santa Fe (ca. 1798), the San José chapel in the parochial church of San Francisco de Santa Fe (ca. 1796), Nuestra Señora de la Asuncion de Zia (ca. 1798), Santa Ana (ca. 1798), and San Esteban de Acoma (1802). See William Wroth, *Christian Images in Hispanic New Mexico* (Colorado Springs, 1982), p. 69.

15 Molleno is said to have executed the side altar screen at San Francisco de Asis, Ranchos de Taos, about 1815, and an altar screen, signed and dated 1828, San Juan de Los Lagos, Talpa. The Church at Ranchos de Taos is well known, partly because it was painted so frequently by Georgia O'Keeffe. But there is debate as to whether the interior restoration is not too great a transformation of the original. While altar panels of Rafael Aragón from at least three churches are now in the Museum of New Mexico, Santa Fe, and two in the Taylor Museum, Colorado Springs, altar screens are still found in place in the following churches: Santa Cruz de la Cañada, San Buenaventura in Chimayo, and San Lorenzo de Picuris. For the history of the chapel at Talpa, New Mexico, and its

reconstruction in the Taylor Museum of the Colorado Springs Fine Arts Center, see William Wroth, *The Chapel of Our Lady of Talpa* (Colorado Springs, 1979).

[16] *La Iglesia de Santa Cruz de la Cañada 1733–1983* (Santa Fe, 1983), p. 52.

[17] William Wroth, *Christian Images in Hispanic New Mexico* (Colorado Springs, 1982), p. 106.

[18] Jane Dillenberger and Joshua C. Taylor, *The Hand and the Spirit: Religious Art in America, 1700–1900* (Berkeley, 1973), p. 128. For additional materials on the New Mexico missions, see the following: *El Santuario de Chimayo* (Spanish Colonial Arts Society, Inc.) 1956; Brother B. Lewis, *Story of the San Miguel* (Santa Fe, 1957, 1968); Christine Mather (ed.), *Colonial Frontiers* (Santa Fe, 1983); Wolfgang Pogzeba, *San Francisco de Asis Church* (Kansas City, Mo., 1981); (————) *Santos of the Southwest* (Denver Art Museum Collection, 1970); Robert L. Shalkop, *The Folk Art of a New Mexican Village* (Colorado Springs, 1969); *Spanish Colonial Painting* (Colorado Springs, 1970); *Wooden Saints: The Santos of New Mexico* (Colorado Springs, n.d.).

[19] *California's Missions and Founding Dates* (Produced for Franciscan Padres, Mission San Luis Rey, by Hubert A. Lowman, Covina, California).

San Diego de Alcalá	July 16, 1769
San Carlos Borromeo de Carmelo	June 3, 1770
San Antonio de Padua	July 14, 1771
San Gabriel Arcángel	September 8, 1771
San Luis Obispo de Tolosa	September 1, 1772
San Francisco de Asis (Dolores)	October 9, 1776
San Juan Capistrano	November 1, 1776
Santa Clara de Asis	January 12, 1777
San Buenaventura	March 31, 1782
Santa Bárbara	December 4, 1786
La Purisima Concepción	December 8, 1987
Santa Cruz	August 28, 1791
Nuestro Señora de la Soledad	October 9, 1791
San José de Guadalupe	June 11, 1797
San Juan Bautista	June 24, 1797
San Miguel Arcángel	July 25, 1797
San Fernando Rey de España	September 8, 1797
San Luis Rey de Francia	June 13, 1798
Santa Inés	September 17, 1804
San Rafael Arcángel	December 14, 1817
San Francisco de Solano	July 4, 1823

Materials available on the California missions include the following: Kurt Baer, *Architecture of the California Mission* (Berkeley/L.A., 1958); *The Treasures of Mission Santa Ines* (Fresno, 1956); Maynard Geiger, O.F.M., *The History of California's Mission Santa Barbara from 1786 to the Present* (Santa Barbara, Franciscan Fathers, n.d.); *The Indians of Mission Santa Barbara in Paganism and Christianity* (Santa Barbara, Franciscan Fathers, 1960); *Representations of Father*

Junipero Serra in Painting and Woodcut, Their History and Evaluation (Old Mission Santa Barbara, Franciscan Fathers, 1958); Hans W. Hannau, *The California Missions* (New York, distributed by Doubleday & Company, Inc. [published in Munich]); Marie Harrington, *Mission San Fernando* (Mission Hills, Ca.: San Fernando Valley Historical Society, Inc., 1971); Paul C. Johnson and Dorothy Krell (eds.), *The California Missions* (Menlo Park, Ca., 1964, 1979); John M. Martin, *The Restored San Juan Bautista Mission in California* (Monterey, Ca., 1978); Sydney Temple, *The Carmel Mission from Founding to Rebuilding* (Fresno, Ca., 1980).

20 Jane Dillenberger pointed out that the decoration of the walls and the painting of the altar differs from the other mission churches of California, as well as those of the other Spanish Catholic churches of the South West in its draughtsmanly accuracy of line. Columns are precisely delineated, and the straight-edged contours of sea shell, rosette, and triglyphs, defines color areas with accuracy. Only in the lower part of the high altar do we find the thick looping, flaccid lines found in the decorative work of so many of the missions.

21 This series is the property of the San Fernando mission.

22 *Indian Iconography: Mission San Antonio de Pala* (1979), unpublished research paper by James Nisbet and Philip J. Faight. Kurt Baer in "California Indian Art," *The Americas* (v. 16, no. 1, July, 1959) argues that such symbols are universal and not particularly Indian. (p. 27) Whether universal or not, the research of Nisbet and Faight discloses that Indians in the area did understand the symbols as here delineated and as a part of their history.

23 A brief history of the interrelation of these two figures may be helpful. Nicolas Point was among the Flathead Indians in the fall of 1841, joined them in their winter hunt, and worked with them in building St. Mary's Mission. But in the fall of 1842 he was sent to establish the Sacred Heart Mission among the Coeur d'Alenes Indians on St. Joe River. Here, the river flooded, and the mission was eventually moved to what is now Cataldo, Idaho. Point's health began to fail and he left the Coeur d'Alenes, sketched St. Mary's in 1846, and left for the east. Ravalli had come to St. Mary's in 1845 and was there until 1850. Hence, Point and Ravalli, respectively French and Italian Jesuits, certainly had contact with each other at St. Mary's. In 1850, Ravalli went to the Coeur d'Alenes mission and is responsible for developing and furnishing the church, still extant, on the new site on the Coeur d'Alenes River. After being stationed in Coville, Oregon, between 1850 and 1860 and Santa Clara, California, 1860–63, Ravalli was sent to St. Ignatius north of Missoula (where his *Dead Christ* may be seen in the museum), and then returned to St. Mary's in 1866, where he remained until his death in 1884. The original St. Mary's, with which Point was associated, had been destroyed. Ravalli here, as at Cataldo, was responsible for a new building and its art, and it, too, is extant. The Saint Ignatius Mission, originally organized in 1845 near the Washington-Idaho border, was moved to its present site approximately forty miles north of Missoula. The present church was not erected until

1891 and its fifty-eight murals were painted in the early twentieth century by Brother Joseph Carignano, an Italian Jesuit.

24 Nicolas Point's manuscripts are to be found in the Jesuit archives in Rome, the archives of the Missouri Province of the Society of Jesus, the National Library of Italy, and the archives of the College Sainte-Marie, Montreal. The most valuable manuscript with text and paintings is in Montreal, but has been published in a handsome edition: *Wilderness Kingdom: Indian Life in the Rocky Mountains, 1840–1847, The Journals and Paintings of Nicolas Point, S.J.*, trans. and introduced by Joseph P. Donnelly, S.J. (Chicago, 1967).

25 *Wilderness Kingdom*, p. 12.

26 Harold Allen, *Father Ravalli's Missions* (School of the Art Institute of Chicago, 1972). St. Mary's is at Stevensville, Montana, about an hour's drive south of Missoula; the Cataldo Mission is in northern Idaho, east of Coeur d'Alene Lake.

27 On the ceiling at the center of the transept is a painting in which the Father presents the Son to the world as the Sacred Heart. This is iconographically purveyed by God the Father, the Son with Cross and Red Heart on his Breast, and the Holy Spirit as a dove, encased in a mandorla in the form of a triangle. On the ceiling of the left transept, the Son bids adieu to the Father, symbolized in earthly terms on the wall of the East transept by a painting of the Nativity. On the ceiling of the right transept, the Son returns to the Father, having borne the crucifixion, symbolized on the wall of the right transept. Over the ceiling of the apse is the Adoration of the Blessed Sacrament, the form of Christ's continued presence subsequent to the drama depicted in the transept paintings. In the center of the painting, the sacrament is seen enclosed in a liturgical vessel in the form of a heart, with surrounding angels engaged in praise. Appropriately below this scene was a painting of the Lord's Supper, over the altar, also by Stechert, but replaced in 1887 by the Apparition of the Sacred Heart to St. Margaret Mary by Costazzini. Stechert also did the Death of St. Francis Xavier on the wall near the apse in the right transept.

28 Material drawn from the pamphlet, *The Basilica of the Sacred Heart of Jesus of Conewago* (Edgegrove, near Hanover, Pennsylvania, 1962).

29 For the Hawaiian churches, see Alfred Frankenstein and Norman Carlson, *Angels over the Altar: Christian Folk Art in Hawaii and the South Seas* (Honolulu, 1961).

30 John R. Weinlick, *Count Zinzendorf* (New York, 1952), p. 200. I am also indebted to Weinlick for the preceding information.

31 Jane Dillenberger and Joshua C. Taylor, *op. cit.* p. 40; Vernon Nelson, *John Valentine Haidt* (Williamsburg, Virginia, 1966), p. 10.

32 In the art of the Southwest, Northwest, and the instances of Haidt, we

already encounter the folk art tradition. Throughout this volume, folk and pro-
fessional art will be considered side by side. Folk art now has an extensive litera-
ture of its own, some of which is listed here: Mary Black and Jean Lipman,
American Folk Painting (New York, 1966); (————) *Plain and Fancy: A
Survey of American Folk Art* (New York, Eminent Publications, Moak Printing
for Hirschl and Adler Galleries, Inc., April 30–May 23, 1970; (————)
Nineteenth-Century Folk Painting: Our Spirited National Heritage. Catalogue
and Selection by Peter H. Tillou (Storrs Conn., 1973); (————) *Pennsylvania
Dutch Folk Arts*, Philadelphia Museum of Art from the Geesey Collection and
Others; Mary Black, *Shaker, the Heaven-Inspired Drawings* (Washington, D.C.,
Smithsonian Institution Press, 1973); Howard Pyle, *A Peculiar People: A Tale of
the Ephrata Cloister*, reprinted from Harper's Magazine (October 1889) by the
Avrand Press; Daniel Hutton, *Old Shakertown and the Shakers* (Harrodsburg,
Ky., 1936); (————) *Shaker* ([Furniture and Objects from the Faith and
Edward Deming Andrews Collections Commemorating the Bicentenary of the
American Shakers] Washington, D.C., Smithsonian Institution Press for the
Renwick Gallery of the National Collection of Fine Arts, 1973); (————) *The
Shaker Museum* (Old Chatham, New York, 1968, foreword by John S. Williams);
(————) *The Gift of Inspiration: Religious Art of the Shakers* (North
Adams, Mass., 1970).

Chapter 3

[1] See footnote, chapter 1, no. 20.

[2] Hence, it is not by accident that the Unitarian and Transcendentalist pro-
tests against Calvinism centered in affirming the creative and imaginative facul-
ties of humanity.

[3] Jonathan Edwards, "The Mind," *Scientific and Philosophical Writings, The
Works of Jonathan Edwards*, Vol. 6 (New Haven, 1980), p. 336. For elabora-
tions of this theme, see pp. 335–37.

[4] Several books have appeared in the last decade which point to the artistry
of Edwards. This is true with respect to a literary sensibility and thus to his own
view of the world. But the visual arts still drop out. See, e.g., Roland A. Delattre,
Beauty and Sensibility in the Thought of Jonathan Edwards (New Haven,
1968).

[5] Perry Miller, *Jonathan Edwards* (New York City, 1949), pp. 109–10.

[6] *Bulletin of the Fine Arts at Yale University* 23 (September, 1957), no. 3.

[7] Ezra Stiles, *The U.S. Elevated to Glory and Honor, A Sermon Preached
Before His Excellency John Trumbull, May 8, 1783.* This story, prompted by
Stiles, is repeated by Timothy Dwight in *Travels in New England and New
York* I (1821), p. 124.

[8] See John Dillenberger, *Benjamin West: The Context of His Life's Work* (San Antonio, 1977), pp. 2–10; also Horace W. Smith, *Life and Correspondence of the Rev. William Smith, D.D.* (Philadelphia, 1880; New York, 1972).

[9] *Massachusetts Magazine* I (1789), pp. 365ff, 401ff.

[10] "American Antiquities," *Rural Magazine* I (Newark, November 10, 1789).

[11] Timothy Dwight, *Travels in New England and New York* I (1821), pp. 18–19; in vol. 4, he takes on the European travelers and their publications one-by-one.

[12] Timothy Dwight, *op. cit.*, I, p. 18.

[13] Timothy Dwight, "Essay on Taste," *American Museum, or, Universal Magazine*, 10 (1791), pp. 51–53. Taste, the sublime, the beautiful are intertwined in the essays of this period. See, e.g., Archibald Alison, *Essays on the Nature and Principles of Taste* (1790; Hildesheim, 1968); Edmund Burke, *A Philosophical Enquiry into the Origin of Our Ideas of the Sublime and Beautiful* (Notre Dame, Indiana, 1968). Walter J. Hipple, Jr., *The Beautiful, The Sublime, and the Picturesque in 18th Century British Aesthetic Theory* (Carbondale, Illinois, 1957).

[14] *American Museum, or, Universal Magazine* 11 (1792, Letter 5), p. 71.

[15] *Ibid.* (Letter 8), p. 92.

[16] Among the many travel books written by clergy, attention is called to the following: William Ingraham Kip, *The Christmas Holydays in Rome* (New York, 1846, 1849, 1869; based on original 1846 version brought up to the date); Orville Dewey, *The Old World and the New World I and II* (New York, 1836); H. W. Bellows, *The Old World in its New Face: Impressions of Europe, 1867–1868* I and II (New York, 1868 and 1869); Cyrus Bartol, *Pictures of Europe Framed in Ideas* (Boston, 1855); George B. Cheever, *The Pilgrim in the Shadow of the Jungfrau Alp* (New York, 1846); James Freeman Clarke, *Eleven Weeks in Europe: and What May Be Seen in That Time* (Boston, 1852); Henry M. Field, *Summer Pictures: From Copenhagen to Venice* (Boston and New York, 1859); George Stillman Hillard, *Six Months in Italy* (Boston, 1853); John Chetwode Eustace, *A Classical Tour Through Italy* (London, 1813).

[17] C. A. Bartol, *Pictures of Europe, Framed in Ideas, op. cit.*, p. 204.

[18] George B. Cheever, *op. cit.*, p. 205.

[19] Notebook kept by Horace Bushnell, Divinity School, Yale University, entry July 27, 1845.

[20] *Ibid.*, December 4, 1845.

[21] Charles Rockland Tyng, *Record of the Life and Work of Stephen Higginson Tyng* (New York, 1890), p. 205.

22 "Dogma and Spirit," in H. Shelton Smith, ed., *Horace Bushnell* (New York, 1965), p. 59.

23 Some of Bushnell's letters and comments on his European trip are reproduced in Mary Bushnell Cheney (ed.), *Life and Letters of Horace Bushnell* (New York, 1880, 1969). This material is neither complete nor well edited. The Yale Divinity School Library has Bushnell's notebooks on his European trip.

24 "Art in the United States," *Home Book of the Picturesque* (Gainesville, Florida, 1967; original edition, 1851), pp. 173–74.

25 George Washington Bethune, "The Prospects of Art in the United States," *Orations and Occasional Discourses* (New York, 1850), pp. 165–66.

26 Also see "Art in the United States," *op. cit.*, pp. 171, 179.

27 George Washington Bethune, *The Claims of Our Country on its Literary Men, An Oration Before the Phi Beta Kappa Society of Harvard University, July 19, 1849* (Cambridge, 1849), p. 50.

28 (New York, 1875). Among comments on art by Samuel Osgood are the following: *Bulletin of the American Art Union* (October, 1851), p. 117; "American Artists in Italy," *Harper's New Monthly Magazine* 41 (August, 1870), pp. 420–25; "Art in its Relation to American Life," *The Crayon* 2 (1855), pp. 54–55; and "Art Among the People," *American Leaves* (Freeport, N.Y.), pp. 229–51.

29 Orville Dewey, *op. cit.*, second part, p. 745, and Cyrus Bartol, *op. cit.*, pp. 239–50.

30 Orville Dewey, *op. cit.*, p. 755. The same point is also made by a clergyman in an article, "Our Artists," *Harper's New Monthly Magazine* 28 (1864), p. 242.

31 *North American Review* 79 (1854), pp. 1–30.

32 H. W. Bellows, *The Old World in its New Face: Impressions of Europe in 1867–1868* (New York, 1868), p. 71.

33 Magoon Papers, Vassar College Library.

34 *Ibid.*

35 Elias Magoon, *Westward Empire or the Great Drama of Human Progress* (New York, 1856), pp. 379–82.

36 The Magoon papers at Vassar include correspondence between William S. Mount and Magoon in which Magoon pressures Mount to make a gift of a painting.

37 Clergy were frequently collectors of works of art. Among them are Bishop William Ingraham Kip of California, Henry Ward Beecher, and Edward H. Chapin.

[38] For information on the Dusseldorf Gallery and the Pre-Raphaelites see the following: David Howard Dickason, *The Daring Young Men* (Bloomington, Indiana, 1953); "The American Pre-Raphaelites," *Art in America*, XXX, No. 3 (July 1942), pp. 159–65; William E. Fredeman, *Pre-Raphaelitism: A Bibliocritical Study* (Cambridge, 1965); W. H. Hunt, *Pre-Raphaelitism and the Pre-Raphaelite Brotherhood*, Vol. I (London, 1905); (————) "Gallery of the Dusseldorf Artists," *Bulletin of the American Art-Union* II, no. 3, (June 1849), pp. 8–17; (————) "Pre-Raphaelitism," *Bulletin of the American Art-Union* (October 1851), pp. 101–4; (————) "The Two Pre-Raphaeliteisms," *The Crayon* 3 (series of four articles in VIII, August; X, October; XI, November; XII, December, 1856).

[39] Washington Gladden, "Christianity and Aestheticism," *Andover Review* I (1884), p. 15.

[40] *Ibid.*, p. 20.

[41] *Ibid.*, p. 16.

[42] Washington Gladden, *The Relation of Art and Morality* (New York, 1897), p. 30.

[43] Washington Gladden, *Witnesses of the Light* (Freeport, N.Y., 1969), pp. 257–58.

[44] *Ibid.*, p. 263.

[45] Henry Ward Beecher, *Norwood, or, Village Life in New England* (New York, 1867), p. 222.

[46] *Ibid.*, pp. 222–23.

[47] Undated newspaper clipping of statement by Beecher, Manuscript Division, Library of Congress.

[48] Henry Ward Beecher, "The Office of Art," *Eyes and Ears* (Boston, 1862), p. 226.

[49] Introduction by Henry Ward Beecher to Charles Dudley Warner, *My Summer in a Garden* (Boston, 1871).

[50] Henry Ward Beecher, *Norwood*, p. 56.

[51] *Ibid.*, p. 326.

[52] *Ibid.*

[53] Henry Ward Beecher, "The Office of Art," *Eyes and Ears*, p. 228.

[54] *The Crayon* 6 (1859), p. 155.

[55] *Ibid.*, p. 157.

56 *Critic* 11 (New Series, July-December, 1887), p. 221.

57 Josiah Strong, *Our Country* (Cambridge, 1963), pp. 225–26.

58 *The Works of the Rt. Rev. John England* (Baltimore, 1849), v. II, p. 145. The correspondence in its entirety is to be found on pages 116–120; 126–56; 310–20.

59 *Ibid*, p. 143.

60 *The Complete Works of Archbishop Hughes* (New York, 1864), vol. II, p. 780.

61 James Cardinal Gibbons, *The Faith of Our Fathers* (Baltimore, 1907), p. 235.

62 *Ibid.*, p. 240.

63 *Ibid.*, pp. 241–44.

64 J. L. Spalding, *Essays and Reviews* (New York, 1877), p. 325.

65 *Ibid.*, pp. 337–38.

66 *Acta Et Decreta Concilii Plenarii Baltimorensis Tertii, A.D., 1884* (Baltimore, 1886), p. lxxxviii.

67 On St. Paul the Apostle Church, see Joseph I. Malloy, C.S.P., *The Church of St. Paul the Apostle in New York* (New York, Paulist Press, n.d.) and Helene Barbara Weinberg, "The Work of John LaFarge in the Church of St. Paul the Apostle," *The American Art Journal* 6, no. 1 (May, 1974).

Chapter 4

1 *Literary Magazine and American Register* 3 (1805), p. 181.

2 *Christian Examiner* 29 (1841), p. 313.

3 *Ibid.*, p. 316.

4 *Ibid.*, p. 320.

5 F. D. Huntington, "The Popular Taste in Gardening and in Rural and Church Architecture," *Christian Examiner* 31 (1842), p. 65.

6 *Ibid.*, pp. 70–71.

7 *Christian Examiner* 39 (1845), p. 329.

8 *Christian Examiner* 48 (1850), p. 205.

9 *Ibid.*, p. 210.

10 *Christian Examiner* 73 (1862), p. 65.

[11] *Ibid.*, p. 71.

[12] *Ibid.*, p. 67.

[13] *Ibid.*, p. 74.

[14] *Christian Examiner* 58 (1855), p. 246.

[15] *Christian Examiner* 75 (1863), p. 121.

[16] *The Illustrated Magazine of Art* 3 (1854), p. 213.

[17] See *Literary Magazine and American Register* 3 (1805), p. 181; *Knickerbocker* 14 (1839), p. 51; George W. Bethune, "Art in the United States," *The Home Book of the Picturesque* (Gainesville, Florida, 1967), p. 188.

[18] George W. Bethune, *op. cit.*, p. 181.

[19] "On the Fine Arts," *North American Review* 3 (1816), pp. 195–200.

[20] *Knickerbocker* 14 (1839), pp. 20–23.

[21] Significant reports on the American Indian in the visual arts include: William H. Gerdts, "The Noble Savage," *Art in America* 63 (July–August, 1975), pp. 64–70; Ellwood C. Parry III, *The Image of the Indian and the Black Man in American Art, 1590–1900* (New York, 1974); Charles Coleman Sellers, "Good Chiefs and Wise Men: Indians as Symbols of Peace in the Art of Charles Willson Peale," *The American Art Journal* 7, no. 2 (1975), pp. 10–18.

[22] *Christian Examiner* 25 (1839), p. 309.

[23] *Ibid.*, pp. 310–11.

[24] Francis J. Grund, *The Americans and Their Moral, Social, and Political Relations* (New York & London: 1968 [reprint of 1837 edition]), pp. 85, 91.

[25] *Christian Examiner* 25 (1839), p. 318.

[26] *Ibid.*, p. 318.

[27] *Ibid.*, p. 319.

[28] *Ibid.*, p. 317.

[29] *Ibid.*, p. 319

[30] *Ibid.*, pp. 319–20.

[31] Henry M. Field, *The Good and the Bad in the Roman Catholic Church: Is That Church to be Destroyed or Reformed. A Letter from Rome* (New York, 1849), p. 22.

[32] Samuel Irenaeus Prime, *Travels in Europe and the East: A Year in England, Scotland, Ireland, Wales, France, Belgium, Holland, Germany, Austria,*

Italy, Greece, Turkey, Syria, Palestine, and Egypt, Vols. I & II (New York, 1856); *The Alhambra and the Kremlin, The South and North of Europe* (New York, 1873).

[33] *Biblical Repertory* 2 (1826), p. 330ff; 10 (1838), p. 346ff; 15 (1843), pp. 88–110.

[34] *Biblical Repertory* 15 (1843), p. 65ff.

[35] *Biblical Repertory* 24 (1852), p. 201ff.

[36] *Ibid.*, p. 38ff.

[37] *Princeton Review* 1, ser. 4 (1878), p. 815ff.

[38] *Ibid.*, p. 827.

[39] *Ibid.*, p. 829.

[40] *Princeton Review* 4, ser. 4 (1879), p. 300.

[41] *Ibid.*, p. 301.

[42] *The Dial* 1 (1840–41), pp. 21, 17, 18.

[43] Roger B. Stein, *John Ruskin and Aesthetic Thought in America, 1840–1900* (Cambridge, 1967), p. 41.

[44] Ruskin was a hot item in the journals of his time. A sample follows: Brownlee Brown, "John Ruskin," *The Crayon* 4 (1857), pp. 329–36; Rev. D. M. Hodge (ascribed to); "John Ruskin," *Universalist Quarterly and General Review*, new series, 10 (January 1873); Professor H. N. Day (ascribed to); "Ruskin's New Lectures on Art," *New Englander* 29 (October 1870), pp. 659–77; W. J. Stillman, "John Ruskin," *Century Magazine* (Nov–April 1887–88), pp. 357–66; Dr. Charles Waldstein, "The Work of John Ruskin. Its Influence upon Modern thought and Life," *Harper's New Monthly Magazine* (Dec.–May 1888–1889), pp. 382–418; (————) "Ruskin and the Pre-Raphaelites," *Bulletin of the American Art-Union* (August 1851), pp. 75–76; (————) "Ruskin's Architectural Works," *Southern Quarterly Review* 27 (April 1855), pp. 372–82; (————) "Ruskin's Religious Suggestiveness," *Boston Review* 1 (July 1861), pp. 323–38; (————) "Ruskin's Writings," *Putnam's Monthly Magazine* 7 (May 1856).

[45] "The Revelation of Art," *The Crayon* 2 (28 November 1855), p. 335.

[46] "Religion and Art in Their Philosophical Relation," *The Crayon* 3 (1856), p. 248.

[47] "Christian Art," *The Crayon* 7 (1860), p. 187.

[48] *The Crayon* 2 (1855), p. 351.

[49] *Ibid.*, p. 351.

50 *Ibid.*

51 T. Harwood Pattison, "The Relation of Art to Religion," *Baptist Quarterly Review* 8 (1886), pp. 324–37.

52 C. M. Butler, "The Relation of Art to Morals and Religion," *American Quarterly Church Review* 46 (1885), pp. 171–92.

53 *The Illustrated Magazine of Art* 3 (1854), p. 214.

54 *Ibid.*, p. 215.

55 *Ibid.*, p. 215. While Cole and Allston are mentioned in the article, it is clear from what is said that Allston's *Evening Hymn* (Montclair) would be more representative of this direction than his traditional religious or classical paintings.

56 *Ibid.*, p. 216.

57 *The Crayon* 3 (1856), p. 195.

58 In reviewing the *United States Catholic Miscellany* from 1822–1835, I noted one article on images and one on the familiar issue of idolatry. Beginning about 1826, the *Miscellany* frequently had a section entitled either "Antiquities" or "Fine Arts" or "Arts and Sciences" or "Arts, Science and Literature." These are reports on what is happening, and sometimes seem to be mere filler for the paper. There are no articles on the nature, place, or role of the visual arts.

59 *Catholic World* 5 (1867), pp. 546–52.

60 *Catholic World* 1 (1865), pp. 249–50.

61 *Catholic World* 7 (1868), pp. 721–35.

62 *Catholic World* 7 (1868), p. 726.

63 *Catholic World* 15 (1872), p. 359.

64 *Ibid.*

65 *Ecclesiastical Review* 23 (1900), pp. 412–13; 47 (1912), p. 616.

66 *Ecclesiastical Review* 1 (1889), p. 52.

67 *Ecclesiastical Review* 1 (1889), p. 59.

68 *Ecclesiastical Review* 3 (1890), p. 289.

69 *Ecclesiastical Review* 42 (1909), p. 482.

Chapter 5

1 John Dillenberger, *Benjamin West: The Context of His Life's Work* (San Antonio, 1977), pp. 1–8.

2 *Memoirs of the Life and Religious Labors of Edward Hicks* (Philadelphia, 1851), p. 71.

3 Samuel F. B. Morse, *His Letters and Journals*, ed. and supplemented by his son, Edward Lind Morse, Vol. 1 (Boston, 1914), pp. 398–99. For additional writing by and on Morse, see the following: Samuel F. B. Morse, *Lectures on the Affinity of Painting with the Other Fine Arts* (Columbia, Mo., 1983); Oliver W. Larkin, *Samuel F. B. Morse and American Democratic Art* (Boston, 1954); Carleton Maybee, *The American Leonardo: A Life of Samuel F. B. Morse* (New York, 1943); Harry B. Wehle, *Samuel F. B. Morse, American Painter*, Metropolitan Museum of Art (February 16–March 27, 1932).

4 *Ibid.*, p. 399.

5 *Ibid.*, p. 176.

6 *Ibid.*, p. 177.

7 The National Academy of Art was founded over against the more conservative American Academy, headed by the aging John Trumbull.

8 For an account of these events, including the petition by fellow artists, see Charles E. Fairman, *Art and Artists of the Capitol of the United States of America* (Washington, 1927), pp. 105–12.

9 Samuel F. B. Morse, *op. cit.*, Vol. 2, p. 31.

10 Among clergy portraits by Morse are the following: *The Rev. Alexander Beach, the Rev. and Mrs. Hiram Bingham, the Right Rev. Nathaniel Bowen, The Rev. Francis Brown, the Rev. Jeremiah Day, the Right Rev. John England, the Rev. Edward Everett, the Rev. Elias L. Magoon, the Rev. William McKinstry, the Rev. Jedidiah Morse* (his father), *the Rev. Richard C. Morse* (his brother), *the Rev. Eliphalet Nott, the Rev. Dr. Skinner, the Rev. John Stanford, the Rev. B. Woodbridge, the Rev. Samuel Worcester.*

11 Irma B. Jaffe, "Fordham University's Trumbull Drawings; Mistaken Identities in *The Declaration of Independence* and Other Discoveries," *The American Art Journal* 3, no. 1 (Spring 1971), pp. 28–29. An interesting and perhaps parallel use of the Pope passage occurs in Madame deStael's *Corinne; or, Italy* (New York, 1844), p. 65:

> Corinne's villa stood near the loud cascade of Teverone. On the top of the hill, facing her garden, was the Sibyl's temple. The ancients, by building these fanes on heights like this, suggested the due superiority of religion over all other pursuits. They bid you "look from nature up to nature's god," and tell of the gratitude that successive generations have paid to heaven. The landscape, seen from whatever point, includes this its central ornament. Such ruins remind one not of the work of man. They harmonize with the fair trees and lonely torrent, that emblem of the years which have made them what they are.

Trumbull's religious outlook is covered by Particia Mullan Burnham, "Trumbull's Religious Paintings: Themes and Variations," *John Trumbull: The Hand and the Spirit of a Painter* (New Haven, 1982), pp. 180–204.

[12] Bernard Lawall in his doctoral dissertation, *Asher Brown Durand: His Art and Art Theory in Relation to His Times* (University Microfilm I [1966], pp. 80–100), contends that Durand's work should be understood in the Unitarian context, particularly that of William Ellery Channing. But Lawall himself admits that the connection cannot be established.

[13] Both in conversation with me on November 18 and 19, 1983, and in a letter to me, dated November 24, 1983, Professor Parry laid out the chronology. My account is entirely dependent on his pioneering work and I thank him for his generosity. I would not hold him responsible, however, for my interpretations. Parry's articles on Cole are a rich source for understanding Cole. In addition to those mentioned here, reference should be made to articles by Parry listed in the footnotes to chapter 7, nos. 6, 11. Ellwood C. Parry III, "Thomas Cole and the Problem of Figure Painting," *The American Art Journal* 4, no. 1 (Spring 1972), pp. 66–86; "Thomas Cole's imagination and work in The Architect's Dream," *The American Art Journal* 12, no. 1 (Winter 1980), pp. 41–59; "Gothic Elegies for an American Audience: Thomas Cole's Repackaging of Important Ideas," *The American Art Journal* (November, 1976). See also Graham Hood, "Thomas Cole's lost Hagar," *The American Art Journal* 1, no. 2 (Fall 1969), pp. 41–52.

[14] Drawings are to be found at the Detroit Institute of Arts. Cole also submitted drawings for the Ohio State Capitol building, for which he won third prize. Some of his concepts were incorporated in the final building, though Cole had scurrilous things to say about some of the results.

[15] Louis Legrand Noble, *The Life and Works of Thomas Cole* (Cambridge, Massachusetts), p. 252.

[16] A similar situation obtained in the case of Benjamin West. His interment in St. Paul's, London, was challenged because there was no record of his baptism, though it was known that West was an active Anglican. See John Dillenberger, *Benjamin West: The Context of His Life's Work* (San Antonio, 1977), p. 4.

[17] Early records of the Church of the Holy Innocents, and of its relation to West Point, do not exist. But a commemorative history of the church, without sources, and materials in the West Point library recall the chronology I have given.

[18] *Mr. and Mrs. Karolik Collection of American Watercolors and Drawings* (Boston: Museum of Fine Arts, 1962), p. 247.

[19] Alfred Frankenstein, *Painter of Rural America: William Sidney Mount, 1807–1868* (Stony Brook, 1968); *William Sidney Mount* (New York, 1975), p. 296.

[20] Alfred Frankenstein, "William Sidney Mount and the Act of Painting," *The American Art Journal* (1969), pp. 41–42. *William Sidney Mount* (New York, 1975), pp. 11; 295–97.

[21] Letters, Hiram Powers to Abby, September 18, 1841; Mrs. Powers to her mother, January 2, 1842. Powers Letters are in the Archives of American Art, Washington, D.C. On George Inness and his relation to Swedenborgian thought, see Nicolai J. Cikovsky, *George Inness* (New York, Washington, and London, 1971) and Le Roy Ireland, *The Works of George Inness: An Illustrated Catalogue Raisonné* (London, 1965).

[22] Letters to L. V. Prescott, February 18, 1849; to Thomas Worcester, December 11, 1850; Worcester to Powers, November 18, 1850, and January 16, 1851.

[23] Powers to Prescott, December 18, 1850.

[24] H. W. Bellows, "Seven Sittings with Hiram Powers V," *Appleton's Journal of Popular Literature, Science and Art* (1869), pp. 595–96.

[25] See letter to my dear cousin, December 14, 1853; to Ben Powers, November 14, 1851; to Edward Everett, September 2, 1852.

[26] For the relation between Emerson and Greenough in the latter's last period of his life, see Nathalia Wright, "Ralph Waldo Emerson and Horatio Greenough," *Harvard Library Bulletin* 12 (1958), pp. 91–116. Charles R. Metzger's book, *Emerson and Greenough: Transcendental Pioneers of an American Aesthetic* (Berkeley, 1954; Westport, Connecticut, 1970), is much too interested in making Greenough into a Unitarian and into agreement with Emerson.

[27] Henry T. Tuckerman, *A Memorial of Horatio Greenough* (New York and London, 1853; reprint 1968), p. 99.

[28] *Letters of Greenough*, ed. Nathalia Wright (Madison, Wisconsin, 1972), p. 363. Similar views were expressed by St. Augustine.

[29] Henry Tuckerman, *op. cit.*, pp. 195–96, for passages cited in the two paragraphs.

Chapter 6

[1] In pulling together the preceding material, I am largely, though not totally, dependent on the interesting volume by Roger G. Kennedy, *American Churches* (New York, 1982). See also Leland M. Roth, *A Concise History of American Architecture* (New York, 1979). For the Southwest, see Vincent Scully, *Pueblo: Mountain, Village, Dance* (London, 1975).

[2] Horatio Greenough, *Form and Function* (Berkeley and Los Angeles, 1969), particularly pp. 22, 65, 67.

3 For the Baltimore cathedral, the classical style was chosen, but for St. Mary's Seminary, Baltimore, a Neo-Gothic style.

4 See Benjamin Silliman, "Architecture in the U.S.," *Journal of Science and Arts* (1830), pp. 11–26, 99–110, 212–36, 249–73. For example:

> Greece was republican in its government. . . . Florence was a republic when she became distinguished in architecture: Genoa built her marble palaces while a republic, and Venice was a republic while her fairest edifices arose. I leave to others to decide why this form of government seems to be best fitted for the success of architectural effort: it is sufficient for our present purpose that we have every encouragement from the fact (pp. 15–16).

and:

> They [the Greeks] took the powers which nature gave them, and by unceasing culture brought them to the very highest perfection: these they applied, and they succeeded: others will succeed when they do all this, and not till then (p. 20).

5 Silliman, *op. cit.*, p. 18.

6 *Ibid.*, pp. 215–17.

7 *Ibid.*, pp. 20–21.

8 *Ibid.*, pp. 222–23.

9 A. Welby Pugin, *The True Principles and Revival of Christian Architecture* (Edinburgh, 1895), pp. 2, 3, 4.

10 Similar arguments for the classical style are found in *The Dial* 4 (1843–44), p. 115; *Christian Examiner* 49 (1850), p. 285.

11 Silliman, *op. cit.*, p. 224.

12 *Christian Examiner* 49 (1850), pp. 285–86.

13 *Christian Examiner* 44 (1847), p. 317.

14 *Ibid.*, p. 317.

15 *Ibid.*, pp. 316–17.

16 G. W. Bethune, "The Prospects of Art in the United States," *Orations and Occasional Discourses* (New York, 1850), pp. 174–75.

17 See the excellent study by James F. White, *The Cambridge Movement: The Ecclesiologists and the Gothic Revival* (Cambridge, 1962).

18 John Henry Hopkins, *Essay on Gothic Architecture, with Various Plans and Drawings for Churches, Designed Chiefly for the Use of Clergy* (Burlington, Vermont, 1836), p. 1.

[19] *Ibid.*, p. 2.

[20] *Ibid.*, p. 9.

[21] *Christian Examiner* 33 (1843), p. 161.

[22] *Ibid.*, p. 162.

[23] John Henry Hopkins, *op. cit.*, p. 15.

[24] From the Boston *Christian Register*, November 28, 1846, quoted in Everard M. Upjohn, *Richard Upjohn, Architect and Churchman* (New York, 1939), p. 82.

[25] Phoebe B. Stanton, *The Gothic Revival and American Church Architecture: An Episode in Taste, 1840–1856* (Baltimore, 1968), p. 159.

[26] *New York Ecclesiological Society Report* (May 12, 1851), p. 19.

[27] *Ibid.*, p. 15.

[28] *Ibid.*, p. 16.

[29] *Ibid.*, p. 15.

[30] Morgan Dix, "The Adaptation of Painting and Sculpture to the Adornment of Churches," *Transactions of the New York Ecclesiological Society* (New York, 1857), p. 50.

[31] *Ibid.*, p. 51.

[32] *Ibid.*, p. 63.

[33] *Ibid.*, p. 75.

[34] *Ibid.*, p. 76.

[35] *Ibid.*, p. 77.

[36] Having been involved in the sale of the Hartford Seminary Neo-Gothic campus and in the building of a contemporary Richard Meier building as the new seminary home, I continually confronted this issue. All but the most sophisticated in architectural knowledge simply preferred and identified church and seminary with Neo-Gothic.

Chapter 7

[1] J. Bard McNulty, *The Correspondence of Thomas Cole and Daniel Wadsworth* (Hartford, 1983), p. xff. William Cullen Bryant, who in 1825 had called for the independence of American literature from the influence of Europe, worried lest his friend Cole forget the grandeur of American scenery as the basis of his art. In this emphasis, Bryant expressed the cultural counterpart of the self-conscious experience of being a new nation as a result of the Revolution, of

winning the War of 1812, and of the Monroe Doctrine.

Many had shared Bryant's reservation about Cole's trips to Europe. But *The New York Mirror*, describing Cole's *A View Near Tivoli*, unreservedly lauded Cole for having profited by the European experience. "When he left us to seek the schools of Europe, we feared that he was departing from the school of nature. We forgot that nature is omnipresent. Mr. Cole profited by the school of art but did not abandon his first love." Vol. 10, no. 46 (Saturday, May 18, 1833), p. 366.

2 See Charles L. Sanford, "The Concept of the Sublime in the Works of Thomas Cole and William Cullen Bryant," *American Literature* 28 (1956–57), pp. 434–48.

3 *Saturday Evening Post* 4 (May 14, 1825). The dramatic experience of a mountain rising out of the sea, until that time foreign to Cole's experience, is analogous to the early experience of visitors to the prairies in the U.S. See, e.g., Charles Dickens, *American Notes* (Penguin, 1972), pp. 22ff. In reverse, those who grew up in the Illinois prairies keep looking for the English Salisbury plains, even even when they are in the midst of them.

4 Quotation from Louis Legrand Noble, *The Life and Works of Thomas Cole* (Cambridge, Massachusetts, 1964), p. 125.

5 J. Bard McNulty, *op. cit.*, p. 20.

6 For fuller information on these and additional new discoveries, the reader is referred to the source I used. Ellwood C. Parry III, "Recent Discoveries in the Art of Thomas Cole," *Antiques* (November, 1981), pp. 1156–1165. For a recent book on Cole, see Matthew Baigell, *Thomas Cole* (New York, 1981).

7 The letter to Luman Reed, September 18, 1833, reproduced in L. L. Noble, *op. cit.*, pp. 129–30, continues as follows, providing a full description of the series.

> The philosophy of my subject is drawn from the history of the past, wherein we see how nations have risen from the savage state to that of power and glory, and then fallen, and become extinct. Natural scenery has also its changes,—the hours of the day and the seasons of the year—sunshine and storm: these justly applied will give expression to each picture of the series I would paint. It will be well to have the same location in each picture: this location may be identified by the introduction of some striking object in each scene—a mountain of peculiar form, for instance. This will not in the least preclude variety. The scene must be composed so as to be picturesque in its wild state, appropriate for cultivation, and the site of a sea-port. There must be the sea, a bay, rocks, waterfalls and woods.
>
> THE FIRST PICTURE, representing the savage state, must be a view of a wilderness,—the sun rising from the sea, and the clouds of night retiring over the mountains. The figures must be savage, clothed in skins, and occupied in the chase. There must be a flashing chiaroscuro, and the spirit of motion pervading the scene, as though nature were just springing from chaos.

THE SECOND PICTURE must be a pastoral state,—the day further advanced—light clouds playing about the mountains—the scene partly cultivated—a rude village near the bay—small vessels in the harbour—groups of peasants either pursuing their labours in the field, watching their flocks, or engaged in some simple amusement. The chiaroscuro must be of a milder character than in the previous scene, but yet have a fresh and breezy effect.

THE THIRD must be a noonday,—a great city girding the bay, gorgeous piles of architecture, bridge, aqueducts, temples—the port crowded with vessels—splendid processions, &c.—all that can be combined to show the fulness of prosperity: the chiaroscuro broad.

THE FOURTH should be a tempest,—a battle, and the burning of the city—towers falling, arches broken, vessels wrecking in the harbour. In this scene there should be a fierce chiaroscuro, masses and groups swaying about like stormy waves. This is the scene of destruction or vicious state.

THE FIFTH must be a sunset,—the mountains riven—the city a desolate ruin— columns standing isolated amid the encroaching waters—ruined temples, broken bridges, fountains, sarcophagi, &c.—no human figure—a solitary bird perhaps: a calm and silent effect. This picture must be as the funeral knell of departed greatness, and may be called the state of desolation.

To this description one may add that Cole had particular difficulty in painting the third of the series, in which large-scale, completed buildings are predominant. While nature and ruins dominated his consciousness, architecture interested him. The Ohio state capital building is based on Cole's design and among his papers are architectural sketches for several churches (New York Historical Society Papers). In 1840, Cole painted *The Architect's Dream* (Toledo Museum of Art), in which the buildings occupy the full frame as if he had not remembered his pains over that third painting in *The Course of Empire*. But the memory may have returned to his consciousness as Cole displayed both distress and anger when the architect, Ithiel Town, who had commissioned the painting, rejected it. In the light of the conflict between classical and Gothic views, and the frequent statement that the classical form was appropriate for public buildings and the Gothic for churches, it is interesting to note that the painting is divided between the public, classical, and "light" buildings on the right, and the Gothic, dark, if not gloomy, church on the left.

⁸ Studies for *The Voyage of Life* exist at the Albany Institute of History and Art, Albany, New York, and completed versions at the National Gallery of Art, Washington, D.C., and the Munson-Williams-Proctor Institute, Utica, New York. The program supplied at the time of the original exhibition of the paintings (*Knickerbocker* 16 [1840], pp. 543–44) includes the following description:

FIRST PICTURE: CHILDHOOD

A stream is seen issuing from a deep cavern, in the side of a craggy and precipitous mountain, whose summit is hidden in clouds. From out the cave

glides a Boat, whose golden prow and sides are sculptured into figures of the Hours: steered by an Angelic Form, and laden with buds and flowers, it bears a laughing Infant, the Voyager whose varied course the artist has attempted to delineate. On either hand the banks of the stream are clothed in luxuriant herbage and flowers. The rising sun bathes the mountains and flowery banks in rosy light.

—

The dark cavern is emblematic of our earthly origin, and the mysterious Past. The Boat, composed of Figures of the Hours, images the thought, that we are borne on the hours down the Stream of Life. The Boat identifies the subject in each picture. The rosy light of the morning, the luxuriant flowers and plants, are emblems of the joyousness of early life. The close banks, and the limited scope of the scene, indicate the narrow experience of Childhood, and the nature of its pleasures and desires. The Egyptian Lotus in the foreground of the picture is symbolical of Human Life. Joyousness and wonder are the characteristic emotions of childhood.

—

SECOND PICTURE: YOUTH

The stream now pursues its course through a landscape of wider scope and more diversified beauty. Trees of rich growth overshadow its banks, and verdant hills form the base of lofty mountains. The Infant of the former scene is become a Youth, on the verge of manhood. He is now alone in the Boat, and takes the helm himself; and in attitude of confidence and eager expectation, gazes on a cloudy pile of Architecture, an air-built Castle, that rises dome above dome in the far-off blue sky. The Guardian Spirit stands upon the bank of the stream, and with serious yet benignant countenance seems to be bidding the impetuous voyager "God Speed.' The beautiful stream flows directly toward the aerial palace, for a distance; but at length makes a sudden turn, and is seen in glimpses beneath the trees, until it at last descends with rapid current into a rocky ravine, where the voyager will be found in the next picture. Over the remote hills, which seem to intercept the stream, and turn if from its hitherto direct course, a path is dimly seen, tending directly toward that cloudy Fabric, which is the object and desire of the voyager.

—

The scenery of this picture—its clear stream, its lofty trees, its towering mountains, its unbounded distance, and transparent atmosphere—figure forth the romantic beauty of youthful imaginings, when the mind magnifies the Mean and Common into the Magnificent, before experience teaches what is the Real. The gorgeous cloud-built palace, whose most glorious domes seem yet but half revealed to the eye, growing more and more lofty as we gaze, is emblematic of the day-dreams of youth, its aspirations after glory and fame; and dimly-seen path would intimate that Youth, in his impetuous career, is forgetful that he is embarked on the Stream of Life, and that its current sweeps along with resistless force, and increases in swiftness as it descends toward the great Ocean of Eternity.

—

THIRD PICTURE: MANHOOD

Storm and cloud enshroud a rugged and dreary landscape. Bare impending precipices rise in the lurid light. The swollen stream rushes furiously down a dark ravine, swirling and foaming in its wild career, and speeding toward the Ocean, which is dimly seen through the mist and falling rain. The boat is there, plunging amid the turbulent waters. The voyager is now a man of middle age: the helm of the boat is gone, and he looks imploringly toward heaven, as if heaven's aid alone could save him from the perils that surrounded him. The Guardian Spirit calmly sits in the clouds, watching with an air of solicitude the affrighted voyager. Demon forms are hovering in the air.

—

Trouble is characteristic of the period of Manhood. In Childhood there is no cankering care; in Youth no despairing thought. It is only when experience has taught us the realities of the world, that we lift from our eyes the golden veil of early life; that we feel deep and abiding sorrow; and in the picture, the gloomy, eclipse-like tone, the conflicting elements, the trees riven by tempest, are the allegory; and the Ocean, dimly seen, figures the end of life, to which the voyager is now approaching. The demon forms are Suicide, Intemperance, and Murder, which are the temptations that beset men in their direst trouble. The upward and imploring look of the voyager, shows his dependence on a Superior Power, and that faith saves him from the destruction that seems inevitable.

—

FOURTH PICTURE: OLD AGE

Portentous clouds are brooding over a vast and midnight Ocean. A few barren rocks are seen through the gloom—the last shores of the world. These form the mouth of the river, and the boat, shattered by storms, its figures of the hours broken and drooping, is seen gliding over the deep waters. Directed by the Guardian Spirit, who thus far has accompanied him unseen, the voyager, now an old man, looks upward to an opening in the clouds, from whence a glorious light bursts forth, and angels are seen descending the cloudy steps, as if to welcome him to the Haven of Immortal Life.

—

The stream of life has now reached the Ocean, to which all life is tending. The world, to Old Age, is destitute of interest. There is no longer any green thing upon it. The broken and drooping figures of the boat show that Time is nearly ended. The chains of corporeal existence are falling away; and already the mind has glimpses of Immortal Life. The angelic Being, of whose presence until now the voyager has been unconscious, is revealed to him, and with a countenance beaming with joy, shows to his wondering gaze scenes such as the eye of mortal man has never yet seen.

[9] See, e.g., *Stages of Man*, ca. 1825 (artist unknown), Abby Aldrich Rockefeller Folk Art Center, Williamsburg, Virginia.

[10] On December 16, 1847, in a letter to Frederick W. Mimée of Quebec, Cole suggests that the religious outlook of a student is important to him. Cole wrote:

I took the liberty of asking Mr. Smith [Mimée's former painting instructor] as to your religious sentiments, but he did not answer. This is a matter on which I hesitate to speak, but you will excuse the desire that I have, that one with whom I may have intimate intercourse should not be strongly at variance with myself who am of the Protestant Episcopal Church (MSPIA, New York Historical Society).

[11] Ellwood C. Parry III, "A Cast of Thousands," *Art News* (October 1983), pp. 110–11.

[12] The first three of the paintings were completed, the fourth unfinished (the fifth not started), each 64 x 96 inches. The paintings, together with oil sketches for all five, were exhibited at the American Art-Union Memorial in 1848. The paintings are lost, but the following oil sketches exist: *The Cross and the World: Two Youths Enter Upon a Pilgrimage—One to the Cross, the Other to the World* (Wichita State University); *The Pilgrim of the World on His Journey* (The Albany Institute of History and Art); *The Pilgrim of the Cross at the End of His Journey* (The Brooklyn Museum of Art and the National Museum of American Art). For an account of the series, see James C. Moore, "Thomas Cole's The Cross and the World: Recent Findings," *American Art Journal* 5 (November 1973), pp. 50–60. For an account that provides the European sources for Cole's series, as well as the chronology and interrelations of Cole's work, see Ellwood C. Parry III's forthcoming volume, *Ambition and Imagination in the Art of Thomas Cole*, scheduled to be published in 1985 as an American Art Journal Monograph.

[13] In addition to the articles written by Thomas Cole to which reference has been made, mention is made of the following: "Lament of the Forest," *Knickerbocker* 17, no. 6 (June 1841), p. 516–19; "The Winds," *Knickerbocker* 17 (May 1841) p. 399; "Sicilian Scenery and Antiquities," *Knickerbocker* 23 (March 1844) pp. 236–44; "Essay on American Scenery," *American Monthly Magazine*, Jan. 1836, pp. 1–12; "To Critics on the Art of Painting," *Knickerbocker* 16 (Sept. 1840) (under alias "Pictor"). Many of his writings were recently brought together in what turned out to be a fugitive publication.

Additional articles on Cole include the following: Louisa Dresser, "A Scriptural Subject by Thomas Cole, Two Sections Reunited," *Worcester Art Museum News Bulletin*, February 1971; William H. Gerdts, "Cole's Painting 'After the Temptation,'" *Baltimore Museum of Art Annual* 2 (1967), pp. 103–11; G. W. Greene (ascribed to), "The Voyage of Life, Course of Empire and Other Pictures of Thomas Cole," *North American Review* 77 (July–Oct. 1853), pp. 302–31; Charles Lamman, "Cole's Imaginative Paintings," *U.S. Magazine and Democratic Review* 12 (Jan.–June 1843), pp. 598–603; Ralph N. Miller, "Thomas Cole and Alison's Essays on Taste," *New York History* 37 (1956), pp. 281–99.

Exhibition catalogues include: *Thomas Cole 1801–1848: One Hundred Years Later* (Wadsworth Atheneum, Hartford and Whitney Museum of American Art, New York City, 1949); *Thomas Cole*, Introduction and catalogue by

Howard S. Merritt (Rochester, 1969).

14 For the first exhibition of the National Academy of Design in 1826, Durand sent *Mary Magdalene at the Sepulchre*; in 1827, *Samson Shorn of His Locks by the Philistines While Asleep in the Lap of Delilah*; in 1829, a *Hagar and Ishmael*; in 1831, another *Samson and Delilah*. See Daniel Huntington, *Asher B. Durand, A Memorial Address* (New York, 1887), p. 20.

 In addition to the religious paintings of the late twenties, Durand did at least three additional paintings of religious themes: *Ruth and Naomi, Healing the Possessed* (the demonic in the latter being reminiscent of the interest in this theme exhibited by Benjamin West); and *God's Judgment on Gog*, done at the request of Jonathan Sturges, and reminiscent in mood, too, of the occasional fury in the paintings of West and Trumbull. (See John Durand, *The Life and Times of A. B. Durand* [New York, 1894], pp. 132, 174.) Durand was unhappy with his biblical paintings. The time for work in the sublime tradition of West was over; nor were such themes congenial to Durand's spirit. No wonder that he did not wish these works to survive.

15 John Durand, *op. cit.*, p. 145.

16 "Letters on Landscape Painting," Letter II, *The Crayon* 1 (1855), p. 34.

17 John Durand, *op. cit.*, p. 158.

18 *Ibid.*, pp. 159–60.

19 *The Crayon* 1 (1855), Letter I, 1–2; Letter II, 34–35; Letter III, 66–67; Letter IV, 97–98; Letter V, 145–46; Letter VI, 209–11; Letter VII, 273–75; Letter VIII, 354–55; Vol. 2 (1855), Letter IX, 16–17.

20 Letter IV, *The Crayon* 1 (1855), pp. 97–98.

21 *Ibid.*, p. 98.

22 *Ibid.*, p. 98.

23 Letter VIII, *The Crayon* 1 (1855), p. 345.

24 Letter III, *The Crayon* 1 (1855), p. 66.

25 The American interpreter of Church, David C. Huntington, sees Church as the artist who represents nature as the book of God, analogous to and illumined by Scripture. Indeed, Church is considered a painter of nature who conveys the special providential role that nature played in American History, that America is a special place God reserved for the last great drama. In his analysis, Huntington makes reference to literary and theological figures, the latter including Horace Bushnell, James McCosh, and George Washington Bethune. He also relies heavily on what others said of Church. Even Church's own reticence is ascribed to his Puritan reserve. That covers all the bases; but it does not make his account more convincing. It could be theological over-kill. See David C. Huntington, "Church

and Luminism: Light for America's Elect," *American Light* (National Gallery of Art, Washington, D.C., 1982), pp. 155–90; *The Landscapes of Frederic Edwin Church: Vision of an American Era* (New York, 1966); *Art and the Excited Spirit: America in the Romantic Period* (Ann Arbor, 1972).

26 Barbara Novak, "On Defining Luminism," *American Light* (National Gallery of Art, Washington, D.C., 1982), p. 25.

27 Beecher believed that spirituality was disclosed through the world around him, and, while not a Swedenborgian, affinities with that view do exist in his thought.

28 There is something Pascalian in this vision, with a greater realism about human perversity than Swedenborgianism suggested. An article, "Mr. Inness on Art Matters" *Art Journal* 5 (1879, pp. 374–77) has extensive quotations by Inness on art, the senses, and theology.

Chapter 8

1 The term *civil religion* has entered the currency of contemporary scholarship through Robert Bellah's seminal essay, "Civil Religion in America," *Daedalus* (Winter 1967). It is an apt term for the materials of this chapter. For books that provide a history and interpretation of the development of American self-consciousness, from an errand in the wilderness to manifest destiny, see Ernest Lee Tuveson, *Redeemer Nation* (Chicago, 1968) and Charles L. Sanford, *The Quest for Paradise* (Urbana, Illinois, 1961).

2 *Gales and Seaton's Register of Debates in Congress*, II, Part I, (December 15, 1834), p. 792. See also session of January 24, 1834.

3 Mary Helen Knowlton, *Art-Life of William Morris Hunt* (Boston, 1900), p. 135.

4 Trumbull's historical paintings covering the American scene, all at Yale University Art Gallery, include the *Battle of Bunker Hill, Charleston, Mass., June 17, 1775*, finished in 1786; the *Death of General Montgomery in the Attack on Quebec, Canada, on the Night of 31st of December, 1775*, finished 1788; the *Declaration of Independence, 4th of July, 1776, at Philadelphia*, painted between 1786 and 1797; the *Capture of the Hessians at Trenton, New Jersey, 26 December, 1776*, painted between 1786 and 1797; the *Death of General Mercer at the Battle of Princeton, New Jersey, 3 January, 1777*; the *Surrender of General Burgoyne at Saratoga, New York, 17 October, 1777*, after 1816; the *Surrender of Lord Cornwallis at Yorktown, Virginia, 19 October 1781, before 1797;* the *Resignation of General Washington at Annapolis, Maryland, 3 December, 1783*, painted between 1816 and 1822. Enlarged replicas of the last four are in the rotunda of the United States Capitol, Washington, D.C. There are also half-size copies at the Wadsworth Atheneum, Hartford, Connecticut.

For information on Trumbull, see the works by Theodore Sizer; first, the edited volume, *The Autobiography of Colonel John Trumbull, Patriot-Artist 1758–1843* (New Haven, 1953); and the volume, *The Works of Colonel John Trumbull, Artist of the American Revolution* (1967, rev. ed.).

A superb up to date exhibition catalogue is that by Helen A. Cooper, with essays by Patricia Mullan Burnham, Martin Price, Jules David Prown, Oswaldo Rodriguez Roque, Egon Verheyen and Byran Wolf, entitled *John Trumbull: The Hand and Spirit of a Painter* (New Haven, 1982).

5 Jared B. Flagg, *The Life and Letters of Washington Allston* (New York, 1892, 1969), p. 235.

6 *Ibid.*, p. 236–37.

7 *Ibid.*, p. 253.

8 *The Picture of the Baptism of Pocahontas Painted By Order of Congress for the Rotunda of the Capitol*, by J. G. Chapman of Washington (pub. Peter Force, Washington, D.C., 1840), p. 3.

9 *Ibid.*, p. 5. The celebration of the "first" in a pattern of events is also expressed in Louisa Lander's sculpture of *Virginia Dare* (Roanoke Island, North Carolina, 1859). Allegedly, Virginia Dare was the first white woman born in the new world in the ill fated and lost colony on Roanoke Island.

10 G. S. Chamberlain, *Studies on John Gadsby Chapman* (Annandale, Virginia, 1963), p. 22. In 1830, Chapman did a stunning portrait of *Horatio Greenough* (1830, Boston Athenaeum). It was at this time, too, that he did his *Hagar and Ishmael Fainting in the Wilderness*, a painting which impressed Mrs. Trollope and which was the first art work by an American to be engraved in Rome (G. S. Chamberlain, *op. cit.*, p. 17). A photograph of this painting is all that remains (reproduced, p. 9, John Gadsby Chapman, *Painter and Illustrator*, December 16, 1962–January 13, 1963, National Gallery of Art Exhibition). His *Hagar Fainting in the Wilderness* (1853, Alexandria [Virginia] Association), some twenty years later, is certainly in the category of swooning melodrama.

11 Henry Tuckerman, *Book of the Artists*, quoted from Wayne Craven, *Sculpture in America* (New York, 1968), p. 160.

12 William H. Gerdts, *American Neo-Classical Sculpture* (New York, 1973), p. 131.

13 For general as well as detailed information on sculpture in the U.S., see, in addition to Wayne Craven, *op. cit.*, the following volumes: Sylvia E. Crane, *White Silence: Greenough, Powers and Crawford—American Sculptors in Nineteenth-Century Italy* (Coral Gables, Fla., 1972); William H. Gerdts, Nicolai Cikovsky, Jr., Marie H. Morrison, Carol Ockmans, *The White Marmorean Flock* (Poughkeepsie, 1972); Albert Ten Eyck Gardner, *Yankee Stonecutters: The First*

American School of Sculpture, 1800–1850 (Freeport, N.Y., 1945).

[14] On the apotheosis theme, see the exhibition catalogue by Patricia A. Anderson, *Promoted to Glory: the Apotheosis of George Washington* (Northampton, Mass., 1980).

[15] Peter Powers, attorney for the Smithsonian, informed me that the low ceiling is the result of a last-minute cut in the budget for the building. The ironic parallel is that the Phidian *Zeus*, upon which George Washington was modelled, would have hit his head on the temple ceiling, had he stood up.

[16] Paris, 1814; see Wayne Craven, *Sculpture in America* (New York, 1968), pp. 107–8.

[17] Nathalia Wright (ed.), *Letters of Horatio Greenough* (Madison, Wisconsin, 1972), pp. 177–78.

[18] *Ibid.*, p. 309.

[19] *Ibid.*, p. 173.

[20] *Ibid.*, p. 314.

[21] *Ibid.*, p. 78.

[22] *Ibid.*, p. 174.

[23] *Ibid.*, p. 177.

[24] Horatio Greenough, *Form and Function* (Berkeley, 1969), p. 34. Greenough undoubtedy read from the poems of Michelangelo. For example,

> Lady, it is the taking off that puts
> into the rough hard stone
> A living figure, grown
> most great just there where a stone has grown most small.

[25] *Greenough Letters*, p. 177.

[26] *The Home Book of the Picturesque* (1852, reprinted 1967, Gainesville, Florida), pp. 183–84.

[27] Further reports on the Greenough statue are found in the following articles: Thomas Brumbaugh (ed.), "The Genesis of Crawford's Washington, A Letter from T. C. to George W. Greene," *Virginia Magazine of History and Biography* 52 (January 1962); "Horatio Greenough in the Classic Mold," *Antiques* 99 (Jan.–June 1971), pp. 252–56; R. D .W. Connor, "Canova's Statue of Washington," *Publications of the North Carolina Historical Commission*, Bulletin No. 8 (1910); Wayne Craven, "Horatio Greenough's Statue of Washington and Phidias' Olympian Zeus," *The Art Quarterly* 26, no. 4 (Winter 1963), pp. 429–40; Alexander Everett, "Greenough's Statue of Washington," *United States Magazine and Democratic Review* 14, no. 72 (1844), pp. 618–21; (————) "Tuckerman Visit

to Greenough Studio," *American Monthly Magazine* 7 (Jan. 1836), pp. 53–56.

The most extensive work on Greenough has been done by Nathalia Wright, as the following books and articles indicate: Nathalia Wright, "The Chanting Cherubs," *New York History* 38 (1957), pp. 177–97; *Horatio Greenough The First American Sculptor* (Philadelphia, 1963); ed., *Lectures on Art and Poems (1850) and Monaldi (1841) by Washington Allston* (Gainesville, Fla.: Scholar's Facsimiles and Reprints); ed., *Letters of Horatio Greenough American Sculptor* (Madison, Wis., 1972); ed., "Emerson-Greenough Exchanges on his Publications," *Harvard Library Bulletin* 12 (Winter 1958), pp. 91–116.

28 For a later (1939) and quite different view of Washington, see Wanda M. Corn's treatment of Grant Wood's *Parson Weems' Fable*. Wanda M. Corn, *Grant Wood: The Regionalist Vision* (New Haven, 1983), pp. 120–23.

29 Kent Ahrens, "Robert Walter Weir" (Ph.D. Diss., University of Delaware, 1972), p. 141.

30 The painting by Weir, *Moses Viewing the Promised Land* (National Museum of American Art) could possibly be a preliminary sketch for the opposite end of the War and Peace Chapel, its shape and contours, Jane Dillenberger suggests, fitting into the architecture of the building. The subject matter would be appropriate for the time, i.e., seeing the United States as the promised land. A second sketch of the same subject is owned by a Weir descendent.

31 On Erastus Salisbury Field, see: Mary C. Black, "Erastus Salisbury Field and the Sources of his Inspiration," *Antiques* 83 (Feb. 1963), pp. 201–6; Agnes M. Dods, "Erastus Salisbury Field (1805–1900): A New England Folk Artist," *Old Time New England* 33 (Oct. 1942), 1926–32; *Erastus Salisbury Field: A Special Exhibition*, Williamsburg, 1963; Frederick B. Robinson, "The Eighth Wonder of Erastus Field," *American Heritage* 14 (Apr. 1963), pp. 12–17.

32 Barbara S. Groseclose, *Emanuel Leutze, 1816–1868: Freedom is the Only King* (Washington, 1975), p. 61.

33 *The Education of Henry Adams An Autobiography* (Boston, 1918, 1946, 1961), pp. 340, 343.

34 When the decision was made to finish St. John the Divine in the Gothic style, the Romanesque setting for the chapel was neglected. As a result, Tiffany received permission to dismantle the chapel, and it was installed at Laurelton Hall. After the dispersal of some of the materials and the Laurelton Hall fire, Mr. and Mrs. Hugh F. McKean pulled together the remaining chapel material. Now those works of art belong to the Charles Hosmer Morse Foundation in Florida. See *The Art of Louis Comfort Tiffany*, An Exhibition Organized by the Fine Arts Museums of San Francisco, from the collection of the Charles Hosmer Morse Foundation, by Donald L. Stover (San Francisco, 1981) and Hugh F. McKean, *The "Lost" Treasures of Louis Comfort Tiffany* (New York, 1980).

Chapter 9

1 Many American artists spent considerable time abroad and returned to the United States at various times. They were concerned about an American art. West and John Singleton Copley, however, did not return and the major setting of their work was England. Hence, I have not given much attention to their works in this volume. West's major religious works in the American scene can be seen on a grand scale at the Pennsylvania Academy of Arts, Philadelphia. For other major subjects, see John Dillenberger, *Benjamin West: The Context of His Life's Work* (San Antonio, 1977). In the case of Copley, mention should be made of *The Ascension* (Museum of Fine Arts, Boston, 1775), *Samuel Relating to Eli the Judgment of God upon Eli's House* (Wadsworth Atheneum, Hartford, 1780), and *Saul Reproved by Samuel for Not Obeying the Commandments of the Lord* (Museum of Fine Arts, Boston, 1798). All three were painted in England.

2 R. W. B. Lewis, *The American Adam* (Chicago, 1955) and David W. Noble, *The Eternal Adam and the New World Garden* (New York, 1968).

3 Salomon Gessner's *The Death of Abel* was translated into English in 1778 and was published in London in several editions. It is a sentimental elaboration of the biblical account.

4 Louis Legrand Noble, *The Life and Works of Thomas Cole* (Cambridge, Massachusetts, 1964), p. 100.

5 For years, this sculpture has been located in the entrance foyer of the Athenaeum, prompting the quip that Adam and Eve were lamenting that they never had the credentials to be admitted to this elite Boston institution.

6 The titles, supplied by Robert Gale in his book, *Thomas Crawford* (Pittsburg, 1966) include: *Christ Ascending from the Tomb, Christ at the Well of Samaria, Christ Blessing Little Children, Christ Disputing with the Doctors, Christ Raising Jairus' Daughter, David and Goliath, David Before Saul, Eve Tempted, Eve with Cain and Abel* (obviously from Gessner's *Death of Abel*, since only there does one find Eve with Cain and Abel), *Lead Us Into Life Everlasting, Niece of Herod with Head of John the Baptist on a Charger, Peri, Prayer, Repose in Egypt, Shepherdess with Lamb and Dead Wolf, Shepherds and Wise Men Before Christ.* Both Thomas Crawford and Robert W. Weir did many religious subjects. In both instances, few survive.

7 Unless otherwise designated, letters to or from Powers are quoted from the letters in the Archives of American Art, Washington, D.C., housed in the National Museum of American Art. They are otherwise identified by date, additional footnotes being unnecessary.

8 Both quotations are from a letter by W. J. Hubard to Hiram Powers, September 20, 1839, in Valentine II Papers, Library, Valentine Museum, Richmond, Virginia.

9 *Powers' Statue of the Greek Slave* (New York, 1847), p. 18.

10 In order to distinguish the various versions of Eve, I have called this first Eve, *Eve Tempted No. 1.* She came with the contents of the Powers' studio and with material from the Powers family to the National Museum of American Art in 1968. She is to be distinguished from *Eve Tempted No. 2,* completed in 1849 for Preston of South Carolina. *Eve Tempted No. 2* is a model of the same subject as *Eve Tempted No. 1,* but the posture is considerably different. The marble version of *Eve Tempted No. 2* is lost, but the plaster version is among the Powers materials at the National Museum of American Art. *Eve Tempted No. 1* and *Eve Tempted No. 2* are to be distinguished from the marble version of *Eve* at the Hudson River Museum in Yonkers (1871) and at the Cincinnati Art Museum (1873–74). This latter Eve has three titles: *Paradise Lost, Eve Repentent,* and *Eve Disconsolate.* The National Museum of American Art has a plaster copy.

11 *Powers' Statue of the Greek Slave* (New York, 1847), p. 17.

12 *Ibid.,* pp. 18–19.

13 Powers was so at home with the nude that, while discouraged by criticism, he never lost his sense of humor. In the same letter, Powers compares Eve's nudity with her grandchildren who are clothed, and of course, the shapeliness of Eve wins out. His humor, too, is illustrated in a letter to the Englishman John Grant, who had purchased *The Greek Slave.* In that letter, Powers talks of *Eve* and *The Greek Slave,* both of whom are then in his studio:

> I hope that nothing will occur to disfigure your slave but if there should you will have reason to attributing it all to jealousy for Mother Eve finds in her daughter a most dangerous rival and although as yet she has preserved at least every appearance of good nature and forbearance, still there is no telling how far she may be tempted to break the peace of the kind attention and numerous compliments which are daily bestowed upon your favorite. Had the circumstances been the same and even at that fatal moment when she ate the forbidden fruit, who knows that her posterity might not have escaped "the many ills which through her they have been heir to" for instead of eating it, she might have thrown the apple—if apple it was—at her daughter's head. Let us hope, however, that the consciousness of having been the cause of all the poor slave trouble, as well as every other variety of human affliction, will induce our great-grandmother to forbear actual hostilities and part as she soon will with her rival in peace (September 14, 1844).

14 For two views of the nude, see one from before the issue posed by Power and one from the contemporary period: (————) "Remarks on Nudity in Art," *U.S. Review and Literary Gazette* 1 (March 1827), p. 464; and William H. Gerdts; "Marble & Nudity," *Art in America* 59 (May–June 1971), pp. 60–67.

Nineteenth-century journals carried many articles on Powers. In addition to the sources already quoted, the following articles are noted: George H. Calvert, "The Process of Sculpture; The Greek Slave," *The Literary World* 2, no. 33 (Sept. 18, 1847), pp. 159–60; James Jackson Jarves, "Hiram Powers and His

Works, Pen Likeness of Art Critics and Artists," *The Art Journal* 36, new series 13 (1874), pp. 37–39; Charles Edward Lester, "The Genius and Sculptures of Powers," *American Review; A Whig Journal* 2 (1845), pp. 199–204; A. M. Migliarini, "Powers the Sculptor," *Knickerbocker* 18 (1841) p. 523; Ellen L. Powers, "Recollections of my Father," *Vermonter* 12 (March 1907), pp. 73–85; C. S. Robinson, "A Morning with Hiram Powers," *Hours at Home* 6 (1867), pp. 32–36; T. Adolphus Trollope, "Some Recollections of Hiram Powers," *Lippincott's Magazine of Popular Literature and Science* 15 (Feb. 1875), pp. 205–15; (—————) "The Greek Slave," *Art Journal* 12 (1850), p. 56; (—————) "Hiram Powers," *U.S. Magazine and Democratic Review* 6 (1839), p. 174; (—————) "Hiram Powers the Sculptor," *Littell's Living Age* 15, no. 179 (1847), pp. 97–100; (—————) "Hiram Powers," *Eclectic Magazine* 71, new series 8, (August 1868), pp. 1028–1029; (—————) "Our Artists in Italy—Hiram Powers," *Atlantic Monthly* 5 (January 1860), pp. 1–6; (—————) "Powers the Sculptor," *Littel's Living Age* 15, no. 179 (16 October 1847); (—————) *Powers' Statue of the Greek Slave* (Boston, 1848); (—————) "Pride in the Success of Hiram Powers," *U.S. Democratic Review* 6 (August 1839), p. 174; (—————) "Reaction to (Powers') Greek Slave," *Western Quarterly Review* 1 (1849), pp. 95–98; (—————) *Statue of the Greek Slave* (New York, 1847).

15 See William G. Wendell, "Edward Sheffield Bartholomew, Sculptor," *Wadsworth Atheneum Bulletin* (Winter 1962).

16 See William H. Gerdts, *American Neo-Classic Sculpture* (New York, 1973), p. 71.

17 W. W. Story, *Hagar and Ishmael*, 1844; Edmonia Lewis, *Hagar*, 1871.

18 Chauncey Ives, *Head of Jephthah's Daughter*, 1845. Hezekiah Augur, *Jephthah and His Daughter*, 1828. William Page, *Jephthah's Daughter*, 1840.

19 Randolph Rogers, *Ruth Gleaning*, after 1853. H. K. Brown, *Ruth*, 1845; Thomas Cole, *Ruth Gleaning*, 1822; Erastus Dow Palmer, *Ruth*, 1857; William Page, *Ruth and Naomi*, 1847.

20 William Rimmer, *Coronation of Queen Esther*, 1847.

21 Chauncey Ives, *Rebecca at the Well*, 1854; Joseph Mozier, *Rebecca*, 1857; Washington Allston, *Rebecca at the Well*, 1816; Erastus Dow‑Palmer, *Rebecca*, 1863.

22 W. W. Story, *Delilah*, 1866–67.

23 Washington Allston, *Miriam the Prophetess*.

24 W. W. Story, *Salome*, 1871.

25 In a conversation with Leo Steinberg, Steinberg suggested that as the artists

of the later nineteenth century accentuated masculinity in the nude form, the Christ figure became more effeminate.

26 The major work on Peale is that of Charles Coleman Sellers, *Charles Willson Peale: A Biography* (New York, 1969). For the Peale family, family, see the volumes edited by Lillian Miller and Sidney Hart, *The Selected Papers of Charles Willson Peale and His Family* 1 (New Haven, 1983).

27 For information on Hicks, see the following: *Edward Hicks 1780–1849: A Special Exhibition Devoted to his Life and Work* (Williamsburg, Virginia, 1960); Alice Ford, *Edward Hicks, Painter of the Peaceable Kingdom* (Philadelphia, 1952); Eleanore Price Mather, *Edward Hicks Primitive Quaker, His Religion in Relation to His Art*, Pendle Hill Pamphlet 170 (Pendle Hill, Pennsylvania, 1970); "A Quaker Icon: The Inner Kingdom of Edward Hicks," *The Art Quarterly* 36 (1973), pp. 84–99; Frederick B. Tolles, "The Primitive Painter or Poet," *Bulletin of Friends Historical Association*; "Of the Best Sort but Plain: The Quaker Esthetic," *American Quarterly* 2 (1959), pp. 484–502; David Tatham, "Edward Hicks, Elias Hicks and John Comly: Perspectives in the Peaceable Kingdom Theme," *The American Art Journal* 13, no. 2 (Spring 1981), pp. 37–50; and Eleanore P. Mather and Dorothy C. Miller, *Edward Hicks: Primitive Master* (Newark, Delaware, 1983).

28 Tolles has identified the figures in the *Quakers Bearing Banners*. Eleanore Price Mather claims that the *Quakers Bearing Banners* is Hicks's way of saying that the Hicksites, too, are orthodox. This does not seem to me to be convincing. In fact, those who formerly represented the ideal of peace, namely Penn's Treaty, have been replaced by the company of believers in the spirit, from Christ to Elias Hicks. Considered in such terms, the painting is not an orthodox defense, but a Hicksite platform.

29 Eleanore Price Mather, *Edward Hicks*, p. 29.

30 *Memoirs of the Life and Religious Labors of Edward Hicks* (Philadelphia, 1851), p. 287.

31 Eleanore Price Mather, "A Quaker Icon: The Inner Kingdom of Edward Hicks," *The Art Quarterly* 36 (1973), pp. 84–97. I find less convincing her views that the fierceness of the animals reflects the tensions of the Quaker controversy. My inclination is to say that the animals reflected Hicks' own anxieties. See Eleanore Price Mather, *Edward Hicks Primitive Quaker: His Religion in Relation to his Art*.

32 Irma B. Jaffe, "Fordham University's Trumbull Drawings, Mistaken Identities in *The Declaration of Independence* and Other Discoveries," *The American Art Journal* 3 (Spring 1971), p. 31; Patricia Mullan Burnham, "Trumbull's Religious Paintings Themes and Variations," *John Trumbull The Hand and the Spirit of a Painter* (New Haven, 1982), pp. 180–204.

[33] "The Conquest of Canaan," Book VI, Lines 641–48, from *The Major Poems of Timothy Dwight* (Gainesville, Florida, 1969), p. 151.

[34] Leon Howard, *The Connecticut Wits* (Chicago, 1943), p. 92. For Dwight's use of Milton, also see George F. Sensabaugh, *Milton in Early America* (Princeton, 1964), pp. 166–76.

[35] Beilby Porteus, *A Summary of the Principal Evidences for the Truth and Divine Origin of the Christian Revelation*, to which is added, a *Poem on Death* (Hartford, Connecticut, 1817), p. 121.

[36] Rembrandt Peale, "Letter on His Court of Death, 1845," in John W. McCoubrey, ed., *American Art 1700–1960, Sources and Documents* (Englewood Cliffs, New Jersey, 1965), pp. 54–55.

[37] While on tour, Peale's *Court of Death* was both praised and denounced by clergy. William Dunlap provides us with an interesting account of the reactions of the public to a traveling exhibit of a painting.

> At one place a picture would be put up in a church, and a sermon preached in recommendation of it: in another, the people would be told from the pulpit to avoid it, as blasphemous; and in another the agent is seized for violating the law taxing puppet-shows, after permission given to exhibit; and when he is on his way to another town, he is brought back by constables, like a criminal, and obliged to pay the tax, and their charges for making him a prisoner. —Here the agent of a picture would be encouraged by the first people of the place, and treated by the clergy as if he were a saint; and there received as a mounteback, and insulted by a mob. (William Dunlap, *History of the Rise and Progress of the Arts of Design in the United States* [New York: 1969], vol. 1, p. 301.) Dunlap himself was the master of the travelling circuit. He wrote: "In January 1826, I had *The Bearing of the Cross* on Exhibition at Charleston, *The Death on the Pale Horse* at Norfolk, and *The Christ Rejected* at Washington." (Dunlap) op. cit., p. 296.

[38] Anita Schorsch has pointed out that it was believed that Goethe's *The Sorrows of Werther*, e.g., "brought people closer to God than the theologians through the sensations of living, pining, dying, and mourning". See Schorsch, "Mourning Art: A Neoclassical Reflection in America," *The American Art Journal* 8 (May 1976), pp. 4–15. See especially page 9.

[39] Jared B. Flagg, *The Life and Letters of Washington Allston* (New York, 1892, revised, 1969), pp. 99–100.

[40] *Ibid.*, p. 100.

[41] *Ibid.*, pp. 71–72.

[42] William H. Gerdts, "Allston's Belshazzar's Feast," *Art in America* (March–April 1973), p. 59. For a full discussion of the issues in Belshazzar's Feast, attention is directed to the two articles by William Gerdts in *Art in America* (March–April 1973, pp. 59–66; May–June, pp. 58–65).

⁴³ For a discussion of Transcendentalism and Romanticism, two key movements in relation to the visual arts, see the following: M. H. Abrams, *Natural Supernaturalism: Tradition and Revolution in Romantic Literature* (New York, 1971); George Boas, ed., *Romanticism in America* (Baltimore, 1940); William H. Gerdts, "Washington Allston and the German Romantic Classicists in Rome," *Art Quarterly* 32 (Summer 1969) pp. 167–96; Marjorie H. Nicolson, "James Marsh and the Vermont Transcendentalists," *Philosophical Review* 34 (1925), pp. 28–50; E. P. Richardson, *Washington Allston: A Study of the Romantic Artists In America* (New York, 1948); Robert Rosenblum, *Modern Painting and the Northern Romantic Tradition, Friedrich to Rothko* (New York, 1975); D. L. Smith, "Romanticism and the American Tradition," *American Artist* 26 (March 1962), pp. 28ff.

In the nineteenth century, Allston was the subject of numerous articles and books dedicated to probing his role. Among these not already mentioned are the following: John A. Albro, "A Sermon occasioned by the death of Washington Allston, delivered in the Church of the Shepard Society, Cambridge, July 16, 1843," *Christian Examiner* 35 (November 1843), pp. 270–72; H. W. L. Dana, "Allston at Harvard, 1796–1800," and "Allston in Cambridgeport, 1830–43," *Proceedings 1943*, Cambridge Historical Society Pub., Vol. 29 (1948); Margaret Fuller, "A Record of Impressions Produced by the Exhibition of Mr. Allston's Paintings in the Summer of 1839," *The Dial* (July, 1840), pp. 73–83; Anna Jameson, "Washington Allston," *Athenaeum* (1844), pp. 15–16, 39–41; Moses Foster Sweetser, *Allston* (Boston, 1880); William Ware, *Lecture on the Work and Genius of Allston* (Boston, 1852); (————) "Exhibition of Pictures Painted by Washington Allston at Harding's Gallery School Street, Boston, 1839," *North American Review* 50 (Jan.–Apr. 1840), pp. 358–81; (————) "Allston's Lectures on Art," *Bulletin of The American Art-Union* (June, 1850), p. 38ff.; (————) "Allston's Outlines—Outlines and Sketches by Washington Allston," *Bulletin of the American Art-Union* (1850), p. 18ff.; (————) "Allston the Painter," *American Monthly Magazine* 7 (1836), pp. 435–46.

⁴⁴ See Charles A. Sarnoff, "The Meaning of William Rimmer's *Flight and Pursuit*," *The American Art Journal* 5 (May 1973), pp. 18–19. See also: Ellwood C. Parry III, "Looking for a French and Egyptian Connection Behind William Rimmer's *Flight and Pursuit*," *The American Art Journal* 13, no. 3 (Summer 1981), pp. 51–60; Jeffrey Weidman, *William Rimmer: Critical Catologue Raisonné* (Bloomington, Indiana, 1982).

Chapter 10

¹ Other religious paintings included the *Nativity* (1776, Museum of Fine Arts, Boston); *Samuel Relating to Eli the Judgments of God Upon Eli's House* (Wadsworth Atheneum, Hartford, Connecticut); the *Tribute Money* (Royal Academy, London); a study for the *Tribute Money* (Metropolitan Museum of Art, New York); a study for *Abraham Offering Up His Son Isaac* (1791–96,

Addison Gallery of American Art, Phillips Academy, Andover, Massachusetts); *Saul Reproved by Samuel for Not Obeying the Commandments of the Lord* (1798, Museum of Fine Arts, Boston); a study for the latter (Addison Gallery of American Art). The Fogg Art Museum, Cambridge, Massachusetts, has an engraving of the *Sacrifice of Isaac*, as well as mezzotints of *Hagar and Ishmael in the Wilderness* and *The Nativity*. See Jules David Prown, *John Singleton Copley* II (Cambridge, Massachusetts, 1966).

2 Jared B. Flagg, *The Life and Letters of Washington Allston* (New York, 1892, 1969), pp. 119–20.

3 *Ibid.*, pp. 222–23. Anna Jameson, in *The Athenaeum* (1844), p. 16, contrasts Allston and West at this point, to the detriment of the latter:

> He [Allston] had planned a great picture of "Christ Healing the Sick," but, on reflection, abandoned it, deterred by the failure of all attempts, ancient and modern, to give an adequate idea of the Saviour. Yet I cannot help wishing that he had entered the lists with West, who never seems to have mistrusted his own powers to represent any theme, however high, however holy. But Allston was a poet—felt, thought, painted like a poet; knew what it is to recoil and tremble in the presence of the divine; and this is just what the pious and excellent West knew *not*.

4 Jared B. Flagg, *op. cit.*, p. 364.

5 C. S. Henry, "Pictorial Representation of Christ," *The Crayon* 3 (1856), p. 257. Weir's letter was originally written on November 18, 1844. For recent catalogues and pamphlets on Weir, see the following: Michael E. Moss, *Robert W. Weir of West Point*, West Point, 1976; Holly Joan Pinto, *William Cullen Bryant, The Weirs and American Impressionism*, Nassau County Museum of Fine Art, Roslyn, New York, 1983; (————) *Robert Weir: Artist and Teacher of West Point*, West Point, 1976.

6 *Ibid.*, p. 257.

7 Passages quoted from Irene Weir, *Robert W. Weir, Artist* (New York, 1947), p. 142, but the total context is given in Weir materials, *Archives of American Art*, Roll 531, p. 727.

8 Painting as a universal language is mentioned in the letter written to C. S. Henry (*The Crayon* 3 [1856], p. 257) and in a letter to J. D. Waddington, *Archives of American Art*, Roll 531, p. 748.

9 *The Crayon* 3 (1856), p. 257.

10 In fact, as a churchman, Weir was so interested in the new Gothic tradition that, according to Phoebe Stanton, he probably traveled throughout England with Bishop Doane of New Jersey, inspecting Gothic churches. Moreover, Weir was largely responsible for the launching and architectural rendering of the small Gothic Church of the Holy Innocents, Highland Falls, New York, just a few blocks

south of the entrance to West Point. The interior of the church has been changed since Weir's time, but a sketch of the interior does provide a view of the interior at an earlier date, and even now there are traces of the early Gothic outlook. Weir's painting of the exterior of the church is apparently the basis of the design reproduced in *The Home Book of the Picturesque: or American Scenery, Art and Literature* (1852, repub. Gainesville, Florida, 1967) (Plate 34).

11 John Landis and John Quidor are two fascinating, but mysterious figures about whom one wishes one knew more. Landis wrote theological tracts of an uncommon kind, and Quidor is mainly known for his paintings of figures and scenes from the writings of Washington Irving. In 1844, Quidor entered into a contract to buy a farm in Northern Illinois near the Mississippi in exchange for Quidor's doing a series of religious paintings, among which were *Christ Healing the Sick, Christ Raising Lazarus from the Dead*, and *Death on a Pale Horse*. They were not meant for a church, but for exhibiting on tours. Some of the paintings were exhibited in New York City. Today there is no trace of the paintings. For further information on Quidor, see the following: David M. Sokol, "John Quidor: Literary Painter," *The American Art Journal* 2 (1970), pp. 60–73; *John Quidor: Painter of American Legend* (catalogue of exhibit at Wichita Art Museum and Art History Galleries at University of Wisconsin, Milwaukee, 1973); (————) *John Quidor 1801–1881*. Exhibit organized by the Munson-Williams-Proctor Institute, Sponsored by the New York State Council on the Arts exhibit November 2, 1965–April 24, 1966. Intro. by John Baur.

 For John Landis, see the following: John Landis, *The Messiah: A Poem*, Lancaster City, Pa., 1846.

12 *Letters of Greenough*, ed. Nathalia Wright (Madison, Wisconsin, 1972), p. 369.

13 Both the *Lucifer* and the *Christ* are in the Boston Public Library.

14 Horatio Greenough, *Form and Function* (Berkeley, 1969), p. 33.

15 Horatio Greenough, *The Travels, Observations, and Experiences of a Yankee Stonecutter* (New York, 1852, reprinted Gainesville, Florida, 1928), p. 215.

16 Thomas Newton, *Works* I (London, 1782), p. 29. It may be noted that the sides of the Washington statue have serpents carved on them, similar to those at the base of *Lucifer* and *Christ*.

17 The late Dr. Joshua C. Taylor, William H. Truettner, Jane Dillenberger, and I did a preliminary comparison of the models in the light of the correspondence. More careful measurements and extensive photographs would be necessary in order to draw final conclusions.

18 The Powers letters are in the Archives of American Art, located in the National Museum of American Art, and are here referred to only in terms of the dates.

19 Story did additional religious figures, of which the most interesting is the massive Saul (Plate 81; plaster, National Museum of American Art), and the Libyan Sibyl (Metropolitan). The Sibyls were messengers of the gods, incorporated into Christian history as prefiguring pointers of the true God.

20 A marble version of the head of Christ can be see at the St. Gaudens studio at Cornish, New Hampshire, and a bronze model of the head was sold by Parke Bernet several years ago.

21 Taylor wonders, pressing this line, whether Page's inadequate portrait of Henry Ward Beecher may stem from his discerning little spirituality in Beecher. "Could Page," he adds, "have suspected things of Beecher, which Tilton had not yet recognized" (Joshua C. Taylor, *William Page: The American Titian* [Chicago, 1957], p. 189). I have no interest in defending Beecher, but doubt that if the accusation is true, that such a Swedenborgian interpretation works in reverse. Certainly, other artists found Beecher fascinating. My conversation with the late Joshua Taylor on Page, Beecher, and Tilton was the only one, over a period of a decade, that ended where it began. For Tilton's defense of Page, see *Golden Age* 1, no. 12 (May 20, 1871). A reading of the materials convinces me that Beecher, even if guilty, received a bad press, while Tilton's own indiscretions were hardly noted. In terms of the understandings of the time, however, Tilton had not violated "property rights," as Beecher allegedly had.

22 Among other religious subjects are: *Two Disciples at the Tomb* (1906, The Art Institute of Chicago); *Angel Appearing Before the Wise Men* (ca. 1910, National Museum of American Art); the *Burning of Sodom and Gomorrah* (n.d., The High Museum of Art, Atlanta); *Moses in the Bullrushes* (1921, National Museum of American Art); *David in the Lions' Den* (ca. 1916, Los Angeles County Museum).

For information on Tanner and additional artists discussed in this section see the following: Marcia M. Mathews, *Henry Ossawa Tanner* (Chicago and London, 1969); *The Art of Henry Ossawa Tanner, 1859–1937* (Glens Falls, N.Y., 1972); *Robert Loftin Newman, 1827–1912*, Catologue by Marchal E. Landgren (Washington, D.C., 1973); Nelson C. White, *Abbot H. Thayer, Painter and Naturalist* (Hartford, Ct., 1951); Lloyd Goodrich, *Thomas Eakins* I and II (Cambridge and London, 1982); Gordon Hendricks, *The Life and Work of Thomas Eakins* (New York, 1974); *Thomas Eakins: A Retrospective Exhibition*. Catalogue by Lloyd Goodrich (Washington D.C., 1961); Lloyd Goodrich, *Albert P. Ryder* (New York, 1959); Frederic F. Sherman, *Albert Pinkham Ryder* (New York, 1920); Corcoran Gallery of Art, *Albert Pinkham Ryder* (Washington, D.C., 1961).

23 *Perceptions and Evocations; The Art of Elihu Vedder*, with an introduction by Regina Soria and essays by Joshua C. Taylor, Jane Dillenberger, Richard Murray (Washington, D.C., 1979), pp. 132 ff., 148. See also: Regina Soria, *Elihu Vedder, American Visionary Artist in Rome* (Rutherford, N.J., 1970).

[24] John LaFarge, "Ruskin, Art and Truth," *International Monthly* 2 (Nov. 1900), pp. 510–25. Also on John LaFarge: Royal Cortissoz, *John LaFarge, A Memoir and A Study* (Boston and New York, 1911); Ruth Berenson Katz, "John LaFarge, Art Critic," *Art Bulletin* 33 (June 1951), pp. 105–18; Royal Cortissoz, intro., *An Exhibition of the Work of John LaFarge*, Metropolitan Museum of Art (New York, 1936); Cecilia Waern, *John LaFarge, Artist and Writer* (London and New York, 1896).

[25] Additional stained glass windows by LaFarge in Trinity Church are: left clerestory window on the south wall of the nave; three lancet windows on the west wall of the nave; the *New Jerusalem* and the *Resurrection* on the west wall over the gallery.

[26] Additonal mural commissions included work for St. Paul the Apostle Church, to which reference has been made, and the *American Madonna* for Emmanuel Chapel, St. Luke's Cathedral, Portland, Maine, in 1904.

[27] See the volume by Walter Muir Whitehill, *Boston Public Library: A Centennial History* (Cambridge, Mass., 1976), and his article, "The Making of an Architectural Masterpiece—The Boston Public Library," *The American Art Journal* 2, no. 2 (Fall 1970), pp. 13–35.

[28] Sargent Manuscript 1320 (2), Boston Public Library.

[29] Richard Ormond, *John Singer Sargent* (New York, 1970), p. 89, and Evan Charteris, *John Sargent* (New York, 1927), p. 108. There is some evidence to the effect that the title may have originated with the staff of the Boston Public Library. It is interesting to add that in *Passages from the Journal of Thomas Russell Sullivan 1891–1903* (Boston and New York, 1917) Sullivan suggests in an entry for April 25, 1895, that Sargent chose for his subject the world's religions. Apparently, that is exactly the subject Sargent rejected as too comprehensive.

[30] Two slightly altered versions of the *Crucifix* for the Dogma of Redemption, were made by Sargent, one to be found in the Hirshhorn Museum and Sculpture Garden, Washington, D.C., and the other in the crypt of St. Paul's Cathedral, London.

[31] Evan Charteris, *op. cit.*, p. 209.

[32] Two factors come to mind. First, considerable anti-Semitism emerged among literary and artistic figures in the light of the Dreyfus incident. Where Sargent stood on this I do not know. Second, on his second trip to Palestine, Sargent was upset by the Jews he saw. They did not represent the dignity he sought.

Chapter 11

[1] The number of people who attend special art events is not in and of itself a clue to its role in a culture, whether one refers to the past or the present.

In both cases, public rather than artistic interests predominate, though artistic interests may be encouraged through such exhibitions.

[2] Information and plates are to be found in the work, *C.C.A. Christensen 1831–1912: Mormon Immigrant Artist* (an exhibition at the Museum of Church History and Art; essay and catalogue by Richard L. Jensen and Richard G. Oman; published by the Church of Jesus Christ of Latter-day Saints, Salt Lake City, Utah, 1984).

[3] Reprinted in the *Christian Century* 101 (1984), pp. 307–8.

[4] See, for example, the articles by Ronald Goetz, "The Creature's Creation: Is Art 'Helpful' to Faith?" *Christian Century* 99 (1982), pp. 367–70, and "Finding the Face of Jesus," *Christian Century* 101 (1984), pp. 299–304.

[5] *Christianity Today* 22 (September 22, 1978), p. 28. Among the books published by Cynthia Pearl Maus were *Christ and the Fine Arts* (1938, revised and enlarged edition, 1959), *The Old Testament and the Fine Arts* (1954), and *The Church and the Fine Arts* (1960), all published under the Harper imprint.

[6] *Christianity Today* 25 (May 8, 1951), pp. 522–23.

[7] Mention should also be made of *Worship* magazine, founded in 1926 by Virgil Michel, O.S.B. It has been published regularly since that time by St. John's Abbey, Collegeville, Minnesota. Although St. John's Abbey is known for its art and architecture, the journal itself seldom deals directly with those subjects. The cover for *Worship* was designed for over thirty years by Frank Kacmarcik, a prominent architectural/liturgical consultant.

[8] In a recent conversation with Susan J. White, I discovered that she had written her doctoral dissertation on *Liturgical Arts* at the University of Notre Dame, where the archives include the materials on *Liturgical Arts*, including Lavanoux's papers.

[9] *Liturgical Arts* 15 (November 1946), p. 1.

[10] *Liturgical Arts* 19 (1950–51), p. 29.

[11] Salvador Dali, "Credo", *Liturgical Arts* 20 (1951–52), p. 75.

[12] Conversation of Dali with Lavanoux in New York City, reported in *Liturgical Arts* 20 (1951–52), p. 93.

[13] *Liturgical Arts* 30 (1961–62), p. 58.

[14] For the nineteenth-century period, attention was given to the religious views of artists. The same could be done for the twentieth century, but the situation is so different that to do so would not appreciably advance the argument. Many twentieth-century artists have an interest in affirming the grandeur and sublimity of humanity, whether their works reflect alienation or more directly its dignity. It is in this sense that spiritual and religious themes enter

their works. While most of the prominent artists of our day have little if any relation to church or synagogue, their human reactions and dispositions are not antagonistic. In the eighties, however, there is a tendency among a fraction of the younger artists to identify with the church, Roman Catholic or Protestant.

[15] *Liturgical Arts* 39 (1970–71), p. 76.

[16] *Liturgical Arts* 20 (1951–52). p. 75.

[17] Among the earliest writings in defense of abstract painting is that of Angelico Surchamp, O.S.B., in his article, "On Behalf of a Truly Religious and Truly Modern Art," *Liturgical Arts* 18 (1949–50), pp. 87–88. The second is by Roman J. Verostko, O.S.B., "Abstract Art and the Liturgy: Considerations from Gislebertus to Twentieth Century U S A," *Liturgical Arts* 30 (1961–62), pp. 129ff. The third is by Thomas Mathews, S.J., "The Future of Religious Art," *Liturgical Arts* 35 (1966–67), pp 86–88. The article by Mathews is particularly perceptive.

[18] Diary Notes by Maurice Lavanoux, 1972–73, on *Liturgical Arts.* He called them a "tocsin to warn our friends against any pessimism as to the revival of *Liturgical Arts.* They hint at the indifference in high places to a constructive and living appreciation of sacred art today, but show that a revived quarterly need not fear a paucity of editorial material, in these United States and in many lands."

[19] *Motive* 10 (1949–50). See the article by Richard A. Florsheim, "Picasso's Guernica," pp. 26ff.

[20] John F. Haywood [Hayward], "Signs of Return in the Alienations of Modern Art," *Motive* 16 (1955–56), pp. 20–26. Hayward, who spent his teaching career at the Federated Faculty and at Meadville Theological Seminary, both in Chicago, and at the University of Illinois, Carbondale, has been interested in the arts thoughout his career and has written many perceptive articles on the subject, indeed, long before others were doing so.

[21] Margaret Rigg, "The Message of the Artist for Today," *Motive* 17 (1956–57), pp. 14f.

[22] "Letter to Subscribers," November 10, 1971, inserted in the last volume of *Motive* in the Graduate Theological Union library.

[23] In many ways, *Youth* magazine, started in 1960 and continuing into the late seventies, served a function similar to *Motive,* only in this case for high school students. It was a joint project serving most of the Protestant churches in the mainstream. While there was considerable photography, sometimes comics by Doug Brunner, and occasional visual arts, it could not be said to have any of the quality of *Motive* magazine, even if the difference in audience between the high school and college levels are taken into account.

[24] Editorial by Otto Lucien Spaeth, *Liturgical Arts* 21 (1952–53).

[25] The exhibition catalogue, published by the Dayton Art Institute, for the exhibition, April 11–June 1, 1944, consists of twenty-four pages of text and twenty-six black-and-white plates.

[26] Paul Tillich, *On Art and Architecture*, ed. Jane Dillenberger and John Dillenberger (New York, 1987).

[27] See Jacques Maritain, *Creative Intuition in Art and Poetry* (Washington, D.C., 1953), and *Art and Scholasticism* (New York, 1930, 1954, 1962); Georges Florovsky, *Christianity and Culture* (Belmont, Massachusetts, 1974).

[28] See Joseph Gutmann, "The Second Commandment and the Image in Judaism," in *No Graven Images: Studies in Art and the Hebrew Bible*, ed. Joseph Gutmann (New York, 1971); and *The Image and the Word*, ed. Joseph Gutmann (Missoula, Montana, 1977).

[29] See John Dixon, Jr., *Nature and Grace in Art* (Chapel Hill, North Carolina, 1964), and *Art and the Theological Imagination* (New York, 1978).

[30] See Jane Dillenberger, *Style and Content in Christian Art* (New York, 1988, reprint of 1965 edition); *Secular Art with Sacred Themes* (Nashville, 1969); with Joshua Taylor, *The Hand and the Spirit;* with John Dillenberger, *Perceptions of the Spirit in Twentieth-Century Art* (Indianapolis, 1977).

[31] Jane Dillenberger, "Visual Arts and the Seminary," *New Directions* 7 (n.d.), a report on a "Survey on the Place of the Visual Arts in Theological Education" conducted in 1967–68. *New Directions* was a publication of the Society for Arts, Religion, and Contemporary Culture.

[32] Wilson Yates, *The Arts and Theological Education* (Atlanta, 1988).

[33] In 1988, the following individuals are teaching in theological schools, or otherwise influencing the area of religion and the visual arts through their teaching and scholarship: Doug Adams, Michael Morris, O.P., Jake Empereur, S.J., and Jo Milgrom, at the Graduate Theological Union; John Cook, Divinity School, Yale University; Margaret Miles and Diana Eck, Harvard Divinity School; Stephen Happel, Catholic University; Cathy Kapikian, Wesley Theological Seminary; Leonard Sweet, Dayton Theological Seminary; John Newport, Southwestern Baptist Theological Seminary, Fort Worth; William L. Hendricks, Baptist Theological Seminary, Louisville; Diane Apostolos-Cappadona, Georgetown University; Gregor Goethals, Rhode Island School of Design; Theodore A. Gill, John Jay College, City University of New York.

[34] Most of the exhibition catalogues discussed in this section are to be found in the Library of the Museum of Modern Art, New York City.

[35] *Magazine of Art* 37 (May 9, 1944) p. 1677.

[36] Charlton Fortune, *Notes on Art for Catholics*, based on the collection of the William Rockhill Nelson Gallery of Art, Kansas City, Missouri (1944). The

text has the imprimatur of the bishop of Kansas City, and consists of fifty-four pages, with black-and-white plates on approximately every other page.

[37] The catalogue for the exhibition, October-November, 1952, includes ten pages of entries, and twenty pages of plates in black and white. In a one-page introduction, the director of the M. H. De Young Memorial Museum (now a member of the Fine Arts Museums of San Francisco), Walter Heil, notes that after the demise of the relation between art and the church in the nineteenth century, a "re-inspiration" seems to have set in. It was also noted that clergy of three faiths had advised the officials of the museum "as to the religious acceptability of the items." At the same time, it is noted that "religious sanction is not to be inferred."

[38] The *Art Sacre* catalogue, while page size in its format, has only seven plates, a five-page introduction by Lamont Moore, associate director of the Yale University Art Gallery, and the entries. Hence, the strength of the exhibition is hardly evident in the catalogue.

[39] *An Exhibition of Contemporary Religious Art and Architecture*, Union Theological Seminary, December 1–16, 1952, presented by the Religious Art Committee of the student body. Essentially, the catalogue consists of eleven pages of entries. There are no plates.

[40] For this catalogue, Tillich provides an early version of the four levels in the relation between art and religion. The developed version style—(1) non-religious style, non-religious content; (2) religious style, non-religious content; (3) non-religious style, religious content; (4) religious style, religious content— is found in "Existential Aspects of Modern Art." Later, Tillich preferred the term "dimensions" instead of levels, as in "Religious Dimensions of Contemporary Art" (1965). Both texts are reproduced in Paul Tillich, *On Art and Architecture, op. cit.* In the Union exhibition catalogue, Tillich does not indicate the level at which he would place any painting, but he does affirm that only in level four do we come to liturgical art.

[41] Jane Dillenberger and Joshua C. Taylor, *The Hand and the Spirit: Religious Art in America 1700–1900* (Berkeley, 1972), 192 pages. The exhibition was sponsored by the Graduate Theological Union, Berkeley; University Art Museum, Berkeley; National Collection of Fine Arts (now National Museum of American Art).

[42] Jane Dillenberger and John Dillenberger, *Perceptions of the Spirit in Twentieth-Century American Art, op cit.*, 177 pages. The exhibition was sponsored by the Indianapolis Museum of Art in cooperation with the Graduate Theological Union, Berkeley.

[43] Maurice Tuchman (organized by), *The Spiritual in Art: Abstract Painting 1890–1985* (Los Angeles, 1986), 435 pages.

[44] For a listing and characterization of many of these exhibitions, see John Dillenberger, *A Theology of Artistic Sensibilities* (New York, 1986), pp. 184ff.

[45] *The Church, the Arts, and Contemporary Culture* (published by the Department of Worship and the Arts, National Council of the Churches of Christ in the U.S.A.). While no date is given, the statement was approved by the Executive Board of the Division of Christian Life and Work on October 4, 1955.

[46] *International Journal of Religious Education* (February 1959).

[47] *Report of the Special Committee on the Council's Role in the Field of Religion* (published for the Division of Christian Life and Mission, National Council of the Churches of Christ in the U.S.A., by the Department of Publication Services, 475 Riverside Drive, New York, n.d.). Since the report was received and adopted in 1963, it must have been published soon thereafter.

[48] From 1952 to 1967, the Commission on Christian Higher Education of the National Council of Churches was responsible for the publication of the *Christian Scholar*. In 1967, the journal came to an end, the National Council reporting (vol. 50, 1967, p. 341) that the journal

> does not go under primarily for financial reasons, though it has had its problems. The basic reasons is one of strategy. After long and careful consideration of the issues involved, the Executive Committee of the Department of Higher Education of the National Council of Churches has decided that a quarterly journal is no longer the best way to carry on the kind of reflective and reportorial communication that expresses its interests. No less concerned for scholarly and intellectual matters, the life of the Department now needs to have less formal expression through a variety of more occasional publications. The process of developing these is underway. Times change and with them human institutions change. The demise of *The Christian Scholar* reflects the mood of a changed situation and direction within the Department.

The National Council is then happy to report that a similar journal, *Soundings*, independent of the National Council, will pick up some of the interdisciplinary debate. *Soundings*, variously sponsored, but now published by the Society for Values in Higher Education and the University of Tennessee, Knoxville, has indeed done that. But in its pages, as in the *Christian Scholar*, the accent has fallen on arts other than the visual.

[49] The papers of the early days of the Society for Arts, Religion, and Contemporary Culture are in the archives, Andover-Harvard Library, Harvard Divinity School, Cambridge, Massachusetts.

Chapter 12

[1] Thomas Cole was unhappy with humans who gouged the terrain in building railroad tracks through hills and valleys, a despoiling which for him

must have felt like the factors that have led to contemporary concerns with ecology. Perhaps the continuity of such concern is evident in Alfred Leslie's *Oxbow,* which shows a freeway going over the bend of the Connecticut, painted precisely from the spot where Cole painted his *Oxbow.* See Doug Adams, "Environmental Concern and Ironic Views of American Expansionism Portrayed in Thomas Cole's Religious Paintings," *The Cry of the Environment and Rebuilding the Christian Creation Tradition,* ed. Philip Joranson and Ken Butigan (Santa Fe, 1984) pp. 296–308.

[2] Sidney Geist, *Brancusi: A Study of the Sculpture* (New York, 1983), p. 5.

[3] See introduction to the catalogue *Perceptions of the Spirit in Twentieth-Century American Art* (Indianapolis, 1977), and *A Theology of Artistic Sensibilities* (New York, 1986).

[4] See, particularly, Jack Cowart, Juan Hamilton, Sarah Greenough, *Georgia O'Keeffe: Art and Letters* (Washington, D.C., and Boston, 1987).

[5] Stieglitz Letter to Duncan Phillips, February 1, 1926, quoted in Yong Kwon Kim, *Alfred Stieglitz and His Time: An Intellectual Portrait* (American Studies Institute, Seoul, South Korea, 1978), p. 98. See also the remarks to Anita Pollitzer by Stieglitz, when shown O'Keeffe"s drawings, "finally, a woman on paper," quoted in Sue Davidson Lowe, *Stieglitz, A Memoir Biography* (New York, 1983), p. 201. Jane Dillenberger has remarked that only a woman could have done most of her paintings.

[6] For a description of how the wall functions, see John K. Simmons, "Pilgrimage to the Wall," *Christian Century* 102 (November 6, 1985), pp. 998–1002. Frederick Hart, who did the figures for the Vietnam Memorial, also did the tympanum on the Washington Cathedral. For a viewpoint more positive of his work than my own, see Sarah Booth Conroy, "A Genesis in Stone," *Horizon* 22 (September 1979) pp. 28–37.

[7] Stephen De Staebler and Diane Apostolos-Cappadona, "Reflections on Art and the Spirit; A Conversation," *Art, Creativity, and the Sacred,* ed. Diane Apostolos-Cappadona, New York, 1985), p.33.

[8] See the booklet, *KPIX Lifeline and the San Francisco Examiner Present a Holiday Tribute to Volunteers in the Fight against AIDS, The Names Project* (Moscone Center, December 17–20, 1987). Also see the article by Rob Morse, "AIDS quilt: Lost Lives that are part of us all," *San Francisco Examiner,* December 20, 1987.

[9] Based on conversations with George Segal, particularly November 7, 1984

[10] There is no doubt in my mind that Newman and the abstract expressionists lived and worked in a social context. But my intention here is to focus on how the artists understood and met the plight of their time through their art. Hence,

while I find the materials of Timothy J. Clark and Serge Guilbaut instructive, it seems to me that what is interesting about art works is the way in which, in meeting their time, they also transcend it, even send it into new directions. Hence, while Guilbaut is interested in showing how the disillusionment of the Expressionist painters led them to a non-political art, which in turn was taken up by the liberal establishment as a sign of their cultural hegemony in the postwar world, I find that viewpoint rather uninteresting, even if true. See Serge Guilbaut, *How New York Stole the Idea of Modern Art: Abstract Expressionism, Freedom, and the Cold War* (Chicago, 1983). While Guilbaut gives considerable attention to Newman, the work *Pollock and After: The Critical Debate*, ed. Francis Frascina (San Francisco, 1985), largely understands Pollock in social and political contexts. See the critical reviews by Michael Brenson, "Divining the Legacy of Jackson Pollock," *New York Times*, December 13, 1987, and by Grace Glueck, "Clashing Views Reshape Art History," *New York Times*, December 20, 1987. For another perceptive account of this material, as well as the critical theories of Clement Greenberg and Harold Rosenberg, see the review by Robert Storr, *Art Journal* 46 (Winter 1987), pp. 323–27.

[11] Wassily Kandinsky's *Concerning the Spiritual in Art* was first published in 1912. It was published in English by Stieglitz in *Camera Work*. It also was published by George Wittenborn, with considerable revision of the 1914 translation, in 1947, 1955, 1963, and 1964.

[12] See my introduction to *Perceptions of the Spirit, op. cit.*, and *A Theology of Artistic Sensibilities, op. cit.*, chaps. 6 and 7.

[13] Robert Rosenblum, *Modern Painting and the Northern Romantic Tradition: Friedrich to Rothko* (San Francisco, 1975).

[14] Peter Krieger, "Caspar David Friedrich," *Gemalde der deutschen Romantik aus der Nationalgalerie Berlin* (Berlin, 1985), p. 9.

[15] *New York Times*, November 8, 1987.

[16] Giles Gunn, "Abstract Expressionism and the Adamic Impulse," *Religion and Intellectual Life* 1 (Fall 1983), pp. 33–53.

[17] Conversation with Barnett Newman, April 12, 1969

[18] Maurice Tuchman (organized by), *The Spiritual in Art: Abstract Painting 1890–1985* (Los Angeles, 1986).

[19] Annie Besant and Charles W. Leadbeater, *Thought Forms* (1901). Rudolf Steiner's works are extensive and in many editions. Among works of particular interest are *Christianity as Mystical Fact and the Mysteries of Antiquity*, *The Bridge between Universal Spirituality and the Physical Constitution of Man*, and *The Arts and their Mission*.

[20] W. Jackson Rushing, "Ritual and Myth: Native American Culture and Abstract Expressionism," *The Spiritual in Art: Abstract Painting 1890–1985, op. cit.,* p. 273.

[21] One also finds Indian affinities in Jackson Pollock's *Male and Female,* in *Totem Lesson,* and in *Portrait and Dream.* In the latter, there is a confluence of the primitive and the psychological.

[22] Introduction to the catalogue *Northwest Coast Indian Painting* (New York, 1946). Newman's writings, which are widely scattered and in publications not easy to find, are being edited by Sam Hunter.

[23] The preceding materials are pulled together from Newman's article, "The First Man was an Artist," *Tiger's Eye* 1 (October 1947), pp. 57–60. In the paraphrasing, inclusive language has been used, particularly since Newman used man as inclusive of both men and women.

[24] Barnett Newman statement in "Jackson Pollock: An Artists' Symposium, Part 1," *Art News* 66 (April 1967).

[25] In this context, Karl Barth's pilgrimage is interesting. In his early writings, he used existential categories, but then repudiated them as the last dependence of theology on a view of humanity. Instead, he declared that God was wholly other, a statement he felt he could make because what was known in revelation was not in the human cards. Still later, Barth affirmed the humanity of God, which was also a rehabilitation of the human. See Karl Barth, *The Humanity of God* (Philadelphia, 1960).

[26] Paul Tillich, *On Art and Architecture,* ed. Jane Dillenberger and John Dillenberger (New York, 1987), p. 133n.

[27] Harold Rosenberg, "The Art World: Icon Maker," *New Yorker,* April, 1969, p. 138.

[28] Jane Dillenberger, *Secular Art with Sacred Themes* (Nashville, 1969), p. 102

[29] Doug Adams first brought this matter to my attention. See Doug Adams and Jerry H. Gill, "Jasper Johns' Painting: Some Philosophical Parallels," *The Tenth Chapter* (Journal of the Erasmus Society) 1, no. 2 (1976), p. 12.

[30] Frank Stella, *Working Space* (Cambridge, Massachusetts, 1986), p. 71.

[31] Harold Rosenberg, "The Art World: Icon Maker," *New Yorker,* April, 1969, p. 140.

[32] It is important to affirm that Newman limited the sublime to a total penetration into the mystery of ourselves. It is not the sublime in the sense of a feeling for infinity, an intuition of the unknown, or a concern with the supernatural/occult. See the penetrating article by Michael Zakian, "Barnett Newman and the Sublime," *Arts Magazine* 62 (February 1988), pp. 33–39.

[33] Jane Dillenberger and John Dillenberger, *Perceptions of the Spirit in Twentieth-Century American Art, op. cit.*

[34] Maurice Tuchman (organized by), *The Spiritual in Art: Abstract Painting 1890–1985, op. cit.*

[35] Thomas Sokolowski, *Precious: An American Cottage Industry in the Eighties* (New York, 1985).

[36] David S. Rubin (curator), *Concerning the Spiritual: The Eighties* (San Francisco, 1985).

[37] The *Christa* sculpture was shown at the Cathedral of St. John the Divine in New York City, then at the Stanford University chapel, and from October to December, 1984, at the Bade Museum, Pacific School of Religion, Berkeley. The *Journal of Women and Religion* 4, no. 2 (Winter 1985), published by the Center for Women and Religion of the Graduate Theological Union, Berkeley, was entirely devoted to "Reflections on the Christa." Ten individuals, writing from different perpectives, gave their views on its significance for their own lives. The article by Jo Milgrom is the only one that deals with the piece with art historical information, pointing out where the theme has emerged before, including context and meanings. It is a most instructive account. The other articles mainly deal with individual experiences with the work. In her introduction, Mary Cross reiterates the familiar viewpoint, one in which religious art is evaluated in terms other than its artistic value. "Religious art carries with it a special standard of value. We judge religious art not by perfection of line or by purely aesthetic excellence, but rather value it through its relationship with a community and the meaning it evokes for people. So when we talk about the value and importance of *Christa*, we are really talking about a relationship that has grown out of our experience with this remarkable work of art" (*ibid.*, p. 33) Hence, while the aesthetic value is never denied, it is never affirmed. The result is the bad state of art in relation to religion. In the previous volume of the *Journal of Women and Religion* 3, no. 2, (Spring 1984) pp. 51–58, Martha Ann Kirk, C.C.V.I., in "Art for Worship, Women as Imaged, Women as Image Makers," gives an interesting and important account of women artists working for the church throughout Western history. She talks about the need for the particular experiences which women can bring into the making of art.

Chapter 13

[1] James Thrall Soby, "Modern Religious Art," *Saturday Review of Literature* 33 (January 7, 1950), p. 36.

[2] *Liturgical Arts* 15 (1946–47), p. 112.

[3] *A New Approach to Living Religions Art: A Church Prototype by André Girard, Painter, and Jean Labatut, Architect* (New York, 1951). See also *Li-*

turgical Arts, November, 1951, as well as the November, 1949, issue. In the latter issue, Girard's paintings for the church in Stowe, Vermont, are illustrated.

[4] See E. A. Carmean, Jr., "The Church Project: Pollock's Passion Themes," *Art in America,* Summer, 1982, pp. 110–22, and E. A. Carmean, Jr., "The Pollock Puzzle," *Washington Post,* March 21, 1982. For an opposing view, see Rosalind Krauss, "Contra Carmean: The Abstract Pollock," *Art in America,* Summer, 1982, pp. 123ff.

[5] This summary, with its quotes, is based on Vatican II's *Constitution on the Sacred Liturgy,* nos. 122–30 and the Appendix.

[6] "Thanksgiving" initially did not mean free of financial matters. Indeed, one of the problems associated with the de Kooning triptych was financial. The Worship Committee felt that donors for the painting might be available for other more important projects. While the triptych was recently given to St. Peter's, the general point still obtains. Such issues are frequently debated in institutions without the possibility of proof one way or the other. Ronald Goetz, writing in the *Christian Century* (March 19–26, 1986, p. 303), suggested that I was much too cavalier about money for the arts. The price of rare major paintings have, of course, skyrocketed to the point of absurdity in recent gallery sales. My own judgment is that, on the other hand, there are always competing claims for funds, and that different individuals do give to different causes and concerns. Moreover, I simply do not believe that the visual arts are the one place to cut. If churches are to give their resources to the poor (and that problem is so massive that a total societal, political change is essential), they could also stop buying and repairing organs. Think of the money spent on organs in churches with hardly a protest, or on fonts, baptistries, pulpits, lecterns, altars, stained glass, and so on. It always seems odd that the visual arts are singled out.

[7] The carefully and clearly written letters to officials in the church are by Gail Ramshaw, a well-known liturgist. Her books are based in sound scholarship and are written with a graceful style. She is conversant in, and appreciative of, the visual arts. Her position is widely shared. I happen to believe that a wider use of the arts is desirable.

[8] Leonard Sweet, "Ten Best Religious Books of 1986," *Supplement to bi•be•lot* 11, no. 3. In raising this question so directly in his appreciative review of my book, *A Theology of Artistic Sensibilities,* Sweet made me face the question more directly than heretofore.

[9] Quoted by Emily Genauer, "Has Abstract Art a Place in Christmas?" *House and Garden* 110 (December 1956) p. 21.

INDEX

The index covers plates, text, and notes. In instances in which the notes refer to the literature on an artist, separate entries for the authors of this bibliography are not included in the index. Clergy portrait listings are also to be found in the notes in the aggregate and are not listed separately in the index. Journals and periodicals are listed under "Journals, Papers, Periodicals." Paintings and sculptures discussed in the text or considered important to the volume are listed alphabetically under the heading "Paintings and Sculptures." Other paintings of religious subjects by artists tangential to this study are listed in the notes under the name of the artist.